The Four Winds Guide to Indian Trade Goods & Replicas

Including Stone Relics, Beads, Photographs, Indian Wars, and Frontier Goods

Preston E. Miller and Carolyn Corey

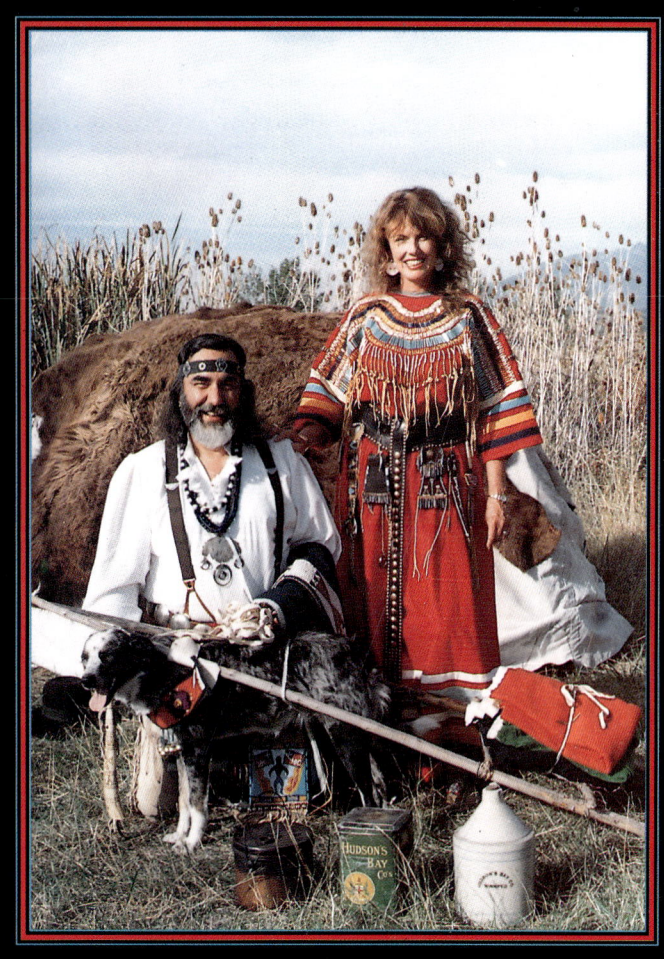

4880 Lower Valley Road, Atglen, PA 19310 USA

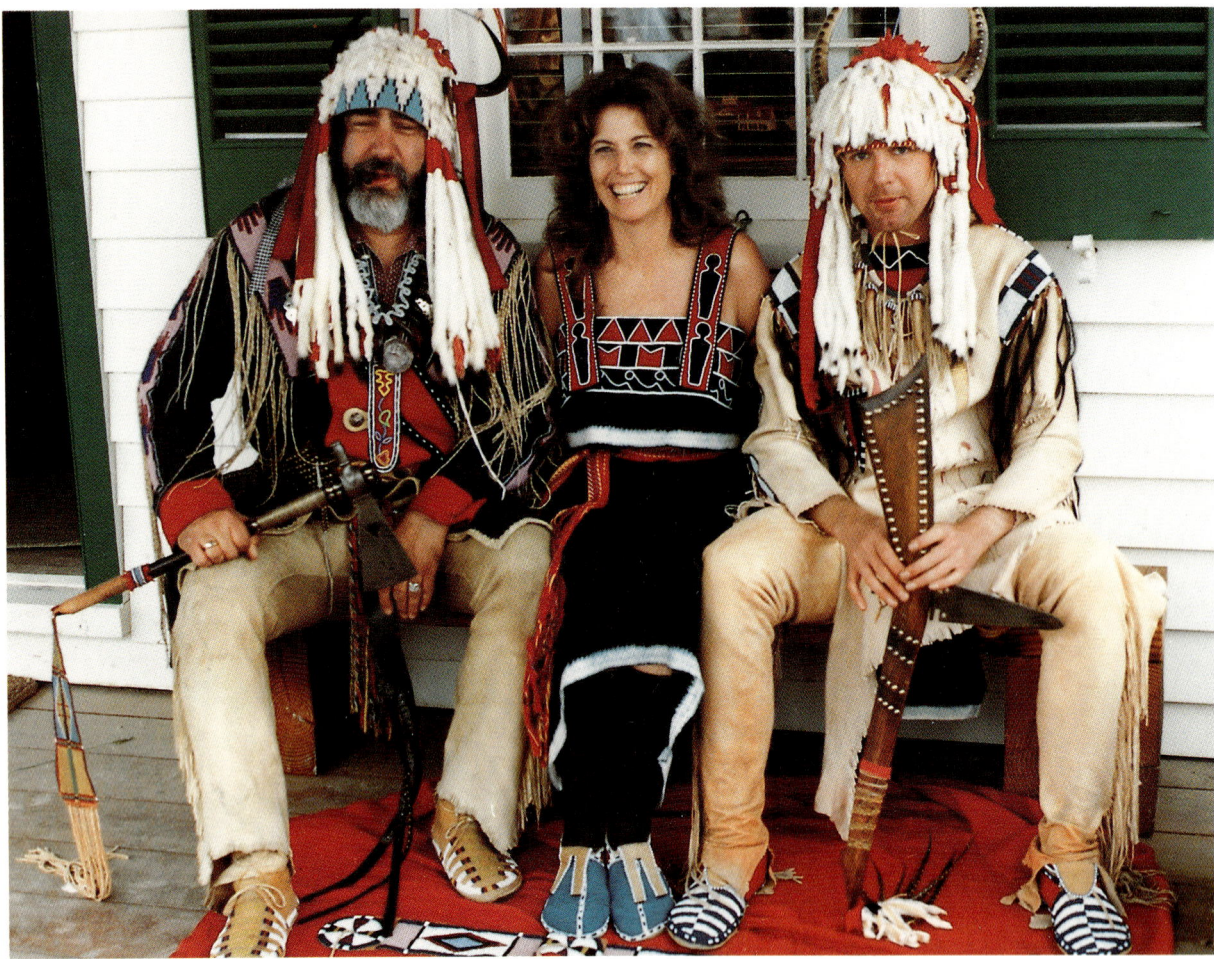

Copyright © 1998 by Preston E. Miller and Carolyn Corey
Library of Congress Catalog Card Number: 98-85449

All rights reserved. No part of this work may be reproduced or used in any
form or by any means—graphic, electronic, or mechanical, including
photocopying or information storage and retrieval systems—without
written permission from the copyright holder.
"Schiffer," "Schiffer Publishing Ltd. & Design," and the "Design of pen and
ink well" are registered trademarks of Schiffer Publishing, Ltd.

All photographs for this book taken by the authors
Designed by Bonnie M. Hensley
Layout by Randy L. Hensley
Typeset in Swiss 721 BT bold/Korinna BT

ISBN: 0-7643-0531-X
Printed in China
1 2 3 4

Published by Schiffer Publishing Ltd.
4880 Lower Valley Road
Atglen, PA 19310
Phone: (610) 593-1777; Fax: (610) 593-2002
E-mail: Schifferbk@aol.com

In Europe, Schiffer books are distributed by Bushwood Books
6 Marksbury Avenue Kew Gardens
Surrey TW9 4JF England
Phone: 44(0)181-392-8585;
Fax: 44(0) 181-392-9876 E-mail: Bushwd@aol.com

Please write for a free catalog.
This book may be purchased from the publisher.
Please include $3.95 for shipping. Please try your bookstore first.
We are interested in hearing from authors
with book ideas on related subjects.

Contents

Introduction ... 4
 How to Use This Book 4
 Reasons for Collecting 4
 Plateau Parade - A Tribute 5

I. Stone Relics & Ethnographic Collectibles 6
 Projectile Points (Stone) 6
 Hide Scrapers ... 13
 Primitive Clubs with Handles 15
 Large Stone Tools 16
 Bone Tools, Misc. Stone & Shell Items 20
 Fossils .. 23
 Metal Relics ... 24
 Eskimo Artifacts 25
 Pipes .. 30
 Wood, Horn & Bark Items 37

II. Trade Goods .. 44
 HUDSON'S BAY COMPANY COLLECTIBLES ... 44
 Weapons, Tools, etc. 56
 Misc. Trade Goods 59

III. Trade Beads .. 63
 African Trade Beads, similar types as traded to
 North America 63
 North American Trade 75

IV. Frontier Goods ... 81
 Garments .. 81
 Buffalo Robes & Skulls 84
 Cowboy Horsegear, etc. 86
 Snowshoes .. 90

V. Military Goods Of The Indian Wars Period ... 92

VI. Photos, Prints & Papergoods 99
 Original Photographs 99
 Stereoscope Cards 107
 Photo Postcards 109
 Documents, Lithographs, Studio Prints & Misc. ... 112

Introduction to Replicas 121
 Collecting Replicas 121
 Bead Glossary & Definitions 122
 Comparison of Old vs. New 124

VII. Reproductions of Traditional Indian Art 129
 Clothing & Accessories 129
 Pouches & Bags 144
 Painted Rawhide Items (Parfleche) 157
 Weapons, Sheaths & Scabbards 161
 Shields .. 173
 Pipes & Pipe Tomahawks 175
 Horse Gear .. 177
 Children's Items 179
 Dance Paraphernalia & Musical Instruments ... 184
 PHOTO ESSAY "REPLICAS AT RENDEZVOUS" ... 186

Abbreviations Used in This Book

See also bead definitions for bead color abbreviations on page 123.

alt.=alternating
apx.=approximately
avg.=average
bkgrd.=background
c.=circa
comm.=commercial
cond.=condition
Czech.=Czechoslovakia
D.=deep (depth)
diam.=diameter
diff.=different
dk.=dark
ea.=each
Ex.=example
exc.=excellent
excl.=excluding
Fdn.=Foundation
H.=high(height)
incl.=including

Is.=Island(place name)
L.=length
lt.=light
mocs=moccasins
nat.= natural
No.or N.=North
nr.=near
pred.=predominantly
pr.=pair
prob.=probably
prov.=provenance
pt.=point
R.=River(place name)
Res.=Indian Reservation or Reserve(Canada)
So. or S.=South
transl.=translucent
turq.=turquoise
VG=very good
w.=white
W.=width
w/=with
yrs.=years

Introduction

How To Use This Book

The American Indian collectibles in this book were sold by Four Winds Indian Auction in St. Ignatius, Montana over a ten year period in their absentee mail/phone/fax auctions. Included in this volume are stone artifacts, photographs, trade beads, frontier and military related items, and replicas made by contemporary craftspeople. Genuine Indian-made items of both old and new vintage were featured in the companion volume to this work, *The Four Winds Guide to Indian Artifacts*. The full range of items in each category with **descriptions, dates, price estimate, and prices realized** will provide useful information to both sellers and collectors.

The **title** of each item is named using terminology that is most accepted by experienced collectors. This is followed by a **date** approximating the year in which the item was made. Without certified provenance, it is difficult to be completely accurate when assigning dates to Indian material based solely on appearance, so that a date of "c. 1870" assumes that an item could be made 10 years earlier or later.

Information on provenance, when available, is *italicized*, following the date.

The **descriptions** contain pertinent construction details, such as a detailed list of bead colors and materials used, as well as the size and condition of the item. All are very important factors in determining the value of an item. For instance, certain bead colors can help verify the age *(See Bead Glossary p.122)*, usually the older a piece is the more it is worth. Also, the use of thread or sinew, brain tan or commercial hide *(see definitions, p.122)*, and whether or not the item is in good condition can be very important when assigning values. Many price guides fail to take these things into account when establishing an item's value. It is important to realize that a pair of moccasins with half the beads missing is worth considerably less than an intact pair with little or no damage. The same applies to torn rugs, damaged baskets, broken pottery or stone artifacts; often the damaged item can be worth less than half the value of a similar but intact one. Sometimes an item will be so undesirable that you might have difficulty finding a buyer. The exception could be when an item has a provenance or rarity that makes it one-of-a-kind. For instance, a stiff torn moccasin that has positive provenance proving that it was picked up at the Battle of Wounded Knee or a damaged but very rare early incised buffalo hide parfleche would continue to fetch a high price.

Finally, we list the price for which each item was sold at our auction preceded by the estimate range. Example: "Est. 400-800 **SOLD** $250(88)". The dollar amount following the word **SOLD** is the amount for which the item was sold and the numbers in parenthesis indicate the year that it sold. This is an accurate method for assigning values to artifacts. At auction, the highest price realized is determined by the bidders. It means that at least two people had similar ideas as to the value of an item. Also, it can be assumed that because participants in any one auction are limited, there must be other buyers outside the auction realm who will pay as much or more. The **estimate range** reflects **the current (1998) market value** as determined by our personal opinion guided by many years of experience. (Preston has been selling, buying & collecting Indian artifacts for over 40 years). Sometimes the range can seem quite broad; for instance, "Est. 400-800" might leave you a little doubtful as to the real value. As the seller, you can always ask $800 and come down but you can never ask $400 and go up when a customer is ready to buy. This principle works vice versa for the buyer. If you can buy or sell an item within our suggested estimate range, you can feel secure that your transaction was financially acceptable. **There are so many variables to every situation that it would be impossible to assign one price value to each artifact.**

It is important to note that if an item sold for a certain amount in 1988 it should have appreciated with time. Since there is no scale that can be assigned to evaluate the appreciation that accrued with time you will have to use your personal judgement. Because some items appreciate slowly, not at all, or even depreciate this can only be determined by knowledge of the current trends in the marketplace.

Any omissions are because information was not available or could not be verified. Also, we have included some noteworthy items that did not sell at auction for which our estimates will serve as a value guide.

Reasons for Collecting

Beginning in the 1970s, the collecting of Indian artifacts reached new levels of popularity, perhaps encouraged by the fact that several major antique and art auction houses began selling collections of old Indian-made items to high paying buyers. Prior to these auctions, Indian-made relics seemed to be viewed as merely craftwork having little or no art value. Because of this new demand, many old and here-to-fore unknown treasures were gradually unearthed from old family trunks, attics, and museum storage areas to be placed into the collectors' market. Today, there are more people collecting Indian artifacts, and the number continues to grow. The reasons for collecting include investment potential, historical value, art and craft appreciation, home and business decoration, and personal adornment. See the companion volume, *Four Winds Guide to Indian Artifacts*, pp. 4-5 for an in-depth discussion of these categories.

Plateau Parade- A Tribute
by Carolyn Corey

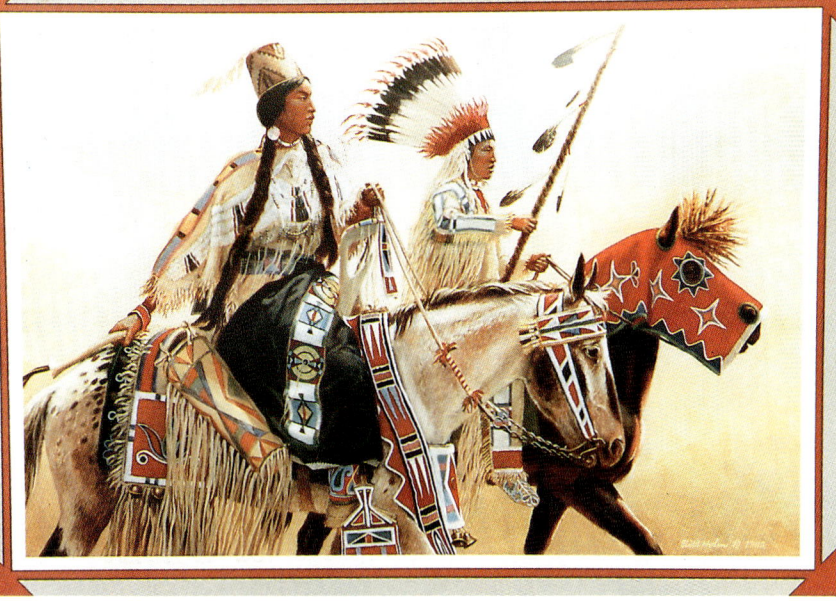

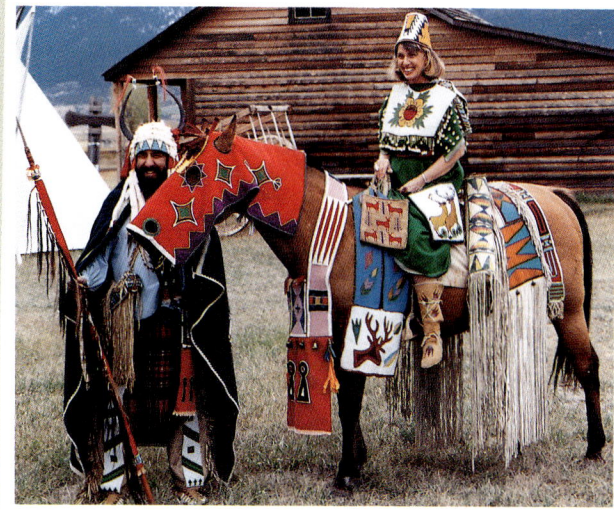

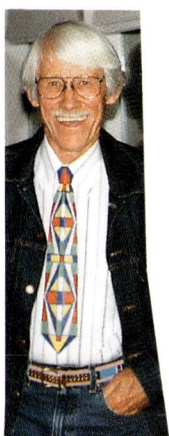

The authors and the horse are decked out in both authentic and replica artifacts (far right). Carolyn's dress, cape and bags are all old; parfleche bag is new. Preston is wearing old Blackfeet leggings and replicas: headdress, bandolier and spear. The horsemask is a replica inspired by Bill Holm's painting *"Parade"* (above left). He says this mask is drawn from his imagination; a composite of several that he has seen. Bill is seen on the far left wearing a rawhide painted tie that he made. His creativity is an inspiration to all who love American Indian Art. Bill's credentials and contributions to American Indian Art are considerable: former curator of the Burke Museum in Seattle, author of numerous books and prolific craftsman. His early Boy Scout "hobbyist" childhood gave him a solid foundation for his later academic achievements.

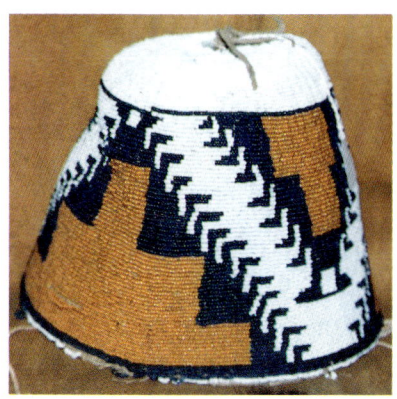

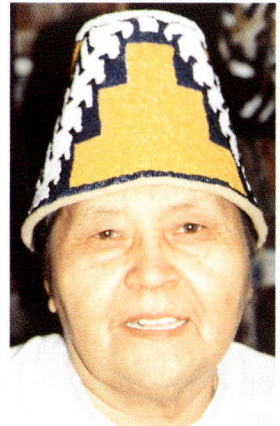

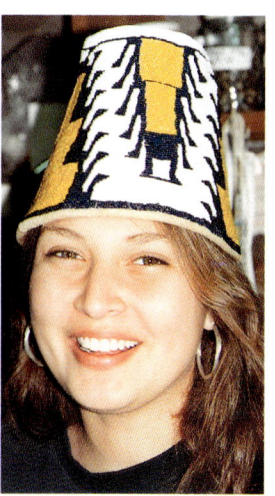

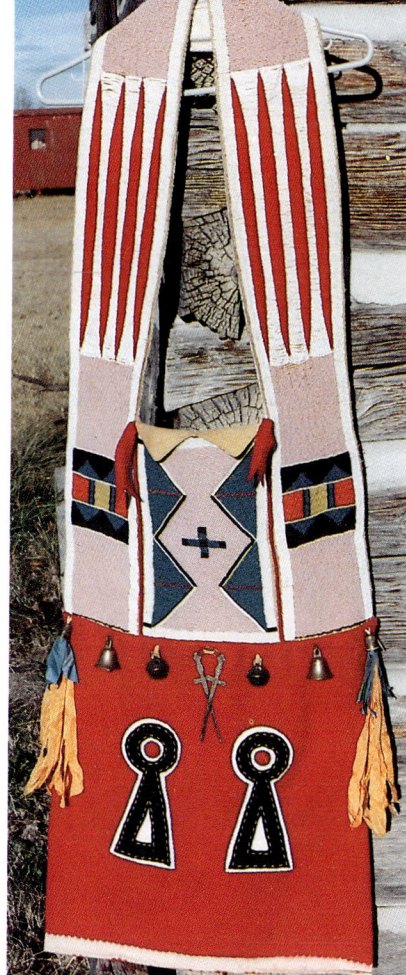

Plateau beaded hat worn by Carolyn was copied from an original sold at an Allard Auction (far left). Cecile Lumprey, Salish from the Flathead Res., wears the hat that she beaded with Preston's instructions.(center left) Our store employee and beadworker, Kahneedah Fleming, Shoshone-Paiute,(center right) models the same hat.

Cecile also did the beadwork on the Ute (or Cayuse) style bandolier which is shown worn around the horse's neck. Preston then put it together using Carolyn's "saved list" cloth for the drop.
Far Right: It was adapted from the original shown in *American Indian Art* by Norman Feder,NYC, Abrams 1965:plate 13. Mr. Feder, then curator of the Denver Art Museum, brought the
attention of the world to the value of American Indian artifacts viewed as works of art rather than solely for their ethnographic value.

I. STONE RELICS & ETHNOGRAPHIC COLLECTIBLES

Projectile Points (stone)

ARROWHEAD COLLECTIONS (Multiple lots)

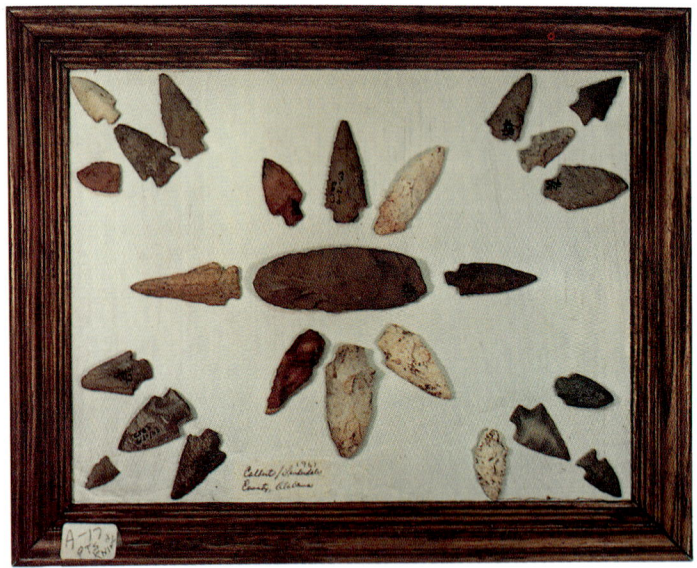

FRAME OF 25 POINTS & 1 KNIFE
Colbert County, AL. 1961. R. Moore Coll. Tan, pink, grey chert. Wood frame; white bkgrd. No glass. 15" X 18.5." Est. 150-200 **SOLD $175(90)**

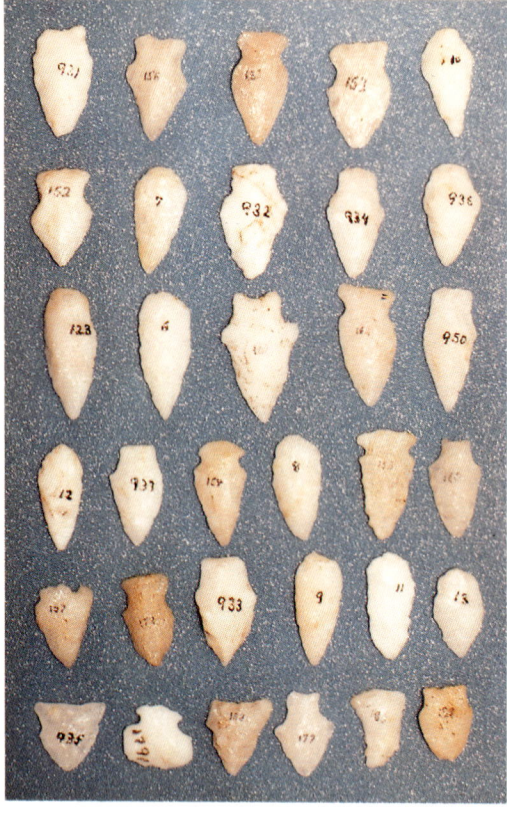

33 WHITE QUARTZ POINTS
Virg. & Penna. Most are from the Frank Flory Collection, York, Penna. sold at auction in 1953. The earliest points were found by him in 1887. The remaining pts. are from the Delman Collection & found along the James R. nr. Richmond, VA around 1900. Each one is documented with date & location on back of mount. .88"-1.75." 8" X 12" Riker mount Est. 150/275 **SOLD $150(91)**

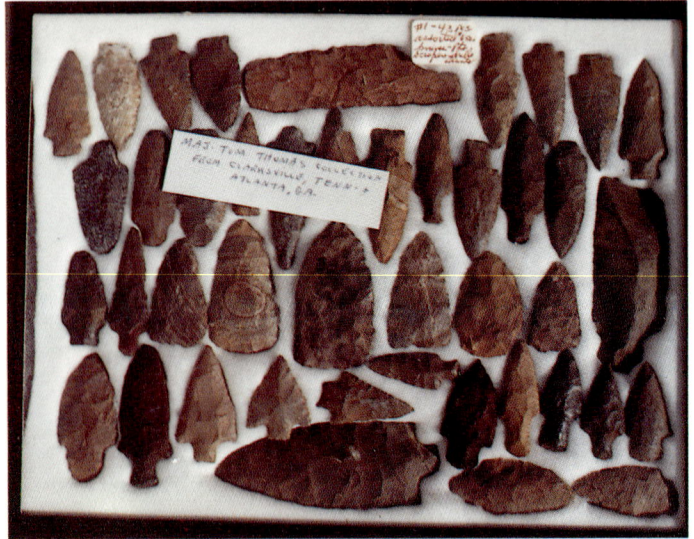
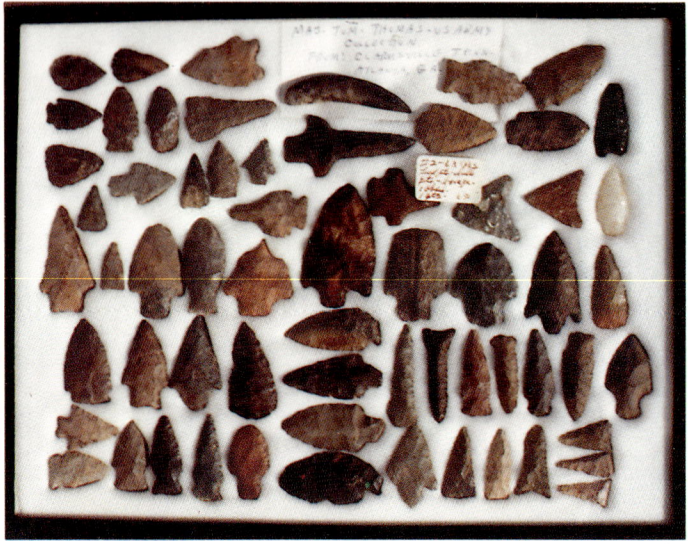

The above 2 lots are of exceptional quality *from the Maj. Tom Thomas (U.S. Army) Collection. Atlanta, Georgia & Larksville, Tenn.* Each is in a 12" X 16" Riker mount:
43 KNIVES & POINTS
Large & interestingly textured stone & flint; 3 pieces are 5." Est. 300-400 **SOLD $185(91)**
63 DRILLS & POINTS
Very fine assortment; deep red, pink grey, tan to black. 1.5"-3." Est. 450/650 **SOLD $300(91)**

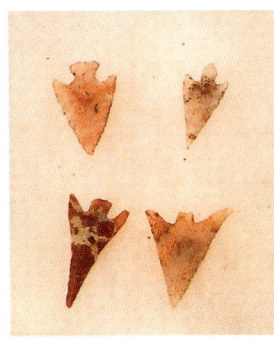

LOT OF 4 AGATE GEM POINTS
2 largest from Ore. 2 smaller from Wyom. Grey, pink to brown stone. Nicely flaked. Largest is 1.5." Est. 150-200 **SOLD $150(95)**

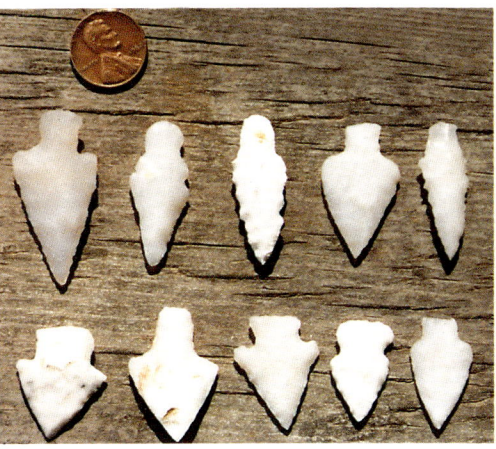

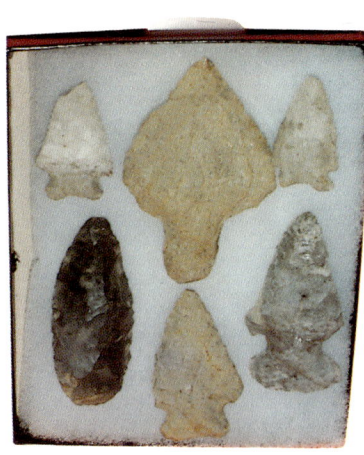

10 POINTS FROM TEXAS
White flints & chert. Perfect points. .88" x 1.88" L. Est. 40-80 **SOLD $45(96)**

6 FLINT POINTS
Unmarked. Dk. grey, tan & grey. 1.63"L to 3"L. 5" X 6" Riker mount. Est.40-60 **SOLD $40(93)**

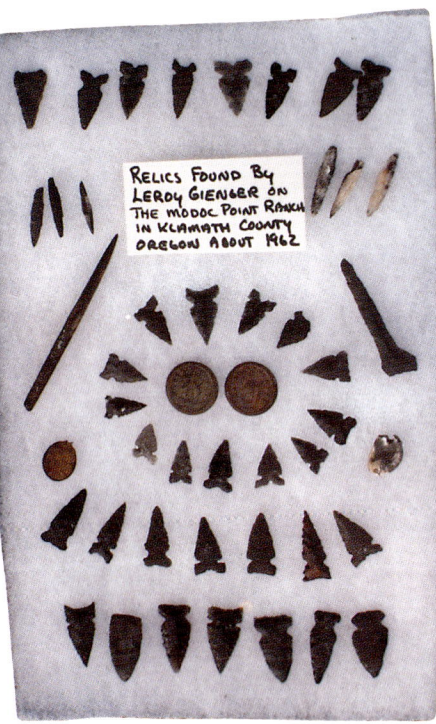

COLLECTION OF RELICS c.1800
found by Leroy Gienger on the Modoc Point Ranch in Klamath County, Ore. around 1962. 35 obsidian arrow points .63" - 1.25"L; bone awl 3.38"L; 2(7/8") brass buttons w/"Massachusetts" & standing Indian holding bow & arrow embossed on front;1 corroded Catholic medal; 6 stone & bone awl points; 2.25" stone drill & an elk's tooth 8.5" Riker mount. Est. 300-500 **SOLD $325(92)**

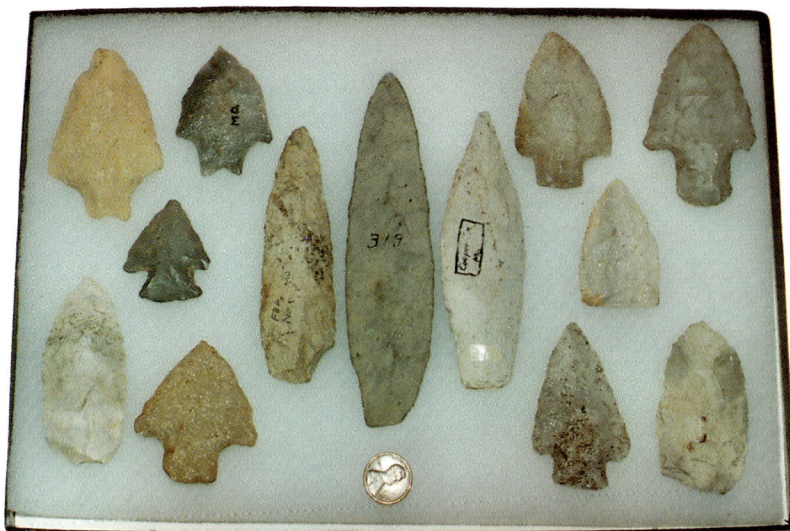

13 MISSOURI POINTS
Colors are tan, gold, greys, & grey-green flint. 3 large blades in center are very old and possibly Paleo. Middle one is heavily water worn & measures 5.5." *Center right blade marked "Copper Co. MO".* 1.5" X 5.5"L. 8" X 12" Riker mount. Est.200-300 **SOLD $175(93)**

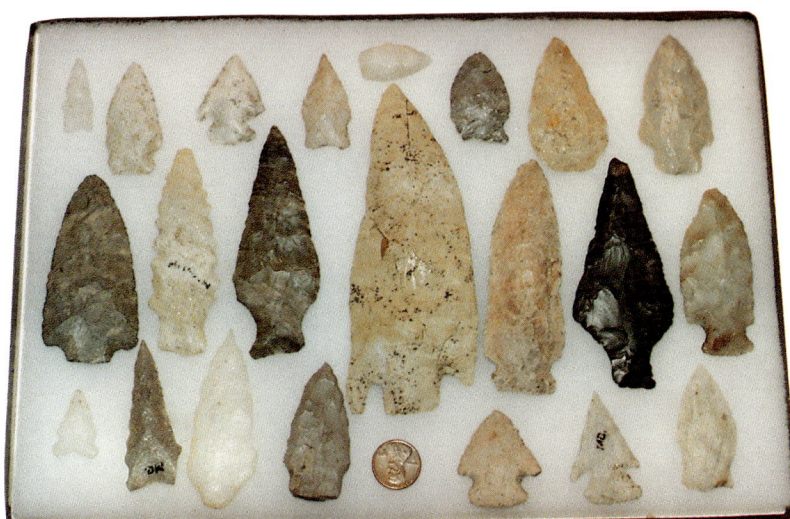

22 FLINT & WHITE QUARTZ POINTS
Many marked from Missouri. Colors vary from tan, pinkish-grey, to black & white. Sizes 1.13" to a 5.25" large tan flint knife in center; *marked "Dunklim Co., MO".* It is in perfect cond. 8" X 12" Riker mount. Est. 200-350 **SOLD $325(93)**

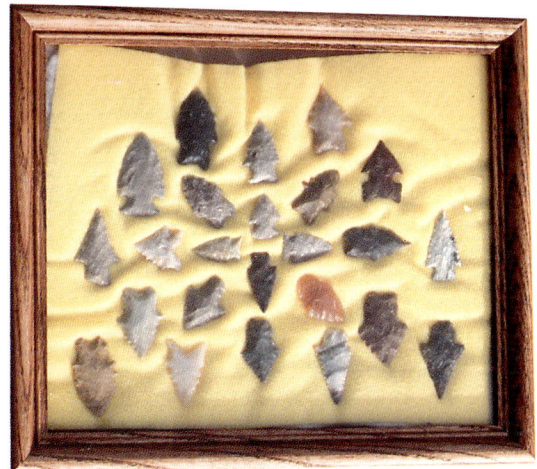

24 FRAMED ARROWHEADS
Tag w/frame reads "No. N. Mexico arrowhead points, Copper Age, flaked from petrified palm, obsidian, carnelian". Colors: grey, brown, red & black. Every point in perfect shape. Sizes range 1"-1.5"L. Oak frame 9" X 11". Est. 250-350 **SOLD $300(94)**

7

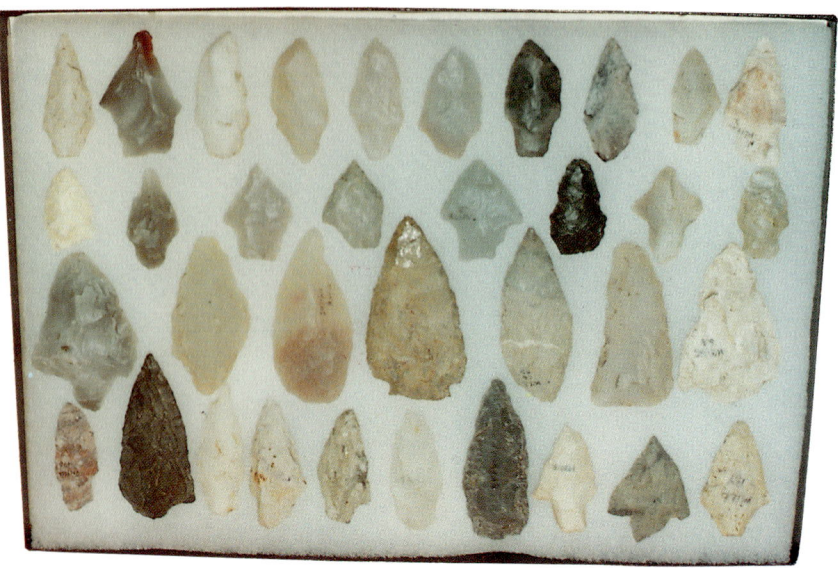

35 FLINT POINTS
Colors are white, pink, tan, dk. grey, grey & black. Some are marked w/specific locales ie.,"Wrights 6N", "Fentor", etc. 1.25" X 2.75." 8" x 12." Riker mount. Est.75-150 **SOLD** $85(93)

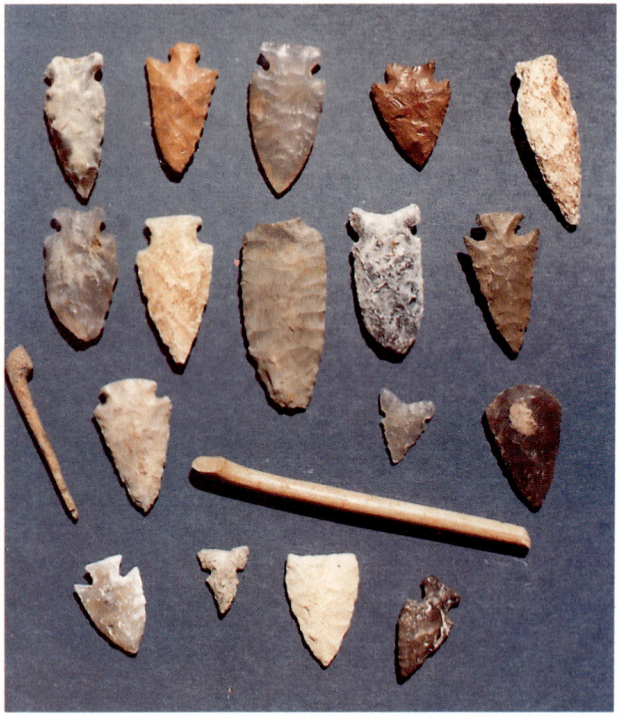

19 ARROWHEADS & 2 WORKED BONES
According to consignor, *these were found on the So. Dakota-Nebraska border. Acquired from an old S.D. ranch collection.* Made from flint & chert in reds, whites, greys & opalescent. Most are in perfect cond. & show exc. patina. Bones are broken pieces. .62"-2"L. Est.200-300 **SOLD** $275(94)

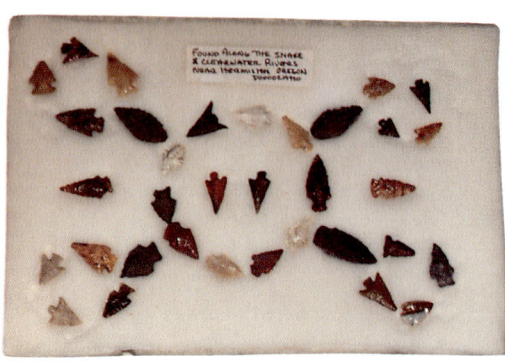

34 ARROWPOINTS
found along the Snake & Clearwater R. near Hermiston, OR. Nice selection of points in various colors:red, grey, white & brown. Flints, greystone, chert, etc. Smallest is 1.5-largest .63." 8" X 12" mount. Est. 195-275 **SOLD** $155(95)

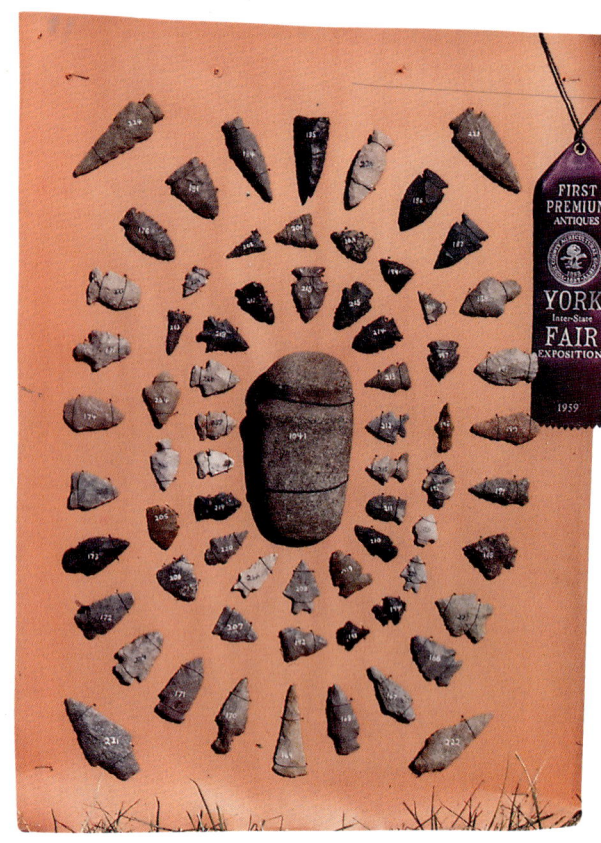

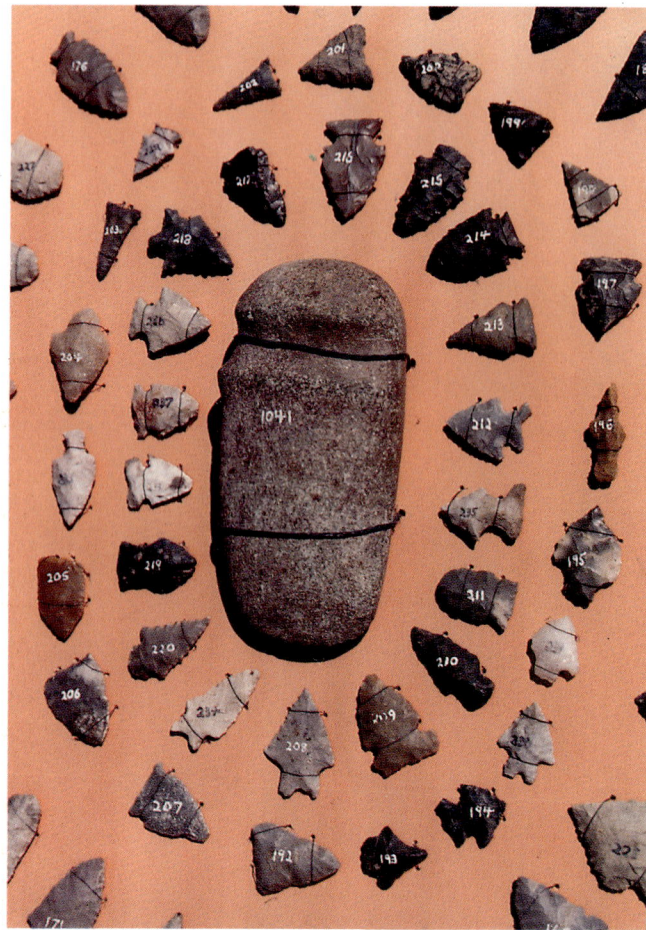

67 PIECE ARROWHEAD COLLECTION
Found by Carl Delman between 1900-1902 while building bridges on the James River for Brunswick Steel. Most were found betw. Richmond & Williamsburg Virginia. Purchased from his nephew in 1954. Includes 1st place prize ribbon won at Penna. State Fair in 1959. Wire mounted to a 16" x 22" cardboard. Mostly rhyolite & various shades of flint & chert. Largest point-3." Includes polished 3/4 groove axe head (center-see detail photo) 5"L. Est. 395-650 **SOLD** $420(95)

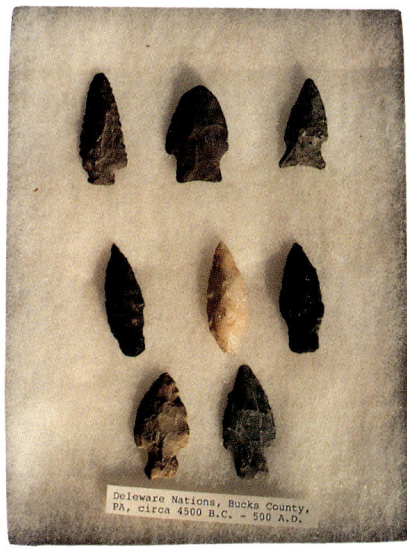
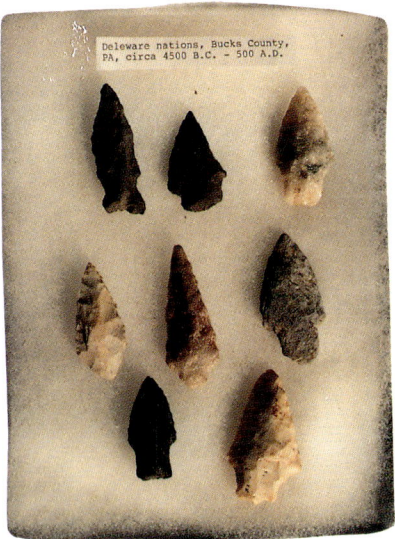

Left to Right:
8 POINTS *"from Bucks Co.,PA"*. Various colors:white, black, grey. Largest-2.25"L Est.81-125 **SOLD $75(95)**
SIMILAR. *Same provenance as preceding.* Est. 81-125 **SOLD $80(95)**

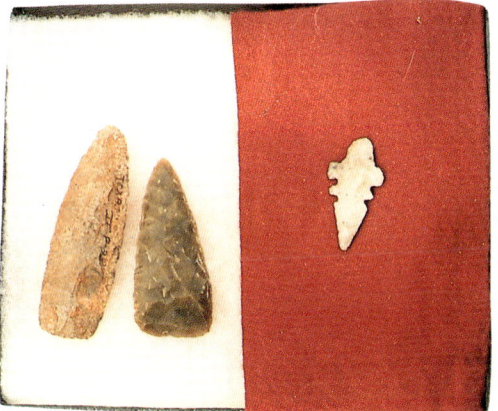

BARBED ARROWHEAD & 2 KNIVES
"Texas JTP20" written in black ink on largest blade- red brown 2.25"L. Grey flint knife & grey/white arrowhead. Est.50-120 **SOLD $40(95)**

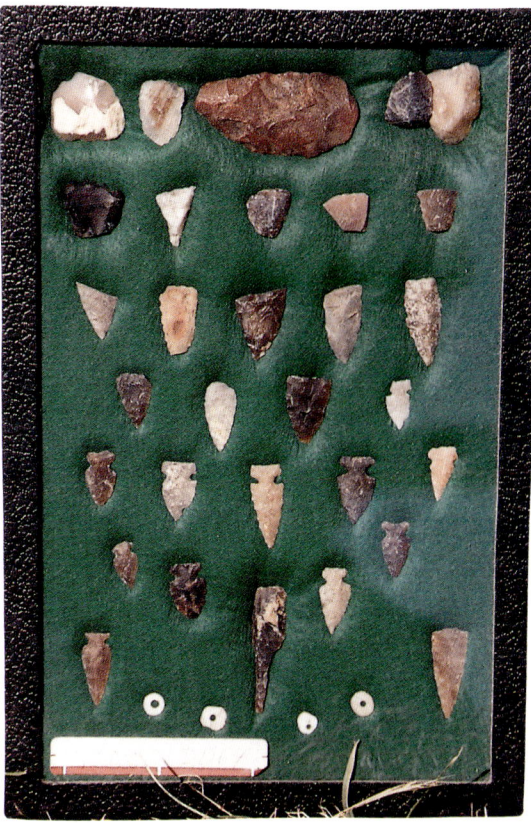

LOT OF 35 ARIKARA RELICS
Found in 1950's along Missouri R. No. of Chamberlain, So. Dak. 17 exc. small points (some are Knife R. flint), nice drill minus the tip, 4 shell beads, 5 scrapers, 1 knife blade & 7 broken points. Est. 75-150 **SOLD $85(95)**

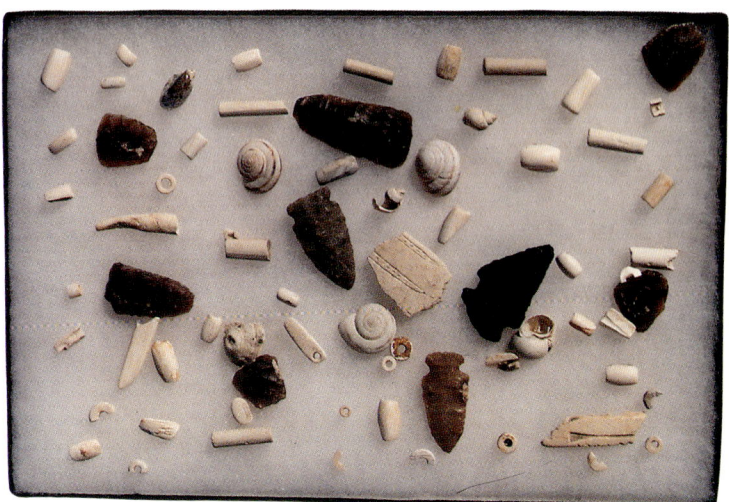

COLLECTION OF SO. DAK. ARTIFACTS
found No. of Chamberlain. Includes shell beads & ornaments, Knife R. flint points & scrapers, pipe stem beads, etched shells, etc. Apx. 70 pieces. Est. 95-150 **SOLD $75(95)**

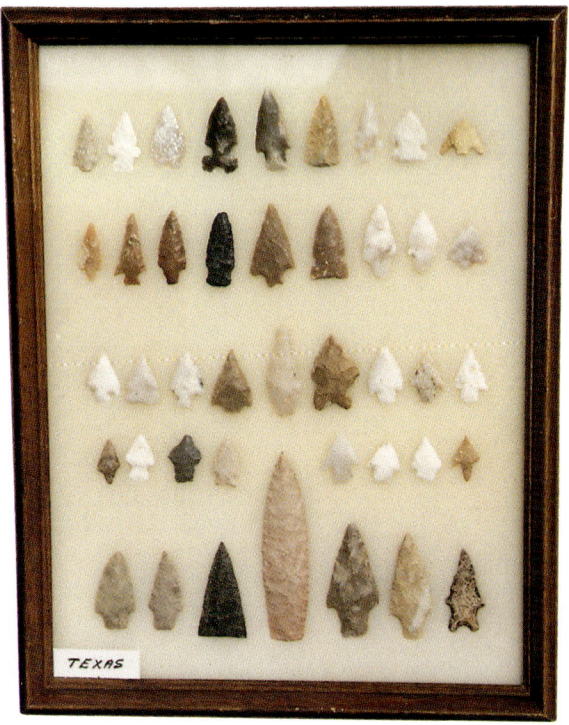

FRAME OF 42 ARROWHEADS FROM TEXAS
Flint & chert ranging from black & brown to white in color. All appear to be good old points, but some experts would like to see the large paleo point out of the frame as it should be examined more closely to determine its authenticity. It is a nice tan color & perfect. Sizes are from 1" to 4.13" (large Paleo). Frame is 12.25" X15.25." Est. 250-400 **SOLD $375(95)**

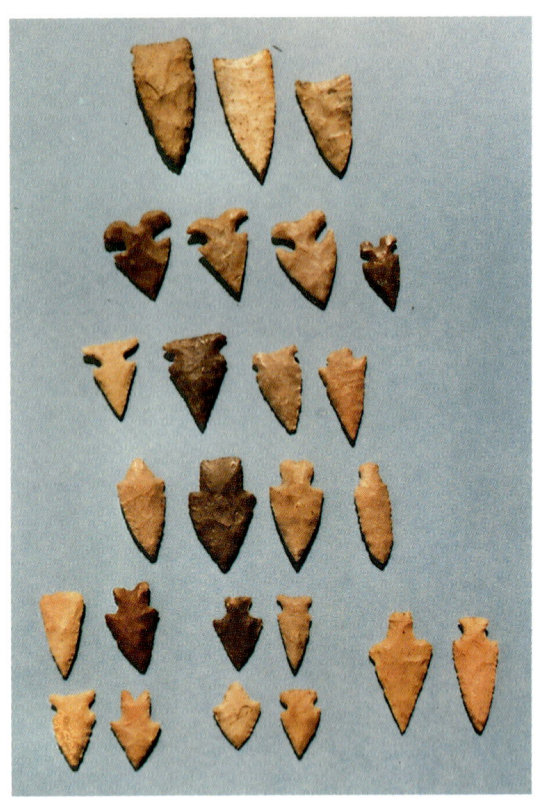

Top to Bottom (by row): **3 EARLY (POSSIBLY PALEO) FLINT BLADES** *All are from Texas.* The light colored one is graduated from almost white to lt. tan. 2.38" to 1.75" L. Good patina. Est. 75-150 **SOLD $70(95)**
4 GREYISH BROWN FLINT ARROW POINTS Nicely chipped w/deep notches. There are no signs of dirt on these which means either they were well scrubbed or they were never in the ground. That's all that is known about them. 1.75" X 1.25"L. Est. 25-50
4 FLINT POINTS Reddish brown, grey, tan & dk. grey. Good patina. 1.75"X1.38"L. Est. 20-50 **SOLD $25(95)**
4 FLINT POINTS lt. tan & 1 dk. brown. Good patina. 1.88"X1.38"W Est. 20-50 **SOLD $30(95)**
4 FLINT POINTS FROM TX Nicely flaked. 1 shows re-flaking. Good patina. 2"-1.88." Est. 20-50 **SOLD $25(95)**
FOUR FLINT POINTS Tan to grey colors. VG patina. 1.25" - 1.13." Est. 20-50 **SOLD $25(95)**
2 CHERT POINTS One is pinkish tan, other is lt. tan. The larger one has a slight chip missing on one corner. 2" X 2.13." Est. 15-40

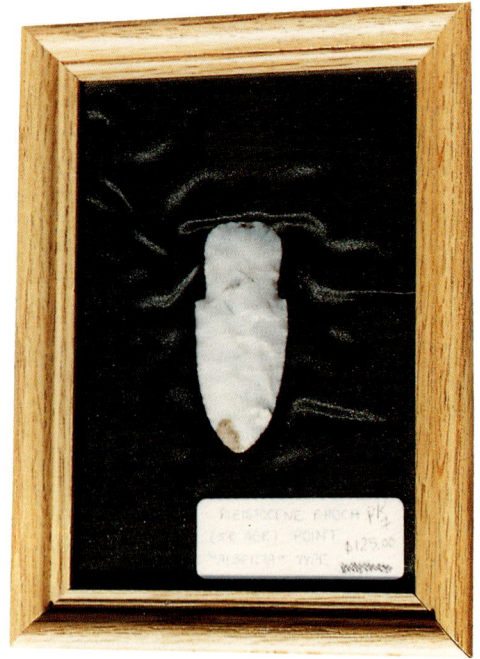

FRAMED OPALESCENT AGATE POINT *Tag on frame reads "Pleistocene epoch (Ice Age) point 'Alberta' type".* Exc. color, patina, shape & workmanship. 2.75"L. Oak frame is 6" X 8". Est. 175-275 **SOLD $190(94)**

LARGE SINGLE ARROWHEADS

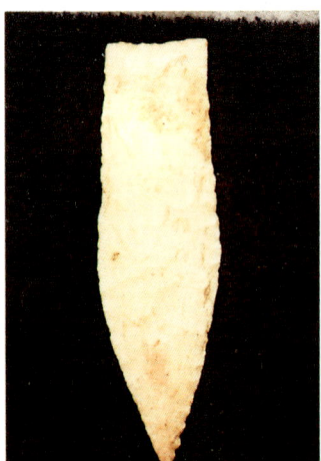

LT. TAN FLINT BLADE *from "Sedalia, Ill.".* Good patina. 5.25"L. Est. 125-200 **SOLD $125(95)**

Top to Bottom: **2 FOLSOM-TYPE POINTS** Largest is 2", grey flint w/slight fluting; other is brown flint w/very obvious fluting on both sides. 1.63." Hard to find. Est. 100-200 **SOLD $100(95)**
LOT OF 1 FLINT KNIFE & 1 FLINT SPEAR White knife *"from N. Nevada"* nice flaking & perfect, 3.13." Red spear *from "Scottsbluff, MO."* 3.75" Est. lot 125-200 **SOLD $182(95)**

Top to Bottom (Left to Right): **LOT OF 4 KNIFE BLADES** "Delaware R." All show water wear. Tan quartz 2.5"L. Grey. 2.63"L. Grey. 2.5"' L brown. 3.25"L. Each in small Riker mount. Est. Lot 50-125 **SOLD $50(95)**

LOT OF 3 FLINT POINTS
Good patina. Largest is 3"L. Est. 40-100 **SOLD $40(95)**

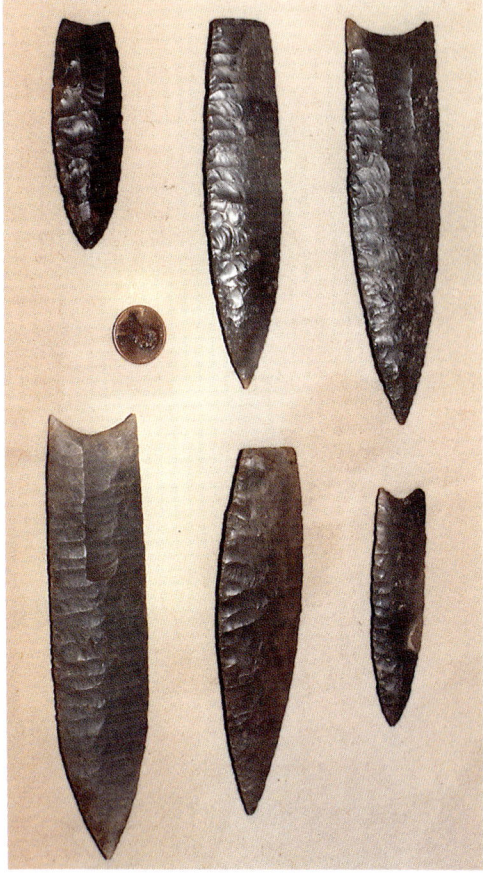

TOP TO BOTTOM (Left to Right): FINE PALEO POINTS *from Missouri & Illinois.* The following belonged to the consignor's Father & have been in the family since 1940:
Grey to tan chert. 2.75"L. *Possibly from Chariton Co.* Est.40/80 **SOLD $50(92)**
Same locale as above. 4.75"L. Grey & well-made. Est.95/185 **SOLD $95(92)**
Same locale. 5.5"L. Concave fluted base both sides. Est. 100/200 **SOLD $125(92)**
From Illinois. 5.75"L. Partial fluting both sides. Est.150/250 **SOLD $150(92)**
Chariton Co.,Ohio. 5"L. Est.85/200 **SOLD $125(92)**
Missouri. 3.25"L. Est.75/125 **SOLD $90(92)**

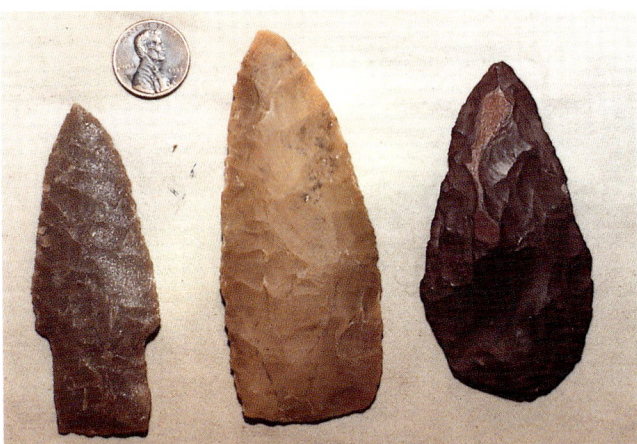

Left to Right: LT. TAN FLINT KNIFE
Western U. S. Exc. shape. 3"L. Est. 15-30 **SOLD $40(92)**
BROWN FLINT BLADE
Montana. 3.63"L. Est.20-50 **SOLD $20(92)**
RED FLINT KNIFE.
Montana. Good patina. Shows wear. 3.13" L. Est.20/50 **SOLD $15(92)**

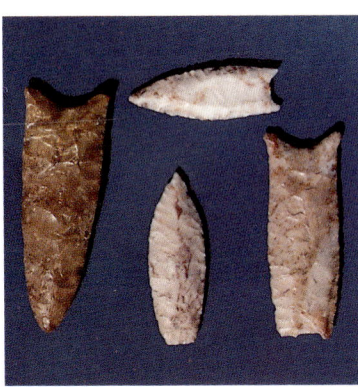

94-124. LOT OF 4 PALEOLITHIC-STYLE FLINT POINTS
The longest is 3.63" of lt. & dk. brown flint. Perfect & beautiful shiny patina. 3" L one has broken tip. Lt. tan shade-shiny patina. Leaf-shaped one is 2.5"L brown-white color. Perfect shape w/matte patina. The Folsom point is 2.25"L w/1.25" flutes on both sides. Perfect. Medium shiny patina. Est. 275-500 **LOT SOLD $225(94)**

MODERN ARROWHEAD REPLICAS

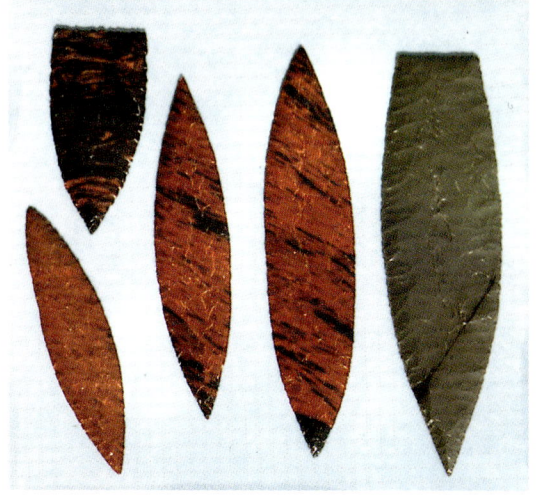

LARGE OBSIDIAN CEREMONIAL BLADES Contemp. *Expertly knapped by full-blood Nez Perce Indian, Brad Kempf.* Very colorful & absolutely beautiful.
A.) Small mahogany (brown) obsidian. 5"L Est. 15-30 **SOLD $30(95)**
B.) Rare triangular shaped translucent black & brown mahogany obsidian. 3.88"L. Est. 25-50 **SOLD $25(95)**
C.) Double pointed blade of mahogany obsidian. 6"L. Est. 35-60 **SOLD $25(95)**
D.) Same. 7.38"L Est. 45-85
E.) Rare green obsidian. Brad said he digs down 6 ft. to find this stone. A beautiful & large ceremonial blade. 7.5"L Est. 50-125 **SOLD $45(95)**

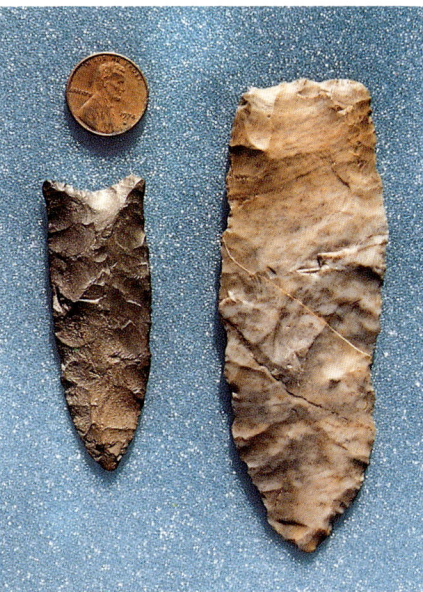

Left to Right: DALTON POINT
w/Cert. of Authenticity from Greg Perino. "Ovachita Quartzite, Early Archaic, 9500 B.P. Range". Black color. 2.88." Est. 60-125 **SOLD $145(96)**
CLOVIS POINT
found in Butler Co., Penn. w/Cert. of Authenticity from Greg Perino. "Paleo period dating in the 11,500 B.P. Range." 4.25." Est. 300-400 **SOLD $275(96)**

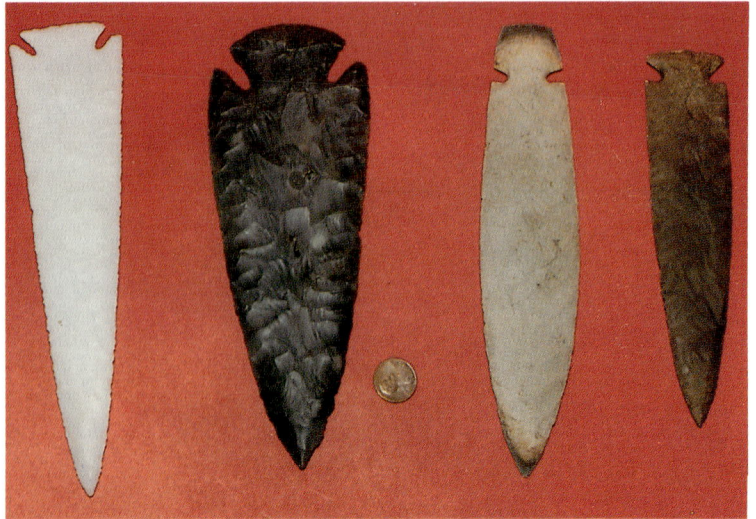

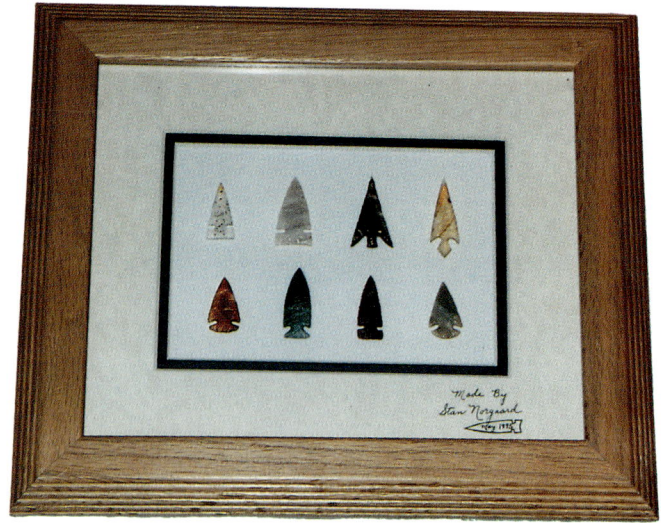

8 POINTS Contemp.
Top Row (Left to Right): Salt & pepper Mont. agate, opalized wood-Mont., Lake obsidian-Oregon, Mont. agate.
Bottom Row (Left to Right): Carnelian agate, Mont. green opalite, purple sugar quartz, Idaho opalite. Expertly framed. 10.5 x 12.5 Est.85-150 **SOLD $150(96)**

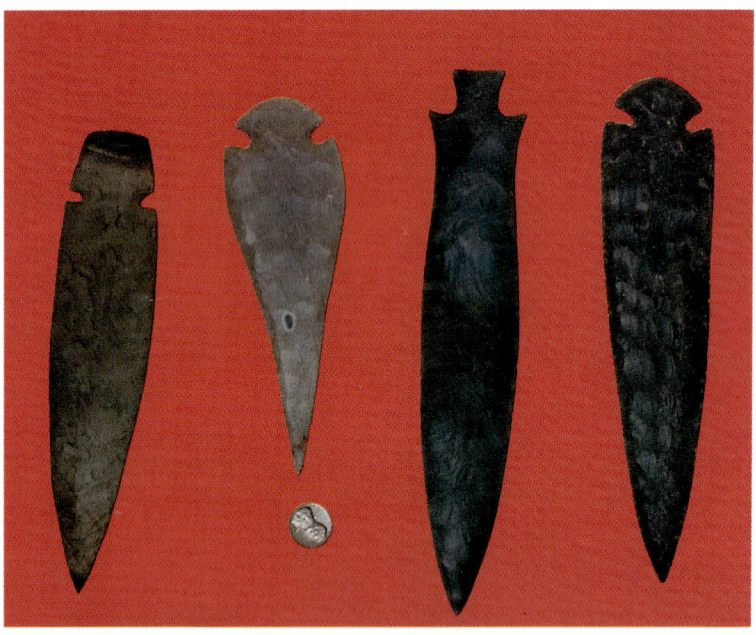

Left to Right: LARGE BLADES
The following are contemporary, but are all in perfect cond. & are superb works of art.
Pure white quartz(?) 8" blade-corner notched. Consignor purchased it from an elderly gent who had owned it for a long time. Est.75-150 **SOLD $95(93)**
Grey-brown Dovetail base. 7.5"L X 2.75" widest pt. Corner-notched. Est.75-150 **SOLD $75(93)**
Tan w/dk. brown at either end. Side notched. 7.63"L X 1.75" widest pt. Est.75-200 **SOLD $75(93)**
Golden brown & corner notched. 6.5"L X 1.5" shoulder. Est.75-150 **SOLD $85(93)**
Left to Right: Lt. brown & side notched. 7.5"L X 1.63" widest pt. Est.100-200 **SOLD $75(93)**
Pinkish grey dovetail. Tapered point. Diagonally notched. 6.44" X 2" widest point. Est.50-110 **SOLD $45(93)**
Large dk. grey corner notched. 9"L X 1.63" widest pt. Est.150-250 **SOLD $125(93)**
Dk. grey Dovetail. Serrated blade. 8.44"L X 2" widest pt Est.75-150 **SOLD $102(93)**

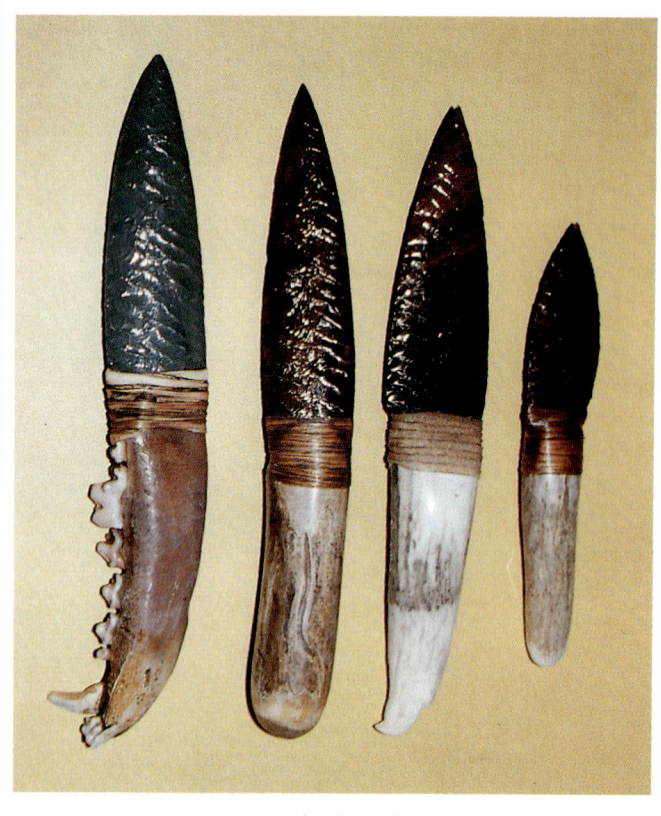

Left to Right: OBSIDIAN KNIFE W/BEAR JAW HANDLE
Grey-green stone expertly knapped. Rawhide wrapped. 10.5"L. Est. 175-300 **SOLD $200(97)**
MAHOGHANY OBSIDIAN KNIFE w/antler handle. Sinew-wrapped. 10.5"L. Est. 115-200 **SOLD $105(97)**
MAHOGHANY OBSIDIAN KNIFE W/ANTLER HANDLE
Eagle head expertly carved on end. Knapping is outstanding. Rawhide wrapped. 10.5"L. Est. 200-300
SAME as 2nd one w/smaller blade. 7.75"L. Est. 75-150

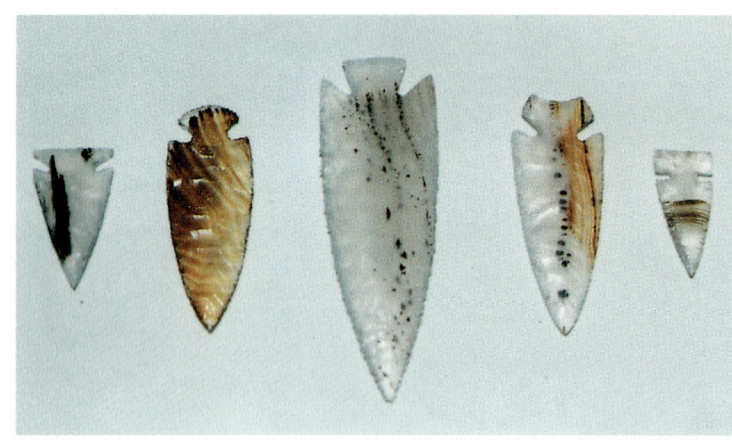

5 POINTS Contemp. Knapped from Mont. transp. picture agate. 10.5" x 12.5" frame. Est. 100-175 **SOLD $150(96)**

12

Hide Scrapers

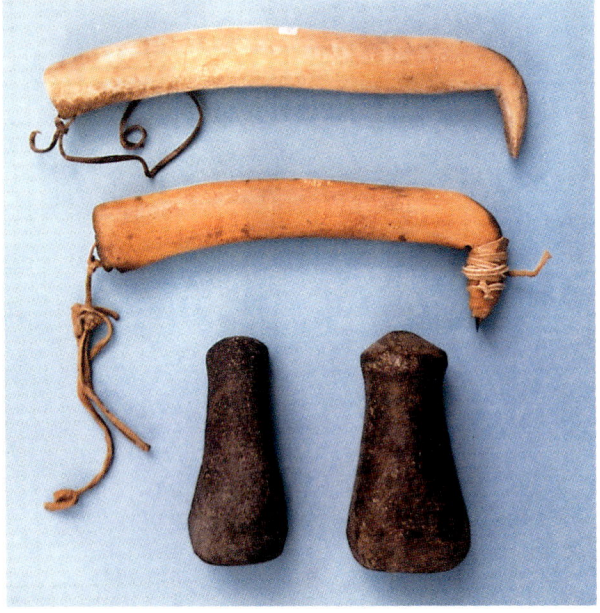

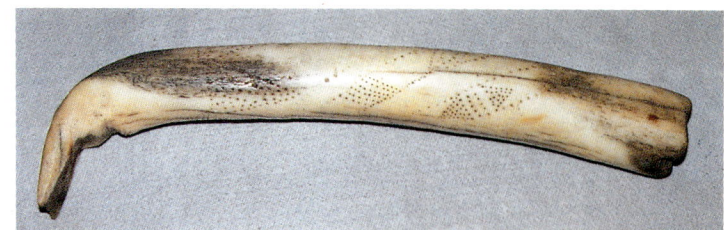

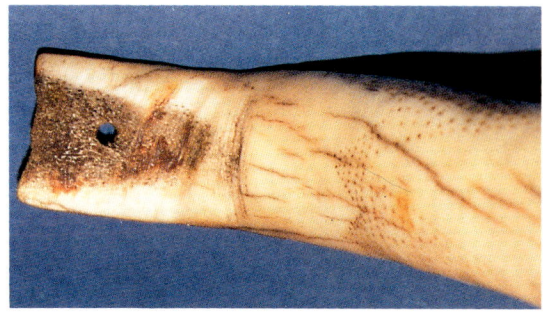

ELK HORN HIDE SCRAPER
RARE Geometric designs applied by drilled dots & incised lines. Has unusual hole for attaching the blade (see detail). Very hard to find w/decorations. Large 14.5": Est. 560-900 **SOLD $565(97)**

Top to Bottom: **DOCUMENTED BLACKFEET ELK HORN HIDE SCRAPER** c. 1870
Originally from Fish Wolf Robe of Browning, Mont. Collected by Harold & Irene Hanneman who operated a store in Browning from 1936-1962. Includes notarized Certificate of Authenticity telling history of this collection. Exc. polish & patina w/buckskin thong attached through hole in handle. Very unusual to find one w/documented history telling about it's owner. 13.25"L. Est. 350-500 **SOLD $425(95)**
BLOOD INDIAN ELK HORN HIDE SCRAPER c. 1880
Flaherty Collection. Collected on the Blood Reserve at Brockett Saskatchewan, Canada. Wonderful polish, color, & patina w/original steel blade attached w/buckskin ties (unusual). Has buckskin thong attached through hole in handle. 11.5"L. Est. 450-600 **SOLD $450(95)**
BOTTOM ROW: See p. 17, for description of hammers.

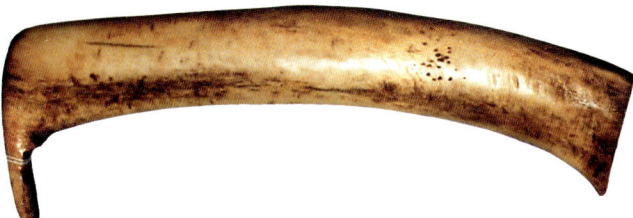

LARGE CROW ELK HORN HIDE SCRAPER c.1890
Antler is smooth from lots of use. A good authentic piece. 4" X 12.25." Est.250-350(96) **SOLD $125(90)**

BLACKFEET ELK HORN HIDE SCRAPER
w/old yellowed tag that reads "Hide scraper 1855. Owner Crow Chief, father-in-law of Tom Running Rabbit." Rich yellow patina. Polished smooth. Exc. cond. Large 14.5"L. Est. 325-450 **SOLD $400(94)**

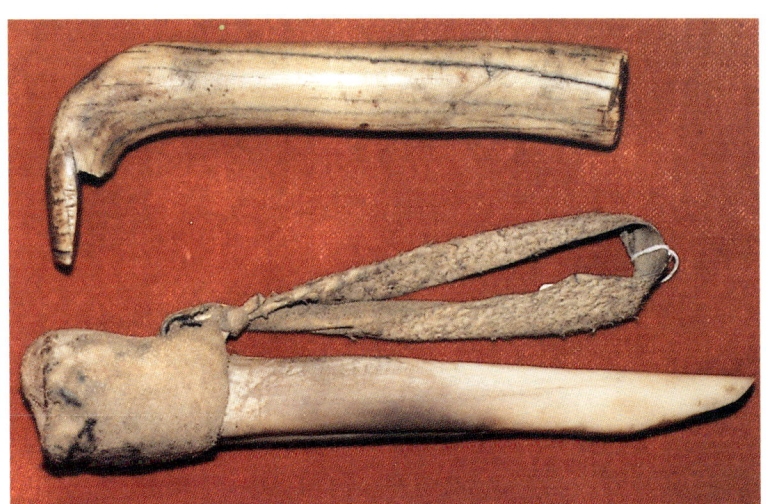

Top to Bottom: **INDIAN-MADE ELK HORN HIDE SCRAPER** c.1870
Smooth from use. Good patina. 11"L X 4.25." Est.100/150 **SOLD $150(92)**
BLACKFEET FLESHING TOOL c. 1910
Made from buffalo or moose leg bone. Brain-tan elbow strap & end cover. The working end has many small notches. This is a heavy-duty working tool. 14.5"L. Est.175/250 **SOLD $125(92)**

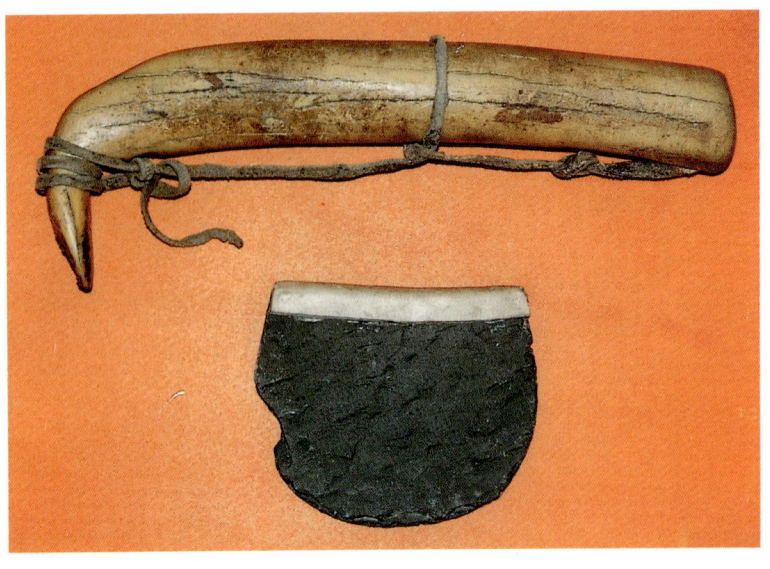

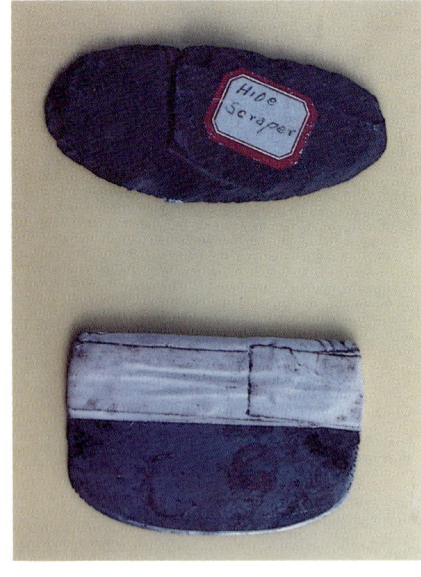

2 FLATHEAD HIDE SCRAPERS c.1890
Indian informants say that this stone is found nr. Bonner, Mont. Both tools were obtained from Molly Big Sam who got them from her mother-in-law, Ellen Big Sam of Arlee, Mont. on the Flathead Res. 1)Oval stone scraper which was used to break the grain & soften the hide. 2.25" X 5." 2)Iron scraper shows notches & sharpening. This tool was used to scrape the hide. 2.75" X 4.25"W. Est. lot 150-250 **SOLD $95(93)**

Top to Bottom: **BLACKFEET(?) ELK HORN HIDE SCRAPER** c.1870
Collected in 1926 by Clifton Worthern of Missoula, Mont. Heavy duty w/rich patina of age. Superb example w/original buckskin ties. 13.5"L. Est. 350-600 **SOLD $350(95)**
FLATHEAD STONE HIDE STRETCHER c.1900
Belonged to Louise Conko, Flathead Res. Mont. These black stones were chipped from rock found nr. Bonner, Mont. & used to soften & stretch hides. 4.5" X 5.75." Est. 75-150 **SOLD $105(96)**

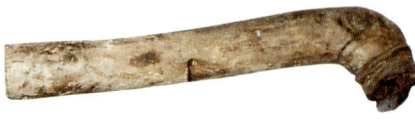

SIOUX WOOD HIDE SCRAPER c. 1890 w/original iron blade. *Collected at Poplar, Mont. on the Ft. Peck Res.* Wood scrapers of this style are very unusual. Original buckskin lacing. 11" L. Est. 175-250 **SOLD $175(96)**

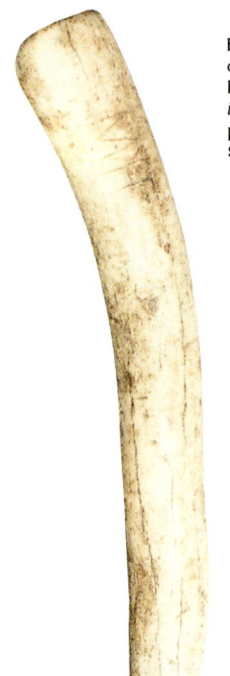

ELK HORN HIDE SCRAPER c.1880
Interesting old piece w/*"MH" incised on side.* Wonderful patina. 12"L. Est. 150-250 **SOLD $225(93)**

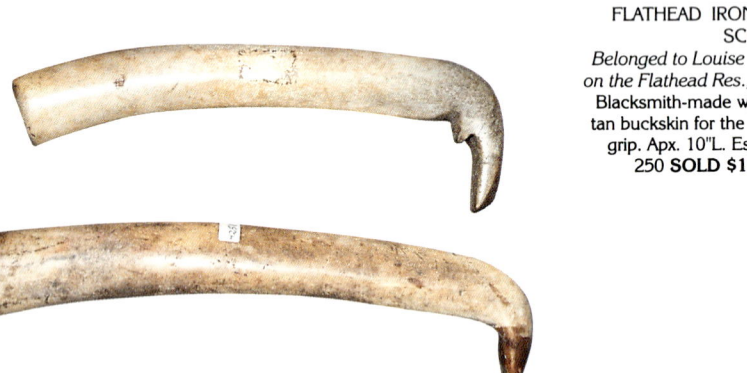

FLATHEAD IRON HIDE SCRAPER
Belonged to Louise Conko on the Flathead Res., Mont. Blacksmith-made w/Indian tan buckskin for the handle grip. Apx. 10"L. Est. 150-250 **SOLD $125(96)**

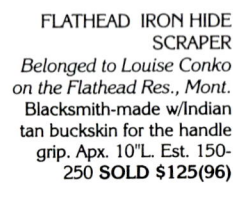

BLACKFEET ELK HORN HIDE SCRAPER c.1880
Wonderful dark patina & age polish. Notch is cut to hold blade in place. Exc. cond. 12" L. Est. 350-500 **SOLD $300(96)**
SAME AS ABOVE c. 1860
w/notarized Certificate of Authenticity stating that it belonged to "No Coat", a well known Blackfeet man who lived nr. Browning, Mont. Collected by Harold & Irene Hanneman who owned a store on the Res. from 1936-1962. Extra large w/41 notches cut into butt end of the horn. Rich dark brown patina. Polish & dark stain shows where buckskin lacing held the iron blade in place. 14.5"L. Est. 375-600 **SOLD $450(96)**

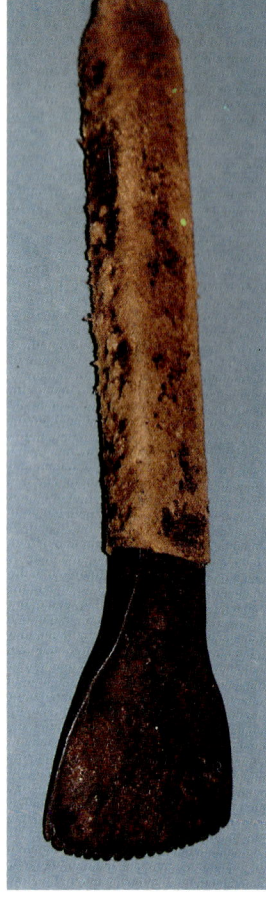

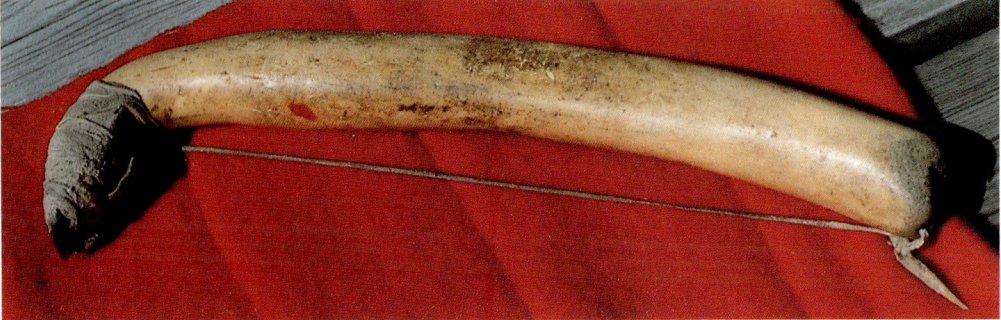

BLACKFOOT ELK HORN HIDE SCRAPER c.1890.
Belonged to Mrs. Naomi Little Walker of the Blackfoot tribe on the Siksika Reserve nr Arrowhead, Alberta. Still has metal blade attached w/buckskin tie thongs. Exc. cond. & great patina. 14" L. Est. 300-500 **SOLD $500(98)**

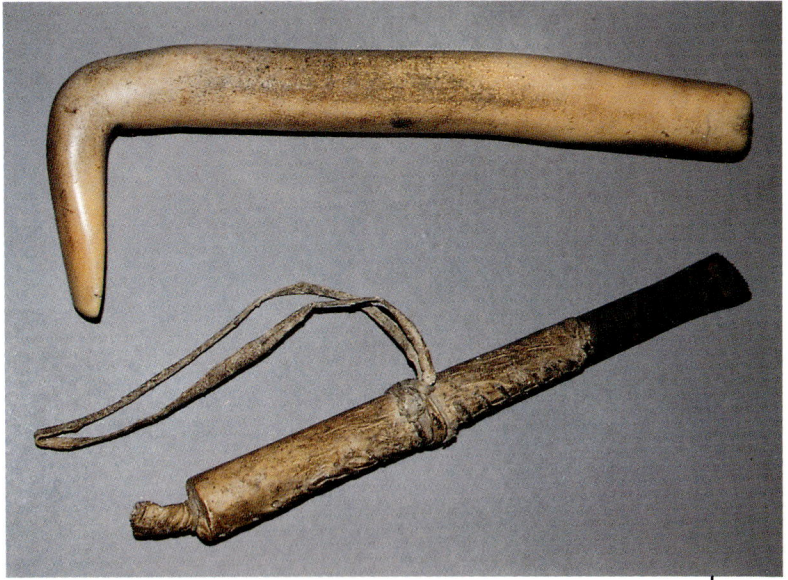

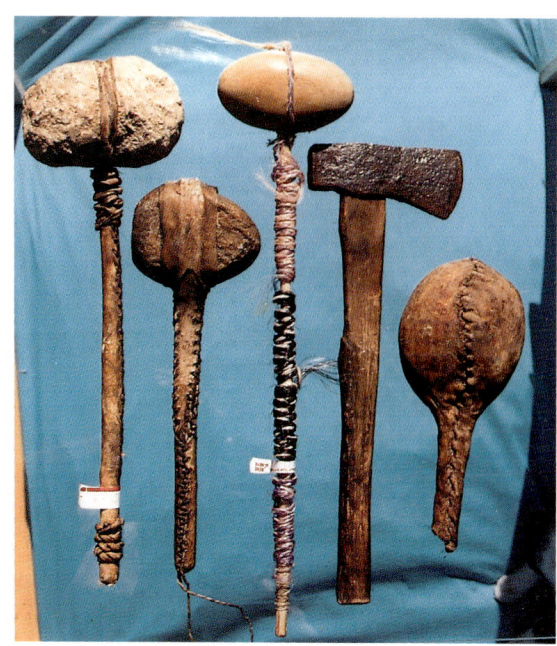

Top to Bottom: SIOUX ELK HORN HIDE SCRAPER c. 1870
Name in faded ink "Katie ???kaddurt." Has large horn section for blade attachment. End has 3 drilled holes-2 w/large rusty screws. Wonderful patina of age. 14"L. Est. 350-500
SIOUX TRADE GUN BARREL HIDE SCRAPER c. 1870
Laced rawhide covers apx. 2/3 surface. All intact w/great patina of age. 9" buckskin handle. 13.5"L. Exc. cond. Est. 400-600 **SOLD** $250(96)

NO. PLAINS ELK HORN HIDE SCRAPER c. 1880
Shows exc. patina, age & use. 11"L. Est. 250-500 **SOLD** $375(93)

Left to Right: STONE HEAD MAUL-TYPE CLUB c.1880
Consignor says "Pawnee from Nebraska"? Sinew-sewn rawhide handle. Exc. patina. 15" L. Est. 125-250 **SOLD** $135(95)
STONE HEAD BERRY MASHER c.1880
Consignor says "Pawnee from Nebraska"? Rawhide cover & lacing. Exc. patina. 11" L. Est. 125-250 **SOLD** $225(95)
STONE HEAD WAR CLUB c.1890
Possibly Turtle Mountain Sioux. Carved & polished white stone head w/braided horsehair-covered handle in white, black, & purple. Braiding loose but is all there. 16.5" L. Est. 125-250 **SOLD** $225(95)
TRADE AXE
Handle is original. Rusted & pitted w/ roughly carved handle. Good patina. Hard to find a complete one like this. 13" total L. 4.75" head. Est. 156-300 **SOLD** $156(95)
SIOUX(?) STONE HEAD BERRY MASHER c.1860
Rawhide covered & sinew-sewn (buffalo?) Quartz stone. 1/2" piece missing from end of handle. Exc. patina. Est. 156-300 **SOLD** $185(95)

Primitive Clubs with Handles

see more clubs under Weapons

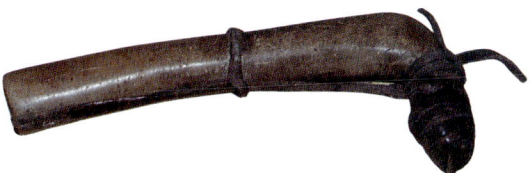

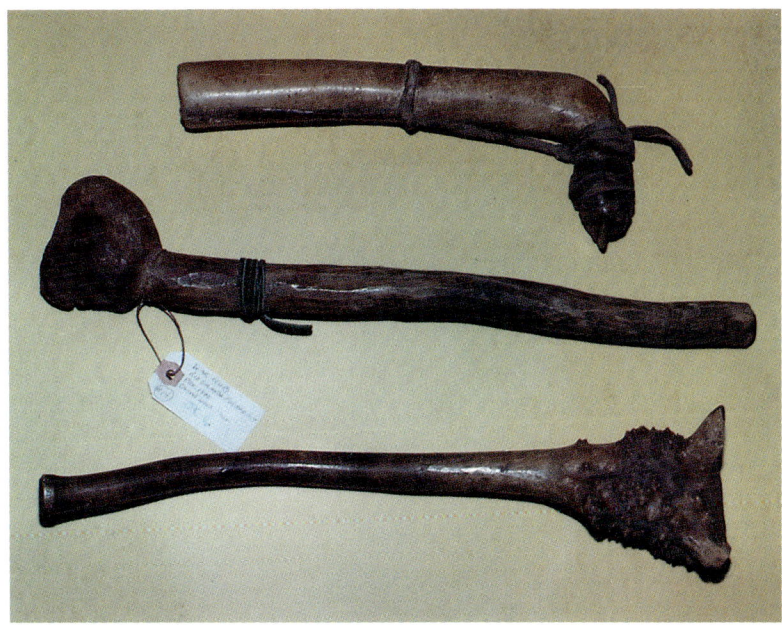

HEAVY GRANITE AXE W/ HANDLE
Large full-grooved axe tightly mounted w/leather lacing to a cherry wood handle. Appears to have been assembled many years ago. The axe blade appears damaged from use, a long time ago, but still has an edge that would split wood. 7"L X 6"W X 2.25" deep. Est. 95-350 **SOLD** $200(94)

Top: See description under hide scrapers, above center left
Center: "RIO GRANDE PUEBLO, NM" WOODEN WAR CLUB c."Pre-1900"
Title according to tag. The ball end is some sort of knot or root. Crack in handle held w/piece of leather to keep it from separating. Shows age w/good patina. 17"L. Est.75-150 **SOLD** $75(93)
Bottom: PASSAMAQUODDY WAR CLUB c.1900
Carved handle w/root on end. This birch root has many small bumps & protrusions. Good patina-shows age. 16"L. Est.75-125 **SOLD** $60(95)

Large Stone Tools

STONE AXEHEADS, MAULS, ETC.

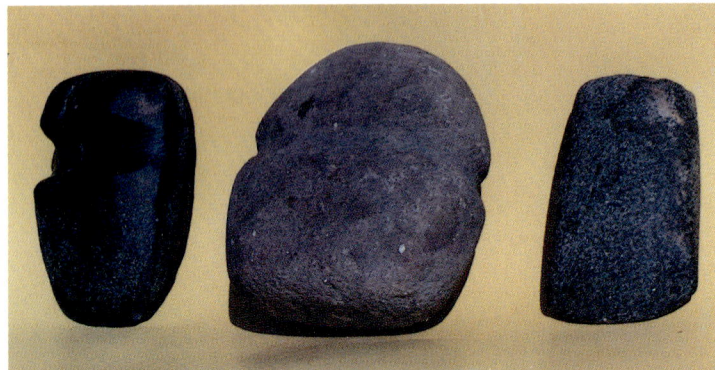

Left to Right: 3/4 GROOVED & POLISHED GRANITE AXE HEAD
Obtained from a collection nr. Stevensville, Mont. Deeply grooved. 3"W X 5"L. Est.95-175 **SOLD $130(93)**
HEAVY BROWN FULL-GROOVED STONE MAUL
From the Janetski Coll., Great Falls, Mont. Found along the Missouri R. nr. Ft. Benton, Mont. 4.5" X 5." Est.75-125 **SOLD $75(93)**
POLISHED GRANITE CELT
Obtained from a collection nr. Stevensville, Mont. 25" X 4." Est.100-200 **SOLD $150(93)**

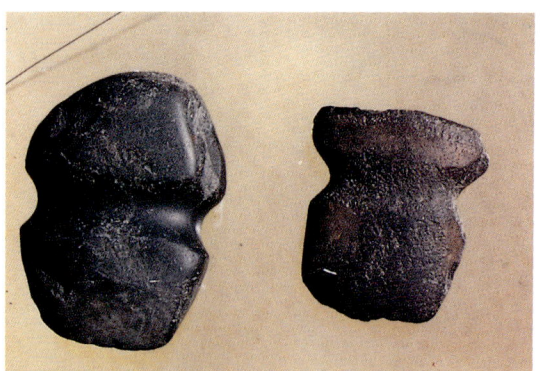

Left to Right: BLACK GRANTITE FULL-GROOVED AXE
Tag reads "Pre-historic, N. New Mex." A roughly shaped stone but it is highly polished. 4.5"L X 3.25"W 1.87 deep. Est. 50-95 **SOLD $60(94)**
GREYSTONE 3/4 GROOVED MAUL
Squarish shape; pecked & polished. One end is rounded the other flat. 4"L X 3.25"W X 1.87" deep. Est. 25-60 **SOLD $30(94)**

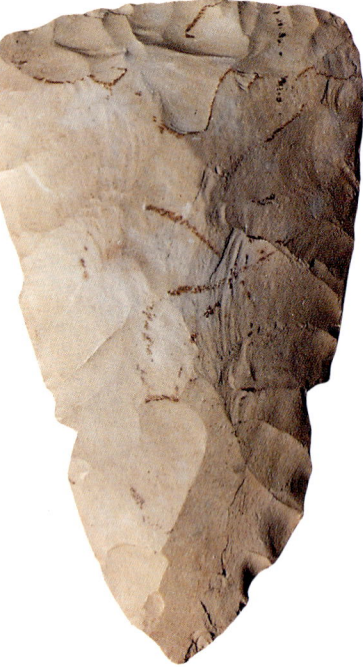

LARGE FLINT HOE
Appears to be a Missouri River type. Looks authentic. Flat one side w/pronounced hump on the other side. Large flakes. VG patina. 8.25"L X 4.75"W. Est. 100-200 **SOLD $120(94)**

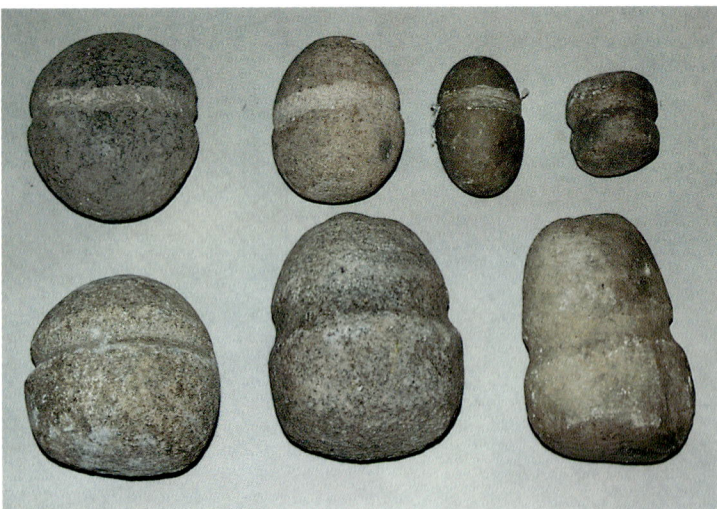

Top Row Left to Right: A) LARGE GRANITE MAUL
From Mandan, Arikara site along the Missouri River before building of Garrison Dam in the 1950's. Full-grooved to within 1/2." 5"L. Est. 45-95 **SOLD $50(96)**
B) EXTRA LARGE FULL-GROOVED GRANITE MAUL *Same provenance as A.* 6"L. Est. 45-125 **SOLD $53(96)**
C) BROWNSTONE FULL-GROOVED HAMMER *Thain White Collection, Mont. Purchased in 1978 from Lookout Museum on Flathead Lake, Lake Co.* 6.5"L. Est. 30-75 **SOLD $25(96)**
Bottom Row Left to Right: D) GROOVED MAUL
from Montana. Same provenance as granite mauls. 4.5 x 5.25. Est. 30-75
E) BROWNSTONE FULL-GROOVED HAMMER *Same provenance as A.* 4.5" L. Est. 40-90 **SOLD $40(96)**
F) BROWN FULL-GROOVED STONE CLUB HEAD *Same provenance as A.* 4"L. Est. 30-75 **SOLD $80(96)**
G) MONTANA BROWNSTONE FULL-GROOVED HAMMER *Same provenance as A. Flat top & bottom. Unusual shape.* 2.5". Est. 45-95

MORTARS, PESTLES

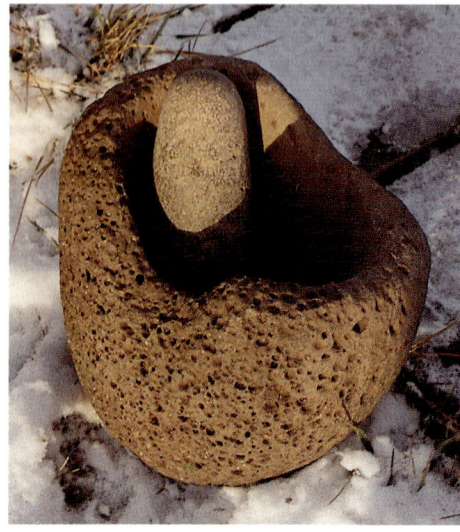

PRE-HISTORIC MORTAR & PESTLE
Found on the marsh by the Chewaucan R., Lake Co., Ore. about 1982. Pestle 7"L. Lava rock mortar-10.5" H. X 10.5"L X 9"W. Shows lots of wear. Est.250-500 **SOLD $335(93)**

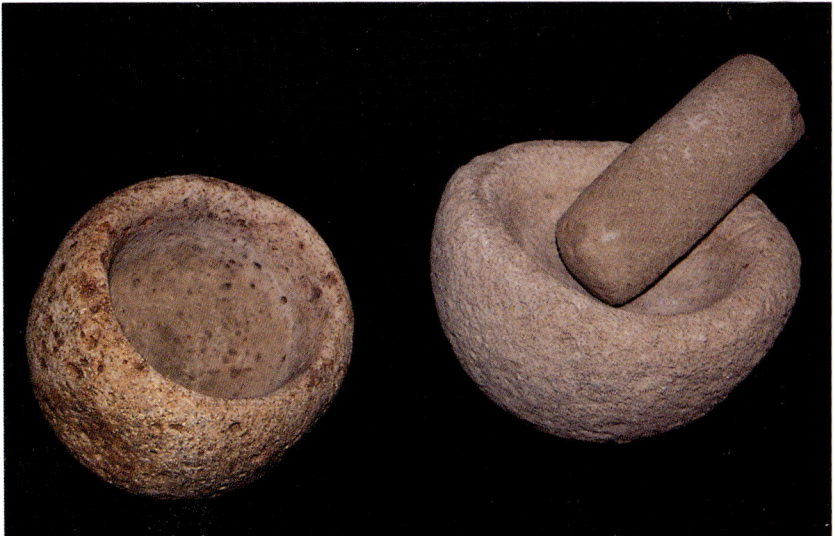

Left to Right: **STONE BOWL-TYPE MORTAR**
"Cent. Calif. Valley" (Consignor's attribution*) 6.5" diam. 5.25" H. Est. 95-150 **SOLD $125**(97)
STONE BOWL-TYPE MORTAR & PESTLE
"Cent. Calif. Valley". 8" diam. 5.25" H. Est. 100-175 **SOLD $150**(97)

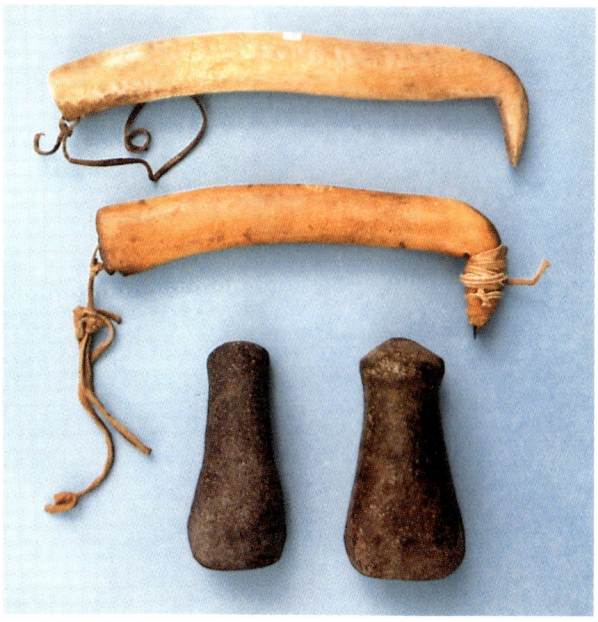

Left to Right (bottom): **PECKED STONE COLUMBIA RIVER HAND HAMMER c. 1800**
Nice shape, patina & perfect cond. These were used for pounding pegs, mashing things, splitting wood, etc. 6.13." Est. 35-75 **SOLD $40**(95)
Similar c. 1800. Polished patina shows considerable use. Knob shape on top. 6.25." Est. 50-100 **SOLD $60**(95)
See photo, p.13 for hide scraper description.

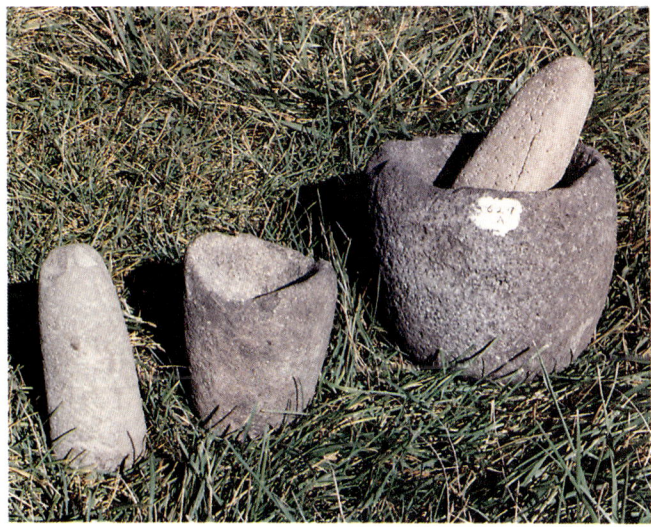

Left & center: **SMALL MORTAR & PESTLE**
Found on Wilson Is., Klamath Marsh, Ore. Pestle 6"L-Mortar 5" H. X 4.5"W. Est. 125-175 **SOLD $125**(93)
Right: **PESTLE & MORTAR**
from Shellog Draw in Klamath Marsh, Ore. in Dec. 1958. 7" pestle (flat on 1 side)-Mortar 7" X 3". Est. 250-300 **SOLD $275**(93)

STONE METATE & MANO
Hopper mortar (made for use w/basket). 19" L. X 13.5" W. 2.75" hole. MANO-7.25" X 4." Est. 275-375 **SOLD $105**(95)

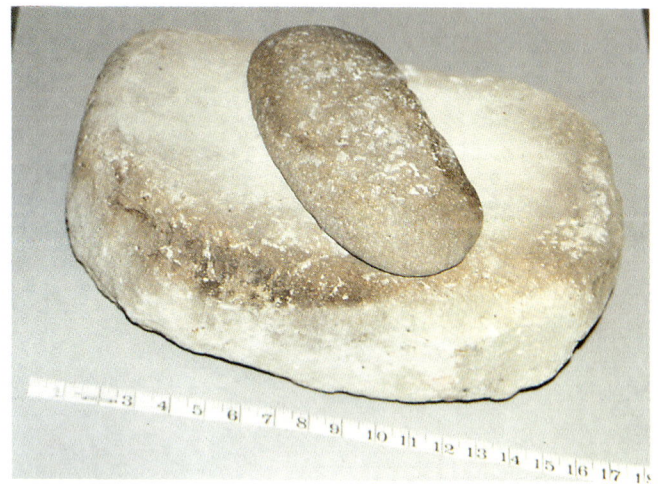

S.W.? PREHISTORIC BROWNSTONE METATE & MANO
Exc. shape. 10 x 16 x 5.5 deep. Est. 65-125 **SOLD $150**(96)

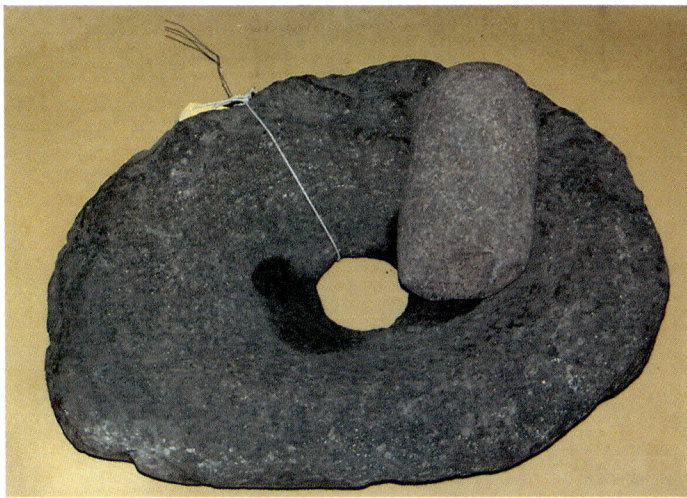

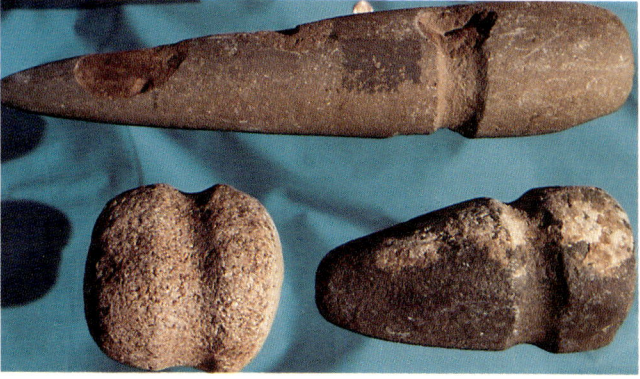

Top to Bottom: **UNUSUAL 3/4 GROOVED PESTLE**
Pre-Historic. from a So. Dak. Coll. Shows surface pecking & polished smooth. (1st one we have seen w/a groove.) Pointed at one end & flat on the other. Several round spots where softer stone eroded away. 15"L. Est. 100-200 **SOLD $180**(95)
LOT OF 2 FULL-GROOVED SO. DAKOTA STONE MAULS
1) Hard grey w/pointed end. 7.5"L.; 2) Brown/grey 4"L. Both show pecking marks & are in exc. shape. Est. lot 100-175 **SOLD $125**(95)

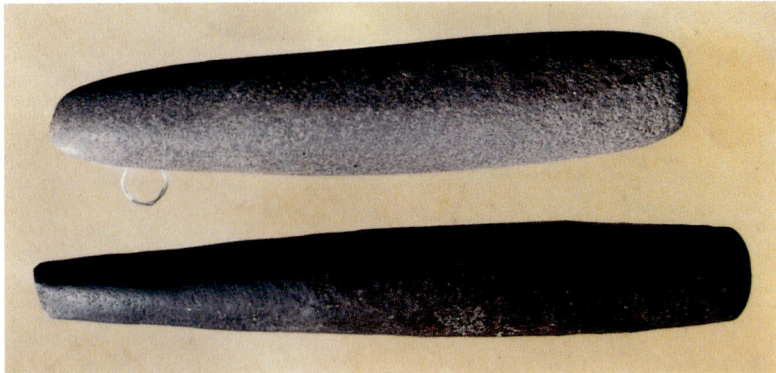

Top to Bottom: GREY GRANITE PESTLE
Attached card reads "1820-Columbia River Pestle." Beautiful shape & perfect cond. Pecked & polished. 12.75"L X 2.5" diam at widest point. Est. 100-200 **SOLD $125(94)**
BLACK GRANITE(?) PESTLE
This is probably a Columbia River pestle. Beautifully shaped, pecked & polished. Shows considerable use & still has dark stains on mashing end. 14.5"L X 2.12" diam. at widest point. Est. 100-200 **SOLD $150(94)**

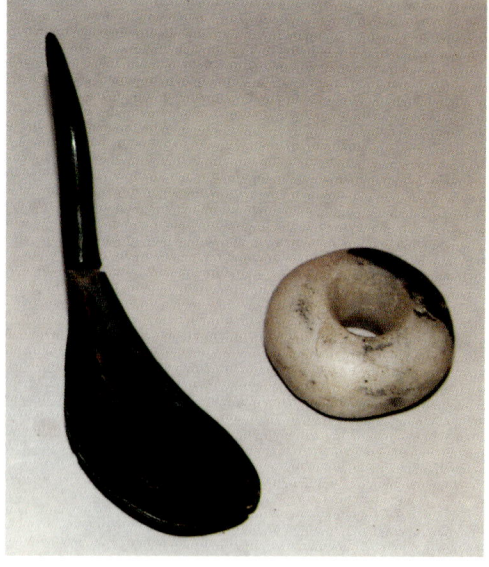

Left to Right: HORN SPOON
Described under horn items, p.42.
CHUMASH STONE GAME RING OR ARROW STRAIGHTENER
RARE. Grey-white marble like stone w/some red & black stains. Polished. 2.5" diam. Est. 250-350 **SOLD $250(96)**

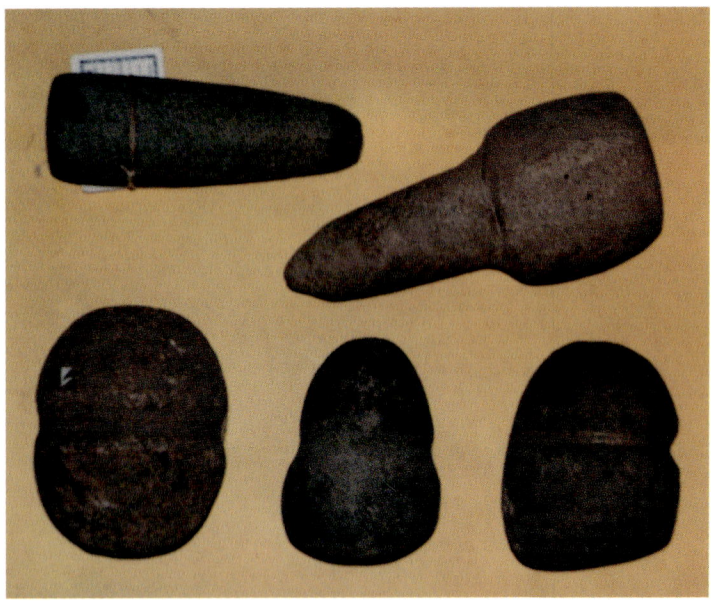

Top (Left to Right): COLUMBIA RIVER GRINDING PESTLE
Found nr. Dalles, Ore. Green granite. Beautifully made-shows pecking & polishing. 7.5"L. Est. 40-125 **SOLD $75(95)**
COLUMBIA RIVER HAMMER
Found nr. Hermiston, Ore. Brownstone. Beautifully shaped, pecked, & polished. Exc. shape. 9.25"L. Est. 175-350 **SOLD $200(95)**
Bottom (Left to Right): MONTANA BROWNSTONE MAUL
Full-grove. 5.5" L. Est. 40-95 **SOLD $68(95)**
SO. DAK. FULL-GROOVED MAUL
Grey granite. Nice pecking & polishing. 5"L. Est. 50-100 **SOLD $58(95)**
CLASSIC 3/4 GROOVED BROWNSTONE MAUL
Found by Dick Weeks in late 1950's during construction of Garrison Dam in No. Dak. From Hidatsa, Mandan & Arikara sites. 5"L. Est. 100-200

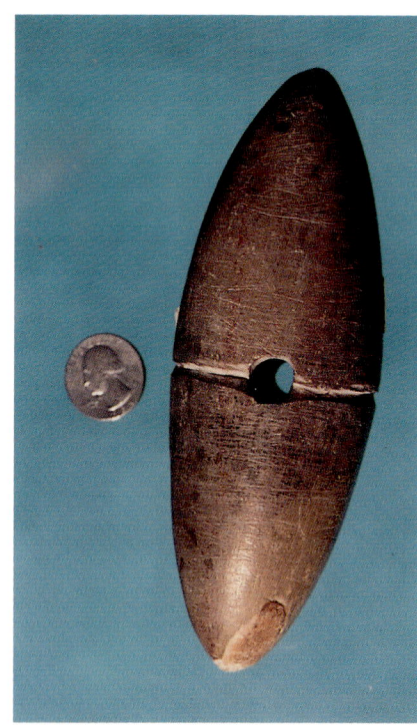

GREYSTONE WAR CLUB HEAD
w/groove & drilled handle, A fine polished specimen. 6.25"L. Est. 94-175 **SOLD $100(95)**

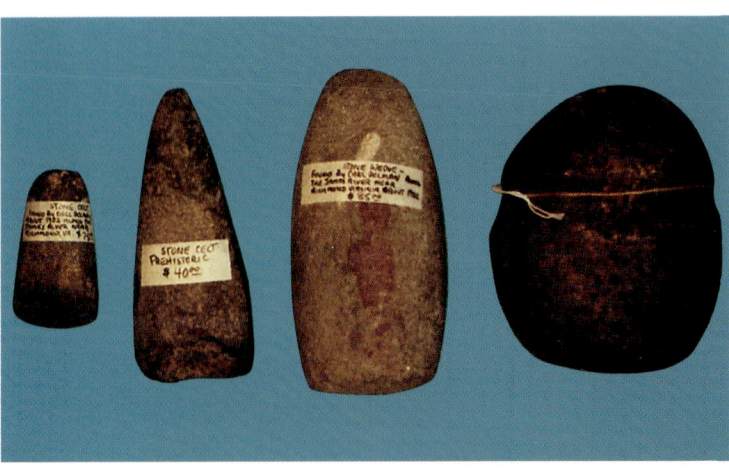

Left to Right: GRANITE CELTS.
each found along the James River nr. Richmond, Virginia. Delman Coll. Highly polished. 3" X 1.75." Est. 35/85
Interesting shape; shows use. 5.5" X 2.25." Est. 35/65 **SOLD $45(90)**
Possibly a wedge. One side spotted w/red-ochre, prob. from a burial. One end is sharpened, one end flat. Est. 40/100 **SOLD $35(90)**
LARGE GROOVED PRE-HISTORIC MAUL.
Turtle Mtn. Res., No. Dak. Orig. handle & rawhide. Used to mash berries for pemmican. Est. 30-60 **SOLD $40(90)**

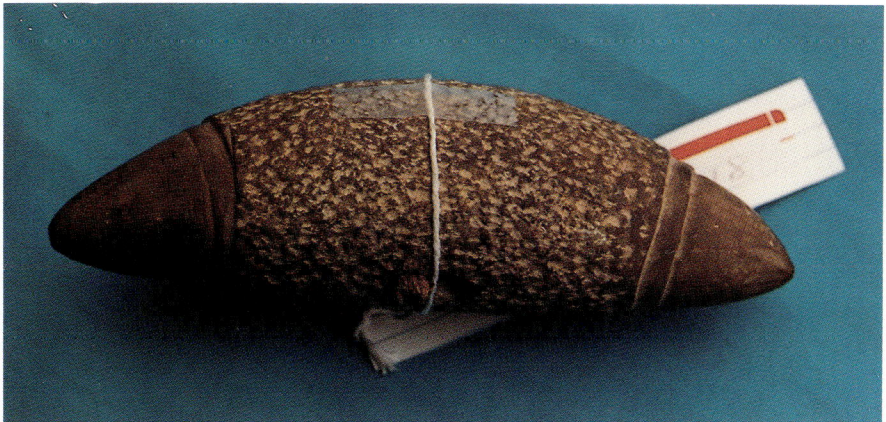

SIOUX DOUBLE-POINTED STONE WAR CLUB HEAD
Pecked & polished greystone. Has 2 drilled holes for wooden handle. 7"L. Est. 240-350 **SOLD $240(95)**

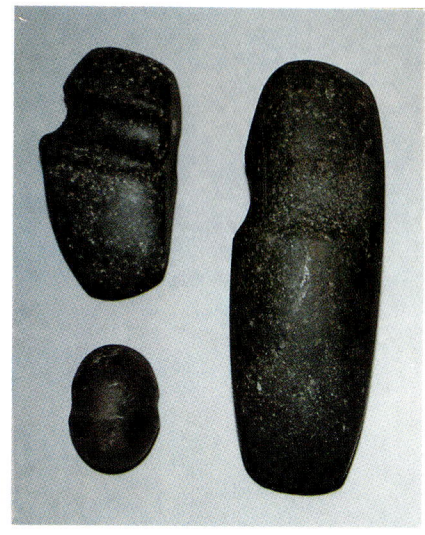

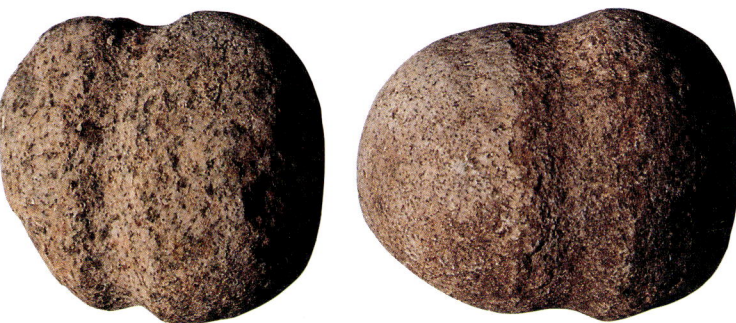

LOT OF 2 FULL-GROOVED MAULS
from the Missouri R. in So Dak. 5.25" & 6"L. Est. 75-125 lot **SOLD $75(95)**

Upper Left: **SMALL 3/4 SLANTED GROOVED GRANITE AXE**
Green to black color. Highly polished w/raised rib around groove edge. Exc. cond. 4.25" Est. 85-150 **SOLD $95(996)**
Lower Left: **SMOOTH 3/4 GROOVED STONE** for skull cracker club. 2"L. Est. 40-95
Right: **HOHOKAM GREENISH GRANITE 3/4 GROOVED AXE**
Good overall polish w/super polished blade. Round shape. 6.75"L. Est. 125-175

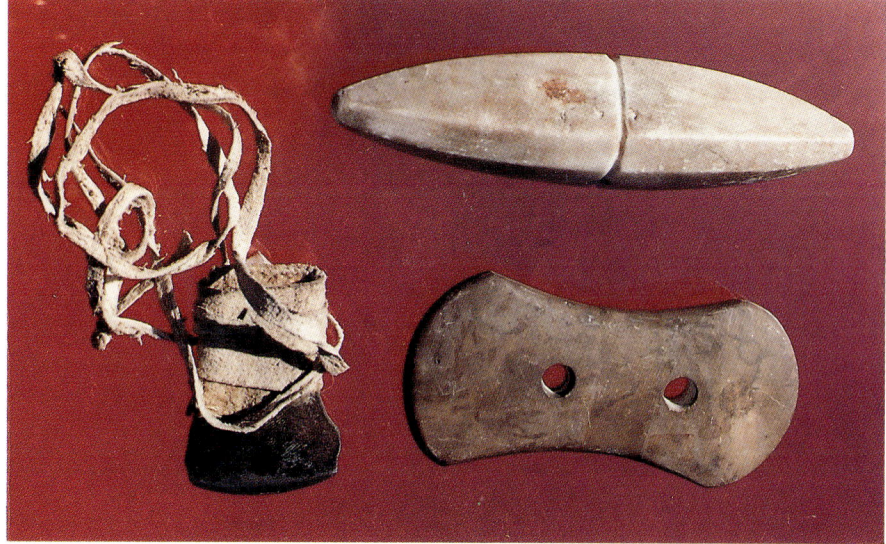

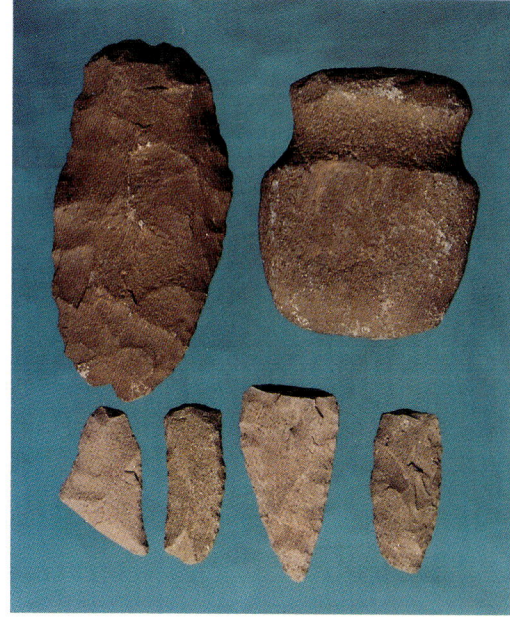

Top: **BAUXITE WAR CLUB HEAD c.1890**
Well-carved white to grey 6-sided club head. Drilled hole & carved groove. 6.25"L X 1.44"W. Est. 65-150 **SOLD $175(94)**
Bottom Right: **BROWNSTONE GORGET**
Bow tie shaped w/2 drilled holes. The holes show drilling lines but seem rather uniform. One hole is straight thru-the other meets in the center. Probably a more recent piece. 5"L X 2.38" X .25" deep. Est. 50-75
Bottom Left: **IRON HIDE SCRAPER BLADE W/BUCKSKIN TIES c.1870**
A good example of the blades that are missing from many elk horn scrapers. The buckskin cover is stitched w/sinew. Scarce & authentic item. Est. 50-100 **SOLD $75(94)**

LOT OF 6 ARTIFACTS
Full-groved brownstone axehead,5"L. Large flaked hoe or scraper blade, 7.25"L. 4 stone scrapers or knives. 3.5"L. Est. lot 65-110 **SOLD $65(95)**

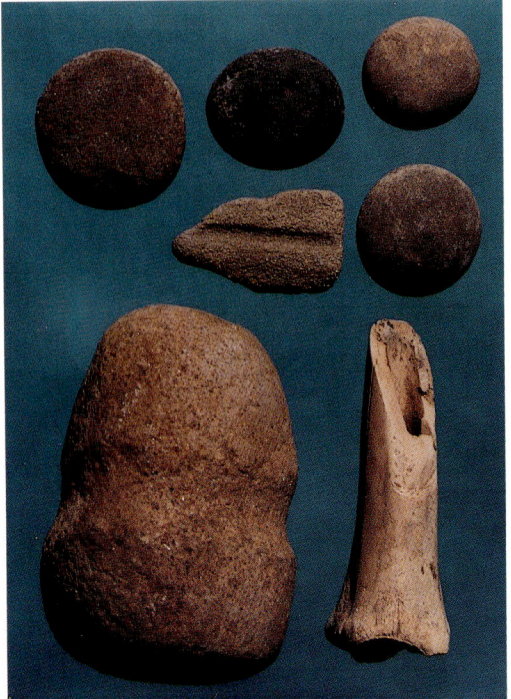

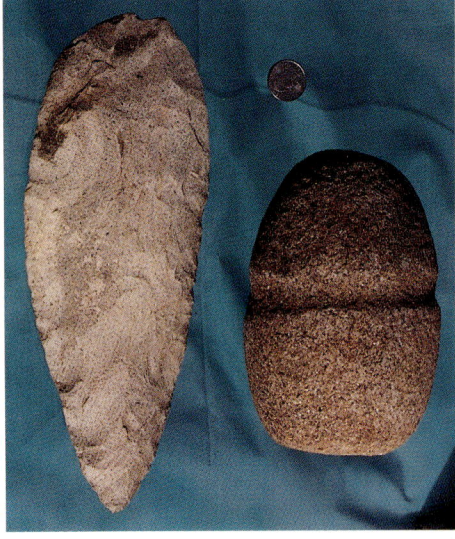

MISSOURI R. BLADE & MAUL
So. Dakota. Both are exceptional. Large green flaked Rhyolite blade 4" X 11." Grooved granite maul 7" L. Est. 94-200 lot **SOLD $192(95)**

LOT OF 7 ARIKARA PIECES
So. Dakota. Large full-grooved brownstone maul, 5.75"L. Buffalo hide flesher w/polished edge, 5.75"L. Grooved sandstone arrow polisher 3"L, 4 round polishing or pecking stones. Apx. 2.5" diam. Est. 100-175 **SOLD $125(95)**

Bone Tools, Misc. Stone & Shell Items

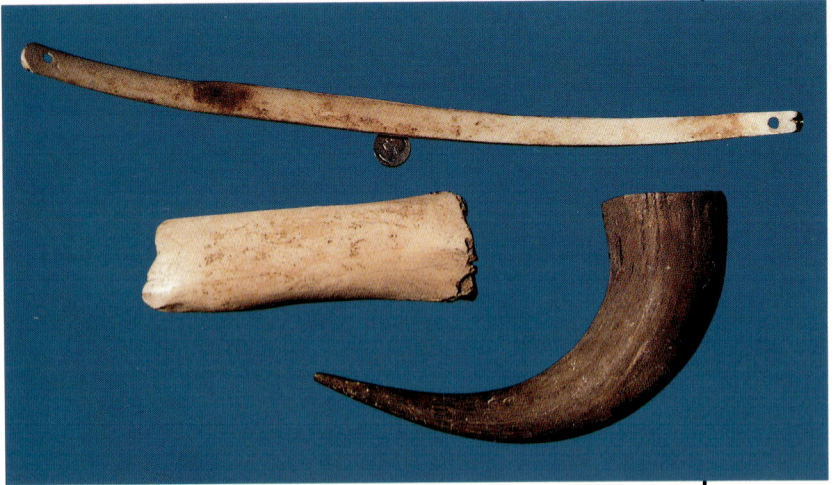

LOT OF 3 RELICS
So. Dakota. Polished buffalo bone stretching tool w/hole for wooden extension 8"L. Buffalo rib bone w/holes drilled in both ends, shows polish & use. Could be a sled runner.18"L. Old buffalo horn 10.75." Est. 75-185 **SOLD $75(95)**

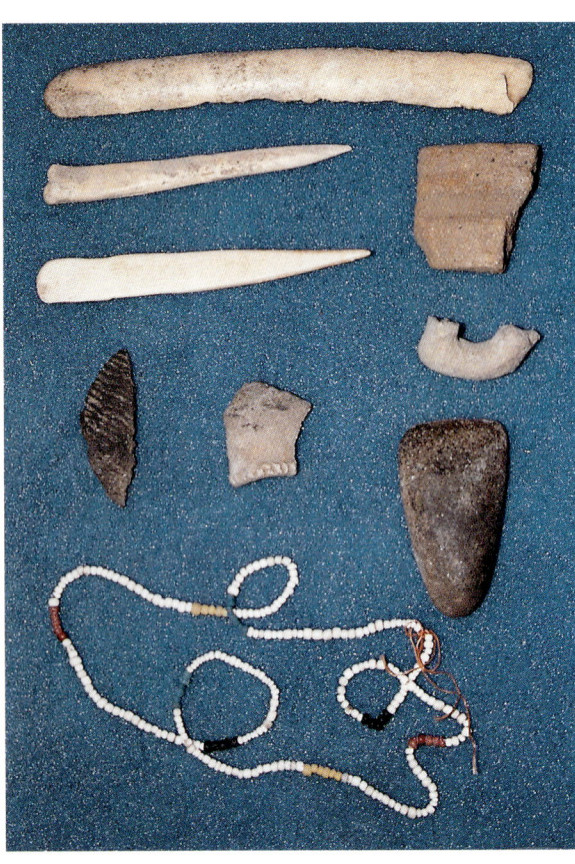

NOOTKA (N.W. COAST) GREY STONE HAMMER
Highly shaped & polished. Outstanding specimen. 6.75"L. Est. 200-350 **SOLD $188(96)**

ASSORTED RELICS
From No. of Chamberlain, So. Dak. along the Missouri R. before 1950. Buffalo rib tool (quill flattener?), 2 bone awls, stone celt, pottery shards & string of w. lined red, gr. yellow, Bodmer blue & black pony beads. Est. 125-250 **SOLD $100(95)**

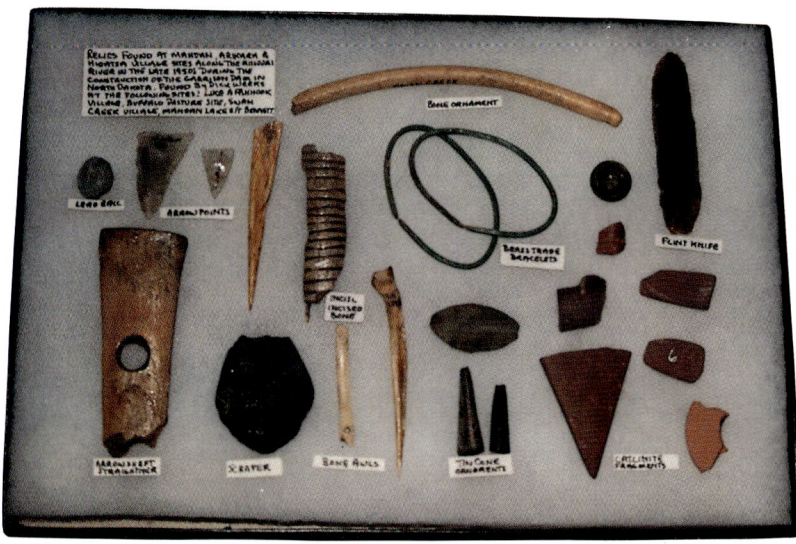

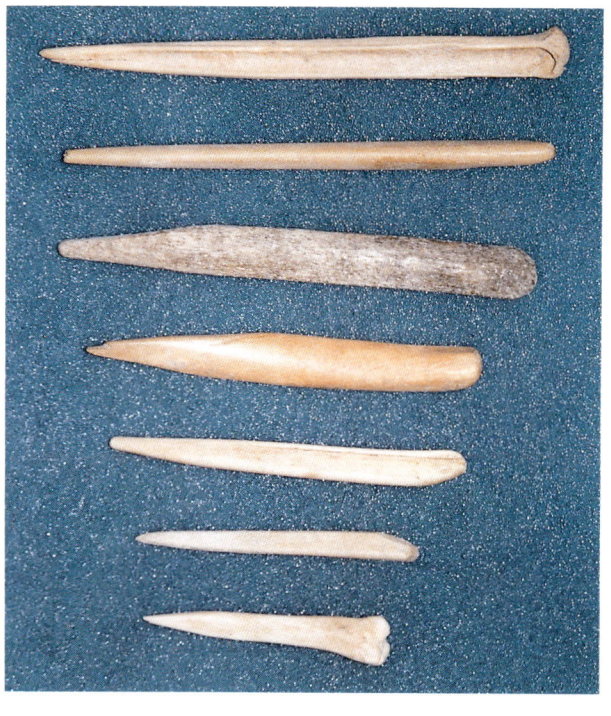

RELICS FROM MISSOURI R. SITES
found at Mandan, Arikara, & Hidatsa Village sites c. 1950 prior to Garrison Dam flooding in No. Dak. 1 arrowshaft straightener, arrowpoints, bone awl, trade bracelets, flint knife, tin cones, carved Catlinite, etc. 8" X 12" Riker mount. Est. 100-200 **SOLD $150(95)**

7 BONE AWLS (far right)
Same provenance. Largest is 5.5." Est. 85-175 **SOLD $125(95)**

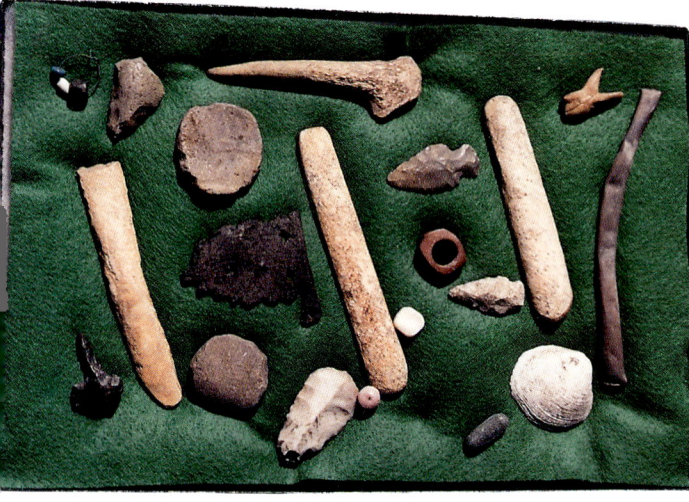

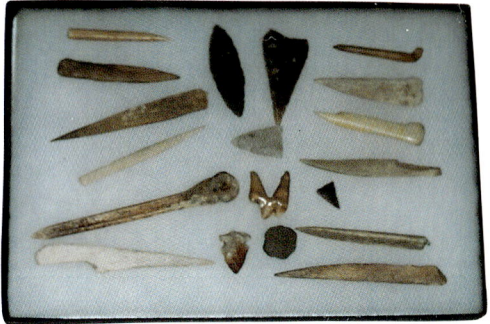

12 BONE AWLS, 5 POINTS, TOOTH & POTTERY SHARD
Prehistoric. Found in Mandan, Arikara sites along Missouri River, N. of Chamberlain S.D., by L. Phillip Est.100-185 **SOLD $85(96)**

COLLECTION OF ARIKARA RELICS c.1860
So. Dak. Incl. bone tools, round game stones, arrowheads, tradebeads, stone drill, etc. Est. 65-95 **SOLD $100(95)**

Left to Right: **BUFFALO BONE HOE c. 1850s.**
Found along the Missouri River just N. of Chamberlain So. Dak. where Mandan, Arikara & Hidatsa villages were once located. Out of a pre-1950 collection. Made from buffalo shoulder bone. Exceptionally fine w/no damage; has polished edge from use & exc. brown patina. 13.5"L. Est. 50-100 **SOLD $60(95)**
SIMILAR.
Same provenance. Beautiful polish w/edge worn from use. Good patina w/bone hardened from age. 13"L. Est. 75-150

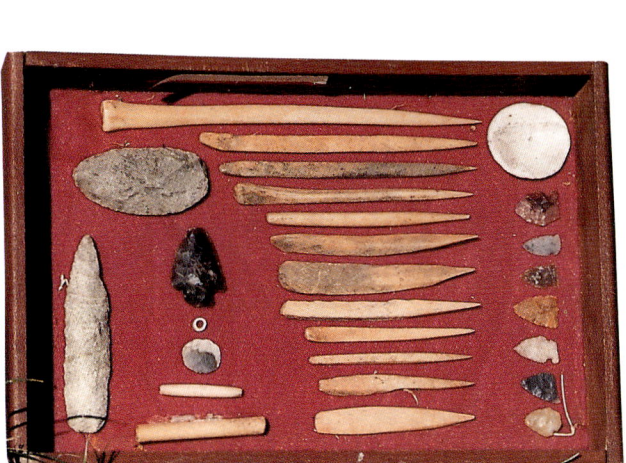

WOODEN BOX W/27 ARTIFACTS
Found in 1950's along Missouri R. No. of Chamberlain,So. Dak. 12 great bone awls(3"-7.25"), 8 arrowheads, 2 stone knives, round shell ornament or gambling dice, birdbone tube, 1.5" bone hairpipe & shell bead. Glued to red felt. Est. 200-300 **SOLD $200(95)**

SPECKLED GRANITE PENDANT
w/one hole. Polished. 4.5" L. Est. 125-175 **SOLD $127(95)**

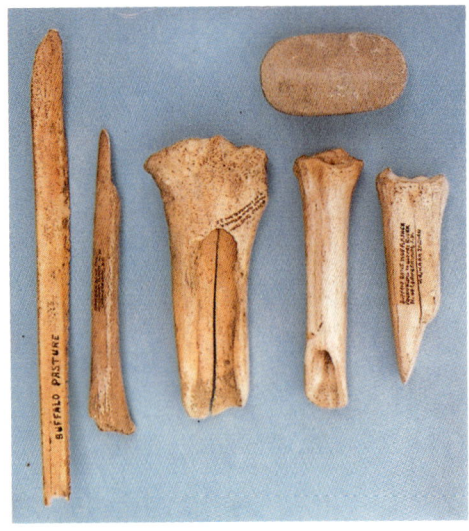

Left to Right: NOTCHED BUFFALO RIB BONE *found by Dick Weeks during the 1950's at the Buffalo Pasture Site in No. Dak. He was working for the Smithsonian excavating sites before they were flooded by Garrison Dam.* 12.5." Exc. patina & provenance. Est. 20-50 **SOLD $25(95)**
BONE TOOL W/POLISHED TIP for incising designs into pottery. *Probably Arikara-found along Missouri River No. of Chamberlain So.Dak. pre-1950.* 8.5." Good patina. Est. 15-30
BUFFALO BONE HIDE FLESHER *Same provenance. Great patina & polish from hard use. Age crack from drying of bone. Has hole in back for attaching to wooden pole. Beautiful piece.* Est. 50-100 **SOLD $50(95)**
ARIKARA BUFFALO BONE HIDE FLESHER *Same provenance. Good old coloring & patina w/ sharpened edge. Perfect cond.* 6.5." Est. 65-100
Same provenance. Notched blade. Nice patina & perfect shape. Est. 50-100
TOP:
ARIKARA SANDSTONE ABRADER for sharpening stone blades. *Same provenance. Fits in palm of hand & shows ground-in lines from use.* 3.75." Est. 10-25 **SOLD $15(95)**

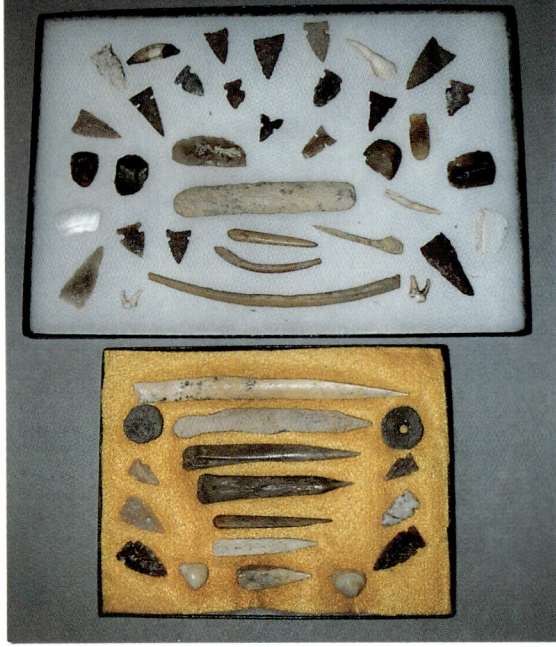

Top to Bottom: 19 FLINT POINTS, 2 BONE AWLS, 4 THUMB SCRAPERS, FLINT KNIFE, bone pottery smoother, 4 teeth, 2 shells & 2 bones. *Same provenance as preceding.* 8 x 12 mount. Est. 120-195 **SOLD $110(96)**
7 BONE AWLS, 6 POINTS, 2 POTTERY GAME DISCS, 2 SHELLS. *Same provenance as preceding.* 6.25 x 8.25 mount. Est. 65-140 **SOLD $91(96)**

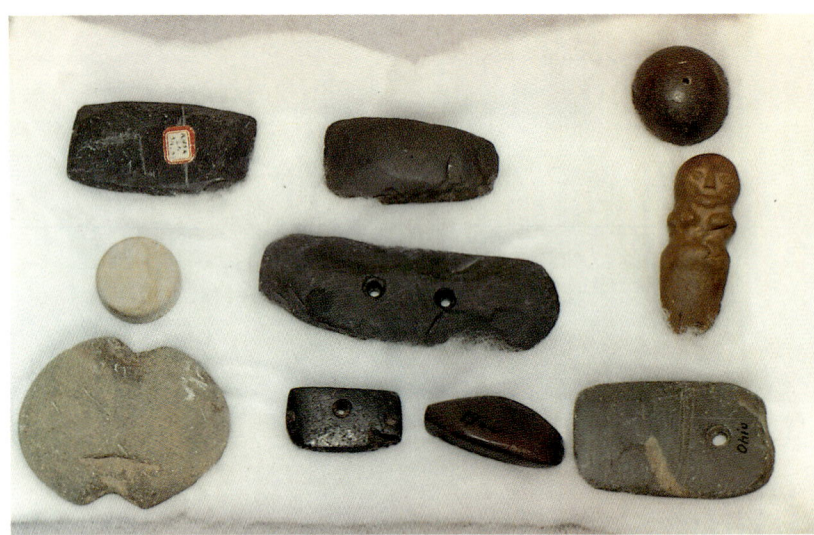

Top to Bottom (Left to Right): 10 PIECES MIDWESTERN STONE RELICS
A. Grey-green stone celt. *Labelled "Knox Co. Ohio".* 2.5"L.Est.15-35
B. Dk grey trapezoidal celt 2.4"L. Est.25-65
C. Ceremonial object-hollow 1/2 sphere w/center hole. 1.5" diam. .5" H. Est.20-50
D. Flat white circular game stone. 1" diam. Est.15-30
E. Dk. grey stone gorget w/2 holes. 4"L X 1.4"W: Est.15-30
F. Venus-style female figurine front view on both sides. Reddish stone w/celt-like blade.2.63"H. Est.150-250
G. Net sinker. Oval grey stone crudely grooved top & bottom. 2.75" X 2.25." Est.10-25
H. Unusual stone ceremonial (?) pendant w/crescent-shaped groove in 1 long side. 2 drilled holes. 1.5"L. Est.50-100
I. 3-sided highly polished brown hematite.I.9"L Est.15-40
J. Grey-stone pendant. *Labelled "Ohio".* Scratched incised lines & top hole. 2.63" X .13." Est.40-95
All 10 stone pieces. Est. 375-775 **SOLD AS 1 LOT $425(93)**

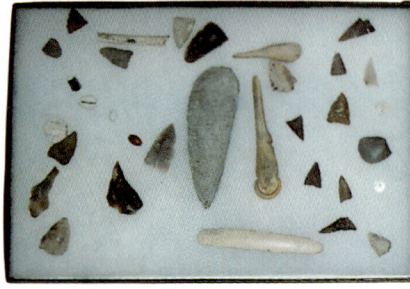

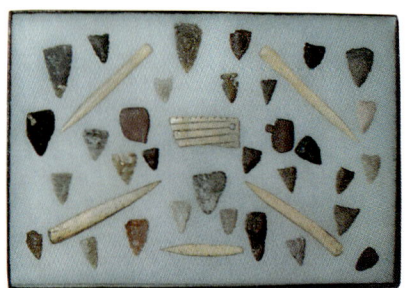

Top: LARGE GREYSTONE KNIFE 4.25", 20 POINTS & SCRAPERS, 6 BEADS & SHELLS, 2 awls, pottery smoother, & bone tube. *Same prov. as above.* 8 x 12 mount. Est. 65-100 **75(96)**
Bottom: 5 BONE AWLS, 2 CATLINITE PIPE FRAGMENTS, 30 TRIANGULAR POINTS, & incised bone ornament w/ drilled hole. *Same provenance as above.* 8 x 12 mount. Est. 95-195 **100(96)**

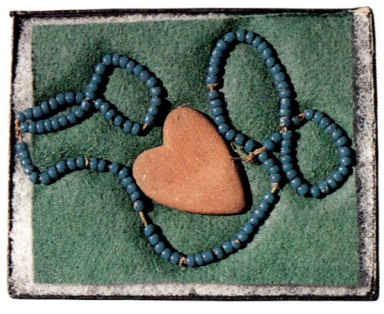

HEART-SHAPED STONE & TRADEBEADS
Old So. Dak. collection. Reddish stone 1.38"L. Bodmer blue pony beads strung on old sinew 15"L. Est. 40-95 **SOLD $45(95)**

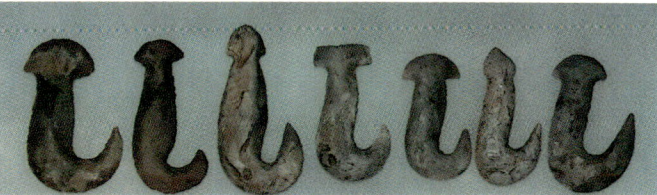

7 FLINT FLAKED FISHHOOKS
Uncertain age & provenance. Each one slightly different & interesting variation of color & shape-2" to 2.75." Est. lot 125-150 **SOLD $135(95)**

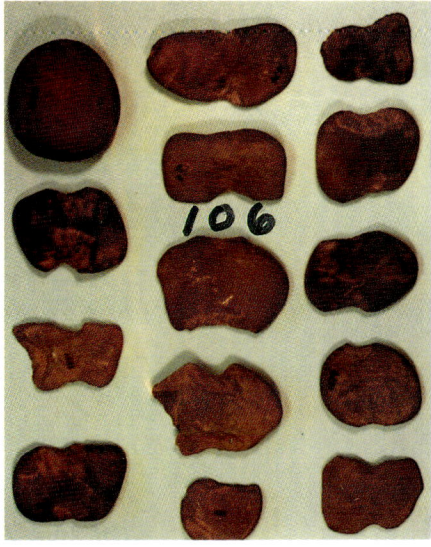

13 STONE NET SINKERS & 1 PECKING STONE
found by Preston Miller in 1957, Washington Boro, Penn. on the Fred Sagrey Property. All found within 10' area. Est. 20/50 **SOLD $25(90)**

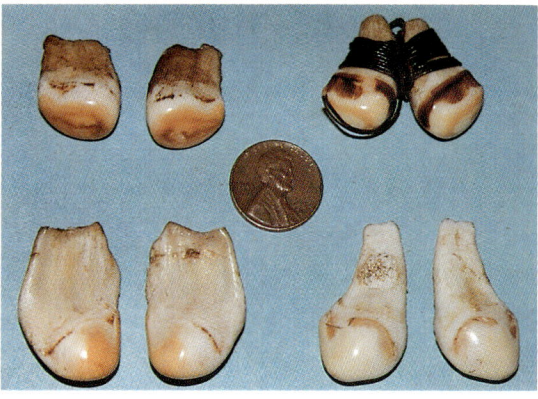

PAIR BULL ELK TEETH
w/dk. brown circle pattern. Apx. 1" L. Est. 40-80 pr. **SOLD $80(96)**
SIMILAR. Large w/dk. brown coloring. 1.25" L. Est. 50-90 pr. **SOLD $80(96)**
PAIR OF COW ELK TEETH w/ exceptional brown coloring (circular pattern). Tied together w/ black cord string. 1" L. Est. 30-60
SIMILAR. Large w/good coloring. 1.38" L. Est. 30-90 **SOLD $50(96)**

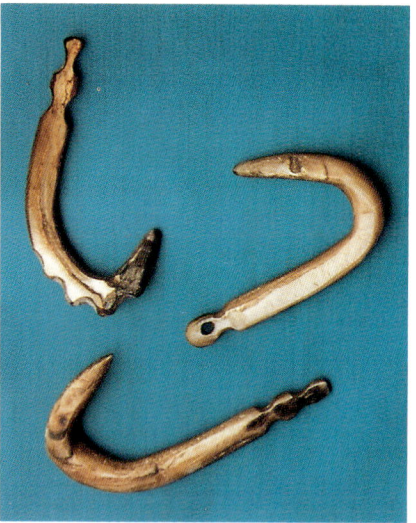

3 SHELL FISH HOOKS
Tag says "Okla." Unknown age. 2-2.5." Est. each 25-55 **SOLD $26 EACH**

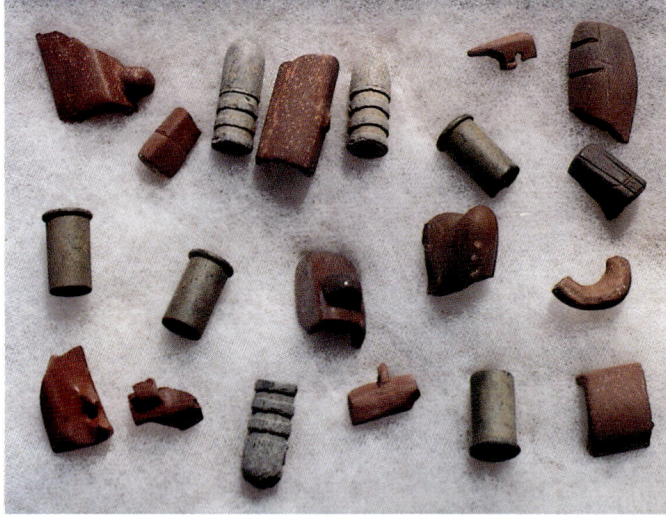

20 PIECE RELIC ASSORTMENT OF CATLINITE & BULLETS
13 early Catlinite pipe fragments. Largest is 1.25"L. 4 Henry rifle shell casings & 3 lead bullets. Est. 65-125 **SOLD $62(94)**

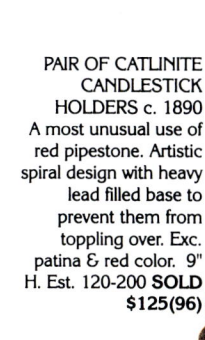

UNUSUAL FLAKED & POLISHED STONE PIN?
"Pike Co., MO." inked on 1 side. Cream colored flint? 4.38"L. Est. 20-50 **SOLD $40(95)**

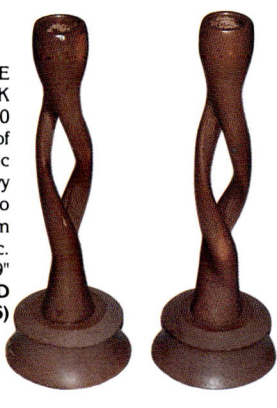

PAIR OF CATLINITE CANDLESTICK HOLDERS c. 1890
A most unusual use of red pipestone. Artistic spiral design with heavy lead filled base to prevent them from toppling over. Exc. patina & red color. 9" H. Est. 120-200 **SOLD $125(96)**

Fossils

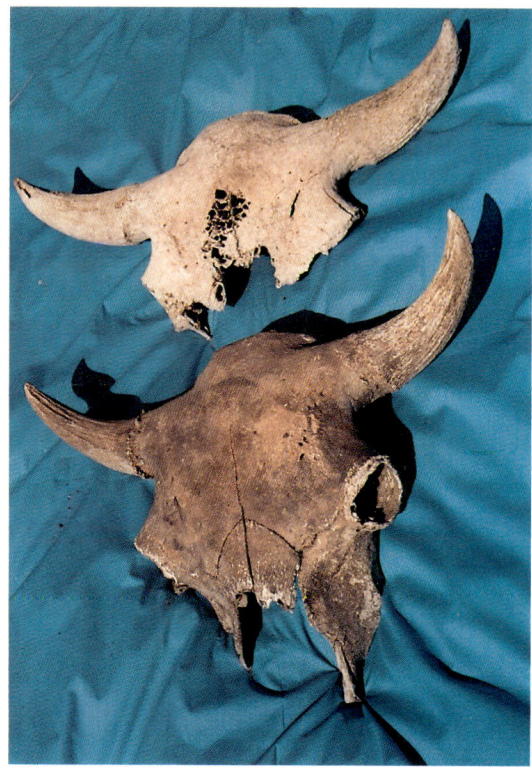

PRE-HISTORIC BUFFALO SKULLS
RARE. These were found on a sandbar in the Missouri R.. nr. Fairfax, So. Dak. They feel like stone & may be so old that they are petrified. Very hard to find. Patina varies from almost white to dk.grey. Measured from horn tip to horn tip.
Top: 27.5" W. Bottom: 24.5" W. Est. 250-500 each **SOLD $300 each**

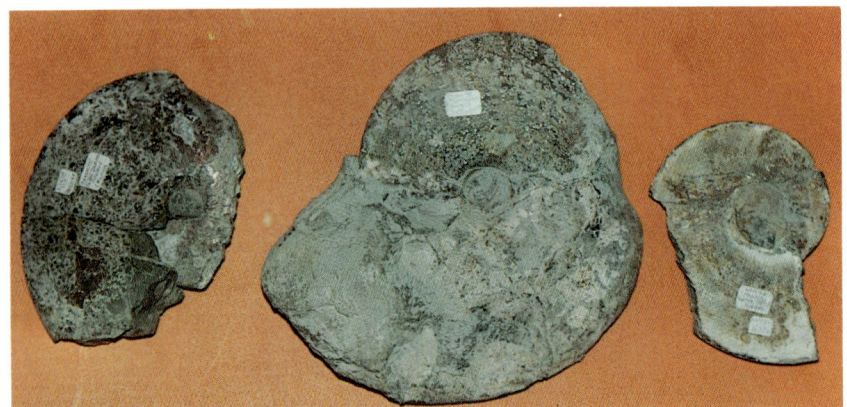

Left to Right: AMMONITE FOSSIL
VERY RARE. *Found by Blood Indians on their Reserve in Canada. Very, very old. These are sometimes seen in Crow & Blackfoot medicine bundles where they are profusely decorated w/fancy beads, shells, hair & bone "offerings".* 6.25." Est. 25-100 **SOLD $20(95)**
SAME but partially embedded in rock. 8." Est. 50-150
SAME. 5.5." Est. 25-100 **SOLD $30(95)**

FORGED IRON SHOVEL(?) BLADE c.1840?
Lightly rusted & pitted. Est. 10-50

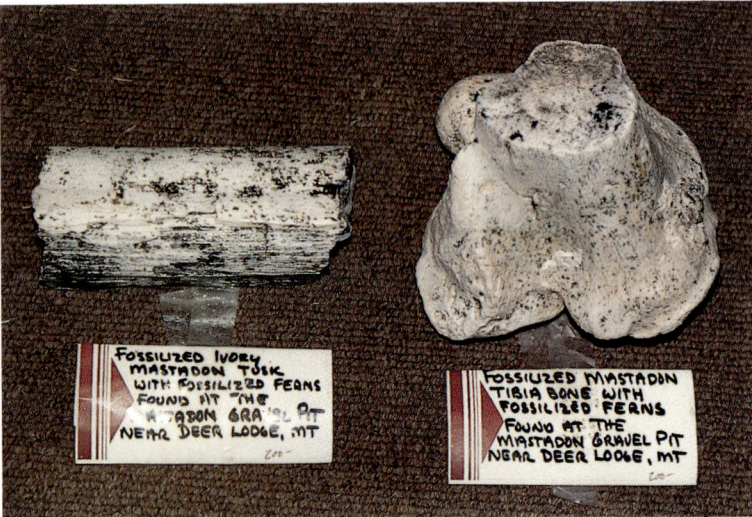

Left to Right: FOSSILIZED IVORY MASTADON TUSK
VERY RARE. *Found at gravel pit near Deer Lodge, Mont. Fossilized ferns on surface.* 5.5" L. Est. 125-250 **SOLD $125(95)**
FOSSILIZED MASTADON TIBIA BONE
w/fossilized ferns. *Provenance same.* 5" X 5." Est. 125-250 **SOLD $35(98)**

FLATHEAD IRON BITTEROOT DIGGER c. 1890
Collected on the Flathead Res. in Mont. Made by early Blacksmiths and used by Indian women to dig bitteroots for food. Exc. patina-shows use. 27" L. w/8.75" handle. Est. 100-200 **SOLD $95(95)**

Metal Relics

FORGED IRON BROAD AXE
Collected in Montana. Good example of the type of axe used to build cabins during Montana's early history. 8.5" X 11." Est. 25/75 **SOLD $25(91)**

Left to Right: IRON BLACKSMITHED SALMON FISHING SPEAR HEAD W/BARBS c.1880
Used by Indians to spear fish. Early trade item made from 1 piece of iron. Apx. 8" L. Est.30-50 **SOLD $60(95)**
SIMILAR
8.75"L w/4 barbs. Est. 40-60 **SOLD $45(95)**

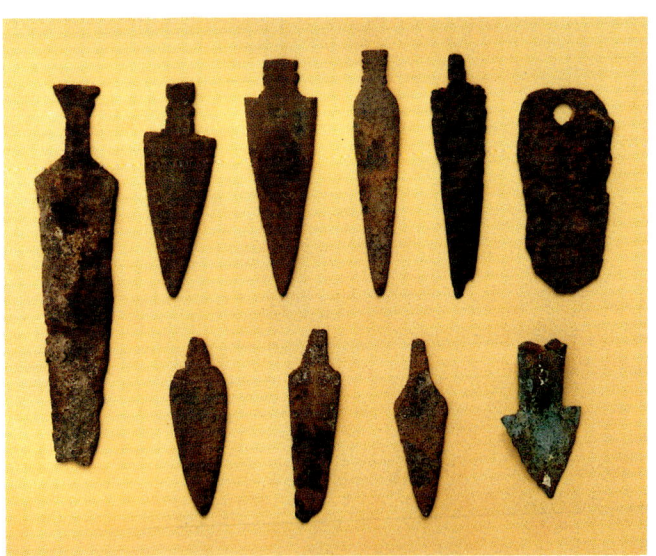

METAL TRADE ARROWPOINTS W/ 1 ORNAMENT, c. 1860s w/ hole. *Found at Ft. Wingate, Ariz.* All have rusted surfaces, but are in good stable cond. 1.88" X 4.38." Est. 200-400 **SOLD $300(95)**

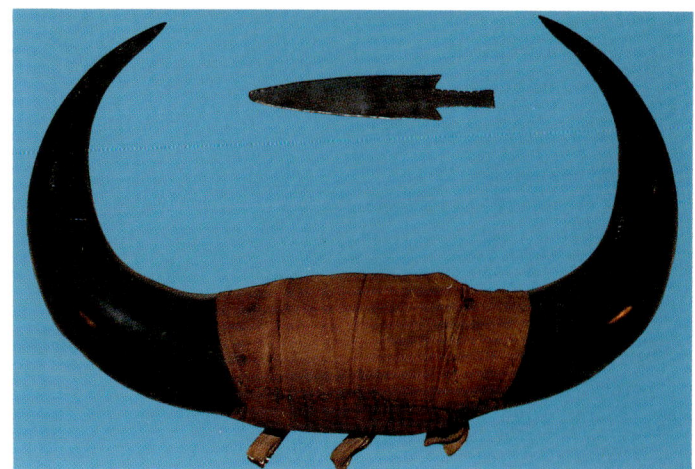

See description on p. 43 for buffalo horn rack
OLD IRON SPEAR POINT c.1860
Janetski collection, Great Falls, Mont. 7"L. Est.40/80 **SOLD $50(92)**

Eskimo Artifacts

IVORY CARVINGS

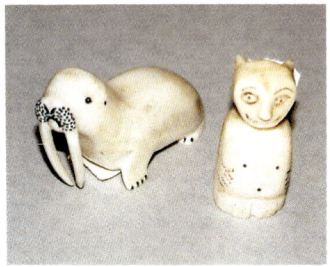

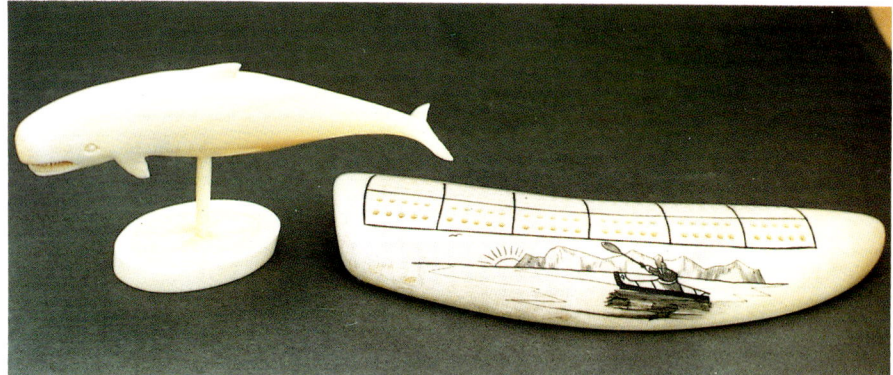

Left to Right: ESKIMO IVORY WALRUS CARVING c.1900
Solid piece of ivory incl. the long tusks. Blackened eyes, whiskers, ears & mouth. Highly polished. Exc. patina. 2.75" L. Est. 200-300 **SOLD $250(96)**
ESKIMO IVORY FIGURE W/ ANIMAL-LIKE EARS c.1900
Features are carved into ivory & blackened. Unusual. Slight crack in base. 1.75"H. Est. 65-125 **SOLD $75(96)**

Left to Right: ESKIMO IVORY WHALE & MOUNT 20th c.
Detailed & highly polished Killer Whale has tiny carved teeth. 2 part stand also made of ivory. 4.5"L X 2.25"H. Est.75-125 **SOLD $70(93)**
ALASKAN ESKIMO IVORY SCRIM-SHAW CRIBBAGE BOARD 20th c.
Signed "Nuguruk". One side depicts seals on the ice;the other Eskimo in kayak w/mountains & sunset. 6"L X 1.9" W. Est.175-250

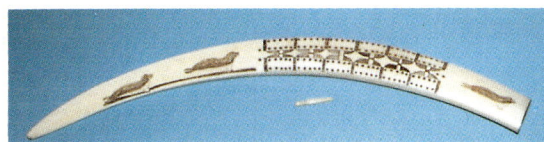

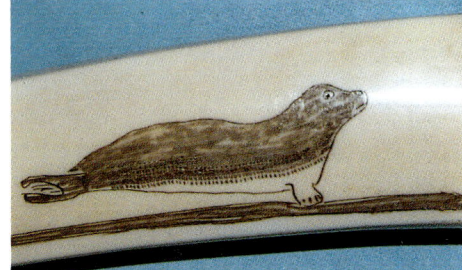

ESKIMO IVORY (WALRUS TUSK) CRIBBAGE BOARD W/ IVORY PEG
Exc. scrimshaw work. TOP: seals BACK: fisherman in kayak harpooning seals on ice floor. (See 3 detail photos). Highly polished. 21"L. 1.75" W. point-1" deep. Est. 325-475 **SOLD $351(96)**

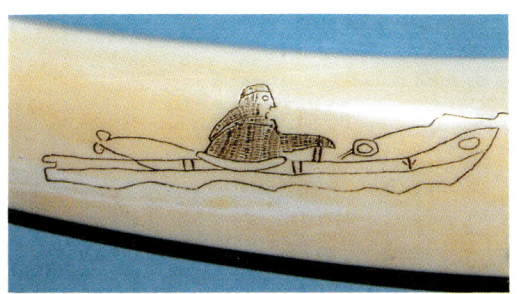

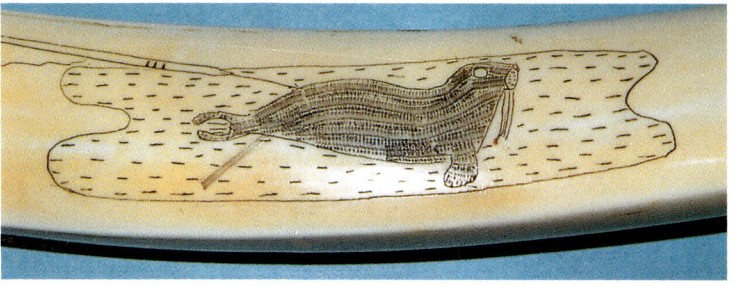

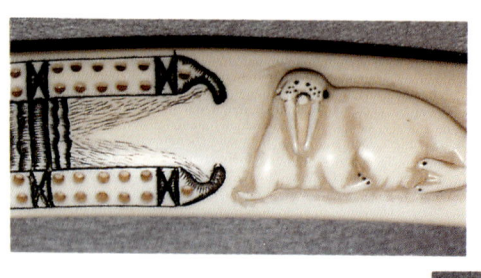

ESKIMO WALRUS TUSK CRIBBAGE BOARD 20th c.
Incredible detailed relief & scrimshaw details. 3-D walrus, 2 foxes, eagle & seal on top. Back has scrimshaw polar bear hunting 2 seals on an ice floe. (See 3 detail photos). Superb execution & cond. 25"L. 1.38"W. Est. 750-1200 **SOLD $650(97)**

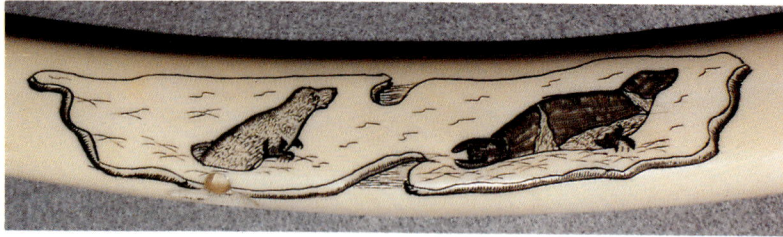

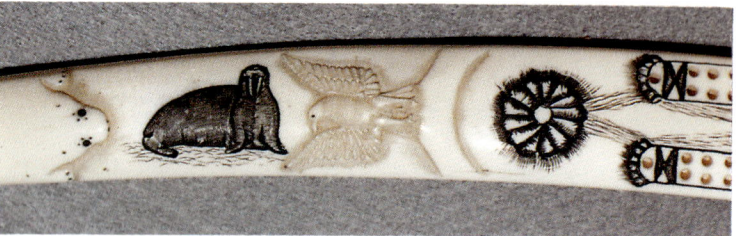

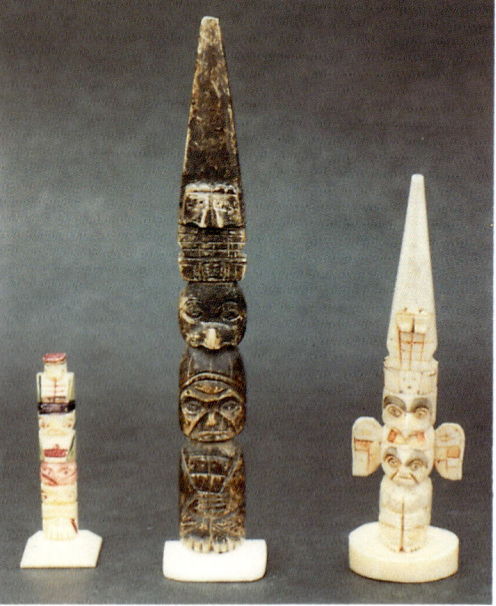

Left to Right: **INDIAN CARVED BONE TOTEMS** c.1900?
A) Miniature colored pink, dk. green & purple on ivory stand. 2.25"H. Est. 30-50
B) *Tlingit from Sitka, Alaska. Copy of Chief Johnson's totem in Ketchikan.* Dark patina-looks very old. New ivory base added. Cross piece missing. *(See Marius Barbeau Totem Poles ,Natl. Museum of Canada, 1964. pp. 607-608)* 5.75"H. Est. 95-150 **SOLD $105(93)**
C) *c.1901. Also from Sitka.* White w/red & black faded ink. Depicts Fogwoman same story as B). 4.4"H. Est. 75-125

ESKIMO FOSSILIZED IVORY ARCTIC FOX KNIFE HANDLE
Highly polished & sculptural. Rich gold to white tones. Black eyes. 2.75"L. Est. 150-250 **SOLD $230(94)**

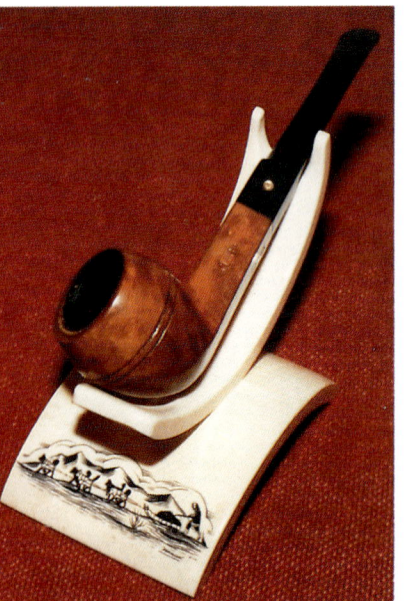

ESKIMO IVORY PIPE HOLDER c.1920
Signed "Nunuk". 3 piece all ivory holder. Detailed scrimshaw of Eskimo driving his sled w/dogs. Highly polished. Pipe not included. Holder is 2.5" X 3.5"; base is 4." Est. 65/110 **SOLD $95(92)**

IVORY RELICS & CHIPPED ARTIFACTS, ETC.

PRE-HISTORIC ESKIMO FOSSILIZED IVORY ICE CLEAT
Has 4 holes for attachment to mukluks & 4 carved protrusions which keep one from slipping on the ice. Shows considerable age, dk. brown patina. 4.5" X 1.75" Est. 150-300 **SOLD $235(93)**

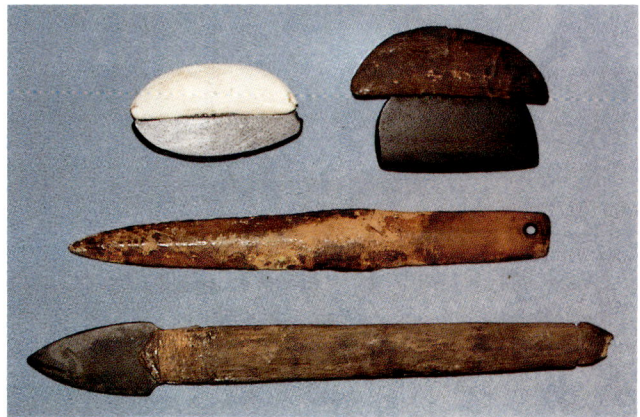

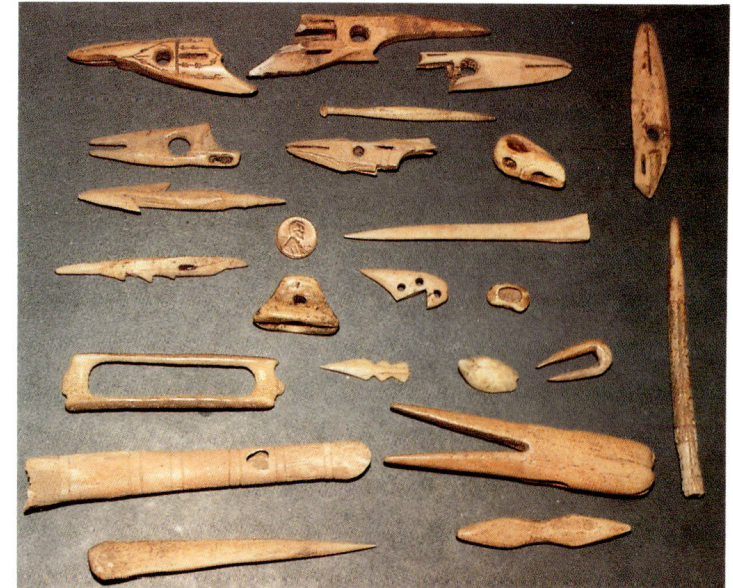

Left to Right (Top to Bottom): ULU KNIFE W/IVORY HANDLE *RARE*
Over 500 years old. Siberian Upik-Thule Culture. Found nr. Kookoolik Village on St. Lawrence Is. 3"W X 1.5." Est. 175-300 **SOLD $150(97)**
ULU KNIFE W/WOOD HANDLE
Over 400 years old. (Same provenance as previous ulu).2.38"W X 2.5"H. Est. 150-250 **SOLD $150(97)**
ESKIMO IVORY LANCE HEAD
RARE 1000-1500 yrs. old. Ponuk Culture Found on St. Lawrence Is. Alaska by Nelson Alowa. Kookoolik site. 8.25"L. Est. 75-150 **SOLD $85(97)**
ESKIMO HUNTING KNIFE W/SLATE BLADE
Siberian Upik, Thule Culture;(same prov. as previous knife.) Wood handled,which is very rare, since most wood has decayed. Apx. 10"L. Est. 150-250 **SOLD $85(97)**

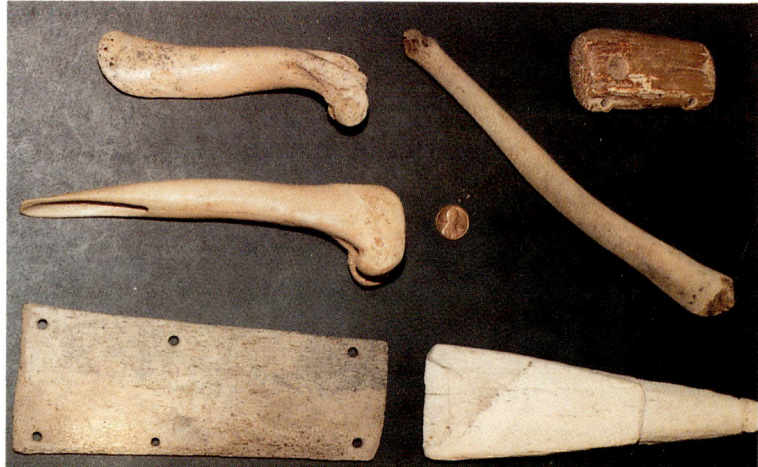

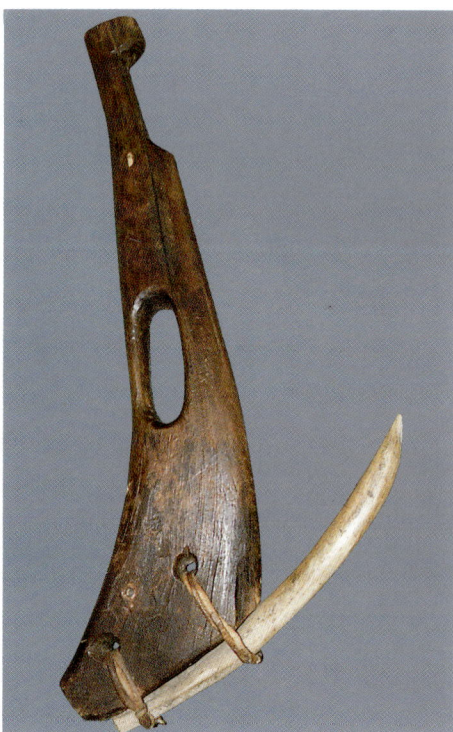

ESKIMO ROOT PICK (*Elautaqa*) c.1890
RARE to find w/handle. Hand-carved wood w/2 hand grips & pointed antler blade attached w/rawhide lacing. Nice old patina from age & use. 21"L Antler blade-13"L. Est. 150-250 **SOLD $200(97)**
See Fitzhugh. W., *INUA*, Washington, D.C., Smithsonian Inst. Press, 1982: 112.

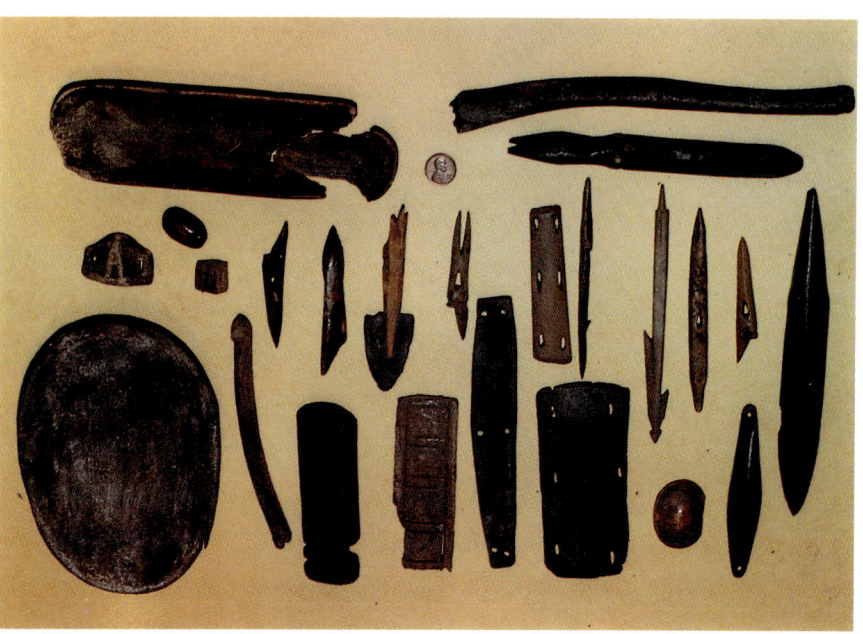

OLD BERING ESKIMO ARTIFACT COLLECTION (3 photos above)
*1500-2000 years old** Bought from native Inuits who gathered it from the ancient campsites surrounding Savoonga on St. Lawrence Is. in the Bering Sea. Purchased Nov. 1988.* Assortment of old Eskimo tools & ornaments;53 pieces of fossilized ivory & *RARE* driftwood carved bowl. Includes 5 Old Bering Sea incised design harpoon heads**, 1 Old Bering Sea fossilized ivory harpoon head w/original slate point, another w/ rusted iron point. Several bone & ivory chisels, engraved bone whistle, fossilized ivory dish, ivory ear hook, labret, button, 4 rare ivory armor slats* w/6 holes each, numerous pins, awls, handles ornaments, etc.
*See Pirjo Varjola, The Etholen Collection, Natl. Museum of Finland, 1990. pp. 270-272, Fig.448-449
** See Dorothy Jean Ray, Artists of the Tundra & Sea, Seattle, Univ. of Wash. Press, 1961. pp.13-23, Fig.14-28 & 108-113 Est. 2500-4000 **SOLD $2300(93)**

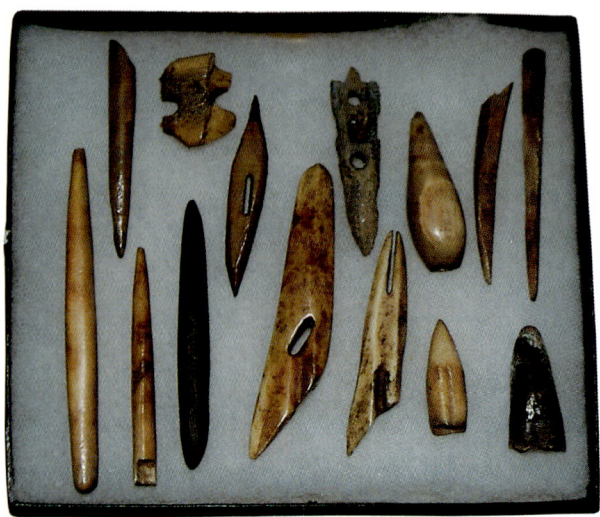

LOT OF 14 ST.LAWRENCE ISLAND BERING SEA FOSSILIZED IVORY ARTIFACTS
Includes 3 harpoon heads, 6 awl points, 3 ornaments, etc. All w/dk. old patina. 5 x 6" mount. Est. 150-350 **SOLD $141(96)**

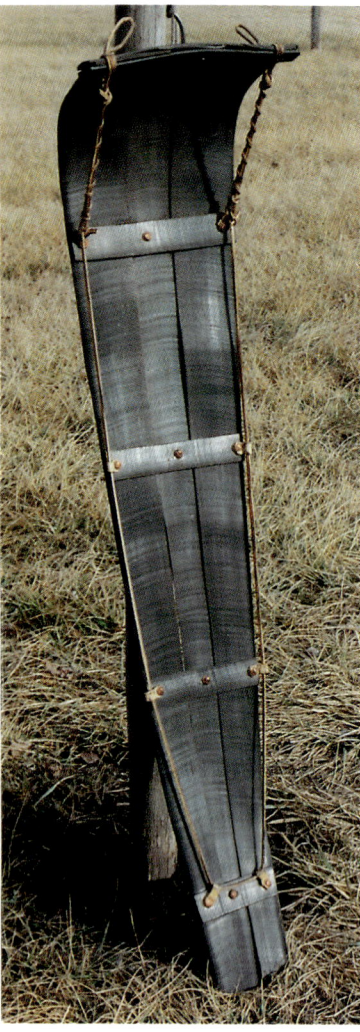

ESKIMO BALEEN TOBOGGAN SLED c.1870-1910
Rare. Three large slabs of black whale baleen laid side by side & held together w/cross pieces held in place w/copper harness rivets. Has rawhide side straps for holding cargo in place. Small toboggans like this are known to have been pulled by men wearing snowshoes-the sled will follow in the depression made by the snowshoes. Pristine cond. 50"L. 12.5"W. front 5"W. rear. Est. 600-900 **SOLD $550(98)**

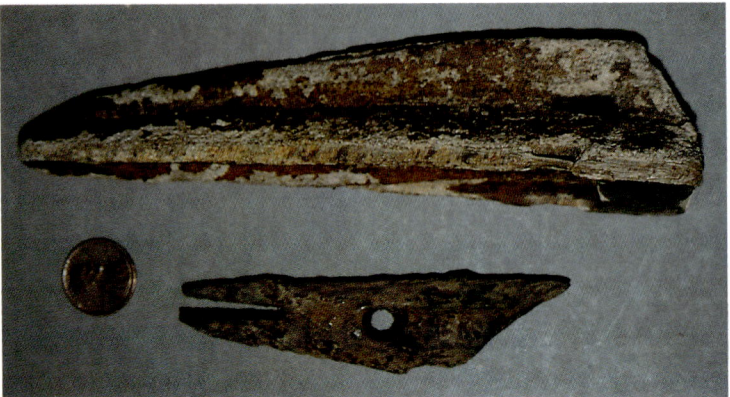

PREHISTORIC FOSSILIZED IVORY SLEIGH RUNNER
Very old patina. Shows wear. 6.5" L. Est. 95-195 **SOLD $75(96)**
PREHISTORIC ESKIMO FOSSILIZED IVORY HARPOON HEAD
St. Lawrence Island Bering Sea Very old patina. 4"L. Est. 25-75 **SOLD $30(96)**

ESKIMO FOSSILIZED IVORY LABRET (?)
Bi-laterally symmetrical double faces inlaid w/metal eyes; noses are double holes. Grooved around bottom. Double holes thru end to end suggest it may not be a labret, but an ornament. 1.25"L X .5" deep X .75"W. Est. 120-175 **SOLD $145(94)**

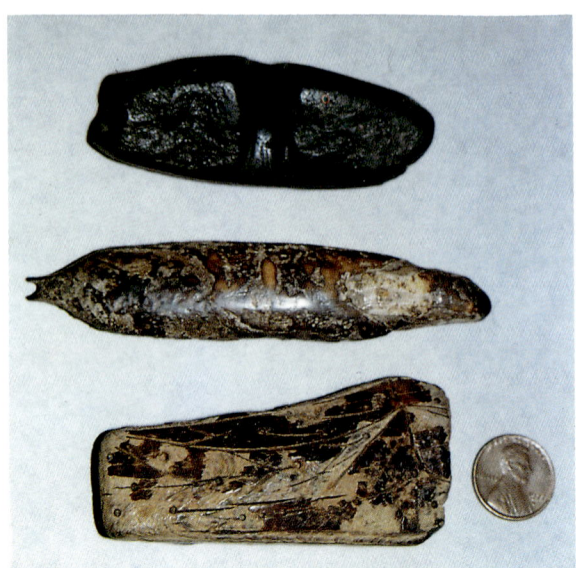

Top: PREHISTORIC BLACK STEATITE ARROW STRAIGHTENER
w/polished groove. *Found near Clear Lake, Calif.* 3"L.Est. 35-95 **SOLD $45(96)**
FOSSILIZED POLAR BEAR TOOTH PREHISTORIC BERING SEA TOOL
Rare. Has 2 fine points shaped into tip. Dk. patina, 4"L. Est. 60-125 **SOLD $63(96)**
FOSSILIZED BERING SEA IVORY ORNAMENT
w/ incised line designs on front surface (very early pattern) & 5 ribbed & curved protrusions on reverse. This is perhaps 1/2 of a very rare ceremonial ornament. Dk. patina of age. 3"L. Est. 95-200 **SOLD $97(96)**

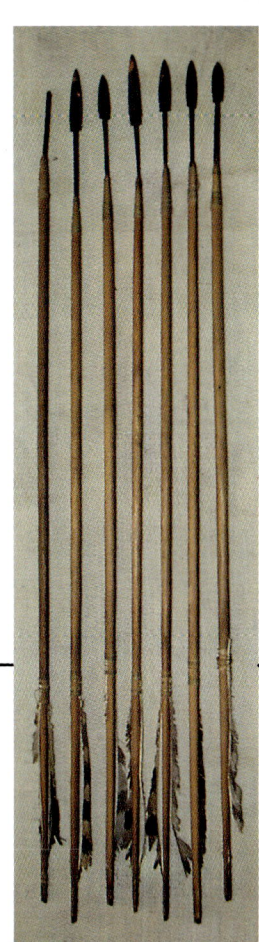 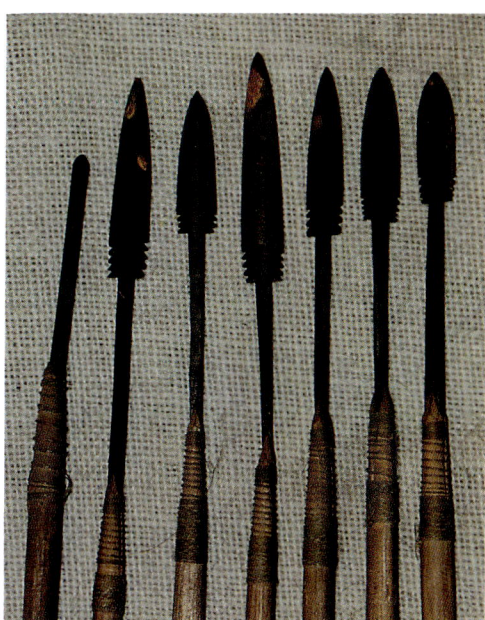

ESKIMO OR N. ATHAPASKAN ARROWS c. 19th cent.
Most likely Interior Athabascan or Cent. Cook Inlet See *A Victorian Earl In The Arctic "The Travels & Collections of the Fifth Earl of Lonsdale 1888-89"*, by Shepard Krech, Univ. of Wa. Press:102-103 for illustrations & history of this type of arrow. Multi-barbed points like these were made from iron hoops w/ material supplied by the Russian-American & Hudson's Bay Co. All these arrows are wrapped w/finely twisted sinew & made from cedar wood. They measure aprx. 31" L. & have two striped feathers (unless otherwise noted). The hand made iron points avg. 5" L. Est. 125-250 each
A. This one has an iron nail point & 3 feathers. The fletching is cut short & about 75% intact. **SOLD $125(98)**
B. Multi-barbed point w/2 feathers. Feather veins intact. **SOLD $165(98)**
C. Same, w/1 feather remaining & loose on one end.**SOLD $125(98)**
D. Same, w/2 feather shafts. **SOLD $125(98)**
E. Same, w/2 feather shafts. 1 feather loose on one end. **SOLD $165(98)**
F. Same, w/1-1/3 feathers. **SOLD $125(98)**
G. Same,w/1 partial feather remaining & loose sinew wrapping on one end. 2" of shaft near nock was broken off & glued back. **SOLD $125(98)**

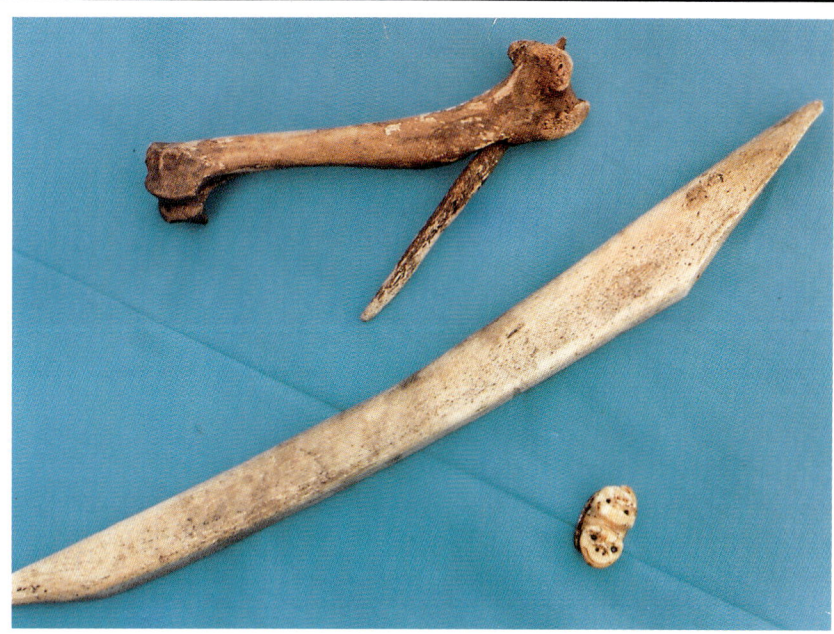

Top to Bottom: LARGE BONE HALIBUT (?) FISH HOOK
 45° bone point thru hole in larger femur(?) bone. Ancient-looking patina. Hole drilled thru largest part at top. 7"L. Est. 50-150 **SOLD $60(94)**
ESKIMO SLED RUNNER Good patina. Polished. 15"L. Est. 50-150 **SOLD $50(94)**
ESKIMO FOSSILIZED IVORY LABRET (?)
 See previous description & detail photo p. 28.

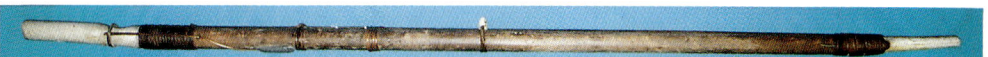

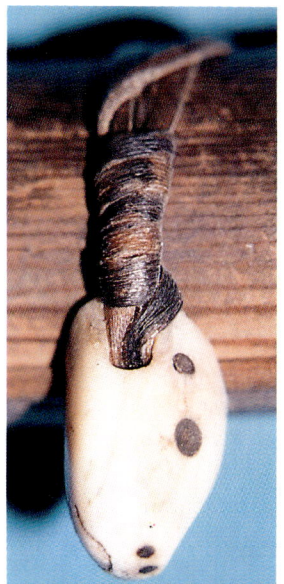

ESKIMO HARPOON w/WOODEN SHAFT c. 1850.
In use, the head separated & stayed under the skin of the seal. Air-filled bladder floats were attached to the head & kept the seal from diving. Carved ivory foreshaft 8.5"W w/3 protruding rings & hole for harpoon togglehead. (Togglehead missing.) Ivory base is 8"L & the tip is broken off. Carved ivory seal head finger rest attached to the middle. (See detail) Lead weight for balance attached to lower end. Everything is attached w/rawhide (babiche) lacing. 5.5'" L. Exc. age patina. (*see Bureau of Ethnology, Bulletin #30, Pt.1, pg. 533.*)
Est. 300-600 **SOLD $312(95)**

Pipes

See also replica pipes & pipe tomahawks, p. 175

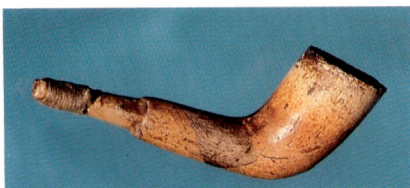

METIS (HALF-BREED) CLAY TRADE PIPE
This is a rare & early style pipe showing considerable use. Cord string wrapping on mouthpiece. Exc. patina 4" L. Est. 50-125 **SOLD $150(95)**

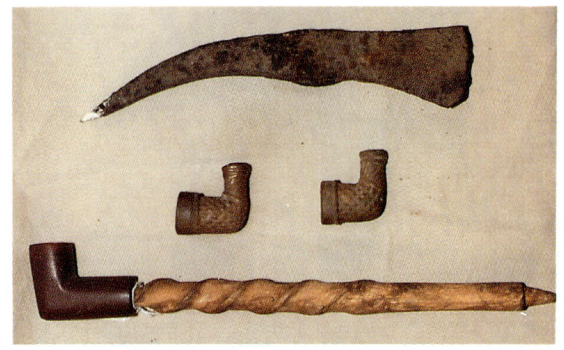

Top to Bottom: SPIKED IRON TOMAHAWK HEAD
See description under trade goods, p.56.
LOT OF 2 OLD CLAY TRADE PIPES c.1830
Shows patina of use. 1.5" X 1.5." Est. 20-40 **SOLD $30(92)**
CATLINIITE PIPE W/SERVICE BERRY STEM Contemp.
L-shaped Catlinite bowl; 2.25" X 1.5"H. 10" stem is spiral-carved. 12.5"L. Est.65-95 **SOLD $96(92)**

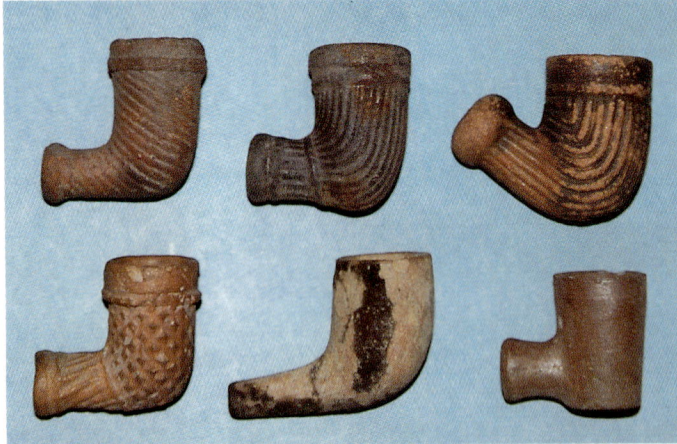

Top to Bottom: LOT OF 3 CLAY TRADE PIPES c. 1820
Ridge patterned pipes. Good patina. Exc.cond. Est. lot 45-75 **SOLD $70(96)**
SAME. First pipe has small nick on rim. 1.5" X 1.5." Second is rare old pattern w/two (1/2") chips on the bowl surface. 2" x 1.5." Est. lot 30-60 **SOLD $45(96)**

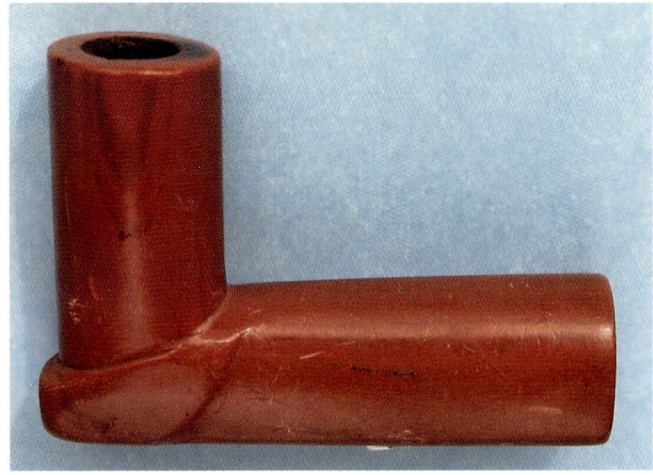

CATLINITE PHALLIC EFFIGY PIPE
Great old pipe bowl w/tapered stem hole & tobacco coated smoke hole. Exc. old patina. Rare & desirable effigy. 2.5"X 3.75" Est. 350-600 **SOLD $385(96)**

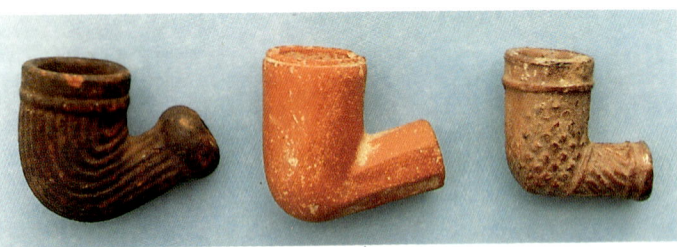

Left to Right: CLAY TRADE PIPE c. 1820
Red clay w/black surface patina. Perfect unused cond. & patina. An exc. example that could still be smoked. 2.13" X1.75" Est. 16-30 **SOLD $42(95)**
SAME. Exc. patina. 1.88" X 1.88" **Est. 16-30 SOLD $37(95)**
SAME. Brown color w/glazed surface & exc. patina. 1.5" X 1.75 Est. 16-30 **SOLD $37(95)**

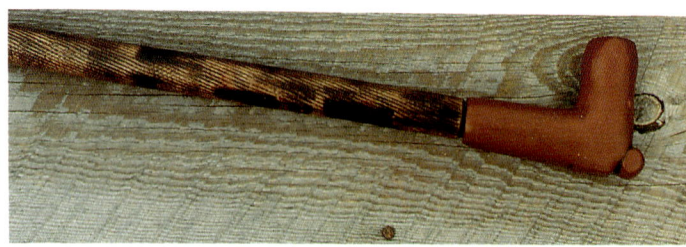

CHEYENNE-ARAPAHO CATLINITE PIPE W/FILE-BURNED STEM c.1900
Came from the Cantonment area of the Cheyenne-Arapaho Res., W. of Canton Lake, Okla. Unusual sculptural rounded forms plus protrusion on front of elbow pipe. Exc. cond. & patina. 19"L-pipe is 4.25" X 3" H. Est. 600-800 **SOLD $500(93)**

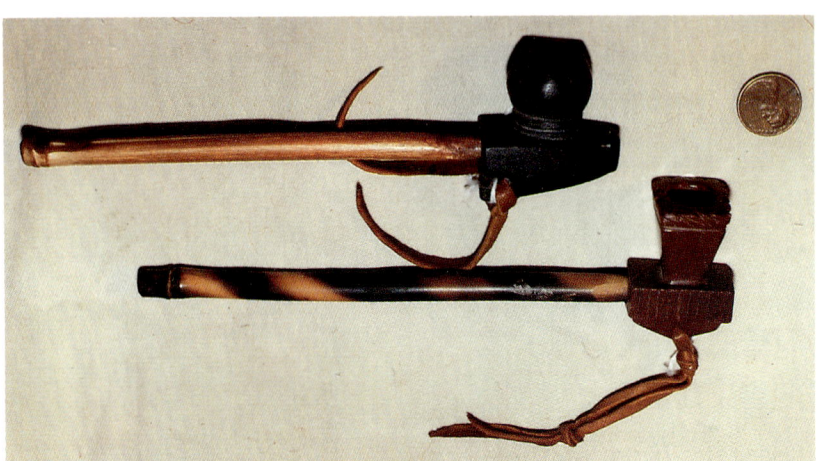

STEATITE STONE PIPE W/BAMBOO STEM c.1980
Leather dangle hangs from drilled hole. Bowl 1.5"; 6.5" total L. Est. 65/95 **SOLD $75(92)**
CATLINITE PIPE W/BURNT BAMBOO STEM c.1980
Bowl 1.88" H. X 1.25 W. 7" total L. Est. 65/95 **SOLD $65(92)**

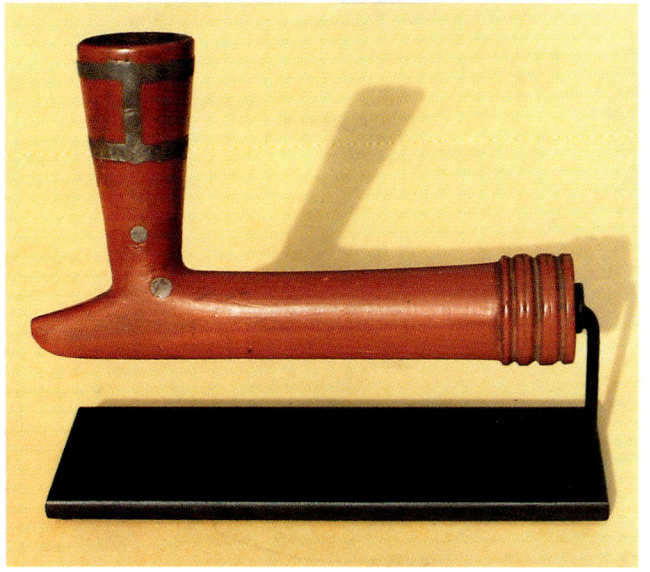

SIOUX EARLY CATLINITE LEAD INLAY PIPE c.1850-65
This could easily be a pre-1850 piece. Consignor says it is from an Oregon family that collected it prior to 1870. Beautiful design & delicate symmetry. Deep red tapered stone w/early-style stem hole. Inlaid bowl w/tapered hole has 4 carved rings & old tobacco coating inside. Includes display stand. 5.75" L X 3.25" H. Est. 1500-2500 **SOLD $1500(95)**

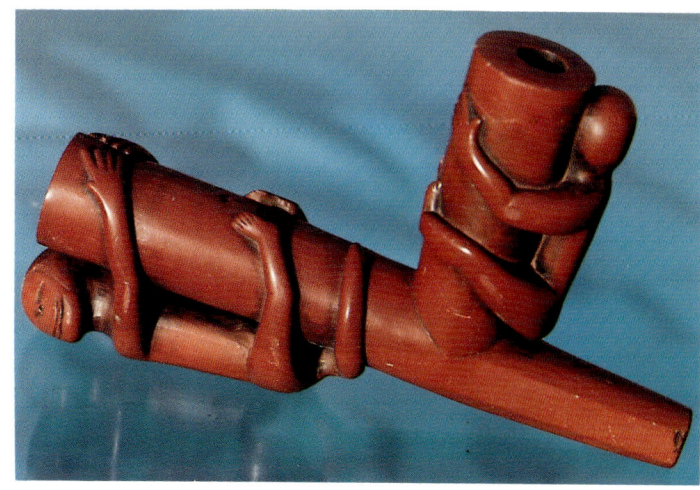

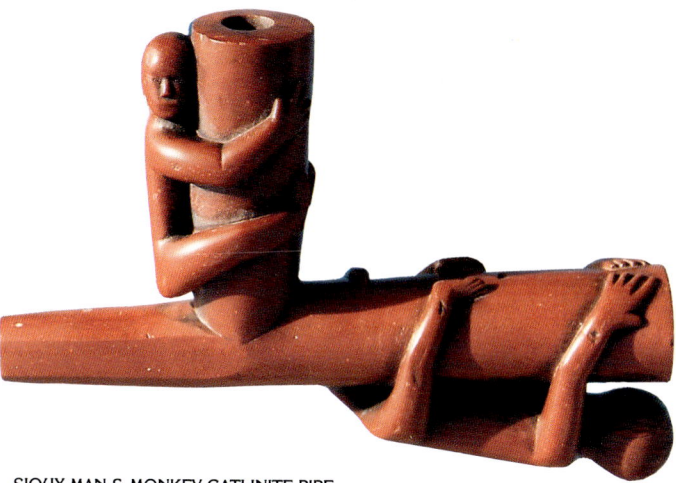

SIOUX MAN & MONKEY CATLINITE PIPE
This is a most handsome & expertly carved pipe. The figure clinging to the bowl is obviously a man-w/precise hands, feet, nose, eyes & mouth. In the same manner, the figure clinging to the base is a monkey w/tail, same hands & feet, monkey face & hair over head & down neck. The man figure is a portrayal of Iktome, the Sioux trickster & central figure in many Sioux Winter stories, which tell of his comical adventures w/ other creatures of the world. This is an exceptional pipe showing great skill, remarkable sculptural quality, exc. patina & high polish. 7"L X 4.75"H. X 1.5"W. Est. 1500-2500 **SOLD $2200(94)**
A similar Flandreau Sioux pipe, collected before 1883, is described by Dr.John C. Ewers in Plains Indian Sculpture, *Washington, D.C., Smithsonian Inst. 1986:98.*

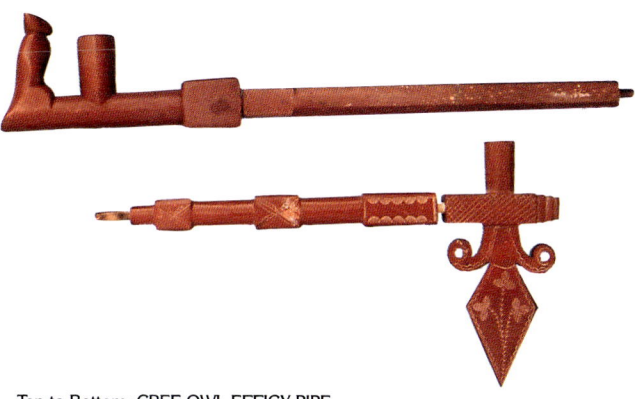

Top to Bottom: **CREE OWL EFFIGY PIPE**
Collected on the Sweet Grass Res. in Saskatchewan, Canada. An owl on a Cree pipe is very unusual as there are many Cree stories about owls being disliked. Bowl & stem are carved from dark red catlinite stone. The stem was broken in half & solidly glued back together. Exc. patina & polish. Tapered tobacco hole. Shows use. Bowl-7.38" X 3.5." 19.75" total L. Est. 550-950 **SOLD $750(95)**
DARK RED CATLINITE TOMAHAWK SHAPED PIPE c. 1900 Stone bowl & stem. Highly carved & etched w/foliate designs. Two breaks have been expertly repaired & are hardly noticeable. Unsmoked. Bowl is 3.5" X7.5." Overall L. is 14.25." Est. 275-400 **SOLD $325(95)**

NORTHERN PLAINS BLACK PIPESTONE LEAD INLAID PIPE & STEM
This pipe may be of recent manufacture;nevertheless, it is an outstanding example of lead inlay on black steatite. Bowl:9"L X 4.5" H. Stem:21.25" L X 1.25" W Est. 1000-2000

Top to Bottom: **BLACKFEET CATLINITE PIPE W/CARVED STEM** c.1900
O'Neil Jones collection in Big Fork, Mont. He says this pipe came from Ace Powell's collection many years ago. Pipestem carved w/single heart & diamond-red ochre stained. T-shaped pipe-5 sided top w/all-over textured surface & concentric lines carved on end. Nice patina-shows tobacco use. Bowl is 3.75" H. X 5.75" L. 18" total L. Exc. cond.Est. 300-400 **SOLD $400(95)**
CATLINITE CARVED BOWL & MATCHING STEM c. 1900 *RARE*. Catlinite stone stem has internal wooden stem extending entire length. T-shaped bowl w/square block connects to 10" stem. Tip in front of bowl was broken & has been repaired. Bowl is 7.5" L X 3" H. Stem is 1.38" wide on top. 19" total L. Est. 450-950 **SOLD $450(95)**

CATLINITE PIPE W/CARVED ASH STEM c."1922" *carved on one side*. Tobacco remnants caked inside bowl. The stem is file burned & carved-painted yellow & red. Bowl is 3.5 x 5.25. Total L. is 20.5" Est. 375-450 **SOLD $375(96)**

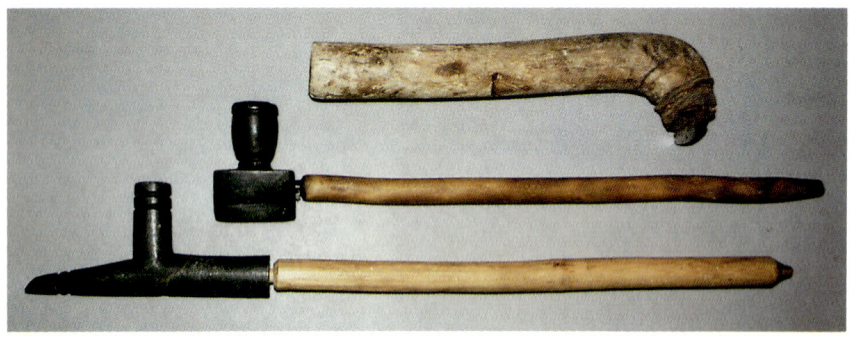

Top to Bottom: **SIOUX WOOD HIDE SCRAPER**
See description p.14.
CLASSIC BLACKFOOT PIPE & STEM C.1870 Typical man's pipe-style. Characteristic acorn shape with wide flare at top, of black steatite with hardwood plain simple stem. Nice patina & subtle fragrant tobacco smell in bowl. 17" total L. Bowl is 3"W x 2"H. Est. 500-750 **SOLD $450(96)**
BLACK STEATITE T-SHAPED PIPE C.1940 Wooden stem. 2 rings incised around bowl & tip. "X" carved in bottom. Bowl 3" X 6.5." Total L w/stem 21.25." Est. 90-175 **SOLD $94(96)**

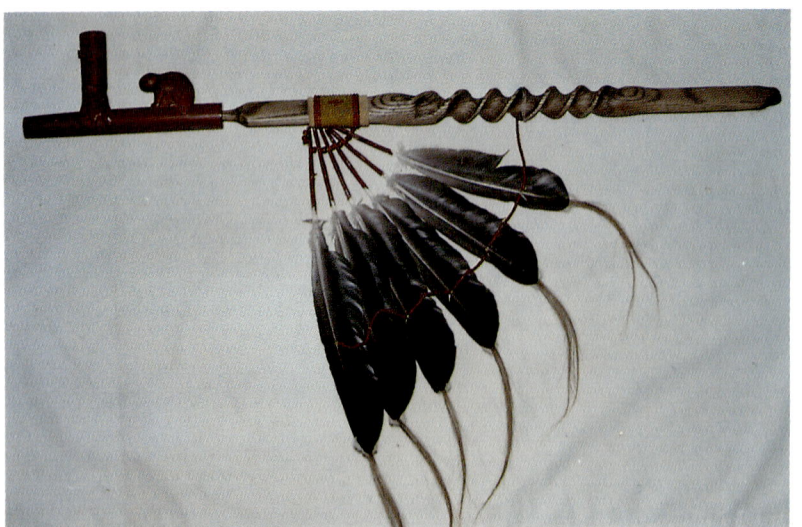

SIOUX CATLINITE FANCY CALUMET-STYLE PIPE AND STEM 20th c. Signed by Myron Taylor "Chaska," famous Chippewa/Sioux 3rd generation pipe maker. See *Lost & Found Traditions* by Ralph Coe. Beaver & tree stump expertly detailed sculptural pipe. Prominently grained wooden twisted stem has 6 legal feather drop connected w/red w. heart beads. Horsehair attached w/white ermine at each feather tip. Pony bead-wrapped buckskin gr. yellow & red w. heart at feather attachment. 10-12" feathers. Bowl 8.25"L. Beaver 2.25" H. X 1.5." Total L. 24." Est. 400-800 **SOLD $550(95)**

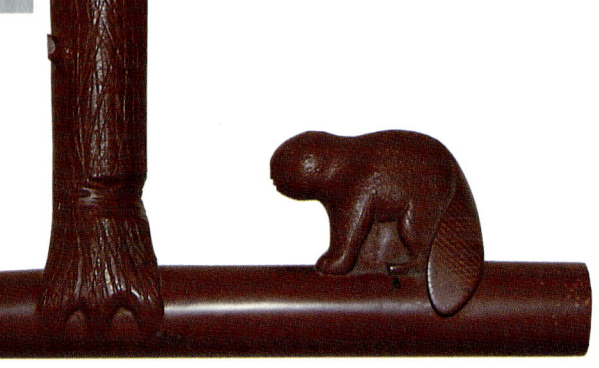

The following pipes were collected by the consignor during the 1950's from New York City galleries, purchased over a period of years, for their artistic merit & investment potential. We informed the consignor that other than the labels of origin to some & the fact that they were purchased 40 yrs. ago; there is NO WAY TO PROVE THEIR AUTHENTICITY. All but 2 have custom-made display stands.

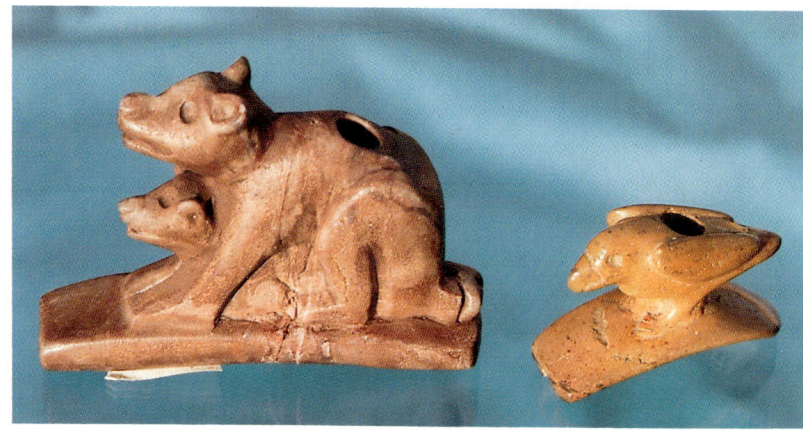

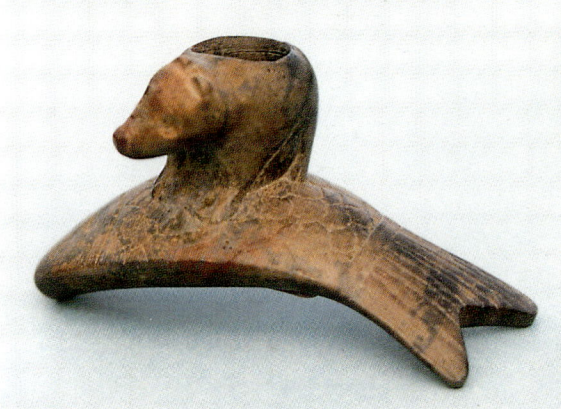

Left to Right: BEAR & CUB EFFIGY PLATFORM PIPE
Red stone nicely polished & sculpted. It was broken in 1/2 & glued together expertly (only noticeable at the bottom.) Judging from the patina, straight drill holes & style, this is probably not a prehistoric pipe. 4.5"L X 3"H. X 1"W. Est. 160-300 **SOLD $150(94)**
HOPEWELL EAGLE CURVED PLATFORM PIPE
Paper tag glued & later Scotch taped to bottom reads "Monitor curved base pipe, ? mound ? -1400, OHIO ? clay-stone-NA". Highly polished of lt. brown pipestone. Eye sockets are drilled & beak is incised. The feet are 3-D incised. The bowl is not very tapered & shows some sign of rings caused by the stick & sand method of drilling. The stem hole has been slightly broken w/1 piece glued back & another 1/4" piece missing on the bottom. There are some ink marks nr. the glued area-word "OHIO" is all that can be clearly read. Good patina & design w/highly polished surface. 2.75"L X 1.75"H. X 1.25" deep. Est. 250-600 **SOLD $250(94)**

BEAR ON FISH EFFIGY PLATFORM PIPE
Prehistoric Hopewell culture. Age unknown. Made of Ohio pipestone w/tan, black & reddish coloring. "Ross Co., Ohio" is printed on bottom in black ink. Tapered hole in bowl shows circular drilling striations as well as perpendicular grinding. Small stem hole in fishes mouth is tapered. The bear's eye sockets are drilled impressions. The fish has incised scales, eye & tail stripes. The bear's nose was broken & glued back, but you have to look very carefully to notice it. Very artistic w/exc. polish & patina. 1.5" x 3." Est. 375-500 **SOLD $375(96)**

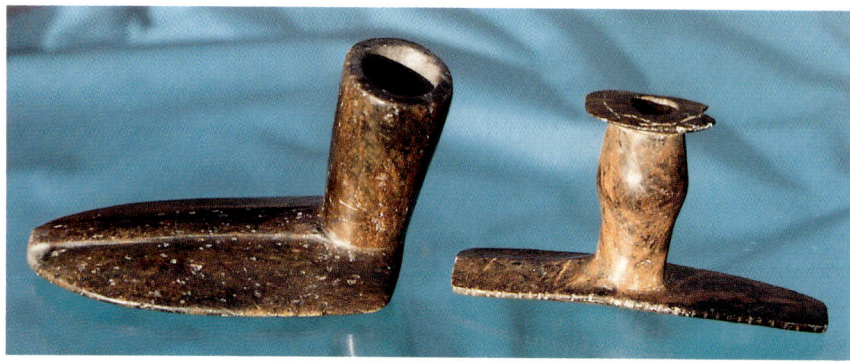

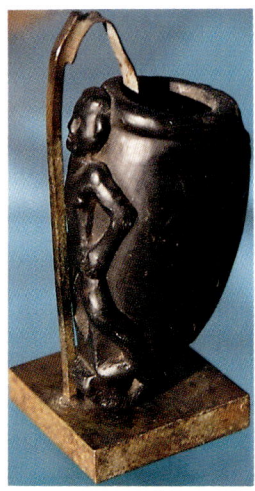
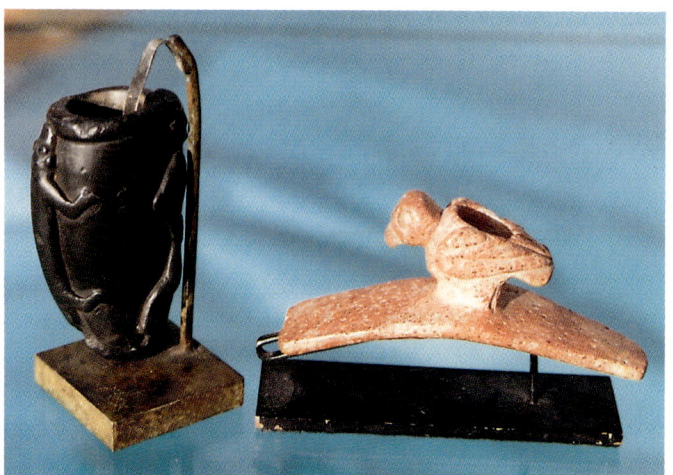

Left to Right: ALATE STEMMED OBTUSE ANGLE PIPE
The word "alate" refers to the wing-like flared shape of the stem on this pipe. Sometimes referred to as spade pipes, they are believed to have been developed during the early & middle Woodland periods in SW Virginia. The angle of the bowl on this piece suggests a date around 700 A.D (Middle Woodland Period). The stone is a variation of red-brown, grey & green colorations. 6.25"L X 3.5"H. X 2.75" across flared stem. Est. 190-450 **SOLD $250(94)**
CURVED BASE MONITOR PIPE
An oval yellowed paper tag glued to the bottom; "Obion Co., Tenn. 1PK." This hard stone has many striations of reddish brown to black making a very beautiful color combination. The curved base is 5.6" L w/numerous notches along each edge. The bowl is 3" H. w/graceful swelling in the middle & a flat platform on the top. 1.3" deep. Est. 350-600 **SOLD $300(94)**

Left to Right: VASE PIPE W/HUMAN & LIZARD
Black pipestone w/full human figure of a man facing the smoker. On the opposite side is the full form of a lizard w/ protruding eyes & ears. There is a raised ridge around the bowls w/a protrusion at the bottom w/a drilled hole. Both the stem & bowl hole are tapered & smooth. Good patina & lots of polish from use. Metal display stand. 2.5"L X 1.5"H. X 1"W. Est. 300-600 **SOLD $500(94)**
HOPEWELL EAGLE CURVED PLATFORM PIPE
Paper tag w/red border glued to bottom reads "Brown Co. OHIO, pipe #192". Shaped from a red porous lt. weight stone. Surface is polished but still shows light striations caused by the carving of the stone. The bowl is tapered & shows definite rings caused by the stick & sand method of drilling. The wings & tail are deeply incised to resemble feathers. The eye sockets are drilled w/a flat bottom indicating that they were once inset w/shell or bone. Perfect cond. Brass painted black display stand. 3.5" L X 1.6" H. & 1.2" deep. Est. 250-600 **SOLD $250(95)**

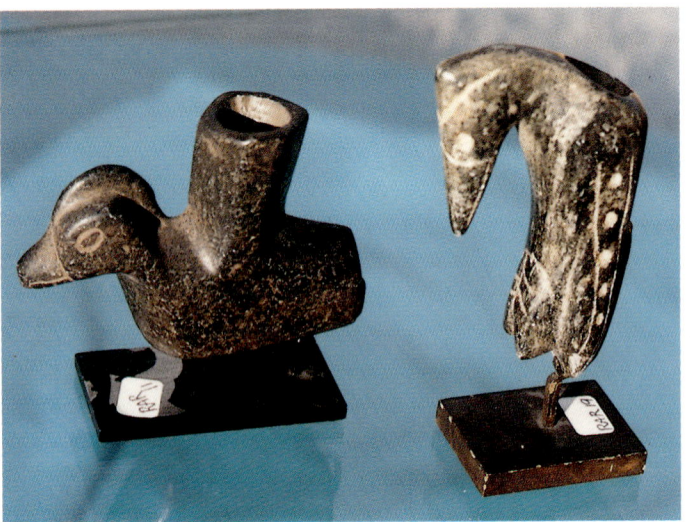

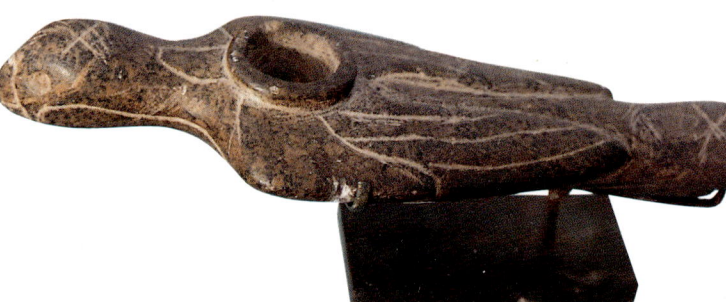

FOLDED WING BIRD PIPE
Paper tag w/red border adhered to bottom says *"Ballard Co. Kentucky"*. Green-brown steatite w/exc. patina. The eye sockets are circular & deeply drilled. The lines are deeply & artfully incised. 8.25" L X 3"W X 1" deep. Iron & brass display stand. Est. 400-800 **SOLD $400(94)**
Gordon Hart's Prehistoric Pipe Rack Bluffton Hart Publ. 1978 identifies several similar style pipes as A.D. 500-600.

Left to Right: **WOOD DUCK PIPE**
Highly polished black steatite. Incised eyes & beak. A thin crest over top of head. An unusual 6-sided bowl extends 1.5" above the back. Both bowl & stem holes are tapered & rather smooth surfaced. Iron display stand. 4"L X 3" H. X 1.13" deep. Est. 300-600 **SOLD $200(95)**
OHIO PILEATED WOODPECKER PIPE Round yellowed paper tag on bottom *"TIA Wood Co. OHIO"*. Highly polished dk. green steatite. Drilled eye sockets w/incised lines indicating bill & crest. Both the smoke & stem hole are tapered. Brass display stand. 4.5" H. X 2.5"W X 1.25" deep. Est. 300-600 **SOLD $300(94)**

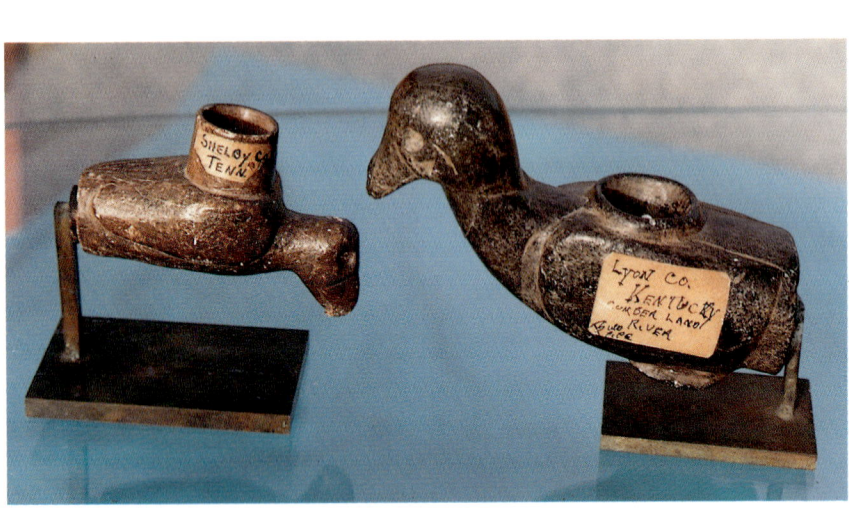

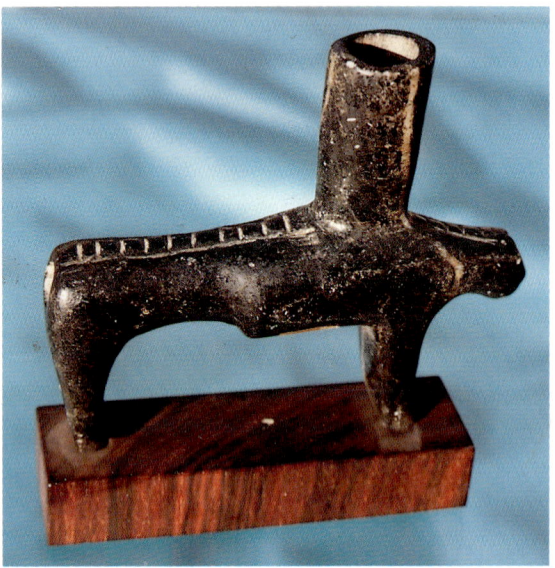

BLACK STEATITE HIGHLY STYLIZED PANTHER PIPE
White paper tag glued under chest w/very faded *"Pike? Co. Ohio;Maeton? 1917;__?__ River ; TNA"*. Highly polished w/ 1.75" bowl protruding up from the panther's back. The face has 2 deeply drilled eye sockets & incised lines for a mouth & nose. The ears are protruding & incised. Rosewood display base. 5"L X 4.5" H. X 1.13" deep. Est. 400-800 **SOLD $350(94)**

Left to Right: **BROWN STEATITE(?) BUZZARD PIPE**
Paper label glued to bowl; *"Shelby Co. Tenn."* also small paper gummed label w/red borders on bottom w/"*#1623"* written in black ink. The sculptured head & beak resemble that of a buzzard. Deeply drilled eye sockets. Large bowl has a delicately thin wall & is polished on the inside. On top behind the bowl are incised lines to indicate a tail. The wings are in relief w/incised lines to indicate feet. The stem hole is a large .88" diam. at opening & shows circular striations from drilling. It tapers to apx. .25" where it joins the bowl. Brass display stand. 4.13"L X 3" H. X 1.75" W. Est. 300-600 **SOLD $300(94)**
DARK GREEN STEATITE DUCK GREAT PIPE
Large paper tag on side:*"Lyon Co. Kentucky, Cumberland River, Bird Pipe"*. 3 tags under neck *"Bird effigy pipe, steatite, Lyon Co. Cumberland River, Kentucky-Missisy. Culture Cir. 1600 PIA"*. *"P. Coll 1930,1265,$125"* & small tag w/red border *"1852"*. This pipe has many interesting features. The crown of the head & the top of the beak have an extra degree of polish. The beak has a small hump nr. the tip & eye sockets are deeply drilled. An incised triangle just below the eyes & other incised lines on the head & beak identify it as a White Winged Scoter. There is an embossed collar around the neck. The large bowl raises .25" above the bird's back. Behind the bowl are 3 incised lines indicating the tail. Underneath is an embossed & incised area representing feet. Heavily polished w/several areas of higher polish from use. Brass display stand. 6.5"L X 3.25"H. X 2.25" deep. Est. 500-900 **SOLD $400(94)**

LARGE FLYING EAGLE PIPE
Yellowish paper tag on bottom reads *"Pipe-flying, Hancock Co. Tenn."* There is a # & another word indeciferable. Green-brown steatite w/wings outspread & a profusion of deeply incised decorative lines & eyes. Smoker's hole is thru the tail. Iron display stand. 8.4"L X 4.6"W X 1.13" deep. Est. 450-900 **SOLD $450(94)**

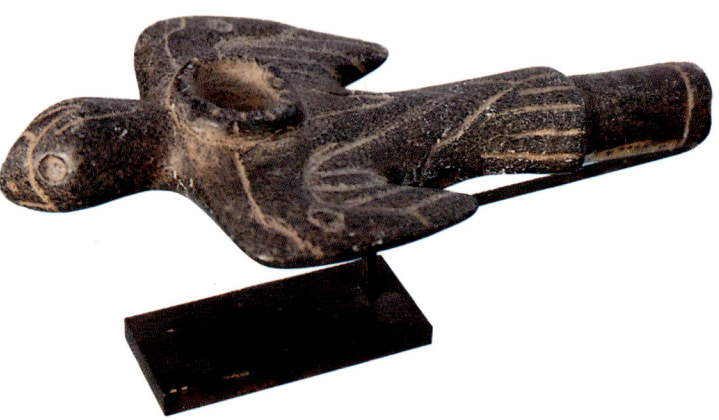

34

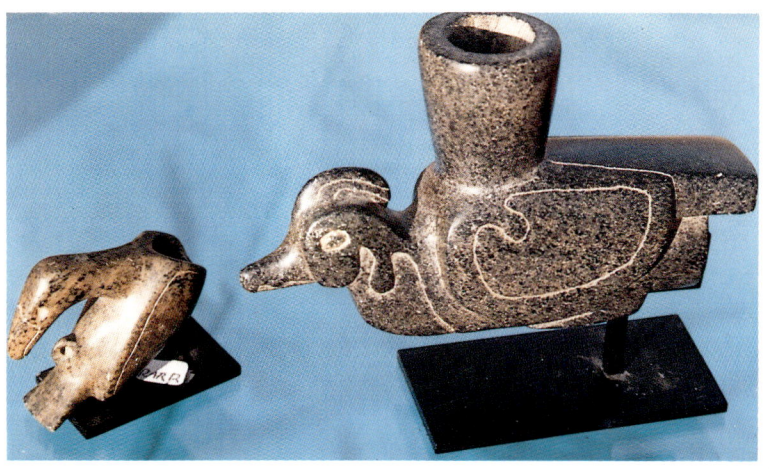
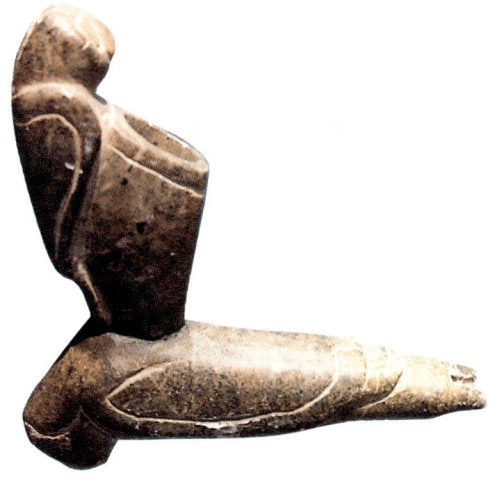

Left to Right: GREY-GREEN STEATITE(?) VULTURE PIPE
According to Hart (pp.232-3), this style bird effigy is recognized as Algonquin or Iroquoian dating A.D.1150 into the early historic era. The stem hole is drilled into the bird's back w/the tobacco hole where the neck is attached to the body. It has incised eyes & decorative lines. A projection w/a drilled hole is placed to resemble the feet. A finely made & highly polished pipe. Iron display stand. 3.25" H. X 2.5"W X 1.25" deep. Est. 300-600 **SOLD $300(94)**

WOOD DUCK GREAT PIPE
This dk. green speckled steatite Woodland Period pipe has no provenance identifying tags. This complex & massive pipe style could date back as early as 500 A.D. This is a very elaborate example of a "great pipe". The head exhibits all the features of this species incl. full crown comb & a well-defined beak. The eyes are incised;bowl is large & rises 2" above the duck's back. The stem hole is under the tail & elaborately carved feet are tucked up underneath. Iron display stand. 7.75" L X 4.5" H. X 1.87" deep. Est. 500-900 **SOLD $500(94)**

TWO BIRD OWL EFFIGY PIPE
Large yellowed paper tag w/red border glued to bottom-"*Lake Co. OHIO ANF*". Grey-brown steatite. An owl is sitting on the front edge of the bowl in relief w/incised lines for the eyes, wings & tail. The bird on the base has drilled eyes & incised lines for beak, wings, tail & ears. The bowl inside is relatively smooth & shows slight gouging marks. A small piece is broken away at the stem hole. It looks like the bowl was broken from the base & repaired. There is a faint crack & a blackish material used to re-attach the bowl which is almost imperceptible. Highly polished & incised. Brass display stand. 6"L X 5.5"H. & 1.6" deep. Est. 350-600 **SOLD $345(94)**

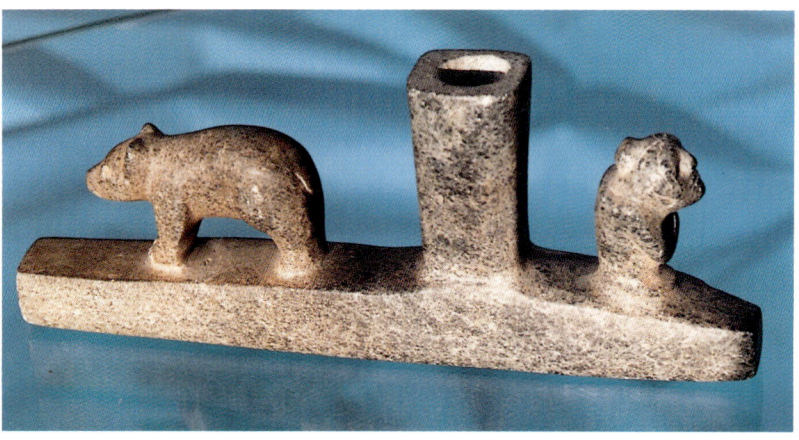
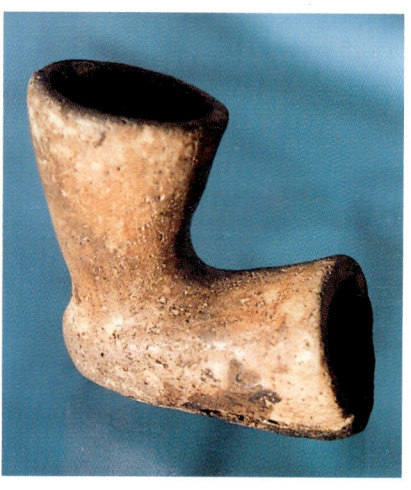

BEAR & HUMAN EFFIGY T-SHAPED PIPE
Green steatite. White paper tag adhering to side;"*South Carolina, Cherokee Ind. Precolumbian-sal.*" A very sculptural pipe w/artful carving of a bear which faces the smoker & a kneeling human figure on the opposite side facing away from the smoker. 9.5"L X 3.75" H. X 1.13" deep. Est. 400-800 **SOLD $550(94)**

HUMAN SKELTON EFFIGY PIPE
Bottom has ink markings-"*KY 172/1900*". Black steatite w/carving of a skeleton protruding from the front of the bowl w/skull looking towards the top of the bowl. The stem hole is small. 1" piece of the stem is broken away & taped in place. Black metal display stand. 4.6"L X 1.75" H. X 1" deep. Est. 200-350 **SOLD $225(94)**

CADDO BROWN CLAY PIPE
Pre-historic This is an old & authentic pipe. Large bowl & stem opening. Fired & polished. A section measuring apx. 1" was broken from the bottom & replaced w/broken pieces filled in w/black pitch(?). 2.75" X 3". Est. 150-250 **SOLD $150(94)**

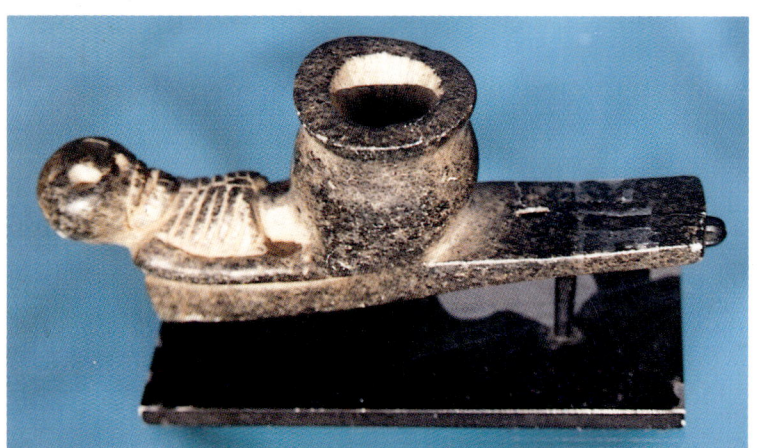

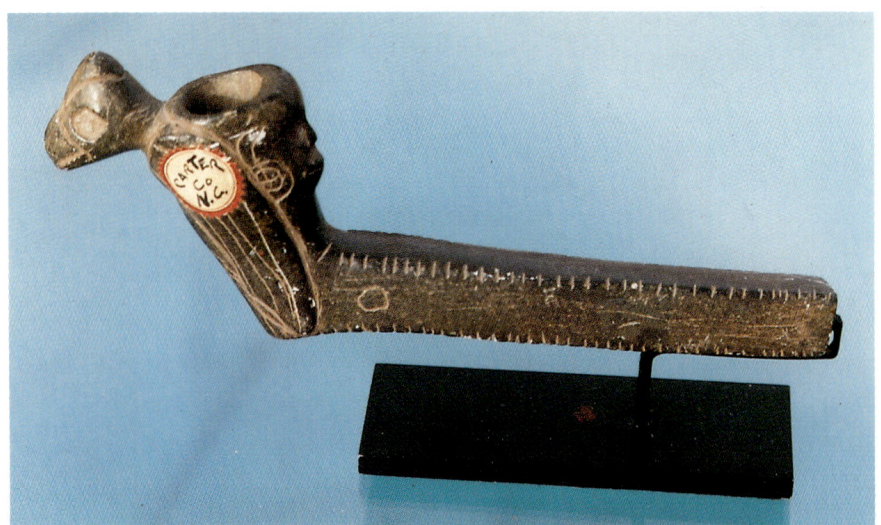

BLACK STEATITE ELBOW EFFIGY PIPE
Round paper tag w/red sawtoothed border glued to side-*"Carter Co. N.C."* The bird's head protrudes from the top of the bowl w/wings & body down the front of the bowl to the bottom where there are incised lines indicating the feet. It has an incised curved beak & crest; eyes are large & gouged out w/a flat surface indicating that they were inset w/shell. The side facing the smoker is carved in the form of a human face w/eyes, nose & mouth in relief. Incised lines indicate the hair & fancy ear plugs. Stem is square & 5.25" L. w/notches carved into all 4 edges. The bowl is gouged & the stem still has a hollow piece of wood stuck into it. Black metal display stand. 8"L X 3" H. X 1/12" deep. Est. 400-650 **SOLD $400(94)**

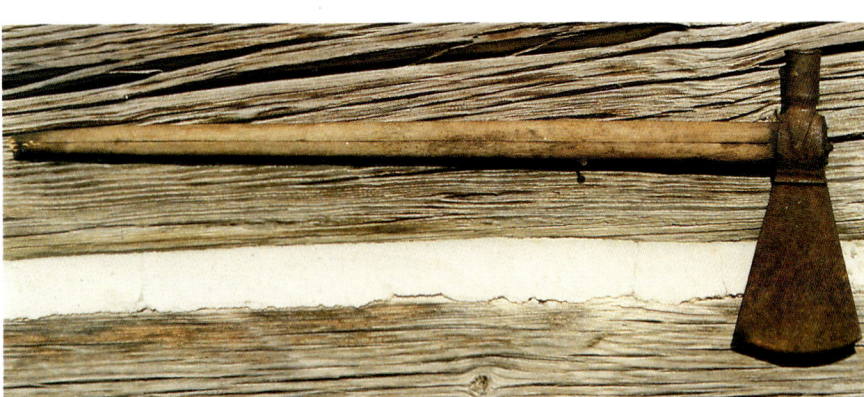

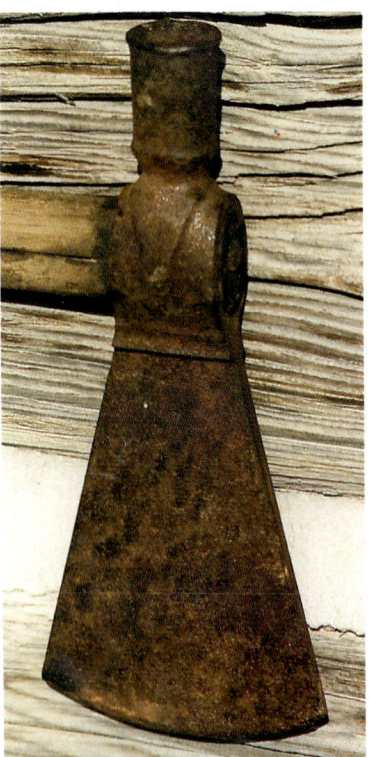

CAST IRON PIPE TOMAHAWK c.1890?
The iron head is rusted more on one side then on the other, indicating that it has laid in one place for a long time. The hard wood stem also appears to have acquired a patina from laying a long time. The stem has several small worm holes, which are another good sign of age. The stem is made from 2 halves glued together after making a groove for the hole. The glue has since dried away & the crack is very visible. The patina on the stem looks very old & natural. There is a rusty tack & iron wedge in the end of the stem to hold it tight to the head. The wood has since aged & dried out so that it is now loose. The head is 7.5" L. overall L. is 22.75". Est. 500-800 **SOLD $950(98)**

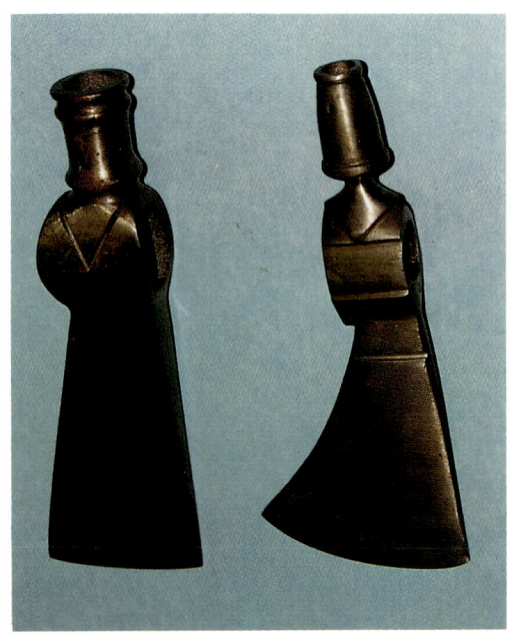

CAST IRON PIPE TOMAHAWK c.1950's
Made by late Gerald B. Fenstermaker of Lancaster, Pa. This is a copy of ones he and his father dug up in old Indian sites along the Susquehanna R. His serial # & the letters *"B & O"* are stamped into the iron. Has oval eye for handle. 7" L. Est. 95-150 **SOLD $95(98)**
SAME provenance but different style with round eye hole. Est. 100-175 **SOLD $170(98)**

Wood, Horn & Bark Items

MASKS-TOTEM POLES-MISC
See ivory totem poles in Eskimo section

WOODEN PAINTED TOTEM POLE c.1930
Stamped "Made by American Indians" on back. Bright colors; yellow, red, green w/white & black outlines. Apx. 18" H. X 8.5" W. Est. 20/35 **SOLD $25(90)**

N. W. COAST RAVEN FRONTLET MASK Contemp.
Signed "JK", a student of Simon Charley, Kwakiutl carver. Abalone-inlaid w/bright blue & deep red & black paint. Ermine trimmed. Striking piece. 13" H. X 7" W X 4" deep. Est.280-395 **SOLD $250(92)**

SMALL CARVED WOODEN TOTEM POLE C.1930?
Metallic tag on back reads "*from Hudson's Bay Fur Co, Inc. Seattle, Wash.*" Also in pencil, "*Wrangell, Alaska*". Nice detailed deep relief carving w/4 major figures bottom to top-bear holding fish; raven or eagle; bird w/small human figure; bird w/hat & 2 small animal figures. Dk. green, black & red painted. Nice rich dark patina of age. 11.5"H. Est. 100-200 **SOLD $200(98)**

LARGE CARVED WOODEN TOTEM POLE C.1900?
Campy birds & figure holding 2 fish. Style as seen in turn-of-century lodges ie; Glacier & Yellowstone. Paint is muted reds, greens, & blue w/black. Cross-piece 6.5"W. 25.5" H.X 2"D. Round wooden base 7" diam. Est. 100-175 **SOLD $154(98)**

LOT OF TWO ESKIMO SEALHIDE MASKS-MAN & WOMAN c.1960
Sinew-sewn. The outer trim is of wolf fur w/mink & caribou eye lashes, beard & hair. The seal hide has been molded to reflect human facial features. Exc. cond. 14" x 9." Est. lot 190-400 **SOLD $226(96)**

NORTHWEST COAST CEDAR "SUN MASK" c. 1950s.
Human face design carved from one piece of wood w/background ring from 2nd piece. *Signed "FD".* Natural cedar w/black, blue-green & red designs. 11"W X 12"L. Est. 200-350 **SOLD $250(96)**

Top to Bottom: N. W. COAST CARVED WOODEN MASK c. 1940
"*Haida*" thin cedar wood portrait mask. *Signed w/ initials look like "AP"*. Painted beard & mustache w/ copper overlay eyebrows. White ermine hair. Several hairline cracks expertly repaired. Very subtle. 8" X 6.5'". Est. 175-350 **SOLD $250(95)**
N.W.COAST CARVED YELLOW CEDAR MASK c.1989 Kwakiutl Shaman Mask w/cedar bark hair. *Inside signed "Vern Etzerza 7/89"*. Painted opaque blue/green w/black, red & white trim. Exc. patination-looks old. 6.5" X 8.5." Est. 250-450 **SOLD $250(95)**

SENECA LONG NOSE (BOGEY MAN) MASK Contemp. White muslin w/red felt eyes & mouth. Complete w/descriptive paper. Est. 50-75 **SOLD $60(95)**

Left to Right (top): IROQUOIS FALSE FACE CARVED WOODEN MASKETTES Contemp. *Onondaga*. Canadian. Guardian-size whistler mask. Red. Brass eyes-long black hair. 5" Est.95-125 SIMILAR. Stained black. 5"L. Est. 95-125
Bottom: SIMILAR. *Signed "P. Longboat, Six Nations"*. 3" w/leather hanger. Red. Est. 50-75 **SOLD $50(95)**

CHEROKEE BOGEY MASK Contemp. *Made by Kenneth Standing Bear, E. Cherokee*. Simple sculptural wolf head of polished buckeye. 11" X 7"W. Est.250-325 **SOLD $250(95)**

38

CANOES & PADDLES

Top to Bottom: MINIATURE TLINGIT(?) CEDAR WOOD CANOE PADDLE c. 1890
These are called "Dance Paddles" because this size is sometimes carried as a dance accessory. Back blade has "*Sitka*" carved into the wood. Front blade is carved w/a bear head(?), 2 beaver tails & an eye. Entire paddle is stained black w/some brown cedar showing through on the edges from wear. Good patina & age. 24" L. Est. 250-400 **SOLD $275(96)**

PAINTED TLINGIT MINIATURE CANOE PADDLE
One side is deep red, blue & lt. blue. 21.75"L. 3.25" at widest point. Est. 95-150 **SOLD $100(96)**

SIMILAR
Painted red & black N.W.Coast abstract animal motif. Varnished. Apx. 18" L. Est. 60-95 **SOLD $70(96)**

CHIPPEWA LARGE BIRCH BARK CANOE MODEL c. 1900
Sealed w/spruce gum like the full-size ones. Wooden seats & hand-carved paddles. Exc. shape. 33"L X 8"W. Est.425/550 **SOLD $500(92)**

ATHABASCAN BIRCH BARK CANOE c. 1870.
Exc. patina. Has trade wool (blue & red) woven into back. 20.5" L. Est. 250-350 **SOLD $300(95)**

BIRCH BARK CANOE w/raffia lacing. c.1950.
Wood seat & side splints. Originally had 4 porcupine quills for decoration on each side. 17.5"L. Exc. cond. Est. 15-25

Top to Bottom: ATHABASCAN BIRCH BARK CANOE c.1890
24"L. Est. 250-350 **SOLD $250(96)**

ESKIMO KAYAK c.1890
Intricate wooden frame covered w/stretched rawhide. Ivory tips each end apx. 3/4." Ivory toggle on sinew w/loose ends. only 1 small tear. 21"L X apx. 2.5"W. Est. 150-250 **SOLD $175(96)**

ESKIMO KAYAK W/ PADDLER c.1870
Sinew-sewn sealskin cover w/ivory accessories. Paddler is carved from wood w/hide parka, bone hands & wooden paddle w/ivory tips(1 tip missing). 1.25" tear in sealskin on 1 side & small hole on other. Exc patina. 21.25" total L. Est. 440-900 **SOLD $465(96)**

Top to Bottom: **MAKAH CEDAR CANOES**
Red cedar carved canoe w/characteristic stylized animal prow (broken & repaired). Red stylized eye painted on prow. Interior burned out. 27.5"L 44.63"W. 4.5"H prow. Est. 150-300 **SOLD $225(97)**
Carved from one piece of yellow cedar. Prow painted w/stylized animal head in red & blue. 5"H. front. 3.75"W. 17"L. Est. 65-150 **SOLD $105(97)**

Top to Bottom: **N.W. COAST PAINTED WOODEN DUGOUT CANOE** c.1920
Red, blue-green & black India ink (?) motifs on sides & interior. Heavy-weight. Made of one solid piece of wood. 23.5"L. Est. 160-275 **SOLD $195(96)**
COAST SALISH MINIATURE WOODEN CANOE c.1890
Finely carved w/black stain on outer surface. 1 seat attached w/wooden pins-other 2 missing. Exc. patina. 17.25"L. Est. 125-175 **SOLD $150(96)**

CONTAINERS, UTENSILS, MISC.

See also misc. quill/beaded items in companion volume p.110-114 for ornamented horn spoons

Top to Bottom: **COW HORN CUP** c.1880
Decorated w/French word *"mer de glase"* (Sea of Ice). 3" H. Est. 45-95 **SOLD $60(95)**
BARK SNUFFBOX W/WOODEN LID c.1850
These date back as early as 18th century. Embossed dot decorations on surface. Fine old patina. 2" X 2.75". Est. 150-300 **SOLD $125(95)**

WOODEN BURL MORTAR c. 1860
Collected from Warm Spring Res. in Ore. Old wooden bowl w/a history. 3 tin can lids & tin piece (4" X 12") nailed to top & sides by Indians to reinforce cracks & knots. Shows considerable use. Ethnographic piece. 12"H. 11" diam. 7.25" bottom diam. Est. 400-1000

NEZ PERCE BURL MORTAR c. 1840.
Hard to date as a burl bowl like this could easily date pre-1800, as this style has been in use for many generations. A very fine example w/carved handle on rim. Exc. dark patina. 11"H. 5" diam base. 9.5" top diam. Est. 500-1000 **SOLD $650(97)**

Left to Right (Top to Bottom): **OJIBWAY BIRCH BARK QUILLED BOXES** Contemp. *Made by Wasskoness, Manitoulan Is. Ontario, Canada.* Beaver quill motif on lid. Coiled sweet grass along lid & bottom edges. 2.5"H. 5.25" diam. Exc. cond. Est. 65-100
SAME w/robin design. New cond. Est. 65-100
SAME w/deer design. *by Bernadette Desmoulin Wukkwemkon Res. Manitoulan Is. Ont. Canada.* 2"H. 4.38"L. New cond. Est. 40-75 **SOLD $37(97)**
SAME w/bear design. 1.88"H 3" diam. New cond. Est. 30-60 **SOLD $30(97)**

BUFFALO HORN CUP w/fitted wood bottom. c. 1880(?) Old & handmade w/exc. patina & wear from use. 2.5" X 2.5" Est. 50-100 **SOLD $100(95)**

PLAINS INDIAN COW HORN SPOON c.1870 Yellow- tone bowl & black handle. Exc. cond. & patina. 9.25" L X 2.5" W bowl. Est.200-400 **SOLD $175(93)**

BLACKFEET (?) MOUNTAIN SHEEP HORN SPOON c.1880 Red ochre covered w/2" handle. Exc. patina & cond. 9" x 5.5. Interesting texture. Est. 150-300 **SOLD $200(96)**

OJIBWAY BIRCH BARK CREEL Contemp. All-over lively fish motif. Aesthetically pleasing design & shape. Heavy leather carrying strap. Exc. cond. 9.5" H. X 10.5" W. Est. 150-225 **SOLD $155(94)**

OJIBWA BIRCH BARK- QUILLED PIECES c.1930 Unusual abstract bi- laterally symmetrical designs in pierced bark quillwork. (The customary designs for tourist pieces are naturalistic. See preceding items.) Outer loops are coiled sweetgrass. All quilled colors are bright & unfaded.
LOT OF 2 SMALL MATS
A) Red heart(?) w/green & white design. Completely intact. Good patina. Exc. cond. 10" diam.
B) Same colors & dk. brown in interesting bird? shape. A few broken quills; otherwise exc. cond. Apx. 8" diam. Est. 35-75 both **SOLD $50(96)**
LOT OF 2 LARGE MATS
Yellow, brown, green, & red-orange abstract motif same on both. 1 is slightly warped w/a few breaks; other quills in perfect shape. 12.5" diam. each. Est. 50-125 both **SOLD $60(96)**
BOX W/OWL(?) MOTIF- quilled motifs on top & each side. Unfaded colors: green, yellow, dk. brown, red-orange, lt. blue. All edges are coiled sweetgrass. A few missing quills on sides. Exc cond. 7.75"L X 7"W X 3"H. Est. 63-125 **SOLD $125(96)**

41

SIOUX BUFFALO HORN SPOONS (3)
c.1880
These artifacts were acquired at Poplar, Mont. on the Fort Peck Res. Attached to a buckskin thong & tied thru hole in a rock probably in preparation for a ceremony or inclusion in a medicine bundle. Top spoon has old sinew wrapping on the handle. Each spoon is 6"L. Overall L. is 29." Est.150-300 **SOLD $250(93)**

SIOUX COW HORN HAIR PARTER c.1880
RARE ITEM. Same provenance as preceding. w/buffalo cut-out w/buckskin ears carved from a flattened horn. Hind leg & tail are missing. 9.5"L. Buffalo is 3.25"L. Est.300-500 **SOLD $375(93)**

Left to Right: **ESKIMO CARVED WOODEN DOLL** c. 1900
Highly conventionalized. No finish. Flat on back. 9.75"L. Est. 95-150 **SOLD $105(95)**
ESKIMO CARVED WOODEN COMB? c.1900
Flat on back. Has slots for hanging. 11"L. Est. 75-95 **SOLD $75(95)**
EASTERN WOODLANDS WOODEN SPOON c.1890
Stylized animal head carved handle. Light colored wood. 9"L. Est. 150-300 **SOLD $200(95)**

MATCHED PAIR OF DEER HIDES c. 1980
Smoked heavy brain-tanned. Yellow-brown color (willow smoked). Top quality for garment making; ie., coat, dress, pants. No holes. 49" widest to 31" narrowest width X 48" L. each. Est.350/450 pair **SOLD $300(89)**

See ring description under Stone Relics, p.18.
N.W. COAST MOUNTAIN GOAT HORN SPOON c.1870
Black-2 small worm holes on ladle edge & a 1.5" crack (barely noticeable) near where handle connects to bowl. 6.75"L. Est. 110-140 **SOLD $125(96)C**

CANADIAN-CREE CONTAINER. c.1950
Made from caribou legs & toes; top has brain-tanned fringe & braided buckskin handle. Completely sinew-sewn & lined w/calico- 8" x 10" x 7." Est. 95/125 **SOLD $110(89)**

BLACKFEET FIRE TONGS & SWEETGRASS BRAID c.1870
RARE.from Chief Short Face's medicine bundle, which was in the Frontier town Museum nr. Helena, Mont. Incl. copy of original bundle description & origin on museum stationery. This style tong was used to pick up hot coals from the fire to light pipes or burn sweet grass durimg medicine ceremonies. Exc. cond. 43"L. Est. 350-800 **SOLD $400(95)**

CREE BUFFALO HORN WALL HAT RACKS c.1870-90
Many were made by the Cree Indians living nr. Great Falls. Mont. to sell to local white folks. There is a Charlie Russell painting of an old Cree man sitting by a Red River cart putting one of these together. You never see 2 exactly alike!

Top: OLD IRON SPEAR POINT
See description under metal relics, p.25.
Bottom: Large black horns mounted to wood that is cloth-covered w/loops to hang on wall.
12" X 17.5" W. Est. 95/150 **SOLD $90(92)**

2 large & 3 medium black horns wrapped w/red worn velvet & black velvet. 22"W X 14"L. Est.150-300 **SOLD $300(93)**

Top to Bottom:
A) Five horns trimmed w/maroon cotton & silk ribbon. Wood base is covered w/ buffalo (hair-on) hide. Hair & cloth are rather shabby, but the horns are in exc. cond. 16" X 21." Est. 220-350
B) Two buffalo horns mounted on wood covered with brown fur (not buffalo). Horn center covered w/well-worn maroon velvet. Horns are 13" (tip to tip). Est. 100-175
C) Two buffalo horns mounted on a wooden connector which is covered with faded fabric & green yarn. 15" W. Est. 95-150

II. TRADEGOODS

Hudson's Bay Company Collectibles

by Preston E. Miller

In 1670, England's King Charles II granted a charter to "The Govenor and Company of Adventurers Trading into Hudson's Bay." Thus, the Hudson's Bay Company was able to control nearly three million square miles of Canadian Territory for over 300 years. Forts and Trading Posts were established for the purpose of gathering fur pelts to be shipped to European consumers. Trappers of Scotch and French descent and Indians brought their furs to the Company and exchanged them for trade goods. Guns, brandy, textiles, knives axes, tobacco and other goods were bartered for furs; of which the beaver was most important. The hair of the beaver hide was shaved off and matted into a felt by European hatters to make beaver headgear which was considered most stylish in European fashions. Millions of beaver were trapped and made into top hats and hundreds of useful items were developed to trade for the hides. The following examples are some of the items that were developed by the HUDSON'S BAY COMPANY and other traders to entice Indians to trap that "Pug-Nosed Rodent with the Lustrous Coat."

See p. 14, Newman, Peter, *Empire Of The Bay,* Ontario, Penquin Books Canada LTD., 1989.

The author is interested in buying and selling trade items, or exchanging information. Contact: Preston Miller, Box 580, St. Ignatius, MT. 59865 Ph. 406-745-4336.

TOP HATS
The soft undercoat of the beaver fur was well suited to the making of top hats because the microscopic barbs on the hair caused it to cling together forming a strong felt. This felt was shaped into hats. These three hats are the styles popular during the early and middle 1800s. The center hat is dated 1879 and the inside crown is labeled "*Missoula Mercantile Co., Missoula, M.T.*" (Montana Territory was pre-statehood). The silver band could date before 1800 and was hand made by silversmiths for trade to Indians. Value for hats is $200 to $350 each and the trade silver hat band has a value of $800 to $1500.

COAT OF ARMS
Prints dating back to 1679 indicate that the Coat of Arms and Motto of the Hudson's Bay Company was adopted soon after the 1670 Charter was granted by King Charles II. It shows up on many items that were traded through the Company Stores. The Coat of Arms has four beaver in the center with a fox sitting on a trader's hat at the top and two moose (sometimes called elk) adding support on each side. The Beavers denoted the main objects of trade. The Sly Fox sitting on a medieval trader's hat was symbolic of the individual trader's ability and the supporting moose symbolized male dominance and power. At the bottom is the motto *"Pro Pelle Cutem"* which explains that the company wanted beaver skins, "cutem", for the sake of the fleece, "Pro Pelle" which would be used to make felt top hats.
See pp. 65-69, *The Beaver,* Autumn 1980, "Pro Pelle Cutem" by E.E. Rich

NORTHWEST COMPANY TOKEN
The Northwest Company of Montreal was the first company to issue a "Beaver Token." Tokens of brass and copper were issued in 1820. It is ironic that by 1821 the N.W. Co. was taken over by The Hudson's Bay Co. and the tokens were outdated. However, they proved very popular with the Indians who used them more as ornamental medallions. Most specimens are found with drilled holes to enable them to be strung on necklaces or to be sewn onto clothing. Most of the known examples were found along the Columbia River in Washington and Oregon. They are very rare. The token on the left is brass and was found under the floor of a fallen down cabin along the Abiquz River near Silverton, Oregon. The one on the right appears to be copper and was found by Leroy Gienger on his Modoc Point Ranch in Klamath County, Oregon. They are 1-1/8" dia. with a value of $600 to $1200.

HUDSON'S BAY COMPANY BELT BUCKLE
This is a rare canvas cartridge belt with a nickel buckle and was distributed by the Hudson's Bay Co. about 1880 to 1910. The buckle is embossed with the Company coat of arms, name, and "Incorporated 1670" date. Value is $400 to $600

HUDSON'S BAY CO. TOKENS
The set of brass tokens on the bottom row were introduced by the Hudson's Bay Co. sometime between 1854 and 1857. Indians and trappers were given tokens in exchange for their furs which they could then spend in the HUDSON'S BAY COMPANY store. These early tokens have the Coat of Arms on one side and the value marks on the opposite side. They were based on the value system of "Made Beaver" skins. The mark for this should be "M.B." but was mistakenly struck as an "N.B." on these tokens. They came in values of one beaver, half beaver, quarter beaver, and eighth beaver. The letters "H.B." stand for the Company and the "E.M." stands for the East Main District in which they were first issued. Values are $50 to $100 each.
The top two rows are aluminum tokens that were issued in Eskimo country in 1946. They were based on monetary values of 5¢ to $1.00. One large square token was worth one arctic fox skin. The third row is aluminum tokens that were issued in Yorkton and Labrador Districts about 1918 and 1919. Aluminum tokens are valued at $50 to $100 per set.

45

HUDSON'S BAY BLANKETS

The most famous items traded by the Hudson's Bay Company were the popular "Point Blankets." These blankets were never made by the Company itself, but were instead contracted out to English woolen manufacturers. Among the most famous was the firm of Thomas Early in Witney, England who was apprenticed as a blanket weaver in 1669. The Hudson's Bay Company began marketing "Point Blankets" about 1780 and they have retained their popularity to the present. Dark lines or "Points" about 4-1/2" long were woven near one corner and each stripe was symbolic of one "Made Beaver." Thus, four stripes meant the blanket was worth four beaver skins. Blankets came in sizes ranging from 1, 1- 1/2, 2, 2-1/2, 3, 3-1/2, and 4 "Made Beaver." In modern times even 6 and 8 point blankets are available. The number of points indicated the blankets size and weight. Presently the number of points indicates the size of the blanket with a four point being 72" X 90." The earliest color was the white with a black stripe as seen in this photo. Notice the small embroidered HUDSON'S BAY COMPANY tag which was replaced with a larger tag about 1940. Tags that have "Made in England" on them indicate the blanket was made after 1890. Earlier blankets generally have a more fluffy nap which can be seen on the four points on this blanket. HUDSON'S BAY COMPANY blankets never have the ends whip stitched at the time of manufacture. This is a good way to identify blankets that were made for the Hudson's Bay Company. Some later colors were scarlet, green and blue with a black stripe at each end. Starting about 1880 a white multi-color version with black, yellow, red and green stripes became the most popular. Many people identify these multi-striped colors as "Hudson's Bay" or "Chief's Blankets." Used blankets in excellent condition are collectible and usually sell between $75 and $150.

*See pp. 2 - 10, Hanson Jr., Chas. *The Museum of the Fur Trade Quarterly, Vol. 12, #1.* "The Point Blanket." Chadron, Nebr. 1976.

HUDSON'S BAY COMPANY SASHES

Brightly colored wool sashes were worn by Canadian fur traders along with their Great Coats, beaver hats and other finery to impress the natives. These sashes were known as *Ceintures Fléchées*, or Arrow Sashes, because the earliest examples had designs resembling arrows. Most were made just northeast of Montreal at L'Assomption and because of this they are often called Assomption Sashes. By the 1820s they became a standard accessory for many Indians and half-breeds. The earliest examples, starting in the late 1700s, were made from very "fine hard wool" using the finger weaving method. By 1885, in order to cut costs, The Hudson's Bay Co. began importing mechanically woven sashes from England. The sash on the left is an early "hard wool" sash dating from the early 1800s. It is 6" W. and 10' 10" L. including the fringe. Value is $1000 to $2000. The example on the right is of the loom woven type that became popular in the later 1800s. It is 9" W. and 11' 6" L. including the fringe. Value is $800 to $1500.

BLANKET COAT (CAPOTE)
This is an early hooded coat (capote) made from a Hudson's Bay blanket about 1800 to 1840. It is lined with linen cloth, has a hood and is trimmed around the collar, neck, cuffs and shoulders with red wool trade cloth, military braid and silk ribbon edge binding. (The ribbon has disintegrated from age) This is early and rare with a value of $2000 to $3000.

Figure from a painting c. 1845 showing similar capote in use.

Left to Right (Top to Bottom):
HUDSON'S BAY CO. WOOL TRADE BLANKET
*Small 1-1/2" X 1-5/8" "Seal of Quality" tag indicates this blanket dates before 1940. White blanket w/multi-color stripes (black, yellow, red and green) w/4 black *"Beaver Point"* stripes to indicate the size. Exc. clean cond. 5'1" X 7'4" Est. 125-250 **SOLD $150(98)**
Same. Brown 3-1/2 point blanket w/small early tag*. Shows some use but no holes and clean. 5'2" X 5'8" Est. 95 - 175 **SOLD $125(98)**
Same. White 3-1/2 point blanket w/black stripes. This was the most popular size wearing blanket and colors for early Indian trade blankets. One edge nr. center has a 5"X 2" piece missing. Small tag* and exc. cond. 5' X 5'10" Est. 95-175 **SOLD $120(98)**
Same. White 4 point blanket w/black stripes. No holes, but there is a tear on the center of each end up to the black stripe. Small tag*. 5'9" X 7'. Est. 95-175 **SOLD $100(98)**
* see p. 46 for full description

HUDSON'S BAY COMPANY KETTLES
Lidded copper kettles were introduced by The Hudson's Bay Co. about 1780 and continued to be sold into the early 1900s. They were especially popular with Indian customers and were far superior to wood, bark or pottery vessels. They were made in varying sizes that could be fitted or nested inside one another to conserve space while being transported. The size is always stamped into the lid. In this photo the largest is 3 quarts and the smallest is 1 quart. These are difficult to find and most desirable when complete with the lids. Values range from $300 to $800 depending on size and condition.

NESTED KETTLES
Brass and copper kettles like these, with hand made handle lugs riveted to the sides, were made in graduated sizes. They could be nested together for the purpose of transporting. Kettles like these were already being traded in the 17th and 18th centuries. Later kettles have cast metal handle lugs. Value is $75 to $250.

FORT GARRY COFFEE TINS
These two large coffee tins are among the most beautiful and collectible of the Hudson's Bay Company types. The blue *"Fort Garry Brand Pure Coffee"* 5 lb. tin was distributed by the wholesale branch in Winnipeg. It is 10" high and includes a wire handle. Values range between $300 to $500. The red Fort Garry tin is also from the wholesale division in Winnipeg, Man. and Vancouver, B.C. On the back it has a nice lithograph of the Hudson's Bay Company flag and stands 8-3/4" high. Value would be $250 to $450. Both examples have beautiful lithos of Indian and trader activities outside the walls of Fort Garry. If you look carefully you can see three Indians in front of their tipi smoking calumets (stone pipes). See p. 50 for more on tins.

HUDSON'S BAY COMPANY BOTTLES
There are many variations of HUDSON'S BAY COMPANY bottles available to the collector. They include grocery store products and the more popular bottles for wines and spirits. (L. to R.) The first bottle is *"Hudson's Bay Co's 'Special' Best Procurable Old Highland Whiskey."* It is green glass with a paper label. This bottle is illustrated in the HUDSON'S BAY COMPANY 1910-11 catalog. (9-3/4" high with a value of $75 to $125) The second bottle is a dark brown whiskey bottle with the HUDSON'S BAY COMPANY Coat of Arms embossed into the glass. It has a cork stopper and dates from about 1930. (8" high, value $20 to $50) Number three is clear glass with the Coat of Arms embossed on one side and a nice sitting fox and traders hat on the other side. The paper label is missing. It has an aluminum screw cap and the year 1938 embossed into the bottom. (9" high, value $25 to $75) Number four is embossed with *"Hudson's Bay Co., Incorporated 1670"* and has acquired a purple tint from age. It is 11-3/4" high with a value of $150 to $250. The fifth bottle is full of whiskey and can still be purchased in Canadian liquor stores for under $20.

POTTERY JUGS

Pottery jugs were made for The Hudson's Bay Co. in various sizes with the company name applied as part of the surface glaze. These photos show some of the known varieties. Dates and information about these is still a bit scarce. The jug with the brown top and the *"HB Co."* pressed into the clay is the oldest and possibly dates before 1850. Values can be from $250 to over $600.

SMALL TOBACCO TINS

After 1892, the Hudson's Bay Company packaged its popular *"Imperial Mixture"* smoking tobacco in a variety of red tin containers. The paper tax seals on three of these are dated 1908 and 1915. The two largest tins in the bottom center are 2-7/8" high. In excellent condition they sell for $75 to $150.

TOBACCO TINS

This photo shows three large HUDSON'S BAY COMPANY tobacco tins. (L. to R.) The round 1 lb. *"Imperial Mixture"* tin is 6" high and is dated 1915 on the paper seal. The next two are 1/2 lb. tins. The one on the right is dated 1915 and has illustrations of a Hudson's Bay Transport Steamer on one side and the Winnepeg Store, which was the HUDSON'S BAY COMPANY Canadian "Headquarters" on the other. Value $100 to $200.

TEA TINS
Hudson's Bay Company tea tins were made with red and green background colors. The lids are attached with a wire pin and are lithographed with the Company Coat of Arms. They come in two sizes, 6-1/2" high and 8-1/2" high. Each of the four sides has a different design. In this photo the side showing Upper Fort Garry and Jack Canuck standing in a field of wheat is not shown. (6-1/2", value $75 to $175; 8-1/2", value $100 to $250)

LARGE COFFEE TIN
This large coffee tin is from the wholesale department of the Winnipeg and Vancouver store. It is 13-3/4" high and has a value of $50 to $100.

TEA AND COFFEE CONTAINERS
Also see p. 48 for more on coffee tins. Left to Right: Fort Garry Tea and Coffee Boxes were being sold during the 1940s. (value $10 to $20.) The small Fort Garry Smoking Tobacco tin in the center is rather hard to find and has litho's of Fort Garry on either end with a Coat of Arms on the lid. It is 2-1/2" high and valued at $50 to $125. The Fort Garry Fine Cut Tobacco Tins contained tobacco for rolling cigarettes. This one does not have the correct lid and is in rather poor condition which would reduce its value to about $20. A better example would be worth $50 to $100,

DAGGER BLADES

This photo shows three dagger blades traded by The Hudson's Bay Co. Indians could construct their own handles or use them on lances or war clubs. The left/top blade is stamped "*Jukes Coulson and Co.*" which was a Sheffield cutler who used this stamp between 1774 and 1867. It was found along a creek north of Joplin, Mont. by William Meldrum about 1916. 12-1/2" long. The center/middle dag is also stamped "*Jukes Coulson and Co.*" and was found in Montana. The right/bottom dag has the initials "*I and H S*" within a jagged cartouche stamped into the tang. This stamp was used by John and Henry Sorby of Sheffield sometime after 1827. The name "*Foster*" appears within a similar cartouche on the opposite side. It was collected in Montana. Each of these dagger blades has a value of $300 to $600.

DAGGER KNIFE AND CAMP KNIFE

Top: Knife is a dagger made by "*Baldwin and Hill*" of New York. The name is controversial as the only blacksmith in New York city directories with a similar name is "*Baldwin and Heyl*" from 1869 to 1871. Some have the maker's name stamped into the blade and some do not. This example does not have the stamped blade and is perhaps an earlier version. These are rare and always have the Indian shooting his muzzle loader over a tree stump burned into the handle. 14-3/4" long, Value $5000 to $10,000.

Bottom: Knife is a "*Hudson's Bay Company Camp Knife*" with the blade stamped "*Unwin & Rodgers, Sheffield.*" This company was established about 1833, and among other things, advertised "*Indian Hunting Knives.*" This style knife is sometimes called a "*Buffalo Knife*", however, the name "*Camp Knife*" seems more fitting because the blade is made from heavy steel that can be used to split wood, chop bones and do many other camp chores. The handle is made with black horn scales that are held in place with a brass plate and two brass rivets. This knife was collected from Assiniboine Indians on the Ft. Belknap reservation in Montana. The handle has horse tracks and notches carved into it and shows much wear from long hard use. 13-1/2" long, Value $3000 to $6000.

SCALPING KNIVES

In early fur trade inventories knives of this type are referred to as "*Scalpers*." Early references date back to the French and Indian War Period and continue until the mid 1800s when the term "skinning knife" becomes more common. The shape of their blades are always similar and the three holes for riveting the diamond shaped wooden handle are most always prevalent. The top knife was made by "*Jukes Coulson and Co.*" of Sheffield, England who was a prominent supplier to the HUDSON'S BAY COMPANY and was first listed as an iron merchant in 1767. This knife was found along the Teton River in Montana by Ernest White in 1906. It is 9" long. The next two knives have the "Cross and L" mark stamped into the blades. This mark was first registered in Sheffied in 1750 and was used by both "*The Hudson's Bay Co.*" and the "*Northwest Company.*" The third and fourth knives are rare because they still have their unique diamond shaped handles. The fourth example is extremely rare because the blade is stamped "*P.C.J. and Co.*" which is the trade mark of Pierre Choteau Jr. and Company, a major trading firm operating out of St. Louis beginning in 1838 thru til the 1860"s. It has "*T.I. 1849*" carved into the handle and is 12 inches long. The scarcity of these knives makes it difficult to establish a set value. Our estimate would be that blades should sell from $200 to $800 and examples with handles from $500 to $2000.

CROOKED KNIFE

The Crooked Knife (also Canoe Knife) is unique to the American Indian Trade. It was used by Indians and Eskimo craftsmen to make canoes, paddles, ax handles, wooden spoons, bowls, cups, snowshoe frames, etc. Natives traded for the blades and fitted them to handles. Auguste Choteau, an early fur trader, submitted a bill for a crooked knife in 1806. Many blades were made by natives and blacksmiths at forts and trading posts throughout the north country. The top knife was collected by Sheriff Boots Combs of Eureka, Mont. from Kootenai Indians during the last Sun Dance at Tobacco Plains. The curved blade is forged from a file and attached to a wooden handle with rawhide lacing. The end of the handle thumb rest is decorated with a carved birds head. (10-1/4" long, value $800 to $1500) The next four knives have straight blades for carving. Two blades are attached with wrapped brass wire and the fourth one has an antler handle. (Value is from $300 to $600 each) The fifth and largest knife has "Hudson's Bay Co." etched on the blade and was still being sold by the HUDSON'S BAY COMPANY in the 1970s. (11-1/2" long, value $50 to $100) The bottom curved blade was made in Sheffield and was still being sold by the HUDSON'S BAY COMPANY in the 1960s.

VOLUTE DAGGERS

Four "*Volute Daggers*" as made and used by tribes in the Northwest. The name Volute is derived from the spiral or scroll like shape on the end of the handle. Most appear to have been made by native craftsmen. They were made by Subarctic Athapascans living in an area from around the U.S. border and north into Alaska. Tribes such as Tlingit, Tahltan, Tanana, Kutchin, Slave and Beaver used this style knife. Often they are fitted into special knife cases and worn around the neck or over the shoulder. Also they are sometimes seen mounted to wood shafts and used as lances to kill Polar Bears. There is an early drawing of Kutchin men in canoes stabbing caribou, that are swimming along side their canoes, with this type of knives. They are expertly made and show a high degree of metal working skills. The one on the left is made from iron and includes a beaded buckskin sheath. It is 14-1/2" long with a value of $1000 to $2000. The second one is iron and was made with only one volute. It is 11-1/4" long with a value of $600 to $1200. The third appears to be made from brass. The point appears to have been melted from heat and the volutes are broken off. It probably dates back several hundred years. (11-1/2" long, value $200 to $500) The fourth example is a spectacular copper version and is made from natural drawn copper. (12-3/8" long, value $1000 to $1800)

AXES

Iron trade axes were among the earliest and most popular items traded to Indians and trappers. Large felling axes and smaller belt or squaw axes in many sizes were made in large quantities by French, English and American makers. Iron axes were traded to most all Indian Nations starting in the 1600s.

Top to Bottom, Left to Right: The belt axe at the top is unique because it still has its original handle. It was collected from Sioux Indians in South Dakota. The axe is 4-3/4" long, with a value of $125 to $250. The first axe in the second row is triple stamped with the "*I.S.*" and crown stamp of John Sorby, a maker in Sheffield, England, who began manufacturing edged tools about 1790. (The first axe in the closeup photo shows the stamp more clearly) (7" long, value $200 to $400. Next is a large felling axe with the "*I. and H. Sorby*" stamp that was first adopted in 1827 when his son Henry joined the family firm. (See 2nd axe in closeup photo) (9-1/2" long, value $100 to $200) Of the next two belt axes the top one shows much use and is shortened from continued sharpening. It has no makers marks and was collected in South Dakota. It is interesting because it shows so much use. (4" long, value $75 to $150) Under it is an unusual brass belt axe which was found protruding from the banks of the Missouri River just south of Linton, N. Dakota along with the remains of an old tacked knife case and belt. (4-1/2" long, value $100 to $200). The first axe on the bottom was found near the old Catholic Mission on the Flathead Reservation in St. Ignatius, Mont. It has a deep stamp that appears to be an upside down "*J*" and a "*B.*" (5-3/4" long, value $125 to $200) Next is an axe that was deaccessioned from a museum in Spokane, Wa. with the provenance that it was "*found in 1886 on the battleground of a massacre of those at Ft. Kearny in 1866.*" It probably dates much earlier and had already seen much use before it was lost in 1866. This little bit of history makes it a very interesting specimen. (5-1/4" long, value $150 to $250) The third belt axe was found along Kiona Creek near Packwood, Wa. near the site of an early trading post. It is very interesting because the letters "*I.D.*" are deeply stamped into the blade. "*I.D.*" was the early mark applied by the U.S. Indian Department which was the forerunner of the modern Bureau of Indian Affairs. 5" long, Value $200. to $400. The fourth axe was dug by Emil Repac of Red Lodge, Mont. at the site of old Fort Manuel Lisa near the confluence of the Yellowstone and Big Horn Rivers in Montana. This trading fort was established by Manuel Lisa in 1807. (8" long, value $200 to $400)

TRADE GUNS

As early as 1620, the French began to distribute guns to Indians. By 1761 the name "Northwest Gun" was used to refer to the most popular trade gun style. These usually had .60 caliber smooth bore barrels. They are most easily distinguished by their unique brass dragon shaped side plate. Other things to look for are the oversized trigger guard that was developed to satisfy the need Northern Indians had to fire their guns in sub-zero temperatures without removing their buckskin mittens. This need was also responsible for the development of one finger mittens. Use of brass tacks driven into the wooden stock for decoration is another distinguishing characteristic. A *"Tombstone Fox"* stamped into the lock, facing left, with the upstanding tail is exactly like the one on the Company coat of arms. It is inset into a rectangular cartouche shaped like a plain grave marker with the letters *"E.B."* just below the fox. A similar fox, facing right, within a circle cartouche was used by the North West Company until it merged with the HUDSON'S BAY COMPANY in 1821.

Top to Bottom: The first gun is a cap lock with *"Barnett, London"* and 1871 stamped into the lock plate. It was collected in the 1950s from Indians in Alaska who where still using it for hunting. (Approx. 4' L., value $2000 to $3000)

The second gun is a *"Barnett"* flintlock dated 1871 and has a *"Tombstone Fox"* stamped on both the lock plate and barrel. The barrel was shortened by its Indian owner to make it more suitable for use on horse back and in forested areas. This gun has a notarized certificate from the great grandson of Conrad Kohrs, a famous historical rancher and trader from Deer Lodge, Mont., stating that "*it was picked up on the plains S.W. of Fort Benton by C.K. cowboys shortly after the Custer Massacre in 1876.*" It shows many signs of Indian usage including brass tacks in the stock for decoration, carved notches in the stock, hand chiseled front and rear sights on the barrel, stock worn through to the ramrod where it was layed across a saddle while riding and light chisel marks toward top front of the barrel to cut down glare from the sun. It includes a sinew sewn moosehide scabbard. It is 3' 2-1/2" L. Value $3500 to $5000.

The third gun is a *"Chiefs Grade Trade Gun."* As the name indicates they were developed for trade and as gifts to Indian notables and chiefs. This example has the name of the maker, *"Ketland"*, stamped into the lock. Also there is a Boars head surrounded by a Hunting Horn on the lock and on the brass butt plate. The brass trigger guard and side plate are engraved with an Indian Shield, bow and crossed arrows. The most identifying part of a chiefs style gun is the silver medallion inset into the stock at the wrist area. It shows the embossed bust of an Indian with head feathers and a bow and quiver full of arrows. This example still has its original metal ramrod. These are quite rare and most date before 1850. (4' 2" long, with values of $4500 TO $8000) Gun four is a double barreled muzzle loading shotgun with "Hudson's Bay Company, made in England" stamped on both lock plates. The barrel rib is stamped with "*I. Hollis and Sons, London.*" Probably dates from about 1880. Later versions of this shotgun known as Imperial #3 and #4 are listed in the 1910-11 HUDSON'S BAY COMPANY catalog for $12 and $15. 3' 10" L. Value $1000 to $2000.

TRADE GUN BARREL FLESHERS

Long after Northwest guns served their usefulness as a hunter's or warrior's weapon their remains were turned into useful objects. These four fleshing tools were forged from old gun barrels. The top flesher was collected from Mrs. Little Dog of the Montana Blackfeet and still has its original leather wrist thongs. The second flesher was collected from Sioux Indians in South Dakota. The third flesher was collected from Agnus Vanderburg on the Flathead Reservation in Montana. Number four was found in a 2nd Hand Store in Missoula, Montana. All of these date before 1880 and have values of $200 to $500.

STRIKERS

Steel strikers date to the very beginning of the fur trade. Many shapes and sizes were made by blacksmiths on the frontier or imported from cutlery companies in England. For Indians and trappers they provided an easier way of starting a fire in the days before matches were available. Striking the steel against a piece of flint causes sparks to fly. The sparks were caught in tinder which was ignited by blowing on it. With practice you can even light your tobacco pipe with a steel striker. The large striker hanging from a beaded belt tab is Blackfeet and was purchased at a Sotheby's auction in 1972 for $80. It is over 100 years old. The striker part is 6" L. Value is $800 to $1500. The second striker was collected from the Montana Blackfeet and is forged from a triangular shaped file stamped with the word "*Disston*." It has a beaded buckskin belt tab and dates to about 1880. The steel is 4" long with a value of $400 to $900. The third example is a tear drop shaped steel collected from Nora Spanish on the Montana Blackfeet Reservation in 1973. It has a "*Jukes Coulson and Co.*" stamp and was made by this Sheffield cutlery company between 1774 and 1867. This style was traded by The Hudson's Bay Co. Marked strikers are quite rare. It is 3-3/4" long with a value of $600 to $1000. At the top right is a brass tinder box which was used to keep the striker and tinder dry. Under it is a striker shaped like a letter "*D*" which was found by Jim Dressler along the Menominee River in Michigan. It is very early and could date from the 1700s. It is 3-1/2" L. with a value of $200 to $400. The rest are Spanish style strikers made for trade in the southwest and Mexico. Values range from $100 to $250 each.

CALENDARS

Two framed Hudson's Bay Company calendars (1946 and 1931) illustrated with historic prints showing old Fort Garry. 18" X 31" with a value of $75 to $150 each.

References:
Russell, Carl P. *Firearms, Traps and Tools of the Mountain Men*, New York, Alfred A. Knopf, Inc., 1967.
Wheeler, Robert C., *A Toast to the Fur Trade*, St. Paul, Wheeler Productions, 1985.
Gilman, Carolyn, *Where Two Worlds Meet*, St. Paul, Minnesota Historical Society, 1982.
Hanson, James A., *Fur Trade Cutlery Sketchbook*, Crawford, The Fur Press, 1994.
Hanson, James A., *Spirits In The Art*, Kansas City, The Lowell Press, Inc., 1994.
Hanson, Charles E., *The Northwest Gun*, Lincoln, Nebraska State Historical Society, 1956.
Mc Gregor, Doug, personal communication, 1998.

Weapons, Tools, etc.

I. & H. SORBY IRON TRADE AXE
c.1800
RARE. Tag says "bought from Little Big Horn Trading Post, Crow Agency, MT." Has 2 Sorby stamps in blade. Surface rust w/some pitting but very solid. 5.5"L. Est. 250-400 **SOLD $225(97)**

See descriptions of other items on p.30.
SPIKED IRON TOMAHAWK HEAD C.1750 *French & Indian War period.* Rust-encrusted but solid. 9.5"l. X 2." Est.125/160 **SOLD $95(92)**

TWO EARLY 3-TINED FORKS
18th Century.
Black horn handles w/ embossed designs. Early style, in use before American Revolution. Slight age cracks; otherwise, exc. Est. 35-95 **SOLD $40(95)**

RARE ATHABASCAN DAGGER
w/voluted & buckskin wrapped handle. These dags were made by Canadian No.West tribes & used as knives or tied to lances for killing bears. Exc. patina. 12.5"L. Est. 800-1000 **SOLD $950(96)**
See Chas. Hanson, *Museum of Fur Trade Qrtly*, Vol. 6, #1, Chadron Nebr., 1970. pp.4-5 Ex. Kutchin Ind on Yukon R.

Bottom to Top: **BOWIE KNIFE W/ANTLER HANDLE**
This knife has been part of Preston Miller's collection since 1978, collected in Wyoming. Would guess it dates before 1900. It is 17"L w/ heavy 12" pointed blade. It has a 5" iron cross bar. Exc. overall patina w/ very little rust. Est. 350-600 **SOLD $600(95)**
LARGE 1-PIECE ANTLER HANDLED BUTCHER KNIFE c. 1910 or earlier. *"Russell Green River Works"* stamped into the blade. (see detail photo- Bottom). Exc. & clear stamping with an arrow through the *"R"* in Russell. Exc. example. 20" L. Est. 50-100 **SOLD $110(95)**
BONE HANDLED KNIFE c. 1900 or earlier.
"Lamson & Goodnow MFG Co" stamped within an oval cartouche w/ anchor in the center. This is an old company that shipped knives up the Missouri on steamboats for the Indian & Fur Trade. 12.5"L. Est. 25-75 **SOLD $35(95)**
WOOD HANDLED BUTCHER KNIFE c. 1900 or earlier
"Joseph Rodgers & Sons, Cutlers to His Majesty" stamped into the blade. (See detail photo-TOP) It also has an *"E Crown R"* and 2 different cross marks as part of the stamp. Handle has 4 brass pin rivets. No rust, exc. cond.13.5"L. Est. 40-100 **SOLD $70(95)**
KNIFE & FORK SET c. 1880
"J. Russell & Co., Green River Works" stamped into the knife blade. (See detail photo-knife & fork) Dk. wood handles. Hard to find one of these knives w/matching fork. 10.5"L. Est. 40-100 **SOLD $65(95)**

56

Top to Bottom: HANDMADE KNIFE w/brass bolster c.1900
Two pinned wooden handle. 10"L. Est. 20-40 **SOLD $25(95)**
OLD SKINNING KNIFE
w/handmade wood handle attached w/2 copper rivets. 9." Est. 20-50 **SOLD $20(95)**
I. WILSON SKINNING KNIFE
"*Diamond & Peppercorn*" &"*Sheffield, ENG*" stamped in blade. Handmade wood handle. 9.5"L. Est. 63-95 **SOLD $73(95)**
BUTCHER KNIFE
w/stamped blade: "*Nothing My Equal*" w/most of the name worn off. Wood handle w/iron bolster. Est. 38-95 **SOLD $45(95)**

Top to Bottom Below: CANOE KNIFE W/ANTLER HANDLE. c.1940.
Popular trade type used for carving & gouging. 10" L. Est. 75-50 **SOLD $40(90)**
DAG KNIFE W/HORN HANDLE c.1880.
Blade stamped "*Venture, Slater Brothers, Sheffield*". Heavy brass bolster. Shows lots of use. 10.25" L. Est. 100-175 **SOLD $110(90)**
TRADE KNIFE W/PEWTER INLAID HANDLE c.1890.
Butcher-style. Worn blade. 13"L. Est. 20-45 **SOLD $35(90)**

Bottom to top:
I. WILSON TRADE KNIFE
C.1890
Diamond & peppercorn stamp w/"*Sycamore St. Sheffield, England*" stamped in blade. (See detail photo). Six rivet handle w/added copper harness rivet added later. 11" blade. 16.5"L. Est. 50-95 **SOLD $65(96)**
SAME 17"L. 11.5" blade. (See bottom detail photo).
c.1890 Est. 50-95 **SOLD $60(96)**
FIVE RIVET TRADE KNIFE c.1890.
No stamping, brass rivets. Good patina. 13"L. 8.25" blade. Est. 30-60 **SOLD $30(96)**
"*J. RUSSELL & CO., GREEN RIVER WORKS*" SKINNER c.1900
Name stamped in blade. Five rivet handle. Shows age, but not much use. 11.5"L. 7" blade. Est. 75-125 **SOLD $50(96)**

BUFFALO SKINNER'S KNIFE PACK c.1870
Harness leather case w/ copper rivets. Holds skinning knives, antler-handled butcher & sharpening steel. Case is 12" X 7.5." Est.250/500 **SOLD $300(89)**

Top to Bottom: E. WOODLANDS CROOK TRADE KNIVES Nicely carved wooden handle wrapped w/ brass wire. 9.25" L. Est. 125-160 **SOLD $175**
SIMILAR.
Antler base handle wrapped w/tarred cord string. Hangs on buckskin thong. 9.5" L. Est. 125-160 **SOLD $175**

57

BOATMAN'S FIRE AXE c.1850.
Stamped "A.H." on both sides of handle. Labeled "Trading post item, NY". VG original cond. 19.5" X 7.5."
Est. 150-225 **SOLD $135(90)**

FLATHEAD PAINTED PARFLECHE KNIFECASE W/TWO KNIVES c. 1870.
Found in old log cabin in mtns near Schmidtt Lookout W. of Camas Prairie betw. Perma & Hot Springs, Mt. on the Flathead Res. Rawhide w/ worn painted designs on front & back. Appears to have been made from an old parfleche. This style was used to carry all the camp knives that would be used for hunting & butchering. Contains 2 neat old butcher knives. The handle on one knife has been riveted in place w/old-time copper harness rivets. Great patina showing much use & age. 16" L. X 7.5" W.
Est. 1000-1800 **SOLD $1200(98)**

HATCHET W/FILE-BRANDED HARDWOOD HANDLE c.1910
Unusual pattern burned into handle w/a red hot file. Latigo braided hanger wire-wrapped. Fine patina. Exc. shape. 20"L. Est. 80/175 **SOLD $150(92)**

INDIAN OWNED PISTOL c.1837
From old Nebraska Collection. Percussion single shot pistol with "A.Waters Milbury, MS 1837—" on lock plate. This model often fell into Indian hands during the Fur Trade & later. This specimen is particularly interesting because of the brass tack points in the stock, which most surely proves it was once possessed by an Indian. Iron mountings. Twelve square brass nail shanks still in wood from tacks that once decorated the stock. Missing hammer, nipple & ramrod. 2 arsenal marks stamped into stock. 14.5" L. Est. 285-500 **SOLD $310(96)**

OLD CANVAS LEAD DROP SHOT BAG c.1880
From "Northwestern Shot & Lead Works of St. Paul, Minn." These bags were used to ship shot to the early frontier towns & forts. It could have come to Montana on an early river boat. 25 lb. bag. 6.75" X 10."
Est. 25/75 **SOLD $60(91)**

Left to Right: **INDIAN TRADE FUSIL.**
Cap lock stamped *"Barnett London 1871"*. *"JEB"* stamp in barrel & brass serpent in side plate. Exc. cond. 4' L. Est. 2000/3000
BLACKFEET-STYLE OTTER FUR NECK PIECE.
This is a replica of a style worn by warriors c. 1860. It uses 6 brass trade gun serpents as decoration w/ twisted red-ochred thongs. Ermine strips at neck & bottom w/brass thimbles. Hangs 4'. Est. 175/250 **SOLD $175(91)**

1863 PARKER FIELD & CO. FULL-STOCK INDIAN TRADE FUSIL
This gun was made expressly for the Indian trade & many were traded by the Hudson's Bay Co. It was converted from flint lock to percussion many years ago. It has the large trigger guard for mittened fingers, brass serpent side plate, & 15 brass shanked tacks at various spots. An old ramrod is still w/the gun. Brass butt plate & iron front sight. Exc. patina. 58"L. Est. 2000-3000 **SOLD $1500(91)**

Misc. Trade Goods

1871 ULYSSES S. GRANT BRONZE PEACE MEDAL
Finial & ring for wearing attached to top. Tarnished patina shows age. 2.5" diam. Est. 300-600 **SOLD $650(94)**

HUDSON'S BAY CO. ASSOMPTION SASH c. 1900.
Woven wool w/multiple tears & holes w/ fringe remnants of braided red, yellow, blue & green. Fair to poor cond. 6.75" W. X 6.5' L. Est. 125-195 **SOLD $150(96)**

HUDSON'S BAY CO. ASSOMPTION SASH-C.1800-1830. This is the rarest of the HBC sashes. This style is known as the "ceintures flechees" or arrow sash and was first woven about 1780 in L'Assomption, Quebec for the N.W. Co & later the Hudson's Bay Co. It is finger-woven with over 300 wool threads-very fine tight weave. (see detail photo). 11.5' L. 6" W. Est. 1000-1800 **SOLD** $800(87)
See Barbeau, Marius, *Assomption Sash*, Natl. Museum of Canada, Bull. #93, Series 24, 1958.

HUDSON'S BAY CO. WOOL ASSOMPTION SASH (Half-breed Sash) c.1860-1900
Charlie Russell, the famous artist, wore one of these sashes all of the time. This one was acquired many years ago in a trade made w/Indians at Crow Fair. 5 missing fringes on each end. 7.5" W X 11' L. Est .450-850 **SOLD $450(93)**
See *Four Winds Indian Trading Post Catalog*, St. Ignatius 1996:7.

HUDSON'S BAY COMPANY ASSOMPTION SASH (Half-Breed Sash) c. 1860-1900.
This is the wool sash made by the HBC & worn by breeds, Indians, traders & Charlie Russell, the famous Mont. artist. Colors: red, green, dk. blue, yellow, grey & white. Left: 6.25" X 9' 4"L. Exc. cond. Est. 450-850 **SOLD $400(98)**
Right: This one is bigger & a little older. There is one small hole (1/2") & about 3 of over 80 of the beautifully twisted fringes are a bit shorter. Same colors. 8.5" W. X 11' 8" L. Est. 1000-1500 **SOLD $1200(98)**

HUDSON'S BAY CO. COAT c.1890-1910
Made from a 3-1/2 Pt. white w/black stripe blanket (the earliest trade blanket). Appears to be commercially made w/belt, black enameled metal buckle, belt loops, front pockets. Darts in front make it somewhat fitted, also has set-in sleeves. HBC label still intact. 56"L. Exc. cond. Est.350/495 **SOLD $300(92)**

BLACK BEAVER TOP HAT c.1822
From an old museum in Missoula, Mont. The inside label reads (see detail):"1822, by warrant to his majesty the king" (George IV) "Holt, Renfrew & Co. Limited, Montreal, Winnipeg, Quebec, Toronto". A true Fur Trade specimen. Shows use & age, but still in VG cond. Apx. size 7-1/4. 5.25"H. Est. 100-200 **SOLD $275(97)**

HUDSON'S BAY CO. IMPERIAL MIXTURE TOBACCO TIN
Paper seal w/date 1915. Red tin w/company coat of arms on lid in gold & black. Tin bottom is embossed w/"*The Governor & Company Of Adventurers of England Trading into Hudson's Bay*". Rare & hard to find. Exc. cond. 3.5" diam. 1.75" H. Est. 150-300 **SOLD $290(98)**

HUDSON'S BAY CO. TEA TIN c.1930
Red tin w/gold-colored hinged lid. One side tells of the 1st tea shipped by the HBC; opposite has directions for making tea & *"Importers of tea since 1716"*. HBC coat of arms on top & all 4 sides. 5.5" X 4.75" X 3.5." Est.95-150 **SOLD $120(93)**

Below: Left to Right: 2 HBC IMPERIAL MIXTURE TOBACCO TINS c.1900?
Both are red w/black lettering & gold Co. coat of arms on lid. Bottom tin is embossed "*The Governor & Company of Adventurers of England Trading into Hudson's Bay.*" Each is 3.5" diam. Est. 125-250 each
2" H. good shape Shows use. **SOLD $150(94)**
3" H. A few small rust spots but overall very good shape. **SOLD $150(94)**

Left to Right: HUDSON'S BAY CO. TEA TIN c.1890?
Square red w/Co. coat of arms on top. Sides incl. drawing of Upper Fort Garry & Jack Canuck. Well-worn lithograph from use. 4.5" square X 6.5" H. Est. 200-400 **SOLD $225(94)**
HUDSON'S BAY CO. GLAZED CERAMIC JUG W/HANDLE c.1880's
ORIGINAL & RARE. Grey w/2 lt. blue & 1 white line above & below the lettering:"*Hudson's Bay Co. Winnipeg.*" Interesting patina. 7" diam. X 12" H. Est. 500-800 **SOLD $800(95)**

Far Right: Left: HUDSON'S BAY CO. IMPERIAL DARJEELING TEA TIN c. 1920?
Red & gold colored tin w/HBC coat of arms on 5 sides. Also, a nice history of how tea came to York Factory in 1716. 5- 3/8" H. 3-1/2" W. & 4-3/4" L. Exc. cond. Est. 85-150
SOLD $125(98)
Right: HUDSON'S BAY CO. IMPERIAL MIXTURE TOBACCO TIN c. 1915.
Poor & rusted condition w/rusted hole in bottom & wrong lid. The only good thing on this tin is the little 1-1/2" round gold colored logo containing the name & coat of arms. 4-1/4" diam. X 3" H. Est. 15-40 **SOLD $20(98)**

61

HUDSON'S BAY CO. COPPER TRADE KETTLE c.1870
This is the type of kettle used by Indians on either side of the Canadian-U.S. border. They came in graduated sizes that could be stored one inside the other. Cast iron bungs hold the wire handle. No lid. Difficult to find. Shows use but in exc. cond. 6"H X 6"W . Est. without lid 300-400 Est. with lid 400-600 **SOLD** $350(94)

LARGE BRASS TRADE BUCKET
19th Century
Bottom stamp partially worn off heads "*RW... Pat.... Dec... MANUFACTURED BY THE ANSONIA*" Exc. cond.13" top diam; 9" bottom. 8.5" H. Est. 95-150 **SOLD** $130(95)

CHINESE CAMPHORWOOD TRUNK c.1790-1840
Rare. Covered w/painted pigskin & ornamented w/solid brass tacks & tabs. When Americans entered the China trade in 1785, they brought back these trunks filled w/ tea & traded them to the North West Indian tribes. Many early photos show these trunks being used by Indians to store clothing, beadwork & other valuables. This one is painted red, which was the most popular among the Indians. It shows considerable use: missing part of 1 handle, a few tacks, & tabs; but, is in overall good solid cond. 24.5"L X 12.5"W X 10.5"H. Est. 400-600 **SOLD** $388(91)

Right: **LEATHER-COVERED WOOD CASSETTE BOX**
c. 1820
w/brass tacks. *Similar to one in Wash. State Hist. Society Museum which belonged to Alexander Thompson.* Exc.cond Est. 175-250 **SOLD** $125(87)

EARLY CASSETTE TRUNKS c.1750-1820
Hair-on hide covered & decorated w/square shank-brass tacks. Well-to-do civilians & officers carried their documents & personal effects in these during the Amer. Rev., French & Indian Wars, & at early fur trading posts. George Washington & Alexander Thompson are among the notables who owned such trunks. Both are in unusually exc. cond.
Left: Lined w/lt. blue paper. 12"L X 6"W X 5"H. Est. 200-350 **SOLD** $325(94)
Right: Lined w/brown paper w/hand printed blue dots. In unusually exc. cond. w/original lock. 15"L X 6.5"H X 8"W. Est. 250-350 **SOLD** $475(97)
See George C. Neumann, *Collector's Illustrated Encyclopedia of the American Revolution*, Harrisburg: Stackpole, 1975: 181,182.

III. TRADE BEADS

These fancy Venetian trade beads were collected by "high grading" beads found in Africa over the past 30 years. Most of these types were also traded to No. American Indians. *Author's collection.*

Most of the beads in this section come from the African trade with a lesser amount being those traded directly to American Indians. Genuine American Indian trade beads are scarce, but both African & American Indian trade beads are commanding respectable prices.

African Trade Beads
similar types as traded to North America

We have chosen to illustrate primarily those African trade beads that have a counterpart in the North American Indian trade. Beads exported from Africa are most easily identified by the native grasses on which they are often strung; because these beads are often more than 100 years old they sometimes show considerable wear and darkened patina.

The following are all strung on grass, unless otherwise noted.

TRADE BEADS

ARE MEASURED IN MILLIMETERS:
1" = 25.4 mm 1/16" = apx. 1.6 mm

ACTUAL SIZE:
Beads graduated from 10 to 1 mm in size

About 400 years ago, explorers & traders brought glass beads to America. Most of these beads were being made in European countries with strong glass producing traditions, ie. Italy, Bohemia (now known as Czechosolvakia) and others. These glass beads gradually replaced the shells, bones, stones and quills the Indian people had been using to ornament their bodies, clothing, containers, sacred objects, etc. The Europeans soon discovered Indians might give a horse, beaver skin or other valuable object or service for certain glass beads. Thus, the term "trade beads" came into being.

Meanwhile, beads were also being traded to other countries. Millions of beads were traded into Africa where they became status symbols to denote individual & family wealth. These African beads caught the attention of American "hippies" in the 1960's & were soon being imported to the U.S. by the tons. The values quickly rose as Africans began gathering these beads & bringing them to America where willling buyers were anxious to trade for cash. Today collectors, artists, bead clubs, Native Americans, etc. have created a demand for beads which has caused prices to continally rise.

Example of large Venetian chevrons on original factory strings. Non-African trade. *Author's Collection-formerly Bowser Collection.*

CHEVRONS & LARGE MULTI-LAYERED BEADS

Left to Right: 6-LAYERED LARGE CHEVRON BEAD NECKLACE c.1850-1900
29 graduated cobalt, white & red chevrons strung on grass. Only one has a nick-the rest are perfect. The 2 largest are egg size-46 mm X 34 mm W. 43" loop Est. 1000-1500 **SOLD** $900(97)
6 LAYERED CHEVRON BEADS C.1850-1900 Cobalt, red & white;only 1 has a small nick others are perfect. Apx. 16 mm to 25 mm L. 36" loop strung on grass. Est. 450-700

CHEVRON BEAD

Chevrons are probably the most popular & collectible bead. The name refers to the star-like chevron pattern that forms around the hole at either end. The most popular version is composed of multiple layers of white, red & cobalt blue glass. The earliest & most collectible types were first made around the year 1500 & can be identified by their 7 layers of colored glass. Often the 1st inner layer & the 3rd layer are trans. green glass. Later examples usually have 6 layers of white, red & cobalt. They are still being made today both in Italy & by glass blowers in America. Many variations in size & colors are available; some larger than a chicken egg.

Large chevrons were not prominent in the early North American Indian trade. Some examples about the size of a cherry have been recorded as being found at No. American sites. A collector should check the provenance very carefully if he is told his purchase has come via the American Indian trade.

Small pea size examples have been excavated from 16th & 17th Century sites in New York & Penna. (*See more info under Green Chevrons on p.66.*) These are made from "pinched" glass tubes which give the layers a rounded shape following the curve of the bead. The chevrons found in the African trade are usually chopped or cut glass which produces layers that follow a straight line making the chevron pattern easily visible.

S.S. Haldeman writes about 2 chevron "rosetta"* pattern beads having been found on a site in So. Calif. before 1879. See photo in his 1879 "Report Upon U. S. Geological Surveys" Vol. VII, Archaeology plate XIII, Gvt. Printing Office, Washington, D.C.

See also Dubin, Lois Sherr, *History of Beads*, New York, Harry N. Abrams Publ., (1987):116-117. Concise edition(1995):44-45.

*Rosetta means "star" in Italian.

LARGE 7 LAYER CHEVRON BEAD c.16th Century
Cobalt, white & red w/2 center layers of t. blue-green. Exc. patina & cond. 25mm diam. X 32 mm L. Est.100-150 **SOLD $85(91)**

6 LAYER BLACK CHEVRON BEADS
Date unknown. Well-defined stripes & layers. Perfect cond. 32 mm L X 13 mm diam. Est.70-110 **SOLD $70 each (91)**

Top to Bottom: **7-LAYER CHEVRON BEAD** c.1800
Trans. green center. Shows patina & use. Faceted ends. A few old nicks. 16 X 13 mm. Est. 30-95 **SOLD $30(94)**
6-LAYER CHEVRON BEAD c.1800
Green center. Irregular shape. Lots of red color visible w/streaks of red each end. 19 X 16 mm L. Est. 60-95 **SOLD $75(95)**
7-LAYER CHEVRON BEAD c.1800
Green center. Barrel shape. Faceted ends show lots of red. Good patina. 19 X 25 mm L. **Est. 30-75 SOLD $40(94)**

Left to Right, Top to Bottom: **7-LAYER CHEVRON**
w/two layers of t. green in center. Lots of patina & use w/10 mm nick on one side. Good old coloring. 29 x 19 mm. Est. 60-100 **SOLD $90(96)**
IRREGULAR SHAPED CHEVRON c.15th century.
Rich dark brick coloring. Shows patina & use. 7 layers and very old. 29 x 25 mm. Est. 95-200 **SOLD $80(96)**
COBALT & BRICK CHEVRON
6 layers. 32 x 22 mm. Est. 45-95 **SOLD $45(96)**
COBALT CHEVRON.
6 layers. Exc. cond. 19 x 29 mm. Est. 40-90 **SOLD $40(96)**

15 LARGE CHEVRONS, 3 WHITE DUTCH & 2 AFRICAN LION'S TEETH c.1830
African strung & reputedly worn by Chiefs. VG patina. Largest chevron is 41 X 44 mm. This is an extra large 6 layered bead. Est. 375/750 **SOLD $425(93)**

Left to Right, Top to Bottom: **6-LAYERED CHEVRON** c.1900
From the Bowser Collection. When acquired was still on original factory string. 46 X 29 mm Est.75-150 **SOLD $50(93)**
6-LAYERED CHEVRON c.1900s
Exc. color & patina. 37 X 17 mm Est. 40-80 **SOLD $40(93)**
7-LAYERED CHEVRON. Beautiful bead in exc. shape. 27 X 17 mm. Est.50-100 **SOLD $50(93)**
6-LAYERED CHEVRON c.1900
Bowser Coll. 46 X 29 mm Est.75-150 **SOLD $50(93)**
6-LAYERED CHEVRON c.1900
Very interesting shape & size-good colors. 46 X 19 mm Est.40-100 **SOLD $35(93)**
7-LAYERED CHEVRON BEAD c.1500
Very unusual. 1st layer is t. lt. blue. 2)white, 3)t. lt. blue, 4)white, 5)brick red, 6)white & 7)cobalt blue. Faceted ends. Both ends have sizable chips but the damage is very old. All the sharp edges have been worn smooth & show considerable patina. (These chips give the bead character & show off the unique colors.) 38 X 29 mm. Est. 45-85 **SOLD $75(93)**

65

NUEVA CADIZ Three layer drawn cane beads w/square cross-sections. Usually blue over white w/darker inner core. The earliest versions (not shown) were named for the 15th century Spanish archaelogical island site off So.America, where they were 1st found.

These "2nd generation" beads are much larger & were traded in Africa for slaves mid-19th century & are probably of 19th century Venetian or Bohemian manufacture. Recent discoveries of documented large canes indicate Venetian manufacture (pre-World War I). (Liu, 1995).

See Lui, Robert K. *Nueva Cadiz & Associated Beads* Lancaster, Penna., Fenstermaker, 1982.

Picard, John & Ruth *Chevron & Nueva Cadiz Beads,* Vol. VII, Carmel, Calif., (1993):105-110.

Liu, Robert K. *Collectible Beads*, Vista, Calif. Ornament. 1995: 28, 164.

Left to Right: NUEVA CADIZ RECTANGULAR 3 LAYER BEADS c.19th century
10 X 44 mm L. Slight chip off 1 end. Est. 30-60 **SOLD $12(94)**
16 X 70 mm L. Good patina. Est. 65-125 **SOLD $45(94)**
13 X 83 mm L. Good patina. Est. 75-130 **SOLD $42(94)**

See p.69 for fancy beads description.
Far Right: LARGE NUEVA CADIZ RECTANGULAR 3-LAYER BEADS c.19th century
RARE. 13 beads on 1 string! Bright blue outside over white w/ blue core. Exc. cond. 32-83 mm L X 13 -16 mm diam.
Est.375/425

SMALL CHEVRONS & STRIPED BEADS

Top: GREEN CHEVRONS By the 1600s & 1700s forms of this bead were being traded to tribes on the Eastern coast of America & Canada. They are made from a white core w/brick red, white & green glass layers that are drawn in glass tubes. These are heated & pinched into individual beads. This process gives the bead it's stripes & bulbous shape w/chevron patterns on both ends. Small green & blue chevrons were excavated from sites along the Susquehanna R., Lancaster Co., Penna.
See Francis Jr, Peter, *Beads of the World*, West Chester, Pa, Schiffer Publ. Ltd.,(1994): 56
Picard, *Chevrons & Nueva Cadiz Beads*
Fenstermaker Gerald B., *Early Susquehanna Bead Chart 1550*, Vol.III Lancaster, Pa. 1974.
Center: STRIPED OVAL BEADS An early bead probably dating into the 1700's. made in many color combinations. Identical beads were used in the North American trade. 7 X 12 mm TRADING POST PRICES **(96) $1-2 ea.**
Bottom: LARGE STRIPED BEAD Early style similar to ones traded to North America from 1600-1700. Brick red wire wound core covered w/layer of white to which red & blue stripes have been applied. Apx. 12 X 15 mm.
TRADING POST PRICES **(96) $3 ea.**
See Francis, pp.54 & 64
Fenstermaker, *Early Susquehanna Bead Chart 1550*, Vol.III.

Top to Bottom: CROSS TRAILS BEADS
These were an early pre-1800 style popular with Plains Indians during the 1860-1885 period. Wire-wound oval bead w/red, white & blue stripes applied to surface creating a cross-shaped pattern. Apx. 8 X 12 mm. TRADING POST PRICES (96) **$2 ea.**
DUTCH (DELFT) Dates back to the 1600s
found at a Great Lakes fort occupied from 1700-1781. White oval beads w/blue spiral stripes. 9 X 12mm TRADING POST PRICES (96) **$3 ea.**
See *Beads:Their Use by Upper Great Lakes Indians*, Exhibition Catalog, Grand Rapids Public Museum, MI.,1977:52.

BLUE-GREY CHEVRONS
We have no record of this bead being found at an early No. American site, but it is a beautiful & collectible bead style dating back many years. Note the many variations of stripe patterns. Apx. 6 to 9mm. TRADING POST PRICES (96) **75¢ ea.**

Left to Right: VENETIAN CROSS TRAILS
White center w/red, white & blue crosses. Avg. size-8 diam. x 13 mm L. 19" loop Est. 35-65 **SOLD $40(96)**
DELFT (DUTCH) WHITE W/BLUE DIAGONAL STRIPE Avg. size-9 diam. x 13 mm L. 22" loop. Est. 50-90 **SOLD $50(96)**
VENETIAN YELLOW CROSS TRAILS
Yellow w/red, white & blue crosses. Avg size- 8 diam. x 13 mm L. 24" loop. Est. 35-65 **SOLD $45(96)**
RED FEATHER TRADE BEADS
Many shades of red w/white & blue line designs. None are broken. Exc. cond. Graduated sizes approx. 10 mm diam. x 25 mm L. 23" loop. Est. 60-100 **SOLD $60(96)** *See full description under FANCY BEADS p.70.*
OBLONG MULTI-STRIPE CHEVRONS
White core w/brick red layer. Surface is white w/red, blue & green stripes. Avg. size-7 diam.x 13 mm L. 22" loop. Est. 15-30 **SOLD $20(96)**
OVAL & TABULAR GREEN CHEVRONS
Rich green color has white core w/brick red layer. Avg. size-6 diam.x 13 mm L. 22" loop. Est. 18-35 **SOLD $23(96)**
STRIPED OVAL & TABULAR BEADS
Blue & white striped. Avg. size-6 diam.x 15 mm L. 20" loop. Est. 18-35 **SOLD $15(96)**
ROUND PERIWINKLE BEADS
w/dk. blue & yellow stripes. Avg. size- 10 diam. x 15 mm L. 21" loop. Est. 50-90 **SOLD $50(96)**
BRICK TABULAR BEADS
w/black & white stripes. Avg. size- 12 diam. x 18 mm L. 20" loop. Est. 12-25 **SOLD $17(96)**
STRIPED PONY BEADS
white w/blue stripes. Avg. size-3 diam. x 6 mm L. 21" loop. Est. 10-20 **SOLD $15(96)**
STRIPED BRICK RED PONY BEADS
Some have blue & white stripes and some have black & white. Avg. size-4 diam. x 6 mm L. 19" loop. Est.10-20 **SOLD $15(96)**
LARGE PONY BEAD SIZE GREEN CHEVRONS
White core w/brick layer. Rich green "watermelon" color. Apx. 5 diam. x 7 mm. 22" loop. Est. 20-35 **SOLD $20(96)**

Left to Right: DUTCH DELFT BEADS
c.1700s
Each measures apx. 10 X 13 mm. 23" loop. Est. 65/125 **SOLD $75(92)**
CROSS TRAILS BEAD
c. 1860
Green w/red, white & blue overlay stripes. 9 X 12 mm. 22" loop. Est.35/65 **SOLD $35(92)**
CROSS TRAILS BEAD
c.1840
Yellow w/red, white, blue overlay stripes. 11 X 8 mm. 25" loop. Est.60/95 **SOLD $65(92)**

Left to Right: TRANS. COBALT BLUE DONUT SHAPED BEADS c.1880
Round glass, apx. 13 mm. diam. 20" loop. *See description under solid color beads, p.74.* Est. 50-100 **SOLD $50(95)**
OLD COBALT CHEVRONS c.1840
31 small oval, 16 larger ovals, 19 tube shaped. 1 green & 2 yellow & black tubes. Avg. size 19 X 6 mm. 26" loop. Est. 85/150 **SOLD $75(92)**
Similar size, color & shape chevrons excavated at a Wisc. site dating 1650-1770.
See *Beads:Their Use by Upper Great Lakes Indians*, (1977):51.
OVAL & ROUND GREEN CHEVRONS c.1830
58 beads. Ovals apx. 16 X 8 mm. 28" loop. Est. 95/150 **SOLD $80(92)**
ROUND GREEN CHEVRONS c.1900
6 X 5 mm each. 30" loop. Est.18/35 **SOLD $30(92)**

Left to Right: VENETIAN CHEVRONS c. 1850
A blue-grey tube w/brick red & cobalt blue chevron patterns on surface. Well worn & rounded shape. Avg. 6mm. Est. 30-50 **SOLD $40(95)**
WIRE-WOUND STRIPED BULBOUS-SHAPED BEADS c. 1780.
Opaque white w/red & blue stripes. Some w/red centers. 25" loop. Avg. 13 mm. Est. 85-150 **SOLD $75(95)**

WIRE-WOUND STRIPED BULBOUS-SHAPED BEADS c.1780.
Same as preceding. Avg. size 13 mm . 23" loop. Est. 75-100 **SOLD $85(94)**

See photo on p. 75
18TH c. WIRE-WOUND- STRIPED BULBOUS-SHAPED BEADS c.1780
White w/red & blue stripes. Avg. size-13 mm. 23" loop. Est. 60-120 **SOLD $75(96)**

OVAL BLUE & WHITE STRIPED VENETIAN BEADS c.1700
Avg. 13 X 10 mm diam. This style was used very early in the Indian trade. Est. 15-35 **SOLD $30(95)**

FANCY DECORATED BEADS

ROWS 1-3:"EYE" BEADS, See p. 72
ROW 4:LOBED BEADS, See p. 70
ROW 5: FEATHER BEADS
ROW 6: COBALT TRAILED BEADS. Rare string of perfect round trans. 34" loop. Est.300-400
ROW 7: VENETIAN MILLEFIORI BEADS c.1900
51 beads & each one is different. Aver. size 9mm W & 25mm or more L. 49" loop. Est. 125-200 **SOLD $145(97)**
MOSAIC & MILLEFIORI BEADS made from a wound glass core (usually black) w/thin slices (called murrine) of multi-layered drawn canes melted onto the surface. Many interesting & beautiful patterns have been made. Millfiori means "1000 flowers" in Italian. As far as we know, this bead was not used by American Indians prior to 1900. They are Venetian & probably not made much before 1890. They gained popularity in the 1920's w/ most being traded to Africa. Each one is unique. TRADING POST PRICES (96): UNDER 25mm- $4.00 each. 25mm & up- $6 each
See Picard, Vol. 7-*Millefiori Beads*
Harris,Elizabeth *Late Beads in the African Trade*, Lancaster, Penna., Fenstermaker. 1984.

Top to Bottom: MILLEFIORI CURVED AFRICAN CHIEF'S BEAD c.turn-of-the century
Black core w/murrine (millefiori slice) in brick red, white, blue & yellow. Small chips on both ends. 54 X 14 mm. Est. 10/20 **SOLD $10(92)**
Murrine are yellow background w/red, white, & blue chevron pattern & a red & white stripe in the middle. 49 X 14 mm. Est.12/30 **SOLD $17(92)**
Murrine are placed in rows & separated by a yellow divider. Blue, white & brick red w/yellow center. 49 X 14 mm. Est.12/30 **SOLD $15(92**
Murrine are 8 layer chevron patterns in blue, brick red, white & yellow. 54 X 14 mm. Est. 25/50 **SOLD $25(92)**
Murrine are blue, white, brick red w/a yellow star pattern in center. 49 X 13 mm. Est.12/30 **SOLD $12(92)**

LAMP-WOUND VENETIAN FANCY BEADS

See: Picard, *Fancy Beads* Vol. III.
Jargstrof, Sibylle *Glass in Jewelry*, West Chester, Penna. Schiffer Publ. Ltd.(1991):66-68. Shows actual photos of the process.

*IMPORTANT NOTE: There are dubious origins of the nomenclature *"Lewis & Clark," "French Ambassadors,"* etc. as these beads were made much later in the 19th century to be historically attributed to such names. See: Francis, p. 120, *"Some Bead Fallacies."*

Left to Right: PAIR OF *"LEWIS & CLARK"** TRADE BEADS
Black w/red, white & blue trailed design. 9 X 25-29 mm L. Est. 45-95 **SOLD $50(96)pr.**
PR. OF *"AMBASSADOR"** TRADE BEADS Black w/lt. blue stripes each end. 32 x 13 mm. Est. 50-125 **SOLD $60(96)pr.**

Left: VENETIAN ROUND BLACK & TRANS. GREEN FANCY BEADS c. Late 19th Century
Consignor calls these the "True French Ambassadors". Elaborate pink, white & yellow trailed patterns. Matched string. Apx. 60 beads. Good to exc cond. Apx. 13 mm diam. Est. 225/300 **SOLD $200(91)**
Center: LARGE VENETIAN BARREL-SHAPED FANCY BEADS c. Late 19th Century.
Nicknamed *"Lewis & Clark"* * beads, these are black w/white, red, & blue designs. Fair to good cond. 19 X 25 mm L. Apx. 35 beads. 25" loop. Est.275/325
Far Right: See description under Nueva Cadiz, p.66.

The following beads are fancy trade beads all have black base color. Sizes range from 10 to 13 mm.
Left to Right:
1) Both beads are made by dropping glass on the bead to make raised blue & white dots; which creates textured surface. Est. 10-20 PR.
2) Large white dots have smaller red & blue dots within them. Also, individual white stripes w/red center separated by yellow dots. Est.30-60 **SOLD $40 PR. (96)**
3) Yellow diagonal stripes w/thin green line. White dots. Est. 10-20 PR.
4) Blue center stripe. White undulating stripe w/yellow dots. Est. 30-60 PR.
5) Center double row raised blue dots; yellow row each end. Est. 20-45 PR.
6) Twisted stripes & yellow dots. Est. 20-40 PR.
7) Base is dk. green w/intricate trailed designs in yellow, golden yellow, shades of pink, blue & white. Est. 30-60 PR.
8) Two stripes of pink (over white) w/center undulating stripe of yellow. Est. 20-50 PR.
9) Variation of #7. Est. 30-60 PR.
10) Oblong w/muted red/white/blue spiralling stripe design. Est 15-25 PR.
11) Floral trailed designs made by applying red, blue, yellow & white glass. Est. 30-70 PR.
12) Same trailed designs as #11, not so intricate design. Est. 20-40 PR.
13) Same trailed designs as #11; more color. Est. 30-70 PR.
14) Aventurine center stripe w/pink & blue stripes on either side. Est. 35-70 PR.

VENETIAN FANCY TRADE BEADS c.19th Century
Each bead is very different: 7 blue eye beads, chevrons, 2 rare curved Chief's beads (millefiores) 9 mm X 57 mm w/transecting aventurine lines, 7 blue/white Delft flower beads, etc. Graduated & matched. 20" loop. Est. 85-150 **SOLD $150(94)**

Left to Right: **FANCY VENETIAN TRADE BEADS** c.1840
18 black beads w/red & white eyes; 2 flower design fancies, 18 "End of Day" or crumb beads. 3 black w/white trailed designs, green eye bead w/ crossing lines of yellow & red, 2 black beads w/yellow & red center lines & white trailings, etc. 25" loop. Est.140-200 **SOLD $200(92)**
ETHIOPIAN FEATHER & EYE BEAD NECKLACE 19th century
Probably Goramora Province. Assortment of red to rose w. heart white eye beads, opaque blue hexagons, & rose to dk. red feather beads w/white & blue stripes, some opaque red Prossers, greasy yellow oval & a few white & amber Crow beads.
A polished & incised bone amulet hangs at the end (4.5"). Hangs 31." Est.100-250 **SOLD $125(92)**
NOTE: Came to us described as a "good eye amulet medicine necklace w/zebra bone amulet." See Francis, p.4. He says "There are many stories about (them) "(Ethiopian necklaces)" but (they) are worn as adornment by Ethiopian women."
DEEP RED FEATHER BEADS c.1880
White & blue line designs. Apx. 20 of these beads are perfect w/the rest showing minor chips & cracks. 26" loop. Est.65-110 **SOLD $65(92)**

BLACK BEADS W/WHITE STRIPE c. 1800
Pressed lines. If there ever was a "skunk bead"*, this must be it. Aver. size 9 mm. 25" loop Est. 50-95 **SOLD $50(97)**
This black lobed bead is characterized by a prominent central white stripe of varying widths. They were traded as early as 1800 throughout No. America & were esp. popular in the North-west. TRADING POST PRICE (96) 9 mm-**$3.00 ea**
See Fenstermaker *Vol. VI- Northwest Coast. Bead Chart*, 1978.

*Nowadays, this term has been erroneously applied to every color of eye bead, esp. black w/white eyes. The origination of the term "skunk" bead seems to be Blackfeet & refers to a very early "large blue bead w/meandering lines & white & red flowers" as recalled by elderly informants to John Ewers in *Blackfeet Crafts* Haskell Inst. 1945:33.

FEATHER or COMBED BEADS
A lamp-wound bead w/white & blue stripes that are combed into a feathery design.
TRADING POST PRICES (96) 9 X 22mm RUBY RED **$6.00 ea** BLACK or GREEN **$10 ea** Less common.
van der Sleen, W.G.N., *A Handbook on Beads*, York, Penna. Liberty Cap Books (1973):42-47
Francis, pp. 64 & 69.

WHITE HEARTS & EYE BEADS

WHITE HEART, white lined or white center all refer to a style of bead with a white interior, also known as CORNALINE D'ALEPPO. A rose-red outer layer was made in imitation of the red agate carnelian (French word is cornaline); Aleppo is a city in Syria, well-known as a trade center, where carnelian was traded. The term CORNALINE D'ALEPPO is usually reserved for larger necklace beads. In North America they are sometimes called HUDSON'S BAY BEADS, or "under whites" by the Blackfeet, prior to the 19th Century.

The earliest examples are made by melting 2 layers of glass over a wire rod which produced a hole when cooled & slipped off. This method can be identified by the visible spiral lines which are produced when the the glass is wrapped around the wire. Most all of the early white center beads made for North America were made in this manner. Later, probably after 1890, most were made by the drawn glass method, in which long glass tubes were cut into bead size, heated, then tumbled in sand to round off the sharp edges. This method produced a more uniform bead in size & shape. Most modern white hearts are produced in this method; however, in the last few years wire-wound examples have been produced in India distinguished from earlier Venetian counterpart by a more blocky & less rounded shape. *See next photo example on p. 71.*

Beginning in 16th century or earlier, this style of bead was first made with a trans. dk. green center(looks black until seen thru light) & an opaque brick red outer layer. They appear to have been made using the drawn glass method and often are found at No. American archaeological sites along with the white "quartz" beads. Also, yellow center rose-red beads were found in large numbers after 1800 in the No. American Indian trade. There is no clear evi-

dence as to when they were 1st made, but most collectors believe they pre-date the white center versions.

Modern French reproduction Crow, pony & seed-beads are being made with white centers in several shades of red, (sometimes brick but not the old rose-red), pink, orange, green, yellow & bright blue.

See Picard, Vol. IV, *White Hearts, Feather & Eye Beads,* 1988.

Woodward, Arthur, *Indian Trade Goods*, Portland. Oregon Historical Society (1967):19-20.

Ewers, John, *Blackfeet Crafts*, p.32.

Left to Right: WHITE CENTER WIRE-WOUND BEADS Contemp.
This bead is now being made in India & is included because the style (& rose-red color) closely resembles those popular in the American Indian trade from 1800-1870. Rose-red 4 X 6 mm- 29" loop(apx. 170 beads) Est. 10-15
Rose-red 6 X 13 mm- $15/29" loop (apx. 113 beads) Est. 15-20 **SOLD $10(97)**
WIRE-WOUND ROSE W/WHITE CENTER c.1800
Very rare & just like the early ones traded to No. America. Strung on grass. Pay attention to these if you like authentic hard to find old beads. Aver. size 9 mm W & L. 28" loop. Est. 100-175
WIRE-WOUND OVAL ROSE W/ HEARTS
Another early bead style dating back to 1800. Aver. size. 8 X 12 mm L. 27" loop strung on grass. Est. 75-125 **SOLD $75(97)**
MOLDED TRANS. RED MELON BEADS c.1800
EXTREMELY RARE. A few still have the gold leaf paint in the depressions. Irregular sizes. Aver. size 10 mm W & L. 29" loop strung on grass. Est. 75-125
CORNALINE D'ALEPPO TRADE BEADS
Brick red w/large green glass centers. This is the earliest style dating back to the 1700s. Irregular sizes. Aver. size 12 mm W X 14 L. 32" loop. Est. 30-60 **SOLD $20(97)**

OVAL ROSE WHITE HEART BEADS This style was very popular in the early Indian trade & is often seen on medicine stones, pouches & necklaces. Wire-wound.
TRADING POST PRICE (96): Apx. 8 X 12 mm **$3.00 ea**

EARLY GREEN CENTER BRICK RED BEADS c. 17th to 18th Century.
Made from tubes of brick red glass w/clear green glass centers. The edges are rounded. These beads show up on early Eastern Indian sites and are often found mixed w/white "Quartz" beads (from the same period) at California & Coastal sites. 27" loop. Avg. 3 mm . Est. 40-80 **SOLD $45(95)**
See Woodward, p.19-20.

VENETIAN OVAL ROSE WHITE HEARTS c. 1800
Subtle variations in shades of dk. red. Avg. size is 8 X 13 mm L. 22" loop. Est. 95-175 **SOLD $125(94)**

Left to Right: FACETED YELLOW CENTER CORNALINE D'ALEPPO TRADE BEADS *RARE.* These are a most unusual bead. The faceting might have been done at the Venetian glass factory where they were made or in Africa by the natives. 55 graduated beads from 12 to 19 mm. 29" loop. Est. 250-400
ROUND YELLOW CENTER CORNALINE D'ALEPPO (also known as CHERRIES)
These are a beautiful deep red w/distinctive yellow center. 51 beads graduated in size from 13 to 20 mm. Est 200-400

BLACK EYE BEADS White glass droplets are melted to the surface of each bead to form dots or eyes.
Some will say that the term eye beads originated as an honor to the beautiful eyes of 18th century singer Kitty Fisher & still others say these beads were worn as protection from the feared evil eye. I doubt if most American Indians ever heard of either, but they certainly did like this bead. Indians used them on clothing, necklaces & attached them to medicine stones, pipes & bundles. Apx. 10 X 10 mm.
van der Sleen,p. 48. Woodward,p. 13-14
TRADING POST PRICES (96): Black w/red(over white)eyes **$4.50 ea** Black w/white eyes **$2.50 ea** Black w/red/blue (over white) eyes **$10 ea**
RED EYE BEADS (*Same history as black eye beads*)
These are wire-wound w/white center. The surface is covered w/white dots or eyes. 10 to 12mm
TRADING POST PRICES (96): RED **$4.00 ea**, 10 or more/**$3.50 ea** , ROSE **$6.00 ea,** 10 or more/**$5.00 ea** Mixed strings apx. 56 beads @**$95.00**

Left to Right: RED EYE BEADS
Some are a rose color. Avg. size- 10 mm. 23" loop. Est. 80-150 SOLD $75(96)
VENETIAN BLACK EYE BEADS
A few of the eyes are red & blue. One is blue w/white eyes. 5 odd beads. Avg. size- 10 mm. 22" loop. Est.65-110 SOLD $60(96)
VENETIAN BLACK EYE BEADS
All have white & red eyes. Avg. size- 12 mm. 23" loop. Est. 80-150 SOLD $60(96)
BLACK EYE BEADS W/CHECKER-BOARD STRIPING
White & light blue eyes w/white stripes. All in good cond. Avg. size- 9 mm. 21" loop. Est. 65-110 SOLD $60(96).
RARE EYEBEADS c.1800
Range from a milky white to clear in color. White eyes w/drops of red & blue. Slightly graduated.Average bead is 10 mm. 31" loop strung on buckskin. 89 beads. Est. 300-500
RARE TRANSLUSCENT WHITE BEADS W/RED EYES
52 beads. Avg. size-10 mm. 22" loop.Est. 85-150 SOLD $80(96)

Left to Right: CORNALINE D'ALEPPO TRADE BEADS
Brick red w/large green center. Graduated sizing. Largest bead is 20 x 13 mm. 26" loop on cotton string. Est. 30-75 SOLD $35(96)
OVAL ROSE WHITE HEART TRADE BEADS Venetian c1800. avg. size is 9 X 13 mm. Est. 80-150 SOLD $50(96)
10 MM RED WHITE HEARTS Contemp. Made in India. Est. 15-35 SOLD $20(96)
6 MM RED WHITE HEARTS 24" loop on cotton string. Est. 10-25 SOLD $15(96)
4 MM ROSE WHITE HEARTS Sizes are varied. 23" loop on cotton string. Est. 10-20 SOLD $15(96)
CORNALINE D'ALEPPO PONY BEADS w/small green center. Varying sizes; largest bead is 4 mm. 24" loop. Est. 10-25 SOLD $15(96)
WHITE PONY BEADS Avg. size is 4 x 2 mm. 23" loop. Est. 6-12 SOLD $10(96)
ROLLED BRASS BEADS Made in Nigeria. Avg. size 4 x 16 mm. 25" loop strung on cotton string. Est. 15-30 SOLD $15(96)
ROLLED COPPER BEADS Made in Nigeria. 23" loop. Est. 15-30 SOLD $15(96)
CORNALINE D' ALEPPO w/green center. Avg size-6 x 6 mm. 26" loop. Est. 20-50 SOLD $25(96)
CORNALINE D'ALEPPO & WHITE "QUARTZ" TRADE BEADS C.1700's. Each one different. Avg. size- 10 x 6 mm. 94 quartz-49 brick. 36" loop-on buckskin. Est. 65-125 SOLD $100(96)

Left to Right: RED & ROSE CORNALINE D'ALEPPO EYE BEADS c.1870
A.White glass droplets are melted to the surface of each bead forming dots or eyes. Colors range from bright red to dk. rose. Apx. 10 mm . 22" loop. Est. 60-95 SOLD $70(94)
B. Same Est. 60-95 each SOLD $60(94)
VENETIAN BLACK EYE BEADS C.1850
A. Mostly black w/eyes in white, red, pink, green & blue. Also white w/blue eyes & 1 white bead w/ blue & red stripes. 3 odd beads. Avg. size-10 mm. 25" loop. Est. 90-150 SOLD $85(94)
B. All black eye beads like above. 51 beads. 1 broken. 10 mm. 25 loop. Est. 75-125 SOLD $70(94)

Top to Bottom: RED EYE BEADS
Many are rose color. Aver. size 10 mm W & L. 27" loop strung on grass. Exc.cond. & patina. Est. 60-100 SOLD $60(97)
RARE MILKY WHITE BEADS c.1870
W/red eyes.Aver. size 12 mm W X 10 mm L. 27" loop strung on grass. Exc. cond. & patina. Est. 80-125 SOLD $80(97)
VENETIAN BLACK EYE BEADS
All w/white, blue & red eyes. *Rarest & most desirable kind.* Aver. size 10 mm W & L. 28" loop strung on grass. Exc. cond. & patina. Est. 65-110 SOLD $80(97)

ROSE CORNALINE D'ALEPPO EYE BEADS c. 1850s
Avg. 13 mm. Est. 75-150 **SOLD $85(95)**

OLD PONY (POUND) BEADS

In the old trading post invoices, these beads are listed as pound beads-the price based on weight. In recent times, they are called pony beads even though most of them were shipped up the Missouri River on steamboats! *See Woodward, pp.11-12.*

Left to Right: ROSE-RED W. HEART PONY BEADS.
These are made at the same Italian glass factories as those made for the Indian trade in the 1800's. Apx. 24" loops. Sizes vary from 2 to 5 mm. **TRADING POST (96)$15**
WHITE PONY BEADS on string. c.1860.
3 mm W & L. 25" loop. Est. 6-10 **SOLD $5(97)**
ROSE W. HEART PONY BEADS c.1860
3 mm W. 24" loop Est.10-20 **SOLD $5(97)**
WIRE-WOUND RED W. HEARTS
Collected in Burma. Exc. cond. w/ varying shades of tran. red & rose. Aver. 3 X 6 mm. 26" loop on heavy string. Est. 12-25
GREEN CENTER BRICK PONY BEADS
Earliest style of lined bead in No. America. Aver. size 3 mm L & W. Strung on grass. 25" loop. Est. 12-25 **SOLD $17(97)**

Left to Right: EARLY WHITE PONY BEADS
6 X 3 mm. 22" loop. Est. 6-15 each **SOLD $15 each (94)**
DEEP ROSE-RED WIRE-WOUND WHITE HEARTS c.1850
Collected in Burma. Each 1 is individually hand-made. Exc. color. Avg. 6 X 3 mm L. 24" loops.Est. 12-25 **SOLD $15 each (94)**

UNDECORATED SOLID COLOR BEADS

PROSSER BEADS Richard & Tom Prosser invented a machine to mold glass shoe buttons in England c.1840. This method was quickly adapted to making beads. Prossers are easily recognized by the middle raised ridge of glass & their uniformity. They became immediately popular in the Indian trade & show up extensively after 1850 on cradle boards, dresses, medicine stones, & necklaces to name a few.
TRADING POST PRICES (96) : BODMER BLUE(sky blue) 6 to 8mm/apx. 75-94 beads **$20.00**
5 X 6mm apx. 104 beads **$15.00** 3 X 4mm-Apx. 174 beads 24" loop. **$12.00**
PADRE BEADS The term "padre"bead has been applied to a turquoise blue wound bead that is said to have been given to Indians by Spanish missionaries in the Southwest.* Though the story can't be easily proven, the application of the name has certainly helped sell thousands of these beads. The truth is that beads of this color blue were popular with most all North American tribes. In the early 1800's, explorers Lewis & Clark presented variations of this bead to many of the tribes they visited. TRADING POST PRICES (96) 25-35¢ ea.
*Sorensonn,Cloyd "The Enduring Intrigue of the Glass Trade Bead," *Arizona Highways,* Phoenix. July, 1971:10-34.

Left to Right: ROBIN'S EGG BLUE PADRES c. 1820
8 mm. 20" loop. Est. 15-25 **SOLD $20(96)**
MILKY WHITE PADRES
8 mm. 22" loop. Est. 15-25 **SOLD $20(96)**
BLACK PADRE TRADE BEADS
80 beads. Avg. size- 9 mm. 20" loop. Est. 18-30 **SOLD $15(96)**
LARGE SKY BLUE & PINK PROSSER TRADE BEADS c.1840
49 blue/20 pink. Avg. size- 10 mm. 26" loop Est. 20-40 **SOLD $20(96)**
SMALL CHEYENNE PINK PROSSER TRADE BEADS
Avg. size-6mm . 23" loop. Est. 12-30 **SOLD $20(96)**
SMALL SKY BLUE PROSSER TRADE BEADS c.1840
100 beads. Avg. size-6mm. 23" loop.Est. 12-30 **SOLD $15(96)**
LARGE SKY BLUE PROSSER BEADS 8 mm. 22" loop. Est. 18-40 **SOLD $23(96)**

STRIPED PONY BEADS
These beads show up on some old Indian items. Mostly yellow, white or brick red background w/various colored stripes. Each string is different-basic color of blue, red or yellow. Apx. 4 X 6mm. TRADING POST PRICE (96) $10/Apx. 190 beads per string

Left to Right: **CHEYENNE PINK MOLDED PROSSER BEADS** c. 1860
8 mm diam. 28" loop. Est.25/60 **SOLD $30(92)**
GREASY YELLOW MOLDED PROSSER BEADS c.1860
Similar. 27" loop. Est.25/60 **SOLD $30(92)**
PADRE BLUE & PROSSER BLUE BEADS c.1840
Mixed string. Each bead is over 6mm diam. 23" loop. Est. 25/50 **SOLD $30(92)**
BODMER BLUE MOLDED PROSSER BEADS c.1860
Intense color. 6 X 8 mm each bead. 23" loop. Est. 20/50 **SOLD $25(92)**
SKY BLUE PADRE BEADS c.1840
Each bead over 6 mm diam. 23" string. Est. 20/50 **SOLD $25(92)**

Left to Right: **COBALT BLUE FACETED RUSSIANS** c. 1800
A. Various sizes & shapes ranging from 3mm W & L to 6mm W X 25 mm L. Varying shades of blue. 22" loop. Est. 30-50 **SOLD $45(94)**
B. Graduated sizes. Large bead is 6 mm. 24" loop. Est. 70-150 **SOLD $80(94)**
C. Same. Large bead is 9 X 6mm. Deep cobalt color. Strung on buckskin. Est. 150-250 **SOLD $200(94)**

FACETED RUSSIAN TRADE BEADS
Collectors & museums have for many years attributed this style of bead to early Russian traders. The truth is they were most likely made in Bohemia & traded by most early traders. They were made in many sizes & were already a popular trade bead by 1820 esp. on the N.W. Coast.
See: van der Sleen, p.12
Picard, *Russian Blues, Faceted & Fancy Beads*,1989.

These are cobalt blue with sharp facets.
TRADING POST PRICES (96): Small 4 to 6 mm **$4.00 ea** Medium 7 to 10mm **$6.00 ea** Large 11 to 16 mm **$10.00 ea**

COBALT DONUT BEADS- 19th Century. Popular wound ring (annular) bead used for earrings & spacers. Quite variable in size & shape. (Less commonly found in amber, clear & green.) Not made after 1900. (Francis, p. 72.)
TRADING POST PRICE (96): 3 X 12mm **60¢ each $75.00/string** (apx. 132 beads)

Left to Right: **BODMER BLUE DUTCH & COBALT BLUE DONUTS** c.1830
24 Dutch beads separated by rings ("donuts") 3 X 12 mm. Strung on cloth. 24" loop. Est. 85-175
COBALT BLUE FACETED RUSSIANS- GRADUATED c.1830
Lt. blue to intense deep blue. Largest bead 10mm L. 22" loop. Est. 75-150 **SOLD $85(94)**

GOOSEBERRY BEADS
Found on Indian sites as early as the 17th century. (Excavated at a Great Lakes fort site occupied 1700-1781.*) This popular bead was made from drawn clear glass w/white stripes.
*See: *Beads:Their Use by Upper Great Lakes Indians*, p.51.
TRADING POST PRICE (96: 3 to 5mm-24" loop **$35.00**

Est. 60-75 **SOLD $50(96)**
SAME. Opaque blue. Avg. size- 10 x 6 mm L. 24" loop. Est. 45-95 **SOLD $45(96)**
COBALT BLUE RUSSIAN & STRIPED CLEAR GOOSEBERRY BEADS
Alternating beads consist of 38 Russian & 28 gooseberry beads. Russian size- 10 x 6mm. Gooseberry size-6 x 19 mm. 26" loop strung on buckskin. Est. 90-150 **SOLD $80(96)**
LIGHT PINK TRANS. GOOSEBERRY BEADS
Irregular sizes. Avg. size-6 x 3 mm. 24" loop. Est. 20-40 **SOLD $20(96)**
OLD DUTCH BEADS c. 1700s.
No two colors, shapes or sizes are alike. Heavy in weight. Nicks on some. Range from clear to white in color. Lots of patina. Graduated sizing. Largest bead is 19 X 19 mm.. 27" loop. Est. 75-150 **SOLD $125(96)**
BULBOUS STRIPED BEADS
Described under striped beads, See p. 68, Est. 100-175 **SOLD $80(96)**

Left to Right: COBALT BLUE TRANSP. "DONUT" BEADS 13 mm diam. 22" loop. Est. 60-95 **SOLD $70(96)**
COBALT BLUE FACETED RUSSIANS c. 1800. Varying shades of blue. Graduated sizing. Ranges from 6 to 10 mm. Est. 135-175 **SOLD $160(96)**
SAME. Elongated & in good cond. 4 x 25 mm L. 23" loop. Est. 75-150
SAME. Varying shades & sizes range from 6 x 6mm to 6 x 19 mm. 2 clear beads. 22" loop.

OLD GREASY BLUE DUTCH TRADE BEADS c.1700
Great string of beads w/many color shades & sizes. Most all of these are in perfect cond.(no chips, cracks, etc.-very hard to find).Largest is 20 mm W X 17 mm L.31" loop strung on grass. Est. 100-195 **SOLD $100(97)**
OLD COBALT BLUE DUTCH TRADE BEADS c.1700
Excellent colors & patina. Varied sizes;largest is 19 mm W X 14 mm L. 31" loop strung on grass. Heavy weight. Est. 95-175 **SOLD $85(97)**

HEXAGONAL WHITE BEAD W/PRESSED FACETS c.1700
Very old & interesting bead apx. 11 mm diam. 23" loop. Est. 50/95 **SOLD $40(92)**

North American Trade

ORIGINAL STRINGS/BOXES FROM COUNTRY OF ORIGIN

WIRE-WOUND CROW BEADS
Made in Germany. These are from the well-known Plume Indian Trading Co. stock found in their NYC warehouse when they went out of business. Most likely these are from the 1920's but they are identical to those made for the Indian trade in the 1800's-on the original twisted paper strings. TRADING POST PRICE (96): 7 X 10mm-100 beads/string **$10** Lt. blue, lime green, & periwinkle

75

PEKING BEADS ON 3 ORIGINAL BAMBOO SKEWERS c.1890
These beads were fitted onto bamboo skewers & packed in special boxes to prevent damage in transit. Almost impossible to find on original skewers. Subtle colors of clear, trans. rose & Cheyenne pink. 16 mm diam. 9.5"L stick. Est.75-150 **SOLD $100(93)**

B. INDIAN OWNED/DUG AT SITES

Crow Rock Medicines often contain fossils that have appeared to their owners in dreams. The rocks were usually encased in buckskin covers, w/a small part of the rock left exposed. The buckskin fringes which were attached to the cover were often strung with beads and shells. The beads were added to enhance it's power or as fees from persons it has helped. They were often used to obtain good luck, good health or other good powers.

For more info. see Wildschut, Wm. *Crow Indian Medicine Bundles,* New York, Heye Fdn. 1975.

Left to Right: **VENETIAN BLUE TUBE BEADS ON ORIGINAL FACTORY STRINGS** c.1900
Trans. med. blue. Apx. 6 mm diam-8 strings apx. 15 beads each. Est.45-95 **SOLD $50(93)**
Milky white. Apx. 35 mm L X 6 mm diam.. 21 strings apx. 8/string. Est.90-150

ANTIQUE BASKET BEADS c.1870
4 boxes in tiny original print tapestry labelled *"Columbian package 5 ct-made in Austria."* A), B), and C) are milky white, D) is black. Mint cond. Est.20/30 each **SOLD $25 each (92)**

COLUMBIA RIVER TRADE BEADS Early 19th Century.
Tokeland Hotel, Wm. Kindred Collection, Wash Pristine string of large yellow center rose cylinders & ovals (glossy finish) Apx. 10 mm. diam. X 18-25 mm L. alternated w/large Peking t. cobalt ovals & several round rose w. heart beads (10 mm) & spaced with clam shell disc beads (2-5 mm thick X 10 mm. diam.). 36" loop. Est. 350-600

These 3 old rock medicines show the types of glass beads which were often added to enhance their power. Sky blue beads seem to predominate w/various fancy beads adding special power. The first example contains 2 brass hawk bells and several blue eye beads with red over white and blue over white dots. On the 2nd one, the buckskin cover is decorated with sewn "pony beads". Numerous white "Crow beads" and black eye beads are visible. The third example has an abundance of fancy and white center rose beads. Notice the long white dentalium shells and the beautiful red eye beads. Just above the large yellow bead, near the top center, you can see the exposed portion of this rock medicine.

WHITE SHELL WAMPUM NECKLACE
c.1860
In old photos of Plateau Indian women almost everyone will be wearing one or more of this style of necklace. This is a beautiful uniform & polished piece collected in the N.W. Today these are scarce & valuable & still handed down as heirlooms in many Plateau families. 39" loop. Apx. 6 mm diam. Est. 220-350 **SOLD $325(97)**

COLUMBIA RIVER TRADE BEADS *Early 19th Century.* The large white fancy floral oval* (17 diam X 25mm) & 2 spiral striped round (15 X 15mm) are extremely rare. The 9 large rose ovals (18 mm L) are the early Cornaline d'Aleppo style w/yellow centers. Several of the large oval cobalts show effects of partial melting from placement in a burial cremation. Est. 400-600
See large string of same type of beads (including rare fancies) on display in the Favel Museum, Klamath Falls, ORE.
*Lui, 1995:167. Photo of identical large oval fancy excavated 40 years ago; possible Nez Perce origins.

Top to Bottom: NEZ PERCE BEAD NECKLACES c.1900-1930
2 strands of Czech. 4mm facets: t. turquoise, t. dk. cranberry & round brass. Hangs 18"L. Est. 125-195 **SOLD $125(96)**
5 mm milky white tile, lt. blue, yellow, pink, black, & red prosser beads;olivella shells 2 cowrie dangles (holes filed in the old way-not drilled). Hangs 28"L. Est. 63-150 **SOLD $63(96)**
5 mm faceted bead gr. yellow, w.lined rose & rare brass wire-wound tube beads. Strung on cord string. Hangs 18"L. Est. 63-150 **SOLD $63(96)**
1" barrel-shaped bone hairpipes; 6mm pink prossers & lt. blue facets on cord string. Est. 25-95 **SOLD $40(96)**
5 mm lt. blue opaque prosser beads on cord string. Hangs 24.5" L. Est. 25-65

32 smooth (old-time) (32 mm) dentalium shells w/Bodmer blue 5mm tile beads & 6mm black facets on heavy thread. Hangs 25.5"L. Est. 125-250 **SOLD $125(96)**
88 smooth dentalium shells (25-32 mm L) w/lt. blue tile glass spacers. Strung on string. Hangs 27"L. Est. 156-250 **SOLD $175(96)**
SIMILAR. 78 smooth 1" L(25 mm) dentalium shells. Hangs 23"L. Est. 156-250 **SOLD $150(96)**

78

Left to Right: BLUE RUSSIAN FACETS
These are the rare Russians with milky-white center, which makes them a slightly lighter color than the dark blue cobalts. These were found many years ago in No. Calif. They have the sharp facets & shiny patina associated with the No. American trade. (African ones are usually dull & worn by comparison). 107 beads-8 mm avg. size. 30" loop. Est. 300-400 **SOLD $325(87)**
SAME. 109 bead string. Est. 300-400

Left to Right: KLAMATH OLIVELLA SHELL BEADS
Gienger collection. Found around Klamath Lake, Ore. in the 1940's. 26" loop. Exc. cond. Est. 20-35 **SOLD $30(95)**
OLD WHITE & WHITE-LINED ROSE WAMPUM BEADS
Very rare. These were made of glass to look like shell wampum; probably of Italian manufacture. Made especially for the North-West trade. 23" loop. Est. 175-250 **SOLD $200(95)**
SIMILAR. *Rare.* White glass wampum beads. 19" loop. Est. 90-150 **SOLD $70(95)**

QUARTZ BEAD An early opaque glass white bead, usually unevenly shaped as a result of the manufacturing process. Extensively found in Northwest & California sites. See photo examples following.
See Woodward, p. 36

COLUMBIA RIVER TRADE BEADS
c.1820 or earlier
Small jarful found in Wash. State contains mostly white "quartz" beads & green center Cornaline d'Alleppo beads. Some appear to have been cremated. Est. 20/50
SOLD $45(92)

DEEP COBALT RUSSIAN FACETS
Collected in No. Calif. & worn by Shasta Indians. Highly desirable dark color & condition-sharp facets & shiny patina characteristic of No. American trade. 6mm to 12 mm. Est 5-15 each bead.

ROLLED COPPER BEADS
c.1800
Found on Wapner Is. in the Columbia River above the Dalles, Ore. Est 50-100
SOLD $50(93)
See Woodward, p.16.

COLUMBIA RIVER TRADE BEADS c.1800 (or earlier)
from the G. Gilbert Collection, Tri-cities, Wash. Pony & seed beads of various colors. One large yellow center rose bead. Old iron button (w/no marking). Est. 50-100 **SOLD $50(95)**

TRADE BEADS FROM POINT BARROW, ALASKA
Collected by A. Eddes in 1955. 22" string w/6 dentallium shells, 3 blue Russian facets, mostly lt. blue pony beads, 3 olivella shells & 1 oval Bodmer blue. Est. 90-150 **SOLD $95(95)**

Left to Right: "QUARTZ" GLASS TRADE BEADS c.1800
Apx. 6mm diam 24" loop. Est.50/100 **SOLD $35(91)**
"QUARTZ" GLASS & GREEN-CENTER BRICK CORNALINE D'ALEPPOS c.1800
From San Migeul Is., Calif. Over 100 beads from 6 mm diam & larger. 33" loop. Est.85/125 **SOLD $95(91)**
ASSINIBOINE TRADE BEAD NECKLACE c.1800
Found on the Ft. Belknap Res. nr. Dodson, Mont. c. 1940. Complete documentation w/beads. Wire-wound blues, white center reds, faceted & round;black, a milky-white tube & 1 blue eye bead. 21" loop on a buckskin thong. Est.100/200 **SOLD $85(91)**
COLUMBIA RIVER TRADE BEADS c.1800-1820
Found nr. Vantage, Wash. along the Columbia River. Powder blue & quartz pony-size beads. 24" loop. Est.50/100 **SOLD $45(91)**
SAME but more blue beads & 25" loop. Est.75/125 **SOLD $60(91)**

The following mixed size beads were collected along the Missouri R. nr. Chamberlain, So. Dak., in the 1950s:
Left to Right: Seed beads (mixed sizes). Bodmer blue. 22" loop. Est. 60-95 **SOLD $46(95)**
Bodmer blue, white, w. lined rose, gr. yellow pony beads. 24" loop. Est. 65-125 **SOLD $50(96)**
White, Bodmer blue, black, w. lined rose, gr. yellow pony beads. 27" loop. Est. 65-125
SIMILAR. 27" loop of pony beads. Est. 65-125

EARLY WHITE QUARTZ & RED WHITE HEART TRADE BEADS c.1800
Found on the Columbia River at Vantage, Wash. Irregular. Alternating pattern of red w. heart & white quartz. 20" loop. Est. 40-100 **SOLD $85(94)**

"UTAH ROCKSHELTER" COLLECTION *Pre-historic.*
Olivella necklace w/other shell, stone & bone beads. Includes 25 mm steatite bead & several bone tube beads. 5" X 6" Riker mount. Est.100/175 **SOLD $150(92)**

80

IV. FRONTIER GOODS

Garments

COWHIDE COWBOY CHAPS C.1915. 12 silver(?)conchos & many German silver spots. "*#700 Hamley & Co., Pendleton, OR*" stamped into belt. Shows lots of use; exc. cond. 36" L. Est. 250-450 **SOLD** $550(95)

BUCKSKIN COWGIRL MATCHING SKIRT & JACKET c. 1910 Lightly smoked Indian tanned hide w/lots of fringe & brass "*GAR*" buttons on jacket. Skirt has 2 pockets on front;1 on back. Adjustable lacings on back waist of skirt. Machine stitched w/an early treadle-machine. Petite size. Est. 900-1500 **SOLD** $1000(95)

BROWN HORSEHAIR COWBOY COAT w/3 wooden toggle buttons. Original tag reads "*Ellsworth Hayer, maker of the Great Western Fur Coat, Milwaukee*". Hide in good cond. w/small tear on back. Lining needs repair-missing 3 buttons. Wearable. Large size:49"L,21" sleeves,44" chest. Est. 125-350 **SOLD** $150(95)

U.S. CAVALRY BUFFALO COAT c. 1880
Purchased from the son of Johnny Jones, a Montana homesteader, who bought it at nearby Fort Buford, across the line in No. Dak. It was worn by cavalry soldiers there during the 1880s. A true frontier relic in exc. wearable shape. Chest 40" X 49"L. Est. 800-1500 **SOLD $900(94)**

BUFFALO COAT c.1890
Used by stagecoach drivers, cowboys, Indians & Cavalry. Mint cond. Extra large size. Est. 1000-2000 **SOLD $1000(93)**

FUR STAGECOACH COAT c. 1870. Angora dyed to look like buffalo. Many people mistake this type to be buffalo which is what the manufacturer intended. Has 10 black wood toggle buttons w/beaver fur trim on collar, cuffs, & pocket tops. Black quilted lining. Exc. cond. No visible tears. Large size 44-46. Est. 300-500

BLACK HORSEHAIR COAT c.1890
Shawl collar. Quilted black lining in good shape. Tear in underarm seam. Dk. wooden toggle buttons. 50"L. 50" chest. Est. 300-375 **SOLD $300(93)**

WOLF(?) HIDE COWBOY COAT c. 1890
10 large wooden toggle buttons. Dk. beaver fur collar & wrist cuffs. Black cloth lining has had some repairs. Exc. wearable cond. Large size. 47"L. 25" sleeves. 47" chest. Est. 220-450 **SOLD $300(96)**

BUFFALO HIDE MITTENS c. 1870s.
Large pair of the type worn by stagecoach drivers, Cavalry & cowboys. Brown corduroy lining. Exc. cond. 15"L. Est. 150-300 **SOLD $275(95)**

HORSEHIDE COWBOY MITTENS c. 1900
Lined w/cloth. Exc. cond. Large size. 10" X15." Est. 75-150 **SOLD $75(95)**

Left to Right: **TANNED BEAVER HIDE**
from Montana. Shiny dk. brown hair & soft hide. 33"L. 28"W. Est. 75-150
SOLD $90(96)
BLACK BEAR HIDE STAGE COACH DRIVERS GLOVES c.1880
Completely covered w/black hair-even the fingers. Corduroy lined. Large size w/ wide cuffs to cover sleeves of old style fur coat. Exc. cond. 16"L. Est. 150-250
SOLD $200(96)

SKUNK FUR & SMOKED MOOSEHIDE MITTENS
Contemp.
Good construction-welted brain tan. Exc. cond. 16"L
overall. Est.125-195 **SOLD $105(93)**

ANGORA STAGECOACH GLOVES c.1880
Rust-dyed to look like buffalo fur. Cuffs lined w/black quilted cotton. 12"L X 8" W.
Est.75/125 **SOLD $45(90)**

SHORN BEAVER CAP W/FLAPS c.1880
Possibly used by the U.S. Cavalry. Fully-lined. Exc. cond. 9" diam. Est. 350-600 **SOLD $475(92)**

Buffalo Robes & Skulls

BUFFALO ROBE
Beautiful, soft & pliable-possibly brain tanned. Winter robe. Long, dark hair. Exc. clean cond. 8'L X 6'5"W. at rear legs. Est. 625-950 **SOLD $700(95)**

BUFFALO SLEIGH ROBE
The hair has been dyed a reddish brown, which was not uncommon. In fact, the printed cloth tag (original) says "Warranty-*the skins from which this robe is made are the very best obtainable and are not damaged by coloring and we guarantee this robe will give better service and wear longer than any other robe on the market. Leak Fur Mfg. Co.*". Mounted on heavy brown blanketing w/green sawtoothed felt trim. Exc. cond., except for some minor bug damage along one side. 55" x 65" Est. 95-150 **SOLD $300(96)**

COW BUFFALO SKULL W/SLIGHTLY DEFORMED HORNS
The horns on this skull make it very unusual, maybe even a medicine skull in the old days. Expertly cleaned. Skull is 19" L. X 19" W. horn to horn tip. Exc. shape. Est.500-600 **SOLD $100(93)**

BUFFALO SKULL W/ HORNS c. 1997.
Bone is nice & white (well cleaned). Horns are 22" from tip to tip & length is 21.5" Est. 650-900 **SOLD $650(98)**
Center: Horns are 19.5" from tip to tip. Length is 23" Est. 700 - 1000 **SOLD $650(98)**
Far right: 24.5" horn tip to tip. 21"L. Est 800-1000 **SOLD $800(97)**

PETRIFIED BUFFALO SKULL
w/tag; "*Buffalo skull from Yellowstone River, found 3/4 mile down from Shadwell Creek near Crane, Mont.*" For many years it was displayed as part of Wood's 2nd Hand Store Museum in Missoula, Mont. Hard & heavy as rock. Horns 25" tip to tip. 23"L w/bulging eye sockets. Very rare to find one in such exc. cond. Est. 650-1500 **SOLD $850(97)**

Left to Right: **PRE-HISTORIC BUFFALO SKULL** *Rare*. It feels like stone and may be so old that it is petrified. *Found in eastern Montana.* 26" from horn tip to horn tip. Good patina and white color. Est. 125-400 **SOLD $150(96)**
SAME 23" from horn tip to horn tip. Est. 125-400 **SOLD $275(96)**

85

BULL BUFFALO SKULL W/BLACK HORNS
Cleaned & ready to hang. Perfect cond. 19"L-21"W horn tip to tip. Est. 600-800 **SOLD $200(93)**

Cowboy Horsegear, etc.

ICE (BUFFALO) SCALE
These have showed up in auctions, books, gun shows, etc. erroneously labeled "buffalo scale" & said to have been used by buffalo hunters to weigh hides & tongues. Actually, this is a turn-of-the-century ice scale. Light rust but exc. cond. Est. 75-150 **SOLD $80(95)**

WOMAN'S SIDE SADDLE c.1900
Beautifully tooled cowhide w/seat stitched in floral pattern. Matching tooled leather side pocket & 1 stirrup. Sheepskin padding. Ready to use. No apparent maker's name. Perfect cond. Apx. 30"L-seat is 13"W. 15"L. Est. 500-700 **SOLD $500(93)**

Left to Right: **HAND-FORGED IRON GRAPPLING HOOK** c.1860
Heavy rust & pitted patina. Oiled. Still very strong. 10.5" L. Est. 30-80 **SOLD $35(94)**
FORGED IRON PUSH DAGGER c.1860
Possibly fur trade era. Iron gun barrel handle. Some rust for patina. Homemade relic. 8.5"L X 2" W blade. Est. 80-150 **SOLD $90(94)**

WOODEN PACK SADDLE c.1930-1950
Possibly of Mexican origin. Completely hand-made & carved in a style that could also be used for riding. Dk. patina. Still usable. 12.5" seat X 18" overall L. Est. 75-200 **SOLD $85(95)**

SOUTH-WEST WOODEN STIRRUPS
RARE. Shows early use, probably pre-1850. This is the style used by the early Spaniards & Mtn. Men in the early 1800's. Exc. patina. Very hard wood. Hard to put a value on them as so rarely seen for sale. Perfect shape. 7.25" X 5.5." Est. 250-500 **SOLD $400(95)**

BRAIDED COWHIDE BULLWACKERS WHIP c. 1900 or earlier. Hide covered iron handle w/leather wrist loop. Good patina. Exc. cond. 12'L. Est. 150-300 **SOLD $150(95)**

SOUTH-WEST WOODEN STIRRUPS c.1850
Similar to preceding. Shows use, probably pre-1850. Beautifully carved w/bird head designs. Geometric & floral designs carved into most flat surfaces. Very hard wood. Exc. patina. Perfect cond. 6 x 5.75." 3.75" bottom W. Est. 250-500 **SOLD $275(96)**

SPANISH RING BIT c.1870
Highly decorated bit w/hand-made chain, silver buttons & copper mouth rings. The iron has interesting stamped designs & shapes. Very little rust. Ring & bit 10"L. Chains 16.5"L. Est.150-250 **SOLD $175(94)**

NAVAJO BLACK HORSEHAIR ROPE
w/Pawn Shop tag from Gallup, NM. C.1960's Exc. usable shape. 18' L. Est. 115-150 **SOLD $125(95)**
PAIR OF IRON MEXICAN SPURS c.1880?
Silver inlaid w/rocker etched rowels. Hand-made. Exc. shape. Small size 5" X 3." Est. 175-350 **SOLD $190(95)**

HITCHED HORSEHAIR QUIRT c.1870-80
Unfaded colors: orange, black, red & yellow intricate geometric designs. 2.5" natural horsehair fringe. 23"L quirt & braided horse hair handle + 17"L double latigo whip. Good cond. Est. 300-500 **SOLD $400(95)**

BRAIDED HORSEHAIR BRIDLE W/ BIT & REINS c.1890-1900
An unusual bridle style using colors, horsehair wrapping, large hitched conchos & Turk's heads that are characteristic of those made at the Arizona Territorial prison at Yuma prior to 1910.* Colors: black, red, dk. orange & natural white; colors are still strong & unfaded. The California-style bit has complete silver overlay w/ stamped & rocker etched flower & leaf designs. 3 small areas of damage. Head stall is 31"L. Reins are 42"L. Est. 1200-2500 **SOLD $1600(94)**
*See Friedman, Michael *Cowboy Culture,* West Chester, Schiffer 1992:121.

HORSE HAIR HACKAMORE c.1915
Collected from late Cecile Vanderburg on the Flathead Res., Mont. Natural white & black in the old style. Black & tan leather. Apx. 18"H X 16"W. Est. 300-500 **SOLD $300(91)**

Top to Bottom: **HITCHED HORSEHAIR HAT BANDS** Contemp.
Made in the prison at Deer Lodge, Mont. Natural white background w/ yellow diamonds outlined in black. Very fine weave. 1/2" W X 22 to 26." Est. 60-110 **SOLD $60(93)**
Natural white & brown, purple & pink diamonds. 22 to 25." Est. 75-100 **SOLD $80(93)**

HITCHED HORSEHAIR BRIDLE W/BIT & REINS c.1880
Typical colors & style of bridles made at Montana Territorial Prison at Deer Lodge. Bright unfaded colors. Exc. cond. Est. 5000-8000(96) **SOLD $1800(88)**

OLD COWBOY BIT
Iron w/small 3/4" rocker etched silver hearts on each side. Original leather harness still attached (Indian-style). Light rust. Silver exc. shape 5"W X 6"H. Est. 20-100 **SOLD $150(94)**

CAST BRASS CONQUISTADORE STIRRUP c.17th century
This is the same style stirrup that was used by the Spanish Conquistadores when marching thru Mexico in the 15th century. 11"L X 4.5"H X 4.75"W. Est.150-200 **SOLD $125(91)**

Snowshoes

ATHABASCAN MINIATURE SNOWSHOES c.1890
Varnished long ago which has kept them in exc. cond., but makes it hard to tell whether they are laced w/sinew or thread. Some wool tufts & tip decoration. 13" L. Est. 100-250 **SOLD $100(95)**

ATHAPASCAN SMALL-SCALE SNOWSHOES W/ RAWHIDE LACING c.1890
Expertly made. Exc. patina & cond. 20"L X 4.5"W. Est. 100-300 **SOLD $140(94)**

ATHABASCAN SNOWSHOES c.1880
Fine, tight lacing. Exc. patina. Perfect cond. 43"L. Est. 250-375 **SOLD $325(96)**

ALGONQUIN BEAR PAW SNOWSHOES c.1910
Good old patina & unusual shape. Exc. & usable cond. Large size. 16" x 33.5" L. Est. 175-300 **SOLD $250(96)**

CREE MINIATURE SNOWSHOES c.1890-1920
Made from wood w/ yellow string lacings. Red yarn tufts. 10"L X 3.5"W. Est. 60-125 **SOLD $50(94)**

MINIATURE SNOWSHOES c.1900
Center section is all rawhide lacing. The ends are dark patina linen(?) thread. Exc. cond. Apx. 13"L. Est. 95-165 **SOLD $95(96)**

OJIBWAY SNOWSHOES c.1910
Unusual style: painted w/red Indian powder paint (some has worn off w/use). Rawhide laced. Complete w/foot lashings. Exc. shape. 47.25"L. Est. 200-400 **SOLD** $205(95)

CANADIAN CHIPPEWAY INDIAN RAWHIDE-LACED SNOWSHOES c.1880-1910
Characteristic red wool yarn tuft ornamentation. No tears in lacing. Still has foot ties attached. Wearable. 11.5" X 37" L. Est. 200-350 **SOLD** $250(90)

BEAR PAW-STYLE RAWHIDE LACED SHOWSHOES c.1890
Hand-made in Montana. The frame is natural tree branch. Includes original set of foot ties. Exc. cond. & patina. 15" X 29" L. Est. 200-400 **SOLD** $400(93)

ATHABASCAN SNOWSHOES FROM NO. CANADA c.1870
This type of snow shoe is unique to the No. Athabascan tribes. The lacing is very fine & delicate-looking. It is pierced thru the wooden frame so that no rawhide shows on the outside frame, thus preventing the lacing from being worn thru. Exc. cond. 10" X 53" L. Est. 250-350 **SOLD** $425(91)

ATHAPASKAN SNOW SHOES c. 1880.
From No. Canada. Wood has small designs carved into side (4" L.). Very fine lacing and beautiful patina. This is a super pair-in exc. cond. 10" W. X 46"L. Est. 500-650 **SOLD** $500(98)

HAND-MADE CREE SHOWSHOES c.1900
Red & green wool tufts on outside edge. Original old varnished patina w/fine rawhide lacing in exc. usable cond. Unusual square shaped toe. 38.5"L Est. 180-300 **SOLD** $205(97)

V. MILITARY GOODS OF THE INDIAN WARS PERIOD

Suggested Reading:
Emerson, Wm. K., *Encyclopedia of United States Army Insignia & Uniforms*, Norman, U. of Okla. 1996.
Reedstrom, E. Lisle, *Apache Wars, An Illustrated History*, New York: Barnes & Noble, 1995.
Reedstrom, E. Lisle, *Bugles, Banners and War Bonnets,* New York: Bonanza Books, 1986.

McCLELLAN SADDLE Model 1904
Brown leather covered cavalry saddle w/brass fixtures. One cinch strap still attached. Brass *"12 inch seat"* tag still attached. Clean, undamaged & usable cond. 20"L X 13"W X 10" H. Est. 175-350 **SOLD $200(94)**

McCLELLAN CAVALRY SADDLE Model 1904
Complete rigging & stirrups marked *"B.N. Co. U.S."* Model 1912 stirrups. Brown cowhide. Exc.usable cond. 11.5" seat plate. Est. 375-450 **SOLD $400(93)**

Left to Right: **CLASSIC M1874 US CAVALRY SHOEMAKER CAVALRY BIT**
VERY RARE. US medallions on side. 75% original nickel finish. Est. 280-350 **SOLD $280(95)**
1863 TINNED PLATED HORSE BIT
Large brass medallions on sides. Fine cond. Est. 185-250 **SOLD $185(95)**

MODEL 1863 CAVALRY BIT
w/brass "U.S." stamped medallions. *Collected from Nez Perce Indians on Res. in Idaho.* Est. 200-400 **SOLD $360(98)**

Top Left: INDIAN WARS *"FRAZIER'S PATENT"* CARTRIDGE BOX stamped on the leather along w/ *"patent april 23rd 1878"* & *"McKenney & Co., New York"*. Wood insert for 18 cartridges, brass hinges, brass ornamental plate w/ embossed *"NG"*. 2 belt loops. Good cond. 7.5" X 4." Est.150-250 **SOLD $150(95)**

Bottom Left: MCKEEVER CARTRIDGE BOX w/*"US"* stamp on front & *"Watervillet Arsenal"* on back. U.S. Cavalry. Canvas loops inside for 20 cartridges. 2 belt loops. For .45-70 rifle & carbine trapdoor Springfield ammunition. Exc. cond. 4" X 7." Est. 150-250 **SOLD $300(95)**

Center: LEATHER HORSESHOE POUCH as carried by mounted troops. Est. 50-85 **SOLD $135(95)**

Far Right: MCKEEVER CARTRIDGE BOX Same as bottom left. *"Rock Island Arsenal"* stamped. Good cond. 4" X 7." Est. 70-125 **SOLD $68(95)**

US MODEL 1885 INDIAN WAR HAVERSACK Classic Infantry item of the Plains Wars. Canvas w/original leather shoulder strap. VG cond. Est. 94 -150

MCKEEVER CARTRIDGE BOX c.1890 Brown leather w/large *"US"* surrounded by an oval stamped on front. First introduced in 1874 & used for many years. Inside cartridge loops are of cotton webbing in 20 round capacities. 2 belt loops riveted & sewn to back. Closed at top by an escutcheoned billet & brass finial. Exc. cond. Est. 50-150 **SOLD $200(94)**

Left to Right:1873.45-70 SPRINGFIELD RICE PATENT TROWEL BAYONET *VERY SCARCE*. Affixes to rifle. Used at Big Hole Battlefield by Gibbon's troops when they fought Chief Joseph of the Nez Perce tribe. VG original cond. Est. 345-500

US ARMY MODEL 1873 HAGNER ENTRENCHING TOOL w/original leather sheath. SCARCE. Marked *"US"* on handle & scabbard. Used by troops for entrenching against Indians. Est. 345-500

CIVIL WAR UNION INFANTRY KNAPSACK W/LEATHER SHOULDER STRAPS *RARE*. Classic Federal issue, & used by US Infantry into the Indian Wars until the late 1870's. Tarred linen. VG original cond. Est. 180-300 **SOLD $175(95)**

93

US ARMY WATER CUP W/"US" EMBOSSED IN CUP c.1890s. Blue enameled. Exc. shape. Est. 75-100 **SOLD $75(95)**

Top to Bottom: US ARMY BRASS BUGLE c. 1870-1880s. w/floating reinforced bell. No markings. Classic piece for the Fronter Cavalry display. Est. 300-375 **SOLD $225(95)**
US REGULATION BRASS BUGLE Marked. Complete w/set of replacement yellow cords. 18"L. Est. 75-125 **SOLD $225(95)**

Right to Left: *"US ARMY"* STAMPED TINNED DRINKING CUP Three 1" breaks in rim. Est. 25-65 **SOLD $30(96)**
SAME AS ABOVE Bottom has two dents. **SOLD $35(96)**

Left to Right: US ARMY INDIAN WAR CIRCULAR CANTEEN w/ tan canvas cover. *"US"* stenciling on cover. Complete w/original chained stopper. Some age spotting on cover. Est. 90-150 **SOLD $100(95)**
US ARMY INDIAN WAR CIRCULAR CANTEEN w/"US" stencilled cover. Very showy. Fine cond. Est. 110-160 **SOLD $110(95)**
CIVIL WAR TINNED US ARMY CANTEEN as used in the 1860's-1870's by soldiers. Fine cond. Est. 84-125 **SOLD $85(95)**

Right to left: M1873 SPRINGFIELD .45-70 TRIANGULAR BAYONET W/ SCABBARD
"US" medallion & large brass hook. (scabbard pictured separately) . VG cond. Est. 80-110 **SOLD $80(95)**
US CAVALRY SHORT BRASS THROAT CARBINE BOOT c.1885. *RARE*. Black bridle leather. Used to carry the Springfield .45-70 carbine on the saddle. VG cond. Est. 156-200 **SOLD $150(95)**

Top to Bottom: CARVED POWDER HORN c. 1840-1870. For use w/Plains rifle, musket or trade gun. Cowhorn w/initials *"L.B."* carved on surface. Exc. patina. 10.5" L.Est. 77-150 **SOLD $85(95)**
US MODEL 1842 "H. ASTON"S .45 CALIBER PERCUSSION SINGLE SHOT PISTOL w/ *"Middtn CONN.1851"* on lock plate. *RARE*. Brass mountings. Widely issued & carried by US Dragoons & saw much use during the Fur Trade of the 1850's. Choice example in complete exc. original cond. 14.5" L. Est. 600-1000 **SOLD $600(95)**

94

Right to Left, Top to Bottom: **LOT OF SIX 45-70 BULLETS AND SIX 45-70 FRANKFORD ARSENAL CASES** *Found at Fort Custer, Montana Territory.* Used w/.45-70 rifles and carbines in the Indian Wars. Lot Est. 15-60 **SOLD $35(96)**
RUSSET LEATHER SMALL US EMBOSSED REVOLVER CARTRIDGE BOX c.1900.
"Rock Island Arsenal, 1908" is stamped in leather. Fine cond. Est. 50-95 **SOLD $54(96)**
TINNED WOODEN MATCH STICK HOLDER as carried by soldiers in their packs. Est. 15-50 **SOLD $16(96)**
BOX OF REMINGTON/UMC .45-70 AMMO in green labeled box. Est. 45-125 **SOLD $50(96)**

Top to Bottom: **M1876 WINCHESTER OCTAGONAL BARREL RIFLE**
Burned frontier relic. Just as found-never cleaned. Classic relic of the West. Est. 100-150 **SOLD $130(95)**
UNIDENTIFIED IRON GUARD CAVALRY SWORD
No scabbard. Good shape. Est. 30-50 **SOLD $70(95)**
US MODEL 1840 LIGHT ARTILLERY SABER W/SCABBARD
RARE SET. Blade marked "US" "1861";also "MASS" "Ames". Classic Civil War Saber as continually issued w/the US Field Artillery thru the end of the Indian Wars. VG original overall cond. Est. 675-775

Top to Bottom: **MILLS .45-70 GOVT. TAN CARTRIDGE BELT**
altered to Bandoleer for use by soldier, cowboy, etc Est. 80-125 **SOLD $90(95)**
MILLS .45-70 PRAIRIE BELT W/STAMPED PLAIN BRASS PLATE
Used cond. Dirty w/age. Est. 80-125 **SOLD $130(95)**
BLUE MILLS PATENT .45-70 BLUE WEB PRAIRIE BELT
w/original cast brass US pattern buckle. Est. 280-350 **SOLD $280(95)**

INDIAN WAR OFFICER'S SABER BELT W/EAGLE BELT PLATE c.1870-1890
Incl. both saber hangers. Black leather in exc. cond. for age. Est. 340-425 **SOLD $340(95)**
INDIAN WAR US M1872 BELT W/BRASS "US" BELT PLATE
Leather belt has original rectangular belt plate. Classic Indian War Army piece. VG shape. Est. 280-350 **SOLD $280(95)**

First Row, Top to Bottom: INDIAN WAR US 1881 INFANTRY EAGLE PLATE
for Enlisted Dress Helmet. Est. 50-125 **SOLD $53**(96)
BRASS RECTANGULAR US BELT PLATE Original 1872-1890s.
Fine cond. Est. 115-200 **SOLD $100**(96)
CIVIL WAR/INDIAN WAR PACKET
of original cannon ball fuses. Exc. cond. Est. 40-95
US CAVALRY 1881 HELMET SIDE BUTTONS
w/crossed saber side-pair Est. 15-35 **SOLD $18**(96)
Second Row, Top to Bottom: ORIGINAL INDIAN WAR 1872 CROSSED SABERS
for campaign hat or kepi. Est. 50-110 **SOLD $63**(96)
US ARMY ORIGINAL SET OF BRASS US BRIDLE ROSETTES
Pair. Est. 20-65 **SOLD $20**(96)
Left: CS MARKED PLATE
for front of Confederate McClellan saddle. VG cond.
Scarce. Est. 50-95 **SOLD $125**(96)
Right: US INFANTRY MUSICIANS HELMET SIDE BUTTONS
pair Est. 10-40 **SOLD $10**(96)
GOLD BULLION 1872-1895 OFFICERS CHINCORD
Est. 50-110

REPRO US ARMY INDIAN SCOUT CAP BADGE
Silver w/crossed arrows; letters "*USS*" for United States
Scouts. See detail. *Originals are extremely rare-none exist in museums.* Est. 30-75 **SOLD $60**(96)
ORIGINAL 1875 US ARMY INFANTRY CROSSED RIFLES
for use on campaign hat or kepi. Est. 30-95 **SOLD $32**(96)

Top to Bottom: SMALL BRASS EAGLE
Janetski Collection. Indian Wars piece dug years ago at the site of Ft. Fetterman, Wyom From 1872 Infantry Dress Shako Hat. 1.5" X 1.5" Est. 40-75 **SOLD $35**(95)
SMALL BRASS BUGLE INFANTRY HAT & CAP INSIGNIA c.1872-75.
Janetski Collection. Indian Wars Period. From the site of Old Ft. Fetterman in WY. 1.5" X 2.88" Est.30-60 **SOLD $50**(95)
LARGE BRASS BUGLE
Same provenance as preceding. c.1858-1872. 1.75" X 3.5." Est. 50-80 **SOLD $65**(95)

LOT OF 3 INDIAN SERVICE BUTTONS c.1890
So. Dak. Collection. Made for Reservation Period Indian Police Uniforms.
Old type w/round back loops & *"superior quality"* stamp. Brown enameled brass. 3/4" diam. Exc. shape. Est. 50-125 lot **SOLD $125**(95)

Top to Bottom, Row 1: 1881 CROSSED-SABRE BRASS EAGLE HELMET PLATE
Janetski Colllection. Indian Wars Period. Found at site of Camp Cook, Mont. 3rd Cavalry number in center. 4.5" X 4.5." Est. 75-175 **SOLD $45**(95)
SIMILAR. *Same provenance.* 1st Cavalry number attached to center. Est. 75-175 **SOLD $85**(96)
1872 BRASS EAGLE HELMET PLATE
Janetski Colllection. Dug at Ft. Fetterman, Wyom Very rare relic of the type used in Custer Period. Est. 100-200 **SOLD $125**(96)

Top to Bottom, Row 2: BRASS EAGLE BREAST PLATE W/ LEAD-FILLED BACK
Janetski Collection. Indian Wars period. Dug at site of Camp Cook, Mont. Est. 40-80 **SOLD $45**(95)
1881 CAVALRY DRESS HELMET PLUME BASE
Same provenance as preceding. 3.38." Est. 30-55
BRASS CAVALRY UNIFORM EPAULET
w/1 star etched on brass. 3.88" X 6.5." Est. 60-125 **SOLD $50**(95)

CUSTER BATTLE 50TH ANNIVERSARY METAL PIN W/RIBBON
"At the Battlefield, June 24-25-26, 1926" is embossed on back of round medallion. Front shows the Custer Battlefield monument & the words *"Custer Battle, June 25,1876"*. "50th Anniversary" is on pin w/a red, white & blue ribbon. Exc. shape. 1.5" X 3." Est. 150-250 **SOLD $250**(95)

WOOL FELT KEPI c.1890-1910
Black oil cloth browband held in place by brass buttons. Visor is black cardboard bound w/black oil cloth. Round brass ornaments on front. Headband is brown oil cloth. Origin is unknown, possibly it was used at an early military school. Perfect cond. Est. 50-100 **SOLD $60**(93)

INDIAN WAR BLUE WOOL KEPI c.1872-1890
Narrow crown; complete w/sweatband, eagle buttons, & chin strap. A few scattered mothholes; otherwise, exc. cond. Est. 500-800 **SOLD $700(95)**

INDIAN WAR US CAVALRY WINTER HOOD
RARE. Brown wool w/red wool lining as issued to troopers during Winter Campaigns on the prairies against the Indians. Official US Army issue. Exc. cond. Est. 185-250 **SOLD $210(95)**

INDIAN WAR US ARMY ARTILLERY MOUNTED PLUME DRESS HELMET c.1881-1890s.
Has proper replacement cordsonly. Fine cond. Est. 725-900

INDIAN WAR BLUE FATIGUE JACKET
w/all eagle buttons. Exc. shape. Est. 225-280 **SOLD $235(95)**

1881 CAVALRY DRESS HELMET
Yellow horsehair plume & aiguillete cords.
Est. 250-500 **SOLD $300(98)**

US ARMY INDIAN WAR US INFANTRY MODEL 1885 DRESS COAT
RARE. 9 button front (all eagle). White trim on cuffs (3 buttons each); buttoned epaulets & tails (6 buttons). Perfect cond. Bright, superb specimen. Est. 800-1000 **SOLD $1000(95)**

INDIAN WAR US ARMY WOOL OVERCOAT
w/all US army eagle buttons. Complete with cape. Exc. cond. Est. 800-1200 **SOLD $815(96)**

CANADIAN RCMP MOUNTIE UNIFORM c. 1972
Full dress tunic of red gabardine w/brass buttons. Patches on left sleeve-crossed pistols & crossed rifles. Brass crests on stand-up collar & insignia on epaulets. Straight back trousers w/yellow stripe, Dress hat, Sam Browne adj. leather pistol belt has hoster, cuff & leather cartridge case. Exc. cond. w/everything intact. Est. 435-550 **SOLD $438(95)**
See: Scriver, Bob, *The Blackfeet*, Kansas City, Lowell Press, 1990: 159-166 for full-color uniform.

VI. PHOTOS, PRINTS & PAPERGOODS

Original Photographs

CAYUSE WOMEN & CHILDREN c.1900
*This copy is unmarked but Major Moorhouse was the photographer.** One of the women, Wenix, was the sister of the Half-Blood Trader, Donald McKay. 5" X 7." Exc. cond. Est. 125-250 **SOLD $150(97)**
*For more information on this specific photograph see Ruby, Robert H. & Brown, John A., *Indians of the Pacific Northwest*, University of Oklahoma., Norman. 1981:236.

NEZ PERCE GROUP HAND TINTED ORIGINAL PHOTO c.1900
A studio portrait of the Hi-yo-Kutz family. Dressed in white man's clothing. Frame chipped in lower left corner. & water stain in the upper left corner, otherwise exc. cond. 22" x 18" w/silver-tone wood frame. Est. 65-150 **SOLD $60(96)**

CHIEF JOSEPH WARBONNET PHOTO c. 1900
RARE original showing entire shirt, belt & pouch of this well-known pose. Slight water stain nr. left elbow. 8" X 10" incl. frame. Est.150-250 **SOLD $125(88)**

CROW INDIAN WARRIOR PHOTO c.1890
Portrait in clear detail & original frame. VG cond. 10.5" X 12.5" incl. frame. Est. 150-250 **SOLD $125(89)**

OKLA. INDIAN GROUP PHOTO IN ORIGINAL FRAME
Titled "1st Osage Princess Celebration-Bob Morrell Farm-Hominy, Okla.-June 10,1929" Photographer is Paul Strithem, Tulsa, Okla. Includes famous Chief Baconrind. 36" X 10." Est. 350-500 **SOLD $300(90)**

SIOUX WILD WEST SHOW LARGE GROUP PHOTO c.1917
Photographer unknown. Interestiing outfits:pipebags, blanket strips, breastplates, feather bonnets, etc. This is an old copy photo-left corner folded 1"-edges somewhat wrinkled & brown spots of varied sizes over-all (appear to be result of developing). 29" X 8". Est. 150-300 **SOLD $275(94)**

The following portraits are in original gold-leaf oval frames with curved glass. These photos came from Indian families on the NEZ PERCE Reservation. All are 22" x 16", framed. Interior photo is 13" x 19."

Left to Right: **TINTED PORTRAIT OF JIM WHITE** in pompador hair-style & dance outfit. Loop necklace, otterbraids, armband, etc. There is a tear 1/2 way and some scratches on the surface. Gold frame has two large cracks w/other superficial ones. Est. 190-295 **SOLD $200(96)**

UNTINTED PORTRAIT-UNKNOWN WOMAN
There is a 2" tear in the bkgrd., upper left. Tears in bottom colored w/dark pigment. Frame is gold leaf w/ some chips. Est. 190-295 **SOLD $175(96)**

Left to Right: **CAYUSE WOMAN OF THE SEW-SIPS FAMILY**
Faded hand tint. Shows hairpipe choker, braids, bead necklace and shell earrings. Ornate frame has gold leaf rubbed off in high relief spots. Overall exc. cond. Est. 190-295 **SOLD $200(96)**

CAYUSE SEW-SIPS TINTED FAMILY PORTRAIT
Seated pose. Wearing red and white blankets. Woman wears basket hat. *(This family helped find the killers of Marcus Whitman at Walla Walla massacre.)* There are 2 large creases-one near top & other across woman's face. Gold frame w/minor nicks. Est. 190-295

UNTINTED PORTRAIT
Indian woman with braids and shell earrings. Some cracks on surface. Frame is striped wood veneer. Est. 190-295 **SOLD $210(96)**

FIVE OVAL PHOTOS OF FLATHEAD INDIANS c.1920s
4 are identified as Helen Vinson, Josephine Mitchell, Houck & Sam George. All have been color tinted by the photographer. All but 1 are in mint cond. 13.5" X 19.5." Lot Est.150/250 **SOLD $85(91)**

OVAL PHOTO OF ALEC BIG KNIFE, A FLATHEAD INDIAN c.1910
Some color tinting. 11.5" X 18." Est. 50-100 **SOLD $50(91)**

SEATED INDIAN WOMAN IN OVAL PORTRAIT FRAME
c.1900
Hand-tinted photo of Mary Finley, Flathead Res., Mont. Came right out of an Indian house w/Indian-tanned buckskin hanger. 18.5" X 24.5" L. Est. 200-400 **SOLD $175(93)**

LARGE BOUDOIR PHOTO OF CALIFORNIA & TLINGIT BASKETS c.1900
Over 100 Pomo, Mission, Yokut, Mono and Panamint baskets. On back in black ink:*"Private Collection of Indian baskets, belonging to Mrs. S.S. Walkeley."* Brown tones w/sharp clear image. Small piece in upper right corner on mount is missing; lower right mount has a crease. Photo portion is exc. 10.5" x 12." Est. 150-250 **SOLD $125(96)**

LARGE BOUDOIR PHOTO OF PLATEAU BASKET COLLECTION Date on front - *"1904."*
On back is address: *Mrs. Mason L. Bingham, Portland, Oregon* Hundreds of baskets, some beadwork, cornhusk bags and Navajo rug. Unfaded & clean. Brown tones. 8.75" x 10.75." Est.150-250 **SOLD $150(96)**

Left to Right, Top to Bottom:
A) **CABINET PHOTO OF "NAVAJO" MAN**
Brown tones & very clear good image. Corners & bottom trimmed off-minor dirt smudges. 5" x 7.5." Est. 100-200 **SOLD $75(96)**
B) **CABINET PHOTO OF MAN W/HAT & BLANKET** *"San Ildefonso, 1900"* written in pencil on back & Indian name in pencil on the front. 1/2" tear lower left corner. Brown tones-good clear unfaded image. Minor dirt smudges. 5" x 8" Est. 100-200 **SOLD $150(96)**
C) **CABINET PHOTO OF MAN WRAPPED W/BLANKET** Photo has *"Jamez Indian"* in lower left corner. Pencil markings on bottom say *"Jamez-Se-Pa"* & *"KAADT"* in lower right corner. Brown tones with minor dirt smudges. 5.38" x 7.75." Est. 100-200 **SOLD $150(96)**
D) **CABINET PHOTO OF INDIAN MAN IN BLANKET** Lower left corner has *"Pueblo Indian, Santa Fe, N.M.".* Right corner has *"KAADT"* within photo. Brown tones. Good image-clean. Est. 150-250 **SOLD $100(96)**

CHIEF STANDING BEAR c.1920
Taken at *"Pine Ridge Sioux Reserve..in 1920"*. Aqua tint full figure portrait-wearing rainbow selvedge breech clout, fully-beaded moccasins, eagle feather trailer warbonnet, bear claw necklace w/bow & arrow at his feet. Professionally matted. 11" X 14" (outside 16" X 20"). Shrink-wrapped. Exc. cond. Est. 100/175 **SOLD $135(92)**

BOUDOIR PHOTO OF BUCKSKIN CHARLIE, HEAD CHIEF OF THE UTES
wearing bone breastplate. Brown tone. Sharp image w/some fading around the face area. Also, someone inked a feather onto his head. Minor smudges on photo w/ragged edges on right side & bottom of mount. 7" x 9." Est. 75-150 **SOLD $85(96)**

STANDING INDIAN PHOTO c.1915
Signed *"To my friend Princess Wah-le-tka from O. La Mere"*. Holds drum, wears roach, leggings, shirt w/beaded strips. 8" X 10." Professionally matted & shrink-wrapped. 11" X 14." Exc. cond. Est.65/95 **SOLD $90(92)**

The following 3 photos came from the Haynes family estate & were in storage for almost 100 yrs. Haynes was the famous photographer for the Northern Pacific Railroad (1876-1905) & did many photos of Yellowstone Park. (Left to Right)

CABINET PHOTO OF *"SITTING BULL, JR., A SIOUX INDIAN"* c.1880
By F. S. Haynes. The labelling on the back says *"Colored Cabinets of Noted Indians"* & goes on to list 12 Indian names & numbers for this set & the photographers name & address. Hand-colored. Mint cond. 4.5" X 6.5." Est.150-250 **SOLD $90(91)**

HAYNES CABINET PHOTO OF OLD COYOTE, A CROW INDIAN c.1880
The cardboard has Haynes name & St. Paul embossed into it. It is mislabeled *"Yellow Dog"* but this prominent Crow warrior is really Old Coyote. Mint clear image. 4.25" X 6.5." Est. 200-300 **SOLD $185(91)**

#1494 BIG MEDICINE MAN c.1870s
F. Jay Haynes cabinet photo. We believe this to be a Crow Indian. The card is edged w/gold leaf-back is printed w/Haynes address & listing of 12 Indian photos. Mint cond. 4.13" X 6.38." Est.250-400 **SOLD $250(93)**

102

LOT OF 5 BROWN TONE PHOTOS c.1899
Dancers and children at San Juan Pueblo. Photos of actual dances in process are *RARE*. Sharp & clear. Exc. cond. 3.25" x 5.5." Est. 200-300 **SOLD $85(96)**

"THE HUNTERS (OJIBWA)" c.1915
Photogravure by Roland Reed, Master Indian Photographer & Kalispell, Mont. native. C.F.Williams Estate (Reed's cousin in Minn.) 16" X 20" self-matted on art paper w/Bow Hunter in canoe Est. 65-100 **SOLD $70(92)**

'THE WOOING-OJIBWA' c.1915
Original framed photo *"Copyright. Roland W. Reed"* printed by *"Gravure Eng. Co. Mpls"*. 8.38" X 12.13" photo. 15.13" X 19.25" frame. Est. 150-250 **SOLD $135(94)**

SEATED INDIAN DRESSED IN WAR BONNET c.1890s
Mounted photo. He is wearing beaded panel belt, leggings & small beaded bag w/pipe. On back is printed *"#8532, Acme Art Gallery, Pagosa Springs, Colorado-on the hill."* Exc. image. 4.5" X 6.5." Est.150-250 **SOLD $150(93)**

Top to Bottom: A) **PHOTO OF CEREMONIAL DANCERS**
leaving sacred pueblo at San Juan in 1899. Sharp & clear image. Ceremonial photos are very *RARE*. 6.5" x 8." Est. 75-150 **SOLD $85(96)**
B) **POST CARD PHOTO** of *"Bull Bear, old 101 Ranch Store".* 1890s photo w/1942 postmark. Brown tone, exc. cond. 3.5" x 5.5." Est. 10-20 **SOLD $20(96)**
C) **PHOTO OF** *"CHAVARIA & PEDRO CAJETE, Governors of Santa Clara Pueblo, c.1898"*
Brown tone;sharp, clear image. Heavy cardboard mount. Exc. cond. 5" x 7." Est. 75-150 **SOLD $70(96)**

"ARROWMAKER, AN OJIBWA BRAVE" c.1903
Unmounted; hand-tinted from *Detroit Photographic Co.* 7" X 9." Est.75-175 **SOLD $85(93)**

PUEBLO INDIAN DRESSED PLAINS-STYLE c.1890
Wearing a Pendleton blanket, silver armbands & bead breastplate. On front is printed *"#303, Pueblo Indian."* Back is completely covered w/info. about Santa Fe Route, etc. In pencil -*"bought in S. Clara".* VG image. 5" X 8." Est.150-300 **SOLD $125(93)**

103

"PUEBLO INDIAN SQUAW" #4
Unreadable date.
Mounted photo. Pencilled on back "Woman from San Ildefonso." Exc. clear image. 5" X 8." Est.150-300 **SOLD $300(93)**

INDIAN WRAPPED IN A TRADE BLANKET
c.1890s
Mounted photo. Holding pipe & tobacco bag. In right corner is photographer's name & date; all that is clear is "Denver, Colorado" & "1897." Back in pencil "comes from San Ildefonso, C1897". Looks like a Plains Indian. 8" X 10." Est.150-300 **SOLD $150(93)**

Top to Bottom:
ALBUMEN CABINET PHOTO "#14 INDIAN WOMAN MAKING TORTILLAS"
Indian women w/some nice pots & grinding stones. "San Ildefonso" is written on the back in pencil. & "Kaadt" photographer. 5" X 8" Est. 100-200 **SOLD $125(95)**
SIMILAR "Indian Pueblo, Taos, N.M.." #31 w/ "Kaadt" photographer. Dated "1898" in pencil. 5.38" X 7". Est. 100-200 **SOLD $100(95)**
SIMILAR Penciled back is "Santa Fe." This is a street scene photo w/a sign that says "Old Curiosity Shop- Established 1862" on building. Small section of corner cardboard is broken by folding, but doesn't affect photo. 5" X 8." Est. 150-250 **SOLD $150(95)**

"BUCKSKIN CHARLIE, HEAD CHIEF OF THE UTES"
c.1890
Mounted & hand-tinted photo includes his wife, Emma. By *Nast, Paris Panel, 1624 Curtis St., Denver, Colo.* "1890's" written in back in pencil. Small piece of bottom corner is missing-slight break in upper corner. 6.75" X 10." Est. 150-250 **SOLD $150(93)**

CURLEY, THE CROW SCOUT
Positive transparency, titled: "Curley, General Custer's Scout & only survivor of that horrible massacre." Exc. early image of the famous Crow scout. 5" X 6.5." Est.100-200 **SOLD $75(93)**

ALBUMEN CABINET PHOTO OF INDIAN MAN-"KOTCHE INDIAN N.M." Date on back appears to be 1895.
Exc. cond. 5" X 8" Est. 150-250 **SOLD $150(95)**

FORT OWEN IN 1857.
Nr. Stevensville, Mont. McKay photo which appears to be from his original glass plates probably c. 1940. Fort made from adobe bricks (1 building still stands today). Frame-10" X 21." Exc. cond. Est. 75-125 **SOLD $80(93)**

2 CROW WOMEN ON HORSEBACK
Taken in 1906 by a friend of Charlie Russell, who was present when this photo was taken. Exc. clear original photo w/Crow saddles, stirrups, elktooth dress & rare lance case. Professionally framed. 28"W X 24"L. Photo 19.25"X 15"L. Est. 350-650 **SOLD $300(95)**

WOMAN W/PLATEAU BASKETS & BEADWORK c.1920.
Wearing fully-beaded vest w/elk, gloves, old-style flat bag, 1 large Klickitat & 1 large Thompson R. basket. Fancy wood frame. 10.75" X 9." Est. 50-100 **SOLD $35(95)**

FISKE INDIAN PHOTO
Sepia-tone. Blanketed Indian on travois w/Indian woman leading the horse. Black wood frame-broken glass. Photo in good cond. 12" X 9.5." Est. 75-125 **SOLD $95(95)**

PHOTO OF PLATEAU TIPI ENCAMPMENT c.1910
Hand-tinted. Probably Nez Perce. Unusual striped tipi & one painted w/flowers. Exc. cond. w/tissue cover. 5" X 6.75." Est. 50-150 **SOLD $60(95)**

BOUDOIR-SIZE PHOTO OF COMANCHE? ARBOR c.1880 (No date on photo)
No photographer marks. Probably taken in Okla. There are nine people in the photo: some sit on Indian-made beds, two central figures wearing bone breastplates, beaded moccasins, trade cloth leggings, hair ornaments, arrow quiver & blanket wraps. 5" X 8." Est. 250-350 **SOLD $250(95)**

105

FLATHEAD INDIAN MAN c.1900
Original framed photo by H. McKay w/the McKay circular embossed copyright stamp in left corner: *R.H. McKay, C., Missoula, Mont."* Label stamped to back cover of frame is original McKay Art Co. stamp identifying the title as *"Dawn"* & the location as Mt. Sentinel. The paper surface is textured to look like an oil painting; the color tones are gold to dk. brown. Exc. cond. 11.75" X 15". Est. 400-500 **SOLD $450(95)**

SPOKANE(?) WOMAN & BABY IN CRADLEBOARD
Original E.Y. Judd. *"Copyright 93 by E. Y. Judd"* stamped in left corner. Brown tone. Professionally matted & framed. Photo: 6.25" X 8.25." Frame:14.5" X 16.75." Exc. cond. Est. 250-350 **SOLD $250(94)**

"REV. BIG CHIEF WHITE HORSE EAGLE
Hartsook Photo. Studio mark. Hand-tinted portrait. Signed in pen on the sleeve, also *"Born 1822. Age 105. Queen WA-THE-NA"* Side view w/ Sioux-style feather bonnet. He has large shriner pin on his shirt. 7.75" X 9.25". Est. 60-100 **SOLD $75(94)**

BURIAL SCAFFOLD
w/deserted tipi & contents. Original photo w/the letters *"BARRY"* embossed into the photo, center bottom 1/2. Professionally matted & framed. Photo:7.5" X 4.75." Frame:16" X 13.5". Exc. cond. Est. 625-800 **SOLD $625(94)**

2 OLD CARD—MOUNTED PHOTOS. Neither has any identification. Photographer unknown.
Left to Right: WOMAN & YOUNG GIRL
They appear to be wearing Prairie or Great Lakes style clothing & moccasins. Potawatomie or Otoe is our guess. 2" X 4". Est. 75-150 **SOLD $50(94)**
PAWNEE(?) MAN
holding a tomahawk & wearing black ankle wrap Pawnee-style moccasins. Behind him notice base of iron stand to hold him still during long time exposure photo! Slight tear to 1 side. 2" X 4". Est. 100-200 **SOLD $160(94)**

Left to Right: FLATHEAD INDIAN POWWOW
c. 1940s.
Louie Ninepipe at the drum. 9.5" X 6.25". Frame 10.25" X 8.5" Est. 25-75 **SOLD $40(94)**
FAMOUS FLATHEAD SINGERS c. 1940s.
Louie, Happy & Andrew Ninepipe from Arlee, Mont Appears to have been taken at a camp along the Flathead R. Framed apx. 9" X 11". Est. 25-75 **SOLD $30(94)**

106

Stereoscope Cards

Top to Bottom: "*IN THE VILLAGE OF BLACKFEET INDIANS* near St. Mary's Lake, Glacier Nat. Park, Montana". *Keystone View Co. w/ historical data on back.* Image of tipi camp w/ woman & child wearing traditional clothing. Exc. cond. Est. 50-100 **SOLD $45(92) SOLD $60(97)**

"*THE CHOOSING DANCE OF THE BLACKFEET*" by N. A Forsyth, but not marked. c.1907. Shows lots of dance outfits, bonnets, shirts, etc. Old sun dance lodge in bkgrd. Exc. cond. Est. 50-100 **SOLD $50(97)**

"*BLACK BEAR MAKING SPEECH AT SUN DANCE CEREMONY*" N. A Forsyth, Butte, Mont. c.1907
Taken inside sun dance lodge; all wearing their best clothing. Exc. cond. Est. 50-100 **SOLD $40(97)**

Top to Bottom: "*LO! THE POOR INDIAN-SAVAGE RED MEN OF NORTH AMERICA.*"
American Stereoscope Co. dated 1901 in pencil on back. *RARE.* Shows rows of Sioux(?) Indians dressed in traditional clothing w/cowboys & American flags in bkgrd. Our guess is that this a Buffalo Bill Wild West Show photo. Exc. cond. Est. 75-125 **SOLD $60(97)**

"*INDIAN PONIES & RIDERS IN COSTUME*"
Keystone View Co. w/ historical data on back. Sioux Indians, warbonnets, etc. 2 horses have rare buffalo horn face masks. Exc. cond. Est. 50-100 **SOLD $50(97)**

"*MOUNTED SIOUX INDIANS IN 'FULL FEATHER' LEAVING CAMP*"
Keystone View Co. w/ historical data on back Lots of outfits w/tipi camp in bkgrd. Exc. cond. Est. 50-100 **SOLD $95(97)**

Top to Bottom: "*BLACKFEET INDIANS PREPARING FOR MEDICINE LODGE CEREMONY, Glacier Park.*"
Keystone View Co. card. Blackfeet Indians in Glacier Park, dressed in their finest garments. Exc. cond. Est. 75-125 **SOLD $55(96)**

"*FEATHERED & PAINTED BRAVES OF THE WAR-LIKE SIOUX*
Underwood & Underwood Pub. Great image with bonnets, lances, shields & horses. Full historical data printed on back! Exc. cond. Est. 50-90 **SOLD $65(96)**

Top to Bottom: "*INDIAN WARRIORS IN COUNCIL*"
Keystone. Shields, pipes, tipis, etc. One Indian looks Crow. Est. 50-90 **SOLD $45(92)**

"*INDIANS-A MEDICINE MAN*"
Keystone. Crow Indian photo shows martingale, bridle, War shirt, rifle scabbard Ute-style bandolier, bowtie hair ornaments, lance, Mtn. lion & tradecloth saddle blanket, etc. Est.75-125 **SOLD $50(92)**

"LITTLE WAR EAGLE'-THE PRIDE OF THE TRIBE" c.1889
Underwood & Underwood. RARE. Shows a group of Sioux men dressed for dancing w/"War Eagle", a child, standing in front. Lt. brown cardboard w/browntone image. Exc. cond. Est. 75-150 **SOLD $75(97)**

107

Top to Bottom: *"CUSTER'S GRAVE, MONTANA"*. *Keystone View Co. Historical data on back. RARE.* This is the only one we've ever seen. Iron fence w/tombstone in bkgrd. Est. 75-150 **SOLD $100(97)**

"INDIAN TALKING TO A COWBOY IN SIGN LANGUAGE" *Keystone View Co. Historical data on back.* Cowboy wearing a Colt revolver & Sioux Indians.(See detail).Exc. clear image & cond. Est. 75-150 **SOLD $75(97)**

Top to Bottom: *"AN ESKIMO FAMILY AT FORT MAGNESIA CAPE SABINE, ELLSMERE LAND"* *Keystone View Co., Full Historical data on bac.k* Shows family sittting in kitchen. Exc. cond. Est. 20-40 **SOLD $20(97)**

"A GROUP OF ESKIMOS" *Keystone View Co. Full historical data on back.* Wearing traditional clothing. Exc. cond. Est. 20-40 **SOLD $20(97)**

"NEARING THE END OF A NOBLE LIFE, CHIEF LOUISON." *N.A. Forsyth, Butte Mont. C.1907* Shows a famous Flathead Chief sitting in tipi w/lots of great garments. (See ermine bonnet & shield decorated w/eagle feathers.) Exc. cond. Est. 50-100 **SOLD $50(97)**

"INDIAN MOTHERS & THEIR BABIES" N.A. Forsyth, Butte Mont. C.1907 Taken nr. Arlee, Mont.;These are Flathead Indians wearing traditional dresses & beadwork w/floral beaded cradleboard w/baby. Tipi camp in bkgrd. 1 chip of cardboard mount only nr. right bottom (not on image);otherwise exc. cond. Est. 40-90 **SOLD $45(97)**

Top to Bottom: *"SOUTH TO PICTURESQUE WOLPI, A MESA VILLAGE OF HOPI INDIANS, ARIZONA"* *Underwood & Underwood. Pub. Historical data on back.* Terrific clear image w/ Indian men sitting on rocks & pueblos in bkgrd. Exc. cond. Est. 35-75 **SOLD $35(97)**

"DISMANTLED TOWERS & TURRETS BROKEN CLIFF PALACE IN MESA VERDE, COLORADO" *Keystone View Co. w/ historical data on back.* Exc. clear image & cond. Est. 35-75 **SOLD $40(97)**

"THE KACHINA DANCE TO THE RAIN-GODS, HOPI INDIANS OF SHONGHOPAVI, ARIZONA" *Underwood & Underwood w/historical data on back.* Rare image of dancers in Pueblo. Brown tone. Exc. cond. Est. 75-150 **SOLD $70(97)**

"WOLPI-600 ft. above the Plain-a Chief 'Pueblo' of the Mysterious Moki Race (Cliff Dwellers), Arizona, U.S.A." c.1901 *Underwood & Underwood Publ.* Detailed brown tone image on lt. brown cardboard. Exc. cond. Est. 50-100 **SOLD $50(97)**

Photo Postcards

PENDLETON ROUND-UP POSTCARD c.1900
4 Indians on horseback w/outstanding outfits & horse gear. Somewhat faded, but details still there. 3" X 5." Est. 20-30 **SOLD $15(93)**

LOT OF 6 INDIAN POSTCARDS *COPYRIGHT 1906*
By A. Y. & Co.-printed in Germany. Exc. photo images of Blackfeet & Blood Indians dressed in ceremonial clothing. One is photo of Max Big Man, Crow Indian artist. All cards are in mint cond. Est. lot 30-50 **SOLD $35(92)**

LOT OF 6 INDIAN POSTCARDS: a.)"*Blackfeet Indian showing his newly acquired war bonnet*"(color)
b.) "*Curley, sole survivor of Custer Battle*", dated 1909
c.) Folding card w/papoose on cover & fold-out of Manitou, Colorado scenes on inside
d.) "*Bashful*" cartoon by deceased Assiniboine artist William Standing, dated 1950
e.) Max-Big-Man, a Crow artist
f.) "*Indians of the West*" folding card w/18 color Indian cards inside. Lot Est. 15-30 **SOLD $21(95)**

Top to Bottom: POSTCARD TITLED "*INDIAN BURIAL PITS, SALINA, KS*"
Shows lots of bones & skulls. Exc. cond. Est. 10-20 **SOLD $10(95)**
POSTCARD TITLED "*PONCA INDIAN SUN DANCE, OKLAHOMA*" Dated *1907*
Has 1¢ stamp. Showing row of 8 sun dancers painted & dressed for the dance. Some water stain on lower edge, barely noticeable on picture. Est. 10-20 **SOLD $20(95)**
2 PHOTO POSTCARDS OF CHIEFS WEARING WARBONNETS
One shows "*White-Man-Runs-Him*", a Crow Chief. The other shows Chief Marshal & Chief Edmo;their outfits look Crow, but probably are Plateau, maybe Yakima? Mint cond. Est. 20-35 **SOLD $20(95)**

LOT OF 8 POSTCARDS OF INDIANS & COWBOYS dating from 1907 TO 1925
These all came from a Flathead Indian family, incl. is a very good photo of Yakima Canutt, the famous rodeo rider at the Bozeman Round-up. Show use. Lot of 8. Est.25/60
SOLD$45(91)

109

LOT OF 8 INDIAN POSTCARDS: *"Alaskan Belle;" "An Osage Chief;"* Massasoit Statue, Mass.; *"Herman Reel Co."* sign on tree postmarked 1912; Dickson's Mounds State Pk.; Indian Girl at Umatilla Indian Agency; Bannock Chiefs, Pocatello, Ida.; Kootenai Indian in full-regalia. Average to exc. cond. 3.5 X 5.5" Est. lot 30-60 **SOLD $42.50(94)**

LOT OF 6 INDIAN POSTCARDS: St. Michael's Indian School & Kwa Kiutl Totem Pole; A group of N.W. Indians; Hopi Rug Dancer; Lady on horse (B&W); *"Group of Ute Indians;"* Indian ceremonies in the Garden of the Gods, Colo. Average to exc. cond. 3.5" X 5.5". Est. 15-30 **SOLD $25(94)**

Top to Bottom, Left to Right: PHOTO POSTCARD c. 1940
"The Hogan, Parkers Trading Post, Albuquerque, N.M." Hundreds of artifacts;pottery, basket, beadwork, bonnets, etc. Est. 10-25 **SOLD $5(96)**
ACTUAL PHOTO OF TAOS PUEBLO
Exc. sharp image. Brown tone. Est. 15-40 **SOLD $10(96)**
PHOTO POSTCARD c.1915
"Every Rosebud Indian Owns a Farm." Women wearing tradecloth dresses and men with warbonnets, etc. Est. 15-25 **SOLD $20(96)**
PHOTO POSTCARD c.1915
"Dancing Crows". Brown tone. Bonnets, bustles & man w/rifle on horseback. Est. 15-25 **SOLD $10(96)**

6 PHOTO POSTCARDS, TOP TO BOTTOM (Left to Right): *"Crow War Party #12, C Chapples, Billings, Mont."*
Crows crossing the Little Big Horn River. 1945 Missoula postmark & two 1/2¢ stamps. Exc. cond. Est. 15-35 **SOLD $18(96)**
"Crow Indians in War Bonnets, Hardin, Mont'". Woman on horse with shield, lance case, martingale, etc.. Exc cond. Est. 20-45 **SOLD $30(96)**
"Interior of the Church of St. Ignatius" J.W. Meiers photo. 1940 postmark. This church was built in the 1800's to bring the Catholic religion to the Flatheads. Religous paintings on the ceiling and walls. Mint cond. Est. 10-25 **SOLD $10(96)**
"Two ways of Getting to Polson, Mont". J.W. Meiers photo of Flathead woman on horse with travois. Mint cond. Est. 20-40 **SOLD $30(96)**
"Indian Braves". Flathead men on horses and dressed for a parade at Big Fork, Mont. about 1940. Mint conditon. Est. 15-30 **SOLD $30(96)**
Postmarked 1944. Shows Flatheads dressed for a dance w/fine beadwork, dresses and bonnets. Mint. Est. 20-35 **SOLD $30(96)**

110

5 PHOTO POSTCARDS: Nez Perce Girls, Pendleton Roundup-1927, Drummer at Pendleton, White Man Runs Him, Crow Indian in front of tipi (Burlington Route RR card), cartoon card titled *"A Buck Well Spent"*. Lot Est. 40-60 **SOLD $40(96)**

LOT OF 7 COLORTONE POSTCARDS: *Buffalo Medicine Man, Indian Medicine Man, Comanche Brave, Pueblo Indians Selling Pottery, Ruins of Fort Benton, Mont. (RARE card), Indian Mummy-Chief High Backed Wolf, & Crow Girls w/ ponies.* Mint cond. Est. lot 40-90 **SOLD $45(96)**

FOLDING POSTCARDS W/12 COLOR PHOTOS c.1900 Features 12 Indian Chiefs, ie; Geronimo, Two Guns White Calf, etc. 2 sides. Folds to 4" X 6." Exc. cond. Est. 30-60 **SOLD $40(95)**

Left to Right, Top to Bottom: Following are a series of photo postcards of Blackfeet Indians taken at Glacier Park Lodge in 1943. Mint cond. Name of person is penciled on back. Est. 15-35 each **SOLD $15 each (96)** *Paul Old Chief in buckskin suit & warbonnet, Rosie Old Chief, Phillips Sure Chief, Old Lady Sure Chief, George Horn, Willie Buffalo Hide.*

Top to Bottom: Row 1: PHOTO POSTCARD Appears to be Crow Indians near Custer Battlefield. Man wearing Crow hat & women wrapped in Indian blankets. Mint cond. Est. 10-25 **SOLD $10(96)**
PHOTO POSTCARD *"At the Roundup."* W.S. Bowman photo, Pendleton, Ore. Drummers & dancers wearing "good stuff". Small piece of lower right corner is missing. Est.10-25 **SOLD $10(96)**
PHOTO POSTCARD *"Da-Nis, Cass Lake Minn."* Man in bark canoe. Back reads *"J.T. Gardner, druggist Cass Lake, Minn"* Mint cond. Est. 8-20 **SOLD $13(96)**
PHOTO POSTCARD *"Indian Drummers."* Chippewa Indians around medicine drum. Lots of beadwork, bandoliers, shirt collars, etc. Mint cond. Est. 8-20 **SOLD $13(96)**
Row 2: TWO SMALL PHOTOS of man wearing beaded war shirt with long fringe. Shirt strips use brass buttons in design. Pencilled on back is *"San Ildefonso, C.1902."* Brown tone. Exc. cond. 2.88" X 4.13" each. Est. lot 60-125 **SOLD $60(96)**
PHOTO POSTCARD of Nez Perce(?) woman holding sign saying *"Keep Smiling"*. Short hair & 1920's clothes. From Yakima, Wash. Exc. cond. Est. 10-25

Documents, Lithographs, Studio Prints & Misc.

Left to Right, Top to Bottom: A) UNITED STATES INDIAN SERVICE LETTER *Dated March 23, 1894 from Crow Agency, Mont. Signed by J.W.Watson, 1st Lt., 10 Cavalry Acting U.S. Indian Agent, Crow Ind. Res. Written to Merchants Natl. Bank in Helena re:Spending of Indian money. 8" X 9.5."* Est.25/55 **SOLD $25(90)**
B) SIMILAR. *Dated Jan.11, 1896 from Browning, Blackfeet Agency, Mont. Signed by George Steell, U.S. Indian Agent. 8" X 10.5."* Est.25/55 **SOLD $20(90)**
C) DEPT. OF INTERIOR INDIAN SCHOOL SERVICE LETTER *Dated June 26, 1894. Fort Shaw Indian School, Mont. Signed by W.H. Winslow, Supt. 8" X 10."* Est.20/50 **SOLD $20(90)**
D) U.S. INDIAN SERVICE LETTER *DATED NOV. 24, 1890. From Ft. Belknap Agency to Merchants Nat. Bank, Helena.* Est.20/50

Top Left: CHECK *from J.H. Sherbourne, U.S. Licensed Trader, Blackfeet Res., Mont. Oct. 7, 1899 Made out to W. C. Broadwater of Helena. The Sherbourne Mercantile was the main trading post on the Blackfeet Res. Has Indian head cartouche & red 2¢ document stamp attached.* Est. 40-75 **SOLD $30(92)**
Bottom Left: CHECK *Dated Jan. 16, 1900 to Kalispell Lumber. No document stamp.* Est. 40-75
Far Right: INVOICE *from T.C. Power Mercantile, Ft. Benton, Mont. Territory. Sept. 1, 1887 to Mrs.C.E. Conrad of Kalispell. She is the wife of C.E. Conrad, also a well-known Indian trader.* Est. 30-60 **SOLD $30(92)**

INVOICE *from T.C. Power, trader in Ft. Benton, Montana Territory, Feb. 22, 1876. Items sold to Capt. T.S. Kirtblout. This is a genuine document from one of the most influential companies in Montana. Goods were shipped to their store from St. Louis on the Mo. River. Some of the interesting items listed are rum & cigars.* Est.75-125 **SOLD $70(92)**

Heyn Studio photo prints, Omaha, Nebr.

PHOTO PRINT OF TATANKA TAMAHELA (POOR BULL) *Copyright 1900 by Heyn Photo of Omaha. Good clear image. 9" X 12."* Est. 75-150 **SOLD $65(90)**

Heyn Studio photo prints, Omaha, Nebr.

"SHOT IN THE EYE, OGALLALA SIOUX #343" Copyright 1899
Mounted photo by Heyn, Omaha. Some minor smudgings on mount border; otherwise, exc. cond. 8" X 10." Est. 100-200 **SOLD $150(93)**

"CHIEF LAST HORSE, SIOUX" Copyright 1899
Heyn mounted brown-tone photo. Lower left smudged w/black ink. 4" X 5." Est. 80-150 **SOLD $80(93)**

"BATTLE, OGALLALA SIOUX" Copyright 1899
Unmounted Heyn photo Omaha #217. Clear & sharp image. Top center has 2 small thum tack holes. 7.25" X 9.25." Est. 100-200 **SOLD $100(93)**

"THOMAS NO WATER, OGALLALA SIOUX" Copyright 1899
Heyn photo, Omaha, #215. 2 small smudges on mount border. Clear strong image. 8" X 10." Est. 100-200 **SOLD $125(93)**

"CHIEF LAST HORSE #410" Copyright 1899
Heyn Photo, Omaha. Some smudges on border of mount w/red ochre smudge on edge. 8" X 10." Est. 100-200 **SOLD $100(93)**

"BROKEN ARM #114" Copyright 1899
Unmounted Heyn photo, Omaha. Thumb tack hole at top center. 7" X 9." Est. 100-200 **SOLD $155(93)**

The following two color lithographs were being sold in Haynes Photo Catalog, p.12 in 1902 : "*Color Lithographs by Wm. H. Jackson-the printing was done by the old, genuine lithographic process from stone plates many years ago. Jackson developed this process for the Detroit Publ. Co., which he joined in 1893.*" Both in like new cond.

Left to Right: "#51293-AN EMBRYONIC WARRIOR (UTE PAPOOSE)"
3.63" X 7.13 ". Matte 7" X 11". Est. 65-110 **SOLD $70(94)**
"#50624-UTE CHIEF 'SEVARA' & FAMILY" 13.5" X 10.38". Est. 125-175 **SOLD $140(94)**

The following are L. A. Huffman Color Reproductions © J. Coffrin's Old West Gallery, Miles City, Montana, c.1970s: Book reference: Brown, Mark H. & Felton, W.R., *The Frontier Years, L. A. Huffman Photographer of the Plains,* New York, Bramhall House, 1955.

Left to Right: "PLENTY COUPS- Head Chief of the Crows- 1880 Courtesy the Smithsonian."
Title, © & signature printed on front. Shrink-wrapped. Double matte-outer tan; inner dark color. Outside:16" X 20." 13.5"X 10.5" print. Est. 35-50 **SOLD $40(95)**
"SPOTTED EAGLE'S SIOUX VILLAGE, Tongue River M.T." 1879
Same as preceding size, etc. **SOLD $36(95)**

"HUNKPAPA SIOUX LEATHER LODGES NR. FT. KEOGH MONT. 1868," 8" X 10" Est.25-75 **SOLD $35(91)**

"FIRE WOLF-CHEYENNE-MEMBER OF BUFFALO MEN-LIVED AT BUSBY" © L.A Huffman
Described as "an outstanding Cheyenne Warrior" See Brown & Felton: 201. Extra large poster-size enlargement of a hand-colored photo. 15.75" X 30.25". Est. 75-100 **SOLD $50(94)**

"RED ARMED PANTHER"
© J. Coffrin 1973.
Good enlarged copy of a color-tinted original photo. "sometimes called Red Sleeve, a Cheyenne Scout, Ft. Keogh 1879."
Brown & Felton:102, #47.
Brass frame 11" X 14.5".
Est. 50-95 **SOLD $60(94)**

Left to Right: "SITTING BULL-1885 D. F. Barry. Courtesy of the Smithsonian Inst."
Copy of color tinted photo. Heavy mount. 16" X 20." Est. 75-95 **SOLD $40(94)**
"CHEYENNE'S 'BUFFALO HUMP' & 'BOB-TAIL HORSE'"-1879
© L.A. Huffman. Stamped "Coffrins Old West Gallery, Miles City, Montana" on back. Color. "Dull Knife & Bobtail Horse at Huffman's old log studio at Ft. Keogh 1879? The split ears of the ponies indicate they were buffalo ponies; the 'elite' of the horse herds." Brown & Felton:115, #56. 16." X 20". Est. 75-125 **SOLD $70(94)**

114

Left to Right: "WOLF VOICE'-CHEYENNE WARRIOR FT. KEOGH, M.T. 1879 ©L.A.Huffman" Brown tone. *Brown & Felton:126, #64"....in war costume"*. 16." X 20" Est. 75-95 **SOLD $45(94)**
"SNAKE WHISTLE-CHEYENNE"
Brown tone. He carries his whistle, pipebag, dew claw bandolier, etc. 16" X 20". Est. 75-100 **SOLD $60(94)**

"BRAVE WOLF" c.1960s
Made from an original glass plate. Print stamped on back *"L.A. Huffman photo, Miles City, Mont." "Brave Wolf & squaw being interviewed about the Custer fight" by George Bird Grinnell. "Squint Eye interpreter. June 20, 1901"*. 8.5" X 6.6". Est. 25-50 **SOLD $25(94)**

"CHEYENNE CHIEF TWO MOON @ FT. KEOGH M.T.,1879"
Written on negative. c.1950 copy photo. Stamped on photo *"L.A. Huffmam c.1913."* Brown tone on heavy weight matt rough textured paper. 11" X 14". Exc. cond. Est. 75-125 **SOLD $85(94)**

"WHITE SWAN-CROW" © F.A. RINEHART, OMAHA ©1899
Framed & matted color lithograph. Exc. cond. 6" X 8" print. 10.75" X 11" frame. Est. 50-125 **SOLD $60(94)**

These two framed photos are copies of original Huffman cabinet photos. They are all professionally & archivally framed & matted w/brown suede on dk. brown bkgrd. Cut & color identical to originals incl. studio lettering *HUFFMAN'S Indian Portraits STUDIO MILES CITY, M.T. Northern Pacific Views*. Only when inches away can you tell! Each is 4.25" X 6.5". Frame: 9" X 11.5".

Left: "#2 SCORCHED LIGHTNING ASSINIBOINE"
Est. 40-95 **SOLD $45(94)**
Right: "#1-RAIN-IN-THE-FACE"
Est. 40-95 **SOLD $50(94)**

F. A. RINEHART COLOR LITHOGRAPH PRINTS (See also page 115)

Three of the following have original red border w/drawings of Indian symbols ie;tipis, arrow, eagle feathers, etc. & white matte. 13.5" X 17" each. Rinehart was the official photographer for the 1898 Trans-Mississippi Exposition in Omaha, where he set up a studio to photograph many of the 500 Indians (34 tribes) in attendance.

See: Rieske, Bill & Verla, *Historic Indian Portraits, 1898 Peace Jubilee Collection*, Salt Lake City: Historic Indian Publ., 1974.

Right to Left: "CHIEF RED CLOUD (Sioux)" c. 1898
Est. 25-50 **SOLD $20(95)**
"WHITE BUFFALO (Arapahoe)" c. 1898.
Has two small tears. Est. 25-50 **SOLD $20(95)**

"LEFT HAND BEAR" Dated 1903 F.A. Rinehart colored print. Wears a small deer hair roach. Black frame. 12.75" X 10.75." Est. 40/80 **SOLD $40(92)**

Left to Right: 1990s brown-tone reproduction prints from the 1898 originals. Matted & ready for framing. Image is 16" X 20.""ANNIE RED SHIRT, SIOUX". Est. 5-15 **SOLD $5(97)**
"FRECKLED FACE-ARAPAHO NO. 67"
Est. 5-15 **SOLD $5(97)**
"CHIEF AMERICAN HORSE-SIOUX NO. 27B"
Wears moccasins w/beaded soles. Est. 5-15 **SOLD $25(97)**

"KILL SPOTTED HORSE, ASSINIBOINE" c. 1898
Exc. cond. Est. 40-75
SOLD $35(92)

RODMAN WANAMAKER PHOTO PRINTS Dated 1913 From his book *The Vanishing Race*. These are the oldest & best photos from the book. The photogravures were made by J. Dixon in 1913 at "The Last Great Council." Mint cond.

Top to Bottom: "CHIEF PLENTY COUPS ADDRESSING THE COUNCIL"
Apx. 9.5" X 6." Est.25-60
SOLD $40(95)
"THE SONG OF THE ARROWS"
Apx. 9.5" X 6." Est.25-60
SOLD $40(95)

Left: "CHIEF UMAPINE, CAYUSE"
Wearing trailer bonnet, etc. Apx. 9.5" X 6." Est. 25-60 **SOLD $50(96)**
Center: "WHITE MAN RUNS HIM"
Custer Scout & Crow Indian wearing loop necklace and warbonnet. Exc. clear details. Apx. 9.5" X 6." Est. 25-60 **SOLD $35(96)**
Right: "GOES AHEAD, CROW, CUSTER SCOUT"
Holding an eagle feather covered shield. Wearing Crow leggings, loop necklace, trailer bonnet, etc. Apx. 9.5" X 6." Est. 25-60 **SOLD $35(96)**

Brown tone photo prints. Framed: 13.25" X 10.25" w/cream mattes:
Left to Right: *"MOUNTAIN CHIEF"*
Famous Blackfeet in full headdress. Est. 75-110 **SOLD** $85(95)
"THE FLOWER OF THE WIGWAM"
Girl w/blanket wrap. Est. 75-110 **SOLD** $90(95)
"CHIEF BEAR GHOST"
Quilled strap;feathers & ermine in hair. Est. 75-110 **SOLD** $80(94)

ACE POWELL PRINTS. Each is heavy cardboard shrink-wrapped & signed by the artist.
Left to Right: *"CHARLIE RUSSELL COUNTRY"*
Limited edition #260/1000. Lone Indian cowboy taking a cigarette break. 26" X 20." Est. 65-95 **SOLD** $65(95)
"NAPI'S WORLD"
Signed in 1972. Indian creator releasing animals from his parfleche container. 27" X 20.5" Est. 65-95 **SOLD** $65(95)

PRINT TITLED *"RATION DAY AT STANDING ROCK AGENCY"* By H.F. Farny.
This was the centerfold etching in the *July 28, 1883 Harpers Weekly*. Illustrates USID blankets, saddle. Est. 50-100 **SOLD** $50(96)

"A DANCE OF CROW INDIANS" December 15,1883 issue.
Same provenance as above. Indians dancing around blazing campfire at night w/ tourists and train in the bkgrd. 11 x 16 Est. 40-90 **SOLD** $35(96)

"C.M.RUSSELL & WILL ROGERS-HOLLYWOOD c.1923"
A c.1950 copy of the older photo. Original was signed *"Sincerely yours, Will Rogers"*. Also white Inked *"Pub-100"*. Gold-leaf sealed frame. 11.25" X 9.25". Est.35-75 **SOLD** $40(94)

TRAIN POSTER c.1906
Idealized Indian woman w/painted buffalo robe on yellow bkgrd. Tagboard;edges worn. Est. 20-40 **SOLD** $25(92)

117

GEORGE CATLIN PRINTS on heavyweight paper. These may have been taken from a very early edition of his book titled *Letters & Notes on the Manners, Customs & Conds. of N. American Indians* that was first printed in 1841 or from the 1832 *Albums Unique*. They are mint w/slight age browning to the paper. Apx. 5.5" X 9."

Left to Right: *PRINT #298*-Seminole (?) Man Est. 20-40 each **SOLD $25(95)**
PRINT #152-Osage (?) Man, Est. 20-40 each **SOLD $36(95)**

Left to Right, Top to Bottom: *DOUBLE PRINT #235 & 326* LaCrosse players. Est. 20-40 **SOLD $35(96)**
PRINT #76 Horse & rider. Both are wearing warbonnets. Indian has long flowing hair and wears warshirt, leggings, quiver, shield, bow & lance. Est. 30-50 **SOLD $60(96)**
PRINT #167 Warring braves shooting bows while hanging on side of horse. Est. 20-50 **SOLD $60(96)**
DOUBLE PRINT #73 & #74 Warrior w/bow & shield;woman in buckskin dress. Est. 20-50 **SOLD $35(96)**
PRINT #172 Drawing of warrior w/lance, shield, bow, buffalo hide quiver & unusual buffalo hide breechclout. Est. 30-50 **SOLD $45(96)**
PRINT #223 Costumed LaCross player. Exc. color and detail. Est. 30-50 **SOLD $45(96)**
PRINT #55 Mandan or Hidatsa painted for ceremony and holding 2 calumets. Est. 30-50 **SOLD $60(96)**

Left to Right: *PRINT #11*-Blackfeet (?) Man Est. 20-40 each **SOLD $20(95)**
PRINT #154-156-Omaha (?)Warriors Est. 20-40 each **SOLD $25(95)**

WINOLD REISS CALENDARS

Winold Reiss was a well-known German painter who spent several years around Glacier Park painting Blackfeet Indians for the Great Northern Railroad. The prints of these paintings were issued as the tops to monthly calendars from 1930-1950's. Today, collectors are vying to accumulate complete sets.

"CROW CHIEF-BLACKFEET ELDER STATESMAN" Dec.1956. Complete & mint. In original mailing tube. 16"W X 33"L. Est.75-110 **SOLD $85(93)**

GREAT NORTHERN R.R. CALENDARS
w/Winold Reiss' Blackfeet Indian paintings. With the growing appreciation of Reiss' work and scarcity of dated railroad advertising pieces, these mint cond. calendars will increase in value as the years pass. In original tubes. 16" X 33"-total L. Painting 16" X 18" Est. 75-125 **SOLD $65 each (86)**

Left to Right: *Many Guns-Blackfoot Indian Brave* 1954
Julia Wades In the Water 1946
Tom Dawson (Mountain Man) 1950

The following examples were issued as monthly calendars w/ different Indian picture for each month. They came folded in half.

Upper Left: Top to Bottom: 1931 CALENDARS
A) Jan. *Alex Eagle Plume*
B) Feb. *Many Mules*
Left to Right, Top to Bottom:
C) Apr-*Chief Eagle Calf*
D) May-*Nightshoots*
E) June-*Mrs. Devine*
F) Aug-*Tough Bread*
G) Nov-*Big Wolf*
H) Dec-*Dog Taking Gun*

Upper Right: Left to Right, Top to Bottom: 1930 CALENDARS:
I) Feb-*Long Time Pipe Woman*
J) Mar-*Mike Short Man*
K) Aug-*James White Calf*
L) Oct-*Cut Nose Woman*

Lower Left: Left to Right, Top to Bottom: 1932 CALENDARS:
M) Mar-*Jim Blood*
N) Apr-*Buffalo Body*
O) May-*Morning Star* (1" tear bottom center)
P) June-*Heavy Breast*
Q) July-*Big Face Chief*
R) Aug-*Clears Up* (crease in right upper corner)
S) Sept.-*Fish Robe* (taped hole-2 minor bottom tears)
T) Nov-*Morning Gun*
VG to exc. cond. Each is 10" W X 22" L. Est. each 40-80
A. B. D. E. F. G. H. K. M. O. P. Q. R. & S. **SOLD** $35(93) each
I. & L. $60(93) each
C. J. N. & T. $77(93) each

119

All the following are cut off from calendars, bottoms are incomplete.

15 GREAT NORTHERN SERIES PRINTS
RARE. Each has a solid red or blue color backing printed w/the Great Northern mountain goat logo bottom center. 7.5" X 10" on 9" X 12"' backing. Exc. cond. (unless otherwise noted): Est. lot 60-175 **SOLD lot $125(94)**
Left to Right, Top to Bottom:
A. *Chief Eagle Calf.*
B. *Lazy Boy*
C. *Many Mules*
D. *Nightshoots*
E. *Tough Bread*
F. *Dog Taking Gun*
G. *Many Horses, Little Rosebud & Baby*
H. *Yellowhead*
Left to Right, Top to Bottom:
I. *Big Face Chief*
J. *Double Steel & 2 Cutter*
K. *Mrs. Devine*
L. *No Name or backing (blue vest)*
M. *Alex Eagle Plume*
N. *Big Wolf*
Far Left:
O. *No name or backing horn bonnet (a few spots)*

Left to Right: **LOT OF 3 CALENDAR TOPS** c.1950-54 Glacier Nat. Pk.
1) *Many Guns-Blackfeet Brave*
VG cond.
2) *Angry Bull-Blackfeet Indian Hunter*
small tears where metal top was removed, otherwise good cond.
3) *Middle Rider-Young Blackfeet Indian Brave*
Metal top. Small creases & tear at bottom, otherwise good cond.
Apx. 16" X 18." Est.80-120 lot **SOLD $85 lot (95)**

Left to Right, Top to Bottom: **LOT OF 7 GREAT NORTHERN CALENDAR PRINTS**
Monthly Calendars cut-off. Glacier Nat. Pk. A through E are 1932. VG cond. 10" X 11"
A. *Big Face Chief*
B. *Jim Blood*
C. *No name*
D. *Double Steel & Two Cutter*
E. *Mrs Devine*
F. *Not-Real-Bear-Woman*
F. *Mameia & Sopopeia.*
Est. lot 50-100 **SOLD $60 lot(94)**

INDIAN THEME GOODS

43 ANTIQUE INDIAN & COWBOY CIGARETTE CARDS c.1910
By American Tobacco Co. for Hassan corktip cigarettes, *"The Oriental Smoke."* Color pictures w/ descriptions. Ad on back. 25 Indian-8 cowboy. Well handled w/some creases. Est. 30-90 **SOLD $70(96)**

120

INTRODUCTION TO REPLICAS

Collecting Replicas

by Preston E. Miller

In today's marketplace, the replica Indian artifact deserves your attention. Understanding this area of collecting is important regardless if you wish to own any replicas or not. Without knowledge of this phenomena you will, at some point in your collecting, undoubtedly become the owner of an artifake thinking that it is an authentic historic Indian made relic. It may even cost you a lot of money which will most surely be a disappointment to your collecting pleasures. This problem can be eliminated if you take the time to learn about the types of replicas being made and the artists making them. Who knows, once you increase your knowledge, you may even find reasons to add a few replicas to your collection.

An Indian replica is the re-creation of an item to duplicate or resemble something Indians would have made and used in the past. When a replica receives additional efforts to make it appear as though it were actually made in the past it becomes an "Artifake." The value of such an item is not the same as the old original. For instance, the value of a fully beaded vest, in excellent condition, made in 1870 is higher than an exact replica or artifake made in 1990. The value of the replica is determined by the expertise of the maker, the rarity of construction materials, and the amount of construction time (hours, days or weeks).

Some collectors would prefer that these "Artifakes" did not exist. The fact is that some items are more attractive and sellable if they look old. Many collectors seem to equate dirt with wear and age. This, they feel, makes an item look like it was made by Indians long ago. On the other hand, let us suppose that a pair of moccasins, made in 1870, were purchased by the local Indian Agent and immediately stored in a trunk. This trunk has remained in the agents family for three generations. If all conditions, such as no light, no bugs, no dampness, no dust, etc. have remained stable the moccasins should look the same 100 years later. Some collectors will value these moccasins for their excellent condition while others would prefer a little dirt and wear (patina). The choice is up to the individual collector. The trick is to know which items have an original patina and which are replicas with an artificially applied patina. Experience and observation will help you learn to see the difference.* The answer is, don't make a purchase unless an item satisfies you completely.

The importance of whether or not the replica was made by a person identifying themselves as an American Indian must be determined by the purchaser. Generally, this does not make a difference in the value of the finished item. Buyers seem to be more interested in the quality of the work and value finished items accordingly. Currently, most replicators are of non-Indian heritage. Most Indian artists are busy making contemporary items for the Indian and non-Indian markets. However, both Indian and non-Indian replicators are gaining a reputation for their skills and their ability and fame usually determine the monetary value of their replicas.

The lack of authentic old relics and the high prices they command are the reasons for the large number of replicators at work today. Suppose you would like to purchase a fine old Sioux beaded and quilled pipe bag; not only would you find few for sale, but the price would probably be over $2,000. A comparable expertly made replica would be available for under $1200. A more dramatic example would be a rare original shield too costly to purchase or in a museum. Why not a beautiful copy using authentic new materials: hand-made rawhide, brain-tan leather, saved list trade wool that looks wonderful over your fireplace but costs less than $300? *(See Replica Shields, p.173)* Originals can be expensive, whereas replicas are more affordable. Also, original relics are sometimes rather fragile because the materials are old and demand special care. The high cost, alone, can be a reason for special handling. However, replicas are fresh and durable. You can handle, wear and play with them. In fact, limited use usually makes them look even more authentic. Suppose you would like to have a beautiful war shirt you have seen displayed at the Smithsonian Institute. *(See Lakota War Shirt, Replica Section p. 129.)* You can't buy it, but you can have a replica made. Suppose you have an old black and white photo showing a Crow warrior holding a beautiful beaded knife sheath. Not only does no one seem to know what happened to the original, but you probably couldn't afford to own it if it did still exist. For a minimal fee you can have a replica made. The reasons for having replicas made include many such examples. *(See Old and New Comparisons pp.123.)*

Most replicators are good honest trustworthy folks who want your business and have no interest in selling you a replica as being old and authentic. They want you to be pleased so that you will buy more. But, be careful because there are replicators, dealers, collectors and sometimes questionable friends who will try to sell you an artifake as being genuine and authentic. Granted, it is possible they sometimes don't know, or aren't sure if it is genuine or not. Your best protection is education. Look, listen, study and learn to know the origin of what you are buying.

*See *Four Winds Guide to Indian Artifacts,"Is it Real ...or is it an Artifake"*, companion volume, pp.186-193 for photo essay on how to detect the difference between old vs. new.

N. 1 - GENERAL CARD "W" EDITION 1962

SIZES					
14/0		3		732	
5/0		Snow white (4)		616	
13/0		28		18 ½	
4/0		823		507	
12/0		824		18	
3/0		828		102	
11/0		828 ½		63	
2 0		11		64	
10.0		13		735	
0		801		103	
9/0		806		27 ½	
c		807		27	
8/0		807 ½		20	
7/0		808		20 N	
d		812 ½		31	
e		813		30 ½	
f		810		30	
g		811		464	
h		803		448	
i		805		49	
l		38		695	
COLOURS		6		Black (40)	
Cristalux		7		**STRIPED BEADS**	
Cristalux extra		678		CSS 1 R	
2		523		6599	
41		22		6697	
				6721	
				CSS 2	
				6631	
				205	
				6687	
				6657	
				06671	
				06679	
				06686	

SLIGHT DEVIATIONS FROM COLOURS AND SIZES TO BE TOLERATED

MADE IN ITALY

Card #1, Edition 1962 from Societa Veneziana Conterie, Italy in 1970. This card displays both Italian sizes (0 to 5) and Czexh sizes (7 to 14). Notice that bead colors are identified by numbers. 19th century bead cards also used numbers for identification of colors. Notice the many shades of blue, green and red. #28 is greasy yellow; #810 and 811 are white lined reds.

Bead Glossary & Definitions

Terms and abbreviations used in descriptions of GLASS BEADS in this book:

BEAD SIZES (refer to color bead chart)

"**Seed**" beads are the smallest beads verying from Czech 10° (largest) to 22°. Czech 12°-13° and Italian 4° (see bead chart) were the most commonly found sizes on pre-20th century pieces.

"**Pony**" -or more correctly called a "pound" bead- is a large seed bead (Czech size 5° of "1"- see largest beads on the bead chart- to Czech 9°) which usually pre-dates the use of smaller seed beads on Plains and Plateau items. *See also pony and Crow beads in the Trade Beads chapter 3.*

"**Crow**" beads are larger still and have a large hole for stringing on necklaces or thong decorations on objects and clothing. "Old style" size approximately 7mm to 9mm (see companion volume, p. 188).

BEAD STYLES

"**Basket**" beads are cylinders cut from longer tubes manufactured since mid-188s (not currently being made to our knowledge). Very versatile use in sewing and stringing. Ususally transparent, "**lined**" (with interior color), or **satin** (a gleaming satin-like finish).

"**Cuts**" or **cut beads** are multi-faceted beads resulting in a sparkling effect. The best are still being made in Czechoslovakia in size 13° only, transparent and opaque. 19th century pieces frequently have "Czech" cuts in **t.** (transparent), **gr.** (greasy), and even smaller sizes (even 20° and less!).

"**Tile**" bead is an opaque molded cylinder bead with straight sides. Primarily used strung in loop necklace and thong decoration as early as mid-19th c.

"**Tri-cuts**" are a 3-cut faceted bead larger than a cut (see above) often used on Indian items made after the turn of the twentieth century to the present. Usually pearl (lustre) or iris (multi-color metallic) lined (see below), also transparent and opaque.

BEAD COLORS

No adjective with bead color refers to opaque or a solid-color bead: ie. red bead

"**C. pink**" or **Chey. pink** abbreviation for Crow or Cheyenne pink. Both refer to the same old-time bead color, a dusty muted pink popularly used by those tribes in the 19th century and earlier.

"**gr.**" or "**greasy**"- translucent (**transl.**) or cloudy (semi-transparent). Many old beads were made this way; and many are now being re-made in Europe today. Gives an old piece (or modern reproduction) a richly varying beadwork texture.

"**Pony trader blue**" or **Trader blue** - Rich "greasy" medium blue in many color variations (darker than "greasy" blue and lighter than cobalt). This color was popular in the Plains in the early 19th c. in a "pony" bead size along with white, black and rose whit heart. Also "**Bodmer blue**," an tntense greasy blue named for Karl Bodmer, an 1830s painter of Plains Indian subjects.

t. or **trans.** abbreviation for transparent or clear (see-through).

white lined, **w. heart**, or **w. center** all mean the same, referring to the color of the interior of a bead. Outer color usually red, sometimes brick, pink, orange, green, yellow or bright bllue in modern reproductions. Can be any size of bead. A very old style of seed bead was a highly desirable rose or rose-red, no longer being made (*exception: blocky Crow bead now made in India*).

Also see: White hearts, in Trade Bead chapter 3 and Bead Detection in "Artifake" section of companion volume, pp. 187-188.

BEADWORK STYLES

Flat or **applique**- used to cover large areas with solid beading; sewn straight or in curved rows. Overall appearance is flat. Used by many tribes, ie: Blackfeet, Plateau, and Cree.

Lazy-stitch - Multiple (5-12) beads strung and sewn down to create humped or raised rows; often used to cover large areas. Principally used by the Sioux, Cheyenne, Arapaho and Ute; a modification used by the Crow.

Embossed or **raised** - Beads sewn in a crowded arched stitch for a 3-D effect as found on Iroquois and other Eastern tribes beadwork.

Peyote or **gourd** - A netting technique usually used to cover solid objects, ie: fan handles, key chains, ball-point pens, etc. Common to contemporary Indian beadwork items.

References
Miller, Preston, *Four Winds Indian Beadwork Book*, St. Ignatius, Mont., 1971.
Whiteford, Andrew H., *North American Indian Arts*, New York: Golden Press, 1970. Concise visual and factual guide to quick identification of material culture objects.

ABBREVIATIONS AND DEFINITIONS

Special Tribal Designations and terms used in this book:
Intermontane refers to a geometric decorative style shared by Plateau, Crow and some Basin tribes (spanning a large geographic area). See: Conn, Richard, *A Persistent Vision*, Seattle: University of Washington, 1986, 128-131.

Blackfoot or **Blackfeet** - In modern times, Indians of the Blackfoot Confederacy refer to themselves as **Blackfoot** if from Canada and **Blackfeet** if from the United States. We use this designation in the book. See: Hungry Wolf, Adolph and Beverly, *Indian Tribes of the Northern Rockies*, Summertown: Good Medicine Books, 1989, 2-4.

DEFINITIONS OF MATERIALS USED FOR REPLICAS

For in-depth discussion, see photo essay on materials used, in the companion volume, pp.188-193.

HIDES- **Brain-tanned** or **Indian-tanned** buckskin refers to the original hand-worked and organic process of rendering a hide white, soft, supple, porous and easy to pierce w/a needle for bead-work. *The saying goes that each deer has enough brains to tan his own hide!* Considerable time and effort are expended in scraping and stretching by hand. Smoking darkens and waterproofs it.

Commercial (comm.) hide tanning is a modern mechanical and chemical process which doesn't break down the grain, (in comparison to brain-tanning,) so that it is not porous, as supple or able to easily pierce w/a needle;also, smells like chemicals. Usually has a smooth and rough side. Color usually not like smoked but gold, etc. Costs much less than a brain-tan hide.

TRADE WOOL- **White Selvedge Trade Wool** or **Undyed Selvedge** or **SAVED* LIST**

Usually navy (indigo) or red, it is distinguished by the white (undyed) selvede (edge or LIST) that made it the most popular and widely distributed trade cloth to No. Amer. Indians, as early as 1700.

* Saving is the hand-done process of leaving the selvedge white. The term "saved list" is used in early fur trade ledgers, and is the most accurate description.

"**Rainbow**" **Selvedge Trade Wool** has a woven multi-colored edge and was manufactured after the latter half of the19th century. It was especially popular on the So. Plains and later, after "saved list" was no longer available, it was distributed in the North in the 20th century.

Comparison of Old vs. New
by Carolyn Corey

LARGER BEADS WERE THE FIRST TO BE USED BY THE INDIANS; CALLED PONY BEADS AND WERE BROUGHT BY THE TRADERS.

Top: ORIGINAL PLATEAU BEADED BLANKET STRIP FRAGMENT C.1850 or earlier.
Luna House Museum, Lewiston, Ida. Note cloth center inlay is almost completely disintegrated. Only 2 rosettes and a single panel are all that remains of the original.
Bottom: ENHANCED REPLICA
Made into a complete strip and mounted on a newly made "saved list" blanket made by the author. Edges bound w/pinked buckskin edging. Most of these pony beads are new-the Pony Trader blue and rose w. heart are from Venice and are no longer being made. Rosettes are 6.25" diam.

Left: ORIGINAL NEZ PERCE POSSIBLES BAG
Note: cloth has tears and some beads are missing. Original is 13"L. X 8" W. bottom X 10"W. top. *Lowie Museum of Anthropology (now Phoebe A. Hearst Museum); Univ. of Calif., Berkeley. Accession #2-13104.*
Right: ENHANCED REPLICA
is in perfect condition and has same dimensions. Cloth trim and welting is "saved list" made by the author. The Italian 4° beads used were still on the market in 1980, but now rose w. lined and chalk blue are no longer available from Italy.

ORIGINAL PLATEAU BEADED BAG labelled *"Cayuse personal bag dating about 1830"* on display in the Whitman Mission Nat. Hist. Site nr. Walla Walla, Wash. (could also be Washo tribe). Note that the cloth is almost entirely gone. White wrapped quill fringe was omitted in the copy.
ENHANCED REPLICA Cloth was replaced giving the bag an entirely new look! Also multi-colored bead edging on fringe is now complete rather than 1/2 gone as in original. Bag is 12"L X 7.5" W at bottom.

125

Far Left: ORIGINAL MANDAN-HIDATSA QUILLED PIPE BAG
Stuhr Museum of the Prairie Pioneer, Grand Island, Nebr. The quilled panel with complex sewn diamond pattern is characteristic of these Missouri tribes who may have originated this style.* Also note fancy trade beads and Russian facets in white, cobalt and gold.
*See Bebbington, Julia M., *Quillwork of the Plains,* Exhibition Catalog, Calgary, AB. Glenbow Museum, 1982:45
For instructions on multiple quill plaiting, see Heinbuch, Jean *A Quillwork Companion* Liberty, UT Eagle's View Publ. 1990:49-53.
Above: ENHANCED REPLICA
Shown at Rendez-vous; close-up shows difference from original in using 2 rather than 3 motifs. Other features not on original; top has quill wrapped fringes separated w/beads and beaded triangles above panel. Apx. 30"L X 4.75"W.

Left: ORIGINAL CROW QUILLED HAIRBOWS
RARE. *Manitou Auction, Great Falls, Mont.* Same multi-quill diamond plaited style as seen in pipebag above. Outside is 2 quill triangle(stripe) technique. Sinew-sewn. Connecting stick has been quill wrapped. 7"L. Est. 900-1600 **SOLD $1000(96)**
Far Left: ENHANCED REPLICA
has replaced feather fluffs missing from the original. Lt. blue prosser trade beads are old. Sinew-sewn. 7"L + fluffs
Left: ORIGINAL TYPICAL DENTALIUM HAIRBOWS
Copper tube connectors; lt. blue tile beads. Shells 1/2 missing and/or broken. Fluff remnants. Est. 300-600 **SOLD $300(96)**
Above: ENHANCED REPLICA
has brass wire-wound connector and brass sequin trim. Note, shells are the old smooth type now very scarce and selling for apx. $1 each. *See p.XXX, Rendez-vous photo of person wearing this style of hairbow.*

ORIGINAL GROS VENTRES NAVAL AMULETS
Top left and bottm left: from an engraving in, Kroeber, A.L., *Ethnology of the Gros Ventres, Vol. 1, Part IV.* Amer. Mus. of Nat. Hist. New York:1908
REPLICAS copied from the black and white drawing in old-time seed bead colors. Sizes(Left to Right):6" L + fringe;11.5"L. and 6"L + fringe.

The following three shoulder bags are all reproductions of what may be the earliest known example of Comanche beadwork in existence. The bag on the far left most closely resembles the original which is now in the Smithsonian Institution.* The craftsman who made all of the bags shown here, shows his expertise at modifying designs and colors, while maintaining historical accuracy. One of the interesting features of this "game bag", as it is called by Berlandier, is the documented use of both seed and larger pony beads on the same early piece.
*See a photo of the original in *Indians of Texas in 1830* by Jean Louis Berlandier, plate 19;Smithsonian Inst. Press, Wash. D.C. 1969. The drawing next to the bag(figure 18) illustrates an identical pouch as one of the war trophies taken from the Comanches who attacked Corpus Christi in June 1844.
Top Right: 1830-STYLE COMANCHE SHOOTING POUCH Fully pony-beaded w/ cranberry, white and Pony Trader blue designs on brain-tanned moosehide. Red "saved list" tradecloth strap is bound w/dk. blue wool and has white and cobalt pony-beaded motifs. Hangs 43"L. Pouch 15"L. Est. 425-550 **SOLD $450(92)**
Bottom right: Another variation by the same craftsman. Note use of both seed and pony beads as documented in the original. This is the author's favorite bag, and has been to many Rendez-vous!

Frank Jondron (or Jandreau)- Yankton Sioux c. 1870 by Zeno Schlinder-Smithsonian Inst.

REPLICA
Here is a rare style tradecloth pipe bag (present existence unknown) which was copied from the black and white photo on the left. Two expert craftspeople made this bag; one the panel and the other made and assembled the bag. Note that the beadwork is not an exact copy-the quilled slats were done very closely to the original design and size(as determined by the usual size of slat width). The colors are unknown but expert replicators had the knowledge to use appropriate colors and materials of the period. Hangs 48"L include. fringe. 7"W.

VII. REPRODUCTIONS OF TRADITIONAL INDIAN ART
Clothing & Accessories

WAR SHIRTS

LAKOTA STYLE WAR SHIRT
Central Plains (Cheyenne & Lakota) "Hair shirts" were loosely fitting...painted yellow & blue to symbolize earth & sky. Hair locks were obtained from family members, not from slain enemies (scalp locks).
 See: Taylor, Colin F, *The Plains Indians*, London: Salamander, 1994:192-3. Old photo of same shirt worn by Kicking Bear, Lakota warrior, and color photo of shirt.
 This is an exceptional replica w/hairlocks of real hair in varying colors(62 in all); wrapped w/rawhide strips;lt. blue Crow beads at top. 3" W. seed-beaded strips in bar & cross motif:white w/t. red, Sioux green , med. blue, black & gr. yellow. Bibs (both sides): heavy red wool w/ white stripes & center blocks of dk. cobalt. Red wool bound neck opening laced w/buckskin. Body of shirt is made from brain-tanned hides painted authentically in blue-green & yellow w/red-ochred tab extensions; fringed all around. Open sleeves-laced side seams. 42" chest. 47" L. Light patina of use. Est. 3000-5000 **SOLD $3000(97)**

NO. PLAINS-STYLE WAR SHIRT
Rectangular bib lazy-stitched in white, C. pink, emerald, t. gold & cobalt. Fully-beaded strips have white bkgrd (same colors) in old-time block & stripe pattern. Green wool bound bibs & neck opening. Red wool "firecrackers" on hair locks. Made of heavy comm. elk hide that looks like brain-tan. Same both sides. 48" chest. Est. 600-1200 **SOLD $775(92)**

Right: YhisWar Shirt is a copy of the original pictured & described in *Art of the American Indian Frontier "The Chandler-Pohrt Collection"* by David W. Penney, pp. 158-9. The original is "C.1860" has quill-wrapped bib fringes & is painted brown w/red-ochre stripes.
CROW-STYLE WAR SHIRT
Commercial buckskin(looks like brain-tan). Green w/bright red-ochre striped painted design w/red wool wrapped human hair locks. Triangular bibs on each side are red & navy wool inlay w/white pony-beaded triangle borders & buckskin fringes. Sleeve & body strips are pred. turquoise, apple green, Crow pink, cobalt pumpkin, red w. heart & white body strips: Apx. 37"x 3.25" Sleeve strips: 21.25"x 3.25" 41"L. Large size. Est. 1500-2500 **SOLD $1350(98)**

BLACKFEET-STYLE PERFORATED SHIRT
Red ochre vertical stripes;lightly red-ochred all-over. Brown painted crosses & tadpoles one side;circles & eagle the other. Red wool trim on sleeves & bibs. White & black pony beaded stripes on shoulder & bibs. Ermine fur strips & black horsehair "scalp locks" at shoulder. 48" underarms. 25"L. Est. 500-700 **SOLD $450(93)**

CROW-STYLE WAR SHIRT c. 1875-style. Seed-beaded strips are pred. Crow pale blue strips w/Crow pink, gr. green, t. dk. green, w. center rose, white & gr. yellow. Red yarn wrapped ermine tubes & human hair locks on bib. Brain-tanned antelope painted w/lt. blue dots. Est. 1800-2500

CONTEMP. BLACKFEET WAR SHIRT
Made by Jimmy Byrd-Blackfeet Indian. Quillwork is from Brother Simon's Mission School in So. Dak. 3" beaded strips are white & t. cobalt stripes w/bright yellow blocks & t.red, white & gr.blue. Front has 5.25" diam. quill wrapped rosette (see detail photo). Horsehair & white ermine drops on the arms. Exceptional white brain tan w/hair on edges. Open arms and sides. Exc. cond. 58" chest. 33-36" L. 23" sleeves. Est. 1700-2500 **SOLD $2450(96)**

GHOST DANCE-STYLE SHIRT
Design motifs are blue stars & red crescents outlined w/black on heavy cotton drill painted. Heavy mustard-colored wool front bib beaded in gr. blue, brick w. hearts & cobalt border. Red wool binding at neck. Goose feather suspensions. Sleeve fringed w/blue & red wool. Hand-sewn. 45" chest-28"L. Est. 185/275 **SOLD $200(91)**

130

NO. PLAINS EARLY STYLE QUILLED SHIRT c. 1840-style.
Two quill diamond technique quilled strips over shoulder(2" W). Quilled sleeve strips have pony beaded "trader blue" edge. Center flap is red ochred w/pony beaded trader blue & white border. Lt. smoked brain tan-tail is on back. Chest-48." Est. 2700-3500 **SOLD $2000(95)**

CREE-STYLE RED STROUD* MEDICINE SHIRT *Inspired by an original rare medicine blanket from Mont. now in a private collection* Made from Hudson's Bay Co. striped selvedge heavy blanketing(hand-dyed). All over black wool circles w/ermine strip & hawk bell drops. Back has 2 drops w/brass thimbles strung w/dk. blue prosser beads. Partially-beaded shoulders & center front rosette in white & Pony trader blue ponies. Back has wool applique spirit man & crescent w/partially beaded edges in mustard seed beads. Sleeve & hem fringes are cut zig-zag w/ black overlay strip secured w/ tiny brass beads. Green & yellow real silk ribbons both sides. 27"L. Est. 900-1500
*See: companion volume, p. 192.

EARLY STYLE SMOKED BRAIN TAN SHIRT
Sinew sewn & fringed at shoulder & arms. Open sides are laced w/buckskin ties. 45" chest. 36"L. 20" sleeves. Est. 600-750 **SOLD $625(96)**

131

NEZ-PERCE STYLE CHIEF'S COAT
*Early Plateau style * worn by person's of important status, ie; Chief Joseph.*
Red undyed selvedge trade cloth w/bright green undyed selvedge cuffs;front opening & back split bound w/indigo white selvedge wool & all edged w/white pony beads. All hand-sewn. Split back has 2 green wool tabs w/brass button & brass tacks. Moosehide beaded strips are early block design in seed beads: Chey. pink, t. cranberry, & turquoise & white pony. Pony trader blue, black, & white pony bead border w/long buckskin fringe.(15"L) Fringes are fine yarn wrapped (1.5") in alt. pale yellow, red & grey spaced w/Pony trader blue beads. Sleeves muslin lined. Strips-31.5" X 3.5". 43.5"L . Est. 1000-1800 **SOLD $1100(98)**

*See: *Sacred Encounters* by Jackie Peterson, p. 113, U. of Okla. Press:1993. and *Wilderness Kingdom* "Indian Life in the Rocky Mtns, 1840-1847," *Journals & Paintings of Father Nicolas Point*, p.104, Loyola U. Press, Chicago:1967 . Shows early drawing c.1846 of similar style red coat w/split back, fancy cuffs & probable beadwork panels.

SEWN QUILLED ROSETTES
Yellow single line center (1.5") w/pred. white outer simple band outer lanes-muted red & blue design elements. (Only 1 shown). 3.5" diam. Est. 175-250 pr. **SOLD $175 (86)**

FLAG WAR SHIRT
Shirts made from flags were popular during the early Reservation Period. U.S. flags were used because Indians liked the bright colors & star designs. Many Reservations celebrated the 4th of July w/gun firing, staged attacks, flag flying etc. This example is made entirely from an old cotton flag. 54" chest; 36" L. Est. 75/125 **SOLD $90(92)**

LARGE SEWN QUILLED ROSETTES
1830-Style
Natural white, black & bright orange dyed quills in simple band sewn technique. Very large 9" diam. on buckskin. Est. 800-1200 *Author's collection.*

QUILL WRAPPED HORSEHAIR ROSETTES 1840-style
Very few craftspeople have mastered this technique. White w/dk. red, orange & purple motif w/red wool applique centers. On smoked brain-tanned hide. Exc. work & cond. 3.14" diam. Est. 200-350 **SOLD $200(97)**

SHIRT ROSETTES 1830-Style.
Striking white & black pony beadwork w/ red wool insert mounted on smoked buckskin. 6.75" diam. Est. 95-150 pr. **SOLD $110(96)**

DRESSES

EARLY STYLE SIDE-FOLD DRESS c.1800-Style.
Very few originals of this kind of dress exist in present day collections. This style is usually associated w/Sioux & Cree tribes. This example has red painted design elements w/ pony beaded borders, & hand-made tin cones. Completely sinew-sewn; brain-tanned hide. Fits sizes 9-13. Est. 900-1500 **SOLD $900(87)**

SIOUX-STYLE INDIAN-TANNED DRESS
Blue & white pony beaded yoke & skirt front; cowrie shells on yoke. Red wool bound neck edge. Long thong fringe on skirt front. 10" long buckskin fringes on sleeve openings; 5-9" fringe on skirt seam & bottom. 46" long excl. fringe. Est. 700-850

CLASSIC SO. CHEYENNE-STYLE HIDE DRESS 1880-Style.
4 smoked brain-tan deer hide construction. Yellow-ochred yoke adorned (both sides) w/3 rows of elk teeth (21-ceramic hand-painted & 110-real.) Czech cut (size 13°) beaded in white, dk. t. green, cobalt & old rose w. hearts. Lazy-stitched rows on shoulder seams & yoke. Neck opening bound w/red wool. Bottom tabs covered w/3 rows of tln cones & two rows of beadwork. Hem has red-ochred panel & row of beadwork embellished w/tin cones. Decorative thongs embellished w/cobalt old Crow beads. 50"L. 34" underarms. Est. 2000/3000

CROW-STYLE ELK TOOTH DRESS
"Son of the Morning Star" movie prop. Over 200 hand-painted ceramic elk teeth (look real) on heavy bright green undyed selvedge trade wool. Red silk ribbon nr. hem & red wool at neck bordered w/ chalk blue beadwork. 51"L. Fits size 9-13. Est. 600-850 **SOLD $475(91)**

BEADED BUCKSKIN DRESS
w/matching beaded fur hair ties. Geometric shoulder design in size 10° beads: lt. blue, cobalt, yellow, green & black. Beaded waist band. Royal blue lazy-stitch stripes follow hem + red cross on both sides. Cream-colored comm. heavy buckskin. Buckskin tie fringes nr. bottom. 47"L. 46" chest. Est. 750/950

INDIAN-MADE WHITE ELK HIDE DRESS Contemp.
Purchased on Crow Res. at Hardin, Mont. Fully-beaded yoke is Sioux style lazy-stitched white bkgrd. Carved bone elk teeth. Long buckskin thongs w/blue Crow beads. Same both sides. High quality brain tanned hides. 48"L. 48" underarms. Est. 2500-4000 **SOLD $2500(96)**

EARLY STYLE CHIPPEWA STRAP DRESS
c. 1750-1800 style. Made of turkey red wool w/mustard yellow undyed selvedge at hem. Straps are blue selvedge wool w/ 6 large sterling silver trade brooches. Bottom hem has 16 smaller brooches. Hand-made silverwork. White pony bead edging on separate sleeve-cape & straps. 48"L. Chest 34." Est. 750-1000

VESTS

CHEYENNE OLD-STYLE FULLY-BEADED VEST
Narrow lazy-stitched rows of white size 13° seed beads; design elements in trans. navy, trans. red, gr. yellow, gr. green, black cuts-many are size 16! The traditional beadwork designs are made w/ authentic bead colors. The craftmanship is extraordinary. Smoked elkhide lined w/red calico; red wool binding w/brass sequins. 20" long X 40" chest. Est. 3500-6000 **SOLD $4000(90)**
For the original, see Conn, Richard, *Circles of the World*, Exhibition Catalog, Denver Art Museum, 1982:85.

CROW-STYLE HEAVY RED WOOL VEST
Imitation elk teeth. Bone button closure & trim along bottom. Blue plaid wool lining. Looks never worn. 40" chest" 24" L. Est. 95-150 **SOLD $95(93)**

BLUE WOOL SHELL DECORATED VEST
Blue wool w/red ribbon binding. Yellow calico lining. Large cowrie shells in rows both sides. Good cond. Chest 36." Est. 40-85 **SOLD $50(95)**

SANTEE SIOUX-STYLE QUILLED LEATHER VEST Sewn quilled stylized floral motifs on vest front. Smoked brain-tan lined w/calico & bound w/red Fox braid. 24" long X 40" chest. Est. 300/450 **SOLD $325(89)**

RED WOOL PARTIALLY BEADED VEST
Stylized floral bdwk. in lt. t. blue, dk. blue, t. gold, mustard, lt. & med. green. Mother of pearl buttons front & border. 2 small front pockets. Back & lining are black rayon. 25"L X 36"L. Medium man's size. Shows some wear. Est. 225-350

LEGGINGS

CROW-STYLE BLANKET PANEL LEGGINGS
Indigo striped wool. Beadwork on bottom panel of red wool in gr. green, gr. yellow, C. pink w/lt. blue border. Bound w/blue Fox braid. Leather ties thongs on front w/1" brass conchos (2 missing.) Slight fading on front adds to patina. Good cond. 32" L. Est. 300-450

C. 1830-STYLE RED BLANKET LEGGINGS
Pony beaded strips in white w/gr. blue block & stripe design. A few holes and worn nap areas. Used. Buckskin ties at top. 35.5"L. Est. 325-450

ASSINIBOINE-STYLE LEGGINGS
on red undyed selvedge wool tradecloth. Pred white seed-beaded applique stitched strips. Beaded stripes on both sides. Calico ties. 32" L. X 13" Est. 450-650 **SOLD $550(87)**

BLACKFOOT-STYLE INDIAN-TANNED HIDE LEGGINGS
c. 1830 style
Pony trader blue & white pony beaded strip. Painted w/red ochre stripes. Unsmoked. 42"L. Est. 650-850

COMMERCIAL HIDE PLAIN LEGGINGS
Decorated w/small brass hawk bells. Slightly used. Fringed. Good cond. 29"L Est. 60-95
SOLD $70(95)

WOMAN'S EARLY-STYLE BUCKSKIN LEGGINGS
Pony beaded border in white, pony trader blue & old red w. heart. Red-ochre spots. Smoked brain tan lined w/white canvas. L-13.5", W-6.25." Est. 195-275

CHEYENNE-STYLE BEADED HIDE LEGGINGS
Classic pattern beaded entire bottom & central panel. on commercial leather. 23"H. plus long fringe at top. Est.300-450 **SOLD $300(93)**

MISC. CLOTHING & ACCESSORIES

CHILD'S BLANKET CAPOTE
Made from an old multi-striped Hudson's Bay Co.-style 100% wool blanket. Fringed hood. 33"L. Est. 75-150 **SOLD $50(91)**

SIOUX FULLY-BEADED MEN'S MOCCASINS c.1970
Superb design & craftmanship. Lazy-stitched in 9 rows; white & t. green bkgrd. w/w. center rose, t. navy, gr. yellow & periwinkle design elements. Red tradewool cuffs. Rawhide soles. 10.75" long. Est. 700-900 **SOLD $650(89)**

WITNEY 3-1/2 PT. CAPOTE
White point blanket capotes were the most popular on the Northern Plains as they were camoflage for Winter hunting & raiding. Entirely bound w/red Fox braid. Red wool undyed selvedge trim on shoulder & tassels plus red wool welting at sleeve & shoulder. Medium size-fits up to size 40" chest. Est. 300-400 **SOLD $175(87)**

SIOUX STYLE, FULLY-BEADED MOCCASINS
White bkgrd. w/pink, lt. blue, gr. yellow, & brick w. heart lazy-stitched. Beaded forked tongue w/red horsehair trimmed tin cones. Red wool bound cuffs. Worn, but all beadwork intact. Est. 200-350

FINGER-WOVEN SASH
Red, black & green wool yarn. Deep arrow motif characteristic of early finger woven pieces. Est. 250-400 **SOLD $185(88)**
*See p.46-47, for original ASSOMPTION sashes & reference information.

Left to Right: **SIOUX-STYLE QUILLED-LINE MOCCASINS**
Red line-motif is said to be a protective symbol. Deep orange quill stripes. Beaded lazy stitch border in med.blue w/cobalt triangles. Heavy latigo soles. Sinew-sewn. Used, but good shape. 10.5"L. Est. 200-325 **SOLD $300(95)**
NO. PLAINS-STYLE PARTIALLY BEADED MOCCASINS
Sioux green, rose w. heart, cobalt & gr. yellow old-time geometric motif. Soiled buckskin-fair cond. Apx. 11"L. Est. 80-95 **SOLD $95(94)**

ASSOMPTION SASH, HAND LOOM WOVEN WOOL
Color matched to old specimens.* Pred. red w/ med. blue, lt. green, yellow & white. Exc. cond. 7.25" W. 4.5 yards L. + 17" fringed ends. Est. 150-300 **SOLD $175(94)**

See p. 148 pipe bags for other descriptions.
Top Right: CROW-STYLE PARTIALLY-BEADED MOCCASINS Keyhole pattern motif. Old-time bead colors:gr. blue, Crow pink, cobalt, t. red & white. Commercial leather. Latigo sole shows use, but tops are in exc. cond. 11"L. Est. 100-150 **SOLD $125(96)**

SIOUX DEER TOE BANDOLIER
Red, white & blue faceted Crow bead dangles w/star-printed red ribbons, cut-out parfleche "arrows" & dozens of fancy cut deer toes & dewclaws adorn harness leather strap-hangs 35." 3" quill wheel at top. Est. 125-200 **SOLD $75(88)**

SIOUX-STYLE PONY BEADED BELT
Fully-beaded on heavy harness leather. Entirely sewn w/artificial sinew using an awl to punch holes. Gr. blue w/typical Sioux box & cross motifs in gr. yellow, old stock rose w. heart, trans. dk. green & black. Fits 36" waist Est. 350-500 **SOLD $325(97)**

OLD-STYLE TACK BELT
Dk. brown heavy harness leather belt w/very attractive brass tack pattern. Masterfully made. Some of this craftsman's belts seen in movie "Maverick". 37.5" L. x 3.25" 45" L. w/buckle & extention. Est. 250-325 **SOLD $250(98)**

OLD-TIME MEDICINE NECKLACE
Shell discs w/5 buckskin bundles decorated w/black, w. heart red, gr. blue & white pony beads. Fringe hung w/old Crow beads in varying sizes & colors. Strung on leather thong. Looks old. Hangs 18"L. Est.150-195 **SOLD $175(92)**

BEAR CLAW-OTTER FUR NECKLACE
Strung together w/lt. blue crow beads. Otter hide is apx. 46"L. Includes head & tail. Legal horn claws 4" L. Est. 250-400 **SOLD $275(95)**

CARVED WOODEN BEAR CLAW NECKLACE
Otter fur mounted w/red w. heart & black pony bead spacers & buckskin tie. Graduated claws 4-5"L. 18"L. Est. 175-300 **SOLD $185(94)**

Left to Right: **BONE HAIRPIPE BREASTPLATE** Strung on buckskin. 3 rows of hairpipe w/heavy harness leather spacers. Center row-2"hairpipe. Outer rows-3" hairpipe. Yellow ochred fringe. Made w/brass beads & green lined Crow beads. Neck strap strung w/brass beads. 1.5" pink abalone shells on top. Expertly made. 8.5"L X16.5 W. 8" fringe. Est. 375-500
BONE HAIRPIPE NECKLACE
2.13" hairpipe aged to look old. Brass beads & dk.blue trans. Crow beads. Strung on buckskin & very well made. 2" rows are 6 bones wide. 18"L. Est. 175-250

KIOWA-COMANCHE STYLE BONE HAIRPIPE BREAST- PLATE
Lightly aged hairpipes w/t. cobalt & opaque cobalt trade beads. Dk. brown leather spacers w/antiqued brass tacks down center. Bones & beads strung on buckskin laces forming side fringes (12"L). At bottom, a German silver cloud pectoral ornament hangs from lightly green ochred thong. 9.5" breastplate. 4" ornament. 10.25" W. Nice patina-looks old. Est. 350-495 **SOLD $300(98)**

SIOUX-STYLE BEAD-WRAPPED CHOKER
Lt. blue w/dk. cobalt, rose w. heart, & gr. yellow stripes & brass beads at center. Beaded drop hangs from 3" conch shell w/brass beads & red wool w/tin cones-same at back attachment. 17" L X 1.75"W. Est. 275-400. **SOLD $275(97)**

OLD-STYLE BLACKFEET BEADED ROPE LOOP NECKLACE White & old rose- red w. heart seed bead wrapped thongs. Harness leather side strips w/brass tacks & brain tan fringe. Lower dangle:2 carved horn griz claws w/deep cobalt large Russians facets (.38" diam. each) w/4 brass beads. Exc. patina suggest age or very expert artifaker. 29"L. Est. 200-500 **SOLD $275(95)**

Left to Right: **BONE HAIRPIPE & CROW BEAD CHOKER** Trans.rose, trans.green & brass beads w/white genuine 1.5" bone hairpipes. Leather spacers & buckskin thongs. Pink conch shell center ornament. Strung on imitation sinew. 14" L. Est. 30-50 **SOLD $30(95)**
BONE HAIRPIPE & CROW BEAD CHOKER
Cobalt blue & brass beads w/brown aged 1.5" hairpipes. 1.5" pink conch shell w/tin cones for center dangle. 14"L. Est.30-50 **SOLD $35(95)**
BONE HAIRPIPE & CROW BEAD CHOKER
Black & brass beads w/brown aged 1" hair pipes. 1.5" pink conch shell w/dangles. 13.5"L Est. 30-50 **SOLD $35(95)**
OLD-TIME 2.5" BONE HAIRPIPE & CROW BEAD NECKLACE
Brass, trans.cobalt, trans.yellow & w. lined green Crow beads. 1.5" pink conch shell w/dangles. Cowrie shell dangles. Imitation sinew construction w/leather spacers. Est.75-150 **SOLD $75(95)**

139

HEAD GEAR

NEZ PERCE OLD-STYLE HACKLE FEATHER BONNET
Yellow & cobalt rooster feathers w/red "firecracker" wool-wrapped quills. Smoked moosehide browband is lt. blue, apple green, cobalt & red w. heart lazy-stitched. White ermine tube front drops hang 18." Light patina. 32"L. Est.400-600 **SOLD $400(93)**

CHEYENNE OLD-STYLE FEATHER BONNET
Made from 35 goose feathers dyed to look like eagle wing spike feathers. Each feather base is wrapped old-style w/red tradewool & sinew. Tips have white ermine tufts & red hackle fluffs. Brow band has pony beaded thunderbird design in black & white w/saw-toothed piece of red tradewool at top. Hat is Indian-tan buckskin completely covered w/ermine strips, red tradewool & decorated center spike. 15"L. Est. 250-450 **SOLD $250(94)**

SIOUX-STYLE LEGAL EAGLE FEATHER BONNET
Red "fire-cracker" wool wrapped feathers w/ muted red fluffs & 10 ermine tube front drops. Pink conch discs either side of brow band. White bkgrd. w/subtle lazy-stitch pattern in pink w. heart, turq., gr. yellow, & t. dk. cobalt. "Lightning" feathers tipped w/ white fur & orange fluffs, red hackles & orange horsehair. Brain tan cap. Exc. construction. Est. 375-800 **SOLD $400(95)**

NO. PLAINS-STYLE SPLIT HORN BONNET
Fringed ermine strips cover buckskin base. Browband is red wool w/9 flat brass buttons. Horns are studded w/brass tacks. Faded red cotton strips on crown w/braided red, blue & brown braid dangles. Long ermine tubes red wool-wrapped. Red twill tape dangles each side. Strung pony beads attach to tips of horn w/brass bells & ermine strips. 29"L-13"W. Est. 500-1000 **SOLD $475(93)**

CHIRACAHUA APACHE-STYLE WARCAP
Sinew-sewn cap of brain-tan buckskin w/characteristic diagonal striped beadwork in porcelain white & black. Trimmed w/6 hand-hammered & stamped German silver conchos & several painted "legal" red-tail hawk tail feathers & 2 fluffs. Est.250-350 **SOLD $250(93)**

BLACKFOOT-STYLE SPLIT-HORN BONNET
Browband lazy-stitched in mustard & cobalt vertical alternating stripes. 4 tubed ermine w/ties either side are red wool wrapped w/red fluffs. Back canvas trailer panel has 12 tubed ermine w/same wrap & fluffs. Horns wrapped w/navy Fox braid & purple satin ribbon;tipped w/ermine strips & long red horsehair drops & connected by old-time pony beads w/ 4 brass hawk bells. Feathers are pink & red fluffs;striped & spotted legal fluffs. Est. 375-950 **SOLD $700(95)**

140

QUILLED SUNDANCE HAIR ORNAMENT
Quilled rosette is 3 rows of basic zigzag. sewn quillwork in red, white, lt. yellow & lt. blue. Center sewn in single thread technique. Edge beaded in med. blue. Smoked braintan. Porcupine & moosehair apx. 5-6"L. Rosette diam. 2.5" Est. 75-195 **SOLD** $150(95)

SIOUX-STYLE QUILLED HAIR ORNAMENT
Quill-wrapped rawhide slats are pred. orange w/white & blue cross motif outlined in black. Pony trader blue beaded edge on heavy leather back-lined w/faded green wool. Hawkbell top attachment. Partially quill-wrapped buckskin thongs at all corners. Brass beads on top. 1.75"W x 8.25"L. 19" nat. black horsehair drops. Est. 275-350 **SOLD** $300(98)

ORNAMENTED BLANKETS & HIDES

TETON SIOUX-STYLE BLANKET
Undyed selvedge navy blanket w/beaded strip & rosettes. Beadwork is white bkgrd. w/t. dk. blue, t. red, gr. yellow, green, & gr. blue. Bound on 2 sides w/red wool felt (pinked). Strip is 57" L. Rosettes are 4.75" diam. Est. 750-950 **SOLD** $750(86)

PRAIRIE-STYLE OTTER TURBAN
lined w/red undyed selvedge wool & top (same) edge-beaded. Front beaded applique piece is gr. yellow, gr. blue & Chey. pink outlined in opalescent white bound w/red wool. 2 side pieces are beaded hands w/weeping heart in old-time colors. Back has "legal" lightning eagle feather drop. Otter band:6"W. Tail hangs 13"L. Est. 200-400 **SOLD** $450(94)

SEWN QUILLED HATBAND W/ROLLED BEAD EDGING
5 rows of quillwork. Basic zigzag & simple band technique. Smoked braintan. Buckskin thongs to tie. L-22", W-1.75." Est. 300-450 **SOLD** $310(95)

See description on p.177 of pipe bag
Far Right: **SIOUX-STYLE WAR MEDICINE HAIR ORNAMENT**
Made w/ mule deer tail. Bead wrapped handle is Sioux green, red white-lined, white, cobalt & gr.yellow. Red & white quilled rosette w/ quill-wrapped thongs & yellow horsehair. 15"L. Est. 160-225 **SOLD** $200(96)

CLASSIC CHEYENNE-STYLE BEADED STRIP
on navy undyed selvedge blanket. 1880-style lazy-stitched strip cut beaded in white, cobalt & old rose w. hearts. Emerald green ribbons on rosettes. Yellow cotton binding on sides. 58"L X 31.5"W. Est. 800-1000

CROW-STYLE BEADED STRIP
on navy undyed selvedge blanket. Size 9° beads in pale blue, red, Sioux green, cobalt & gr. yellow w/red wool inserts around rosettes. Central rosette has dangles of 4 colors of ribbon & 1 ermine; 2 side rosettes have horsehair dangles. Strip is 45" X 5.25" on moose hide. Blanket is 58"W X 75"L. Est. 900-1500 **SOLD $950(96)**

NEZ PERCE-STYLE BLANKET STRIP
on navy undyed selvedge blanket. The rectangular panels are copied from an original Crow blanket strip section that was recyled into a Flathead cradleboard. *(See old cradleboards, page 142 in companion volume.)* All old-style bead colors plus old rose white heart. Rosettes have red wool inlay & twisted thongs at center. Est. 1200-2000 **SOLD $1200(91)**

HAIDA-STYLE WOOL BUTTON BLANKET
Heavy turkey red wool bound w/navy undyed selvedge wool. Eagle & salmon motifs in dk. blue outlined in varying sizes of old mother of pearl buttons. 5'L X 4'W. Est. 900/1500

142

LARGE SIOUX-STYLE PAINTED BUFFALO ROBE
Coup feather design in black, white, & yellow ochre. 3 prs. of thong dangles w/old red w. hearts & aged brass hawk bells. Winter hair-on back. Patinated. Looks old-time. 90" L. X 76." Est. 750-950

"FEATHERED CIRCLE" PAINTED ELK WEARING ROBE
Hair-on the back. Classic geometric design in red, blue & black. 61" X 47." Est. 350-500 **SOLD** $275(93)

PICTOGRAPHIC PAINTED HAIR-ON CALF HIDE
Illustrates a buffalo herd & mounted Indian hunter. Subtle colors. 33" X 36" L. Est. 150-250 **SOLD** $175(86)

OLD-STYLE PAINTED BUFFALO CALF ROBE
Box & border geometric design in red ochre, yellow ochre & indigo. Looks old. 22"W X 34"L. Est. 300-500 **SOLD** $275(94)

OLD-STYLE PAINTED BEAR HIDE
Pipe & stylized feather painted design; single sewn quilled rosette bordered w/gr. blue ponies has quill-wrapped center thongs. Apx. 4' X 3'. Est. 500-775 **SOLD** $600(96)

EARLY PLAINS-STYLE PONY BEADED STRIP ON CALF HIDE
Black, white, & rose w. heart pony beaded strip w/quill-wrapped thongs. Lightly red-ochred hide. Strip is 30" L X 5" rosettes. Hide is 33" X 30." Est. 350-450 **SOLD** $250(91)

143

Pouches & Bags

LARGE BEADED BAGS
PIPE BAGS & MIRROR BAGS

See also PIPES for pipe bags sold w/pipes

1850-STYLE CHEYENNE PIPE BAG
Lightly yellow ochred w/red ochred tabs. Bottom panel beaded in white & black pony beads. Seed-bead white, black & cranberry triangular motifs. Brain-tan antelope. Beaded both sides. 36"L. Light patina. Est.375/550 **SOLD $375(92)**

CHEYENNE-STYLE PONY BEADED PIPE BAG
c.1830 style. Pony Trader Blue, white & black beads. Tin cone trim w/13" thongs. 29" L. Patinated to look old. Est. 300-500 **SOLD $295(87)**

EARLY STYLE PONY-BEADED PIPE BAG
Original cloth pipe bags are rare & very early. Made from Hudsons Bay Co. navy wool stroud * *w/undyed striped selvedge.* Bead colors are white, Pony Trader Blue, & w. lined red. Bottom buckskin fringes quill-wrapped apx. 1.5" w/ red & blue quills. Entirely sinew-sewn. 30" L.X 5. Est. 300-500 **SOLD $275(87)**
* See p. 192 in companion volume for more information.

1840-STYLE PLAINS PIPE BAG & PIPESTEM HOLDER
Leased to the movie "Son of the Morning Star." Red wool undyed selvedge cloth bag & pipestem holder. Pony-beaded on heavy smoked brain-tan buckskin. Bottom fringes of brain-tan leather are corn-husk wrapped. 44" L. Est. 375-600 **SOLD $550(89)**
See: *Akicita*, Exhibition Catalog, Los Angeles, Southwest Museum, 1983:39.

CROW-STYLE PIPE BAG
Diff. design each side in old-time bead colors. 1) Fully-beaded . 2) Stripe motif. Smoked brain-tan. Red-ochred lower pouch. Bottom has long fringe. 36" L X 5." Est.350/500 **SOLD $375(90)**

CROW-STYLE PIPE BAG W/PIPESTEM HOLDER
Original Crow pipe bags are very rare, even in museums. Smoked brain-tan hide. Old-style seed bead colors. Panels diff. each side; one side pred. pale blue, other pred. Crow pink. Bottom fringes wrapped w/yarn. 30" L. X 5.5." Stem holder-2 " W. Est. 600-850 **SOLD $600(87)**

CROW-STYLE BEADED PIPE BAG
Hour glass & cross motif (1 side); Fully-beaded stripes (1 side). Some red ochre. Braided fringe separated by Pony Trader Blue beads & thread-wrapped at top. Hangs 34" L. X 5.5"W. Est.375/550 **SOLD $375(91)**

CROW STYLE PIPEBAG
Beautiful hour-glass diamond design beaded panel bordered w/*old* red trade wool in *old* rose w. hearts, deep gr. blue, Crow pink, turquoise, t. bottle green outlined & bordered in white. Crow stitched. Design goes all the way around. Sides have lazy-stitch lane Top is rolled edge beaded. Med. patina. This piece is so effectively made & patinaed that the consignor sent it to us thinking it to be old! 11.75" L. x 3.5" W. Est. 375-500 Note: The rarity of genuine OLD Crow pipebags is a clue to a possible artifake!

CROW-STYLE WHITE BRAIN-TAN PIPE BAG
Indian-made on the Rocky Boy Res. (Chippewa-Cree). Beaded applique stitch panel is 6" sq. Colors are Chey. pink, gr. yellow, cobalt, lt. blue & brick w. heart "double track" motif. 29"L. Est.250-325 **SOLD $250(93)**

CROW-STYLE MIRROR BAG
Fully seed-beaded-each side different design. Pred. lt. blue, dk. blue, Crow pink, corn yellow panels w/beaded red cloth insert handle on black wool. Bag 9" X 6.25" L. incl. twisted brain-tan fringe. Est. 450-650 **SOLD $475(87)**

145

CROW-STYLE FULLY-BEADED MIRROR BAG
Classic Crow designs in old-time bead colors diff. each side. Rolled beaded edging in same colors. Handle has red wool inserts w/similar bead colors; white pony-bead edged also opening of bag. Alt. red & blue thread wrapped twisted fringe. 5.5"W X 9" L. panel. Hangs 26"L. Est. 450-650 **SOLD $525(93)**

CROW-STYLE FULLY-BEADED MIRROR BAG
Flathead Indian-made. Diff. design each side in typical Crow geometrics:gr. yellow, gr. blue & cuts:lt. blue, cobalt, red & white. Fully-beaded handle bound w/red Fox braid;handle & bag lined in pink calico. 8" white buckskin fringe. 6"W. 25"L Est. 450-600 **SOLD $435(94)**

SMALL CROW MIRROR BAG
Exactly 1/2 scale of usual size! Handle & bag fully-beaded **all cut beads**. Side 1) Hourglass pattern lt. blue bkgrd. w/Crow pink, cobalt, white & yellow, orange & metallic facet accents.
Side 2) Cross within diamonds:apple green w/cobalt, Sioux green, t. red, white, red & dk. cobalt. Handle is bottle green, white, lt. blue red & cobalt. Hangs 13" incl. fringe. 3" W. Est. 250-450 **SOLD $275(98)**

Left to Right: **CROW-STYLE MIRROR BAG**
Fully-beaded w/diff. design each side.in old-time bead colors. Strap is red wool w/dk. blue binding. 15" fringe wrapped w/red & blue thread. Bag excl. fringe L-8", W-5.5." Est. 475-650 **SOLD $650(95)**
SIOUX-STYLE PIPE BAG
Lazy-stitch. Front has early-style concentric block motif in old-time bead colors. Back has step-triangles. Rawhide quill wrapped slat panel is lt. red bkgrd. White brain tan. Light patina. Bag L-25", W-7." Fringe L-23." Slats L-5.5." Est. 500-750

Top far left: CHEYENNE-STYLE MOOSEHIDE PIPE BAG.
Seed-beaded stripe panel(both sides) in Chey. pink, gr. blue, gr. yellow, t. dk. cobalt, brick w. heart, Crow pale blue & white. Slightly red-ochred on inside top & 2 white edge-beaded tabs. Long fringe is alt. red & yellow thread wrapped w/white bead spacers. 34"L X 5.25"W. Est. 500-650 **SOLD $525(93)**

Top center left: CLASSIC CHEYENNE-STYLE PIPE BAG
Center rectangle is orange w. lined & forest green stripes w/dk. cobalt & gr. yellow blocks; Bkgrd. stripes are porcelain white & forest green. Lazy-stitched. Same both sides. Tin cone drops w/dk. red wool inserts. Bottom fringed w/tin cones, hawkbells & red wool at top. Smoked brain tan. Lt patina. 29" L X 5" W. Est. 475-650 **SOLD $485(95)**

Top center right: Left to Right: CLASSIC CHEYENNE-STYLE PIPE BAG
Light smoked braintan w/yellow ochred top flaps. Lazy-stitched. Center stripes are lt.blue & rose w. heart w/narrow gr. yellow & dk. cobalt stripes. Top flaps are lt.blue edge beaded w/red horsehair & tin cone drops. 26" L. X 4" W. Est. 550-700 **SOLD $650(95)**
SIOUX-STYLE PIPE BAG
Lazy-stitched. Each side is different. Side shown has lt. blue bkgrd. w/gr. yellow "hourglass", red w. heart & dk. cobalt outline. Other side has concentric block design same colors. Yellow ochred buckskin. 9" fringe. Total L. 25" X 6"W. Est. 550-750 **SOLD $700(96)**

Top right: LARGE CHEYENNE-STYLE PIPEBAG W/BEADED TABS
Beaded both sides (diff. design each side) on heavy elk hide. Pred white lazy-stitched w/ dk. stone green(unusual opaque bead color), t. cranberry, cobalt & mustard panels & fringed tabs. Same colors 5" wrapped drops w/4.5" thong fringes. Upper part of bag same colors+ dk. red. 3 vertical lanes each side. Exc. workmanship. Est. 600-1000 **SOLD $650(97)**
See original in Hail, *Hua Kola*, Cat. #245. Haffenraffer Mus. of Anthro. at Brown Univ.

Bottom left: SIOUX-STYLE LARGE PIPE BAG
Green ochred top has feathered circle motif-lower pouch is lazy-stitched in pred. lt. blue w/red w. heart panel w/gr. yellow & Sioux green & dk. cobalt cross motif. Quilled slats pred. red w/early style yellow & purple box design. Red horsehair-tin cone fringed. Apx. 37 "L X 6". Est. 1200-1500.

147

CHEYENNE-ARAPAPHO(?)-STYLE PIPE BAG c.1880-style. *A modification of well-known bag from the Denver Art Museum.* Lt. blue bkgrd.w/gr. yellow, cranberry & dk. cobalt unusual design motifs. Pony bead woven lower panel. Est. 500-800
See Feder, Norman, *American Indian Art*, Abridged Paperback. New York: Harry N. Abrams, 1973, p.33.

EARLY-STYLE TOBACCO BAG
Lazy-stitch pony beaded rosette:white bkgrd. w/ dk.cranberry red stripe;chevron design-gr.blue & gr yellow. Center brass spot. Red ochred brain-tanned bag. 5.5" W. 11.25"L. 8" fringe. Est. 160-250 **SOLD $160(96)**

LARGE CHEYENNE-STYLE PIPE BAG
Beaded 1 side on lightly smoked brain-tan hide. Lazy-stitch beadwork in white w/dk. cobalt, gr. yellow, old stock gr. green & old stock rose w. heart. Double beaded triangular tabs on bottom. 26.5"L X 7.5" incl. bottom tabs. Est. 450-550 **SOLD $425(91)**

SADDLE BAGS, POSSIBLE BAGS, ETC.

See description for moccasins, p. 138; pouch. p.155.
Left: **CROW-STYLE PIPE BAG** Contemp. *Made by Jimmy Byrd-Blackfeet Indian.* Beaded both sides; different designs. Side shown has lt. blue bkgrd. w/Chey. pink & blue triangles outlined in white; inside triangle design is bright yellow, pink & maroon. White border w/same colors-also on sides. Lightly smoked braintan. 6.25 W. x 17.5L. 13" fringe. Est. 350-550 **SOLD $475(96)**

FULLY-BEADED POSSIBLE BAG
Lazy-stitched white bkgrd. design in w. lined dk. red, gr. yellow & cobalt blue. Side fringes w/trade beads (incl. 2 blue chevrons), tin cones & an arrowhead. Heavy white brain-tan elk hide. Beaded buckskin carrying strap. 6" X 10.75." Est. 275-400 **SOLD $300(95)**

SIOUX-STYLE FULLY-BEADED SADDLE BAG
Lazy-stitched in old-time Classic design & bead colors:pred. white, w/gr. blue, muted red w. hearts, dk. cobalt, gr. green, gr. yellow & t. cranberry. Heavy buckskin stained golden-yellow. Sides & flap also beaded & embellished w/tin cone & red horsehair dangles. 22"W X 13.5"H. Est. 800-1200

PAIR OF INTERMONTANE-STYLE POSSIBLE BAGS
Narrow stripes of gr. yellow, Sioux green & lt. blue divided by white, dk. cobalt & w. center red. Flap similar colors plus Crow pink. Red wool bound flap & welted side seams w/white edge-beading. White brain tan hide. Apx. 9"W X 14"L. Est. pr. 375-650

PAIR OF SMALL CROW-STYLE POSSIBLE BAGS
Chalk blue bkgrd. w/cobalt & white horseshoe motif. Blocks & stripes are bright red, maroon, forest green, cobalt & white. Beaded flaps and tabs are chalk blue & bright red. White brain tan hide. 7"L x 11.5" W. Est.pr.275-450 **SOLD $275(96)**

CROW-STYLE POSSIBLES BAG
Narrow stripes in lt. blue w/cobalt, Crow pink & gr. green pattern. Flap is Crow pink w/ cobalt, white, gr. green & yellow triangles. Red cloth edge w/white beading. Beaded tabs on bottom. Light smoked brain tan. 8.25" L.11.5" W. Est. 250-450 **SOLD $300(95)**

BANDOLIERS, SHOULDER BAGS, ETC.

UTE STYLE BANDOLIER
Pouch is Crow pink w/apple green, Crow pale blue, gr. yellow & red w. heart bordered w/ white & dk. cobalt. Classic strap pattern is white w/red wool inlay; pred. lt. blue, gr. yellow, & dk. cobalt blocks. Smoked brain-tan hide. Red undyed selvedge wool drop is 16" W X 20" L. 53" Total L. Est. 1400-1850 **SOLD $1325(86)**

BANDOLIER BAG
Style used by Seminole, Choctaw & Cherokee tribes C.1840-1860. Superb craftmanship. Partially beaded on tomato red white selvedge trade cloth. Geometric design on strap:gr. yellow, Chey. pink, black, white & gr. blue. Front flap of bag has a man design in center:turquoise & red w. heart upper body;black lower body outlined in white. Entire piece bound w/ navy blue ribbon; bottom has red & navy tassles. Back of strap & inside of bag are lined w/black & white checked gingham. Bag 9" W. x 10.5" L. Strap 26.5" L x 4.75" W. Est.600-850 **SOLD $500(98)**

149

HEAVY COWHIDE BAG W/FULLY-BEADED STRAP
Well-constructed w/ brass tacks on flap. Lazy stitched strap is white & black blocks, w/red w. line & lt.blue stripes. Bag-6.5"W, 4.75"L. Strap-2"W. X 44"L. Est. 190-275 **SOLD $150(96)**

PLAINS-STYLE RED TRADECLOTH BANDOLIER c.1830-Style. Fully-beaded pouch panel in Pony Trader blue, white, gr. green, gr. yellow, pumpkin & black ponies on brain-tanned moose hide. Sinew-sewn on faded red undyed selvedge cloth. Cloth bottom drop has navy keyhole cloth overlay w/white bead outline. Straps bound w/blue Fox braid. Mattress ticking back. Hangs 48." Est. 350-500 **SOLD $250(89)**

1840-STYLE PONY BEADED POUCH W/STRAP
U-shaped bag & flap fully-beaded w/lazy-stitched black & white aged ponies. Strap is red undyed selvedge w/dk. blue applique in zigzag pattern w/ white pony outline & lt. blue edge beading. 5" buckskin fringe on bottom. Pouch 6" X 6.5". Hangs 48"L. Est. 150-300 **SOLD $175(94)**

ATHAPASCAN-STYLE APPLIQUE SHOULDER BAG
Bag portion is made from an old hand-woven Hudson's Bay Co. sash. Red undyed selvedge strap backed w/mattress ticking; bound w/black Fox braid & appliqued w/ white & navy seed beads. Hangs apx. 45"L. Est. 350-550 **SOLD $325(91)**

Left to Right: **OTTER FUR BAG**
Tail & flap rosette beaded w/Sioux green bkgrd. The cross design is red w. lined, cobalt & cranberry red. Rosette has a tradebead & otter jaw suspended from center. 23"L. 35" open. 5.75"W. Est. 300-500
CROW-STYLE BANDOLIER POUCH
Applique stitch beadwork:pale blue bkgrd w/ gr.yellow, forest green, cranberry red, pink w. lined, dk. cobalt, white & Arapahoe green. Otter fur handle is lined & wrapped w/red tradecloth. Twisted fringe w/tin cones. Light patina. 4.25" W.X 6.38" L. Hangs apx. 30"L. Est. 350-450 **SOLD $390(96)**

NO. PLAINS FULLY-BEADED CASE
Unusual early style pony-beaded on moosehide. One side is cranberry w/white & Pony Trader blue,other side cobalt w/white & Pony Trader blue. Red wool bound opening; painted parfleche interior. White buckskin fringe 9-15"L. Case 13" X 3." Est.325-475 **SOLD $350(91)**

RED WOOL OCTOPUS BAG
Diff. design each side. 1)Stylized bird & hearts in cobalt, lt. blue & pink;2) stylized hearts & flowers in pale blue, cobalt, gr. green, white & gr. yellow. Bound w/blue & black Fox braid. Blue cotton fringe tassels. Handle of pale green & blue braided Fox braid. Red polka-dot calico lining. Hangs 26" X 8"W. Est. 300-400 **SOLD $300(94)**

CREE-STYLE ELK LEG BAG
Made from four legs w/hoofs still attached. Smoked drawstring top & beaded drops in gr. blue & white pony beads. Cloth lined. 15" H. Est. 150-300 **SOLD $150(95)**

150

QUILLED POUCHES

Recommended craft manuals:
Heinbuch, Jean, *A Quillwork Companion*, Liberty: Eagle's View 1990.
Hensler, C.A., *Guide to Indian Quillworking*, Blaine: Hancock House, 1989.
Recommended reference:
Bebbington, J. M., *Quillwork of the Plains*, Glenbow Museum, 1982

PAIR OF SIOUX-STYLE QUILLED SADDLE BAGS
Sewn quilled red stripes;"Star design" is red, dk. purple & yellow. Simple band quill technique. Beadwork is lt. blue & white blocks w/t. dk. red, forest green & gr. yellow. Tin cone dangles w/dk. yellow horsehair. All sinew-sewn on white buckskin. Top 19.75"W. Bottom 14.5" W. X 13"L. Pair Est. 1500-2000 **SOLD $1700(96)**
See original in Brafford & Thom, *Dancing Colors*, San Francisco: Chronicle Books, 84-85.

SIOUX STYLE FULLY-QUILLED PICTORIAL BAG
Striking double horse motif all in simple band sewn quillwork w/bright red bkgrd. Horses are purple & yellow. Border is lazy-stitched beadwork:gr. blue, cobalt, pumpkin, w. lined red & gr. green. Bottom slat panel is quill wrapped pred. red w/purple & white box motif. Hand-made tin cone fringe. Red quill wrapped hanger. Exc. cond. 5.75"W X 10"L+ 1.5" fringe. Est. 400-800 **SOLD $400(97)**

SIOUX-STYLE LARGE QUILLED BAG
Quill stripes & border are bright rose-red. "Antelope" motif is golden yellow & black. Simple band quill technique. Beadwork is lt. blue w/cranberry red, forest green & gr. yellow. Side dangles are quill-wrapped w/red quills & tin cone w/red feathers. Quill-wrapped handle. All sinew sewn on white buckskin. 8.88" W X 13.25" L. Est. 750-1200 **SOLD $650(96)**
See original in Hanson, James, *Spirits in the Art*, Kansas City MO.: Lowell Press. 1994:124

SIOUX-STYLE FANCY QUILLED TOBACCO BAG
Both sides have red stripe motif w/ "antelope" design on front in muted yellow & red. Simple band sewn quill technique. Top panel is dk. red, blue-gray & white sewn zig zag technique. Bottom quill-wrapped panel is red w/blue-gray horse track motif. Fringe has tin cones w/blue-gray horsehair. 3 lazy-stitched beaded rows are white, gr.green, mustard and cobalt. Feather tufts are in lt. blue & dk. red. Two quill wrapped drops are red w/dk. red & lt. blue tin cone feather drop. 14" total L. 4.5"W. Est. 475-650 **SOLD $500(96)**

SIOUX-STYLE FULLY-QUILLED BAG
Similar to preceding in size, beaded border & quill colors. Abstract star?motif. Same quality workmanship. Est. 400-800 **SOLD $400(97)**

HURON-STYLE SEWN QUILLED BAG 18th century style.
Basic zigzag quilling technique-front only. Middle circle is burnt orange & white. Outer circles are lt. yellow w/connecting line in all 3 colors. White quilled edges. Flap design same colors as circles. Strap has single line of white seed beads in "wavy" design. Tin cones at bottom & on flap w/faded red horsehair. Walnut hull stained brain tan. L-6.5." W-8.25." Est. 350-500 **SOLD $375(95)**

151

Left to Right: **QUILLED OTTAWA POUCH** c.1800-style
Zig-zag bands & single line sewn quillwork in dk. orange, black, white. Thunderbird & cross motifs. Tin-cone fringe on bottom. Smoked brain-tan moosehide. 6" X 7." Est. 150/195 **SOLD $150(91)**
EASTERN WOODLANDS QUILLED KNIFE & CASE c.1800-style
Case is light smoked moose w/rawhide insert. Single line quilled orange & white design. Knife handle is buckskin covered & quill-wrapped w/4 quill-wrapped tin cones & horsehair dangles;blade is forged iron file. 9" + strap. Est.250/350 **SOLD $200(90)**
QUILLED OTTAWA-STYLE POUCH c.1800
Smoked moosehide w/single line water panther design on flap;zig-zag bands on bottom. Red, white yellow, & black. Buckskin fringe on bottom. 5" X 8." Est. 125/200 **SOLD $135(90)**

QUILLED OTTER MEDICINE POUCH
Sewn fully-quilled basic zig zag & single line style: lt. yellow border w/purple, red & white panels on tail & feet. Each foot has red horse hair tin cone dangles. Full pelt. Trade bead & cowrie drop from nose. Apx. 48"L. Est. 950-1100 **SOLD $850(89)**

Left to Right: **SIOUX-STYLE QUILLED BUCKSKIN POUCH**
Stylized old-time feather circle design in dk. red, mustard, & white. Simple band quilling technique. Zig-zag quilled edging & band of alt. yellow & white quills. Soft tanned buckskin w/1" fringe. 9.5"L. Est. 200-350 **SOLD $260(94)**
METIS-STYLE QUILLED BUCKSKIN POUCH
Red & white alt. stripe quill border on 3 sides. Flap & center in stylized floral in subdued shades. Single line & simple band techniques. Apx. 3" fringe on sides. 6"W X 5.5"L. Est. 150-275 **SOLD $125(94)**

Left to Right: **CREE STYLE BAG W/ V-SHAPE FLAP**
Bag is black wool w/lt. periwinkle & pumpkin single line beadwork. Buckskin V-shape flap ornamented w/lt. & dk. brown, & yellow quillwork. Bottom tin cone fringe w/red wool. 5.5" L x 4.25"W. Est. 85-150 **SOLD $95(96)**
CREE STYLE BEADED AND QUILLED BAG
Made of black wool w/black cotton & red Fox braid trim. Pink flower w/pumpkin center;green & blue leaves at the top. Single line beadwork at bottom is white, pink w. lined, gr. blue, red w. lined,forest green, pumpkin & med. blue. Quillwork is red, brown & white w/red wool fringe. Red ribbon handle. Est. 220-300 **SOLD $220(96)**

Left to Right: **CROW-STYLE SEWN QUILLED MIRROR BAG**
Horizontal scallop design in purple w/yellow & med. blue diamonds in simple band quilled technique. Strap handle has 3 rows sewn quillwork same colors in stripe/block design. Rolled beadwork on top edges. Hangs 23" incl. buckskin fringe. Pouch is 6.25"W X 9." Est. 300-500 **SOLD $300(93)**
METIS-STYLE QUILLED 3 SIDED BUCKSKIN POUCH
Sewn "zig-zag" quillwork in old-time floral pattern & stripes w/ single line stems. Each panel has many colors. Lavender & pale green silk ribbons sewn along top & hang from bottom. Drawstring top. 13" + ribbon streamers. Est. 375-600 **SOLD $300(93)**

SIOUX-STYLE QUILLED U-SHAPE BAG
Quilled on front only in simple band technique. Colors are dk. red, gray-blue, orange & purple. Each fringe is wrapped w/dk. red quill. Wrapped grey-blue thongs on top & bottom have tin cones & white feather. Smoked brain tan. L-9.75" W-6.75" Est. 200-375 **SOLD $185(95)**

2" QUILLED ROSETTE BAG
Sewn quillwork is lt. red, yellow, & brown w/white single quill outline bordered by red w. lined beads. Brain-tan buckskin. Est. 75-115 **SOLD $80(96)**

SIOUX-STYLE 3 SIDED QUILLED BAG
Quillwork is simple band in dk. red, white & gray-blue. Quilled on all three sides-same design. Drawstring top. Braintan smoked hide. 13"L. 12" diameter. Est. 300-495 **SOLD $250(96)**

OGLALA SIOUX QUILLED BLADDER BAG
Pine Ridge, So. Dak. Buckskin ends have quillwork in muted colors. Red ochred buckskin fringe along the opening. Filled w/undyed quills. 13"L. Est. 175-250 **SOLD $225(96)**

QUILLED MINI PIPE BAG (center)
See p.183 for description of fetishes.
Quilled slats are yellow w/ dk.blue crosses. Bag is white w/ design in yellow, blue, red, & pink. Rolled edge beading is cranberry, red w. lined, cobalt, Sioux green & gr.yellow stripes. Made of smoked braintan. 16.5" L x 2.5" W. Est. 200-300 **SOLD $225(96)**

PARTIALLY QUILLED POUCHES
Bright sewn quillwork w/long bottom thongs w/tin cone & Crow/brass bead ornamentation. Neck thongs. Edge-beaded. Apx. 2.5" X 3." $45(96) Trading Post Catalog

SMALL BEADED POUCHES

Left to Right: CHEYENNE-STYLE TOBACCO POUCH
Beaded bkgrd. is lt.blue w/"step" design in cobalt, gr. yellow & cranberry red. Same colors-side & rolled edge top. Made of red ochred buckskin. Twisted fringe. Bag is 8.25" L x 2.5" W. 8" fringe. Est. 225-275 **SOLD $250(96)**

MINIATURE CHEYENNE-STYLE PIPE BAG
Old-time bead colors: gr.yellow, red w. lined, gr.blue & white. Top tabs are edge-beaded w/ tin cones & red cloth dangles. Fringe is red & white quill wrapped. Beaded both sides. Made of lightly yellow ochred buckskin. 8.5" L x 2.13"W. 14" fringe. Est. 275-400

MINI CROW-STYLE PAINT POUCH
T. cobalt & pumpkin w/white border on lt.blue bkgrd. Cranberry edge-beaded tabs. Red wool trim. Made of lightly yellow ochred buckskin. 2.13" W. 5.25" L + 5" twisted fringe. Est. 125-200 **SOLD $125(96)**

Left to Right: SIOUX STYLE STRIKE-A-LITE BAG
Lazy-stitched in white, gr. yellow, gr. blue, rust & red w/tin cone fringes. White brain-tan. 6" L X 4." Est. 60-95

SIOUX-STYLE LAZY-STITCHED TOBACCO BAGS
1) Crow pale blue, med. blue, & brick w. heart panel. Edge-beaded flaps. Smoked brain tan. 15" X 4." Est. 75-95 **SOLD $70(89)**
2) Lt. blue, periwinkle, red & pink panel. Edge-beaded flaps. Brass hawkbell & Crow bead trim. Smoked brain-tan. 21" X 4" incl. fringe. Est. 75-95 **SOLD $85(89)**

FLATHEAD-INDIAN MADE OLD-STYLE BEADED TOBACCO POUCH
Stripes are gr. yellow, dk. cobalt, lt. blue, & red w. heart. Buckskin thong at top w/brass beads, bone hairpipe & red w. heart Crow beads. Buckskin. Front lined w/printed calico. 4"W X 7.5" L. Est. 175-250 **SOLD $175(94)**

Left to Right, Top to Bottom: CROW-STYLE MOCCASIN TOE POUCH
Fully-beaded in Crow pink, white, dk. blue & green stripe motif. Leather fringes w/tin cones along side. Copper concho button on flap. Hangs 18" plus 2 long twisted thongs w/ red tradecloth in tin cones. Est.100-150 **SOLD $65(89)**

CROW-STYLE HOURGLASS POUCH
Fully-beaded in Crow pink, turquoise, gr. yellow, white & dk. blue. 6 twisted leather dangles w/blue Crow beads & tin cones. Apx. 15" long. Est. 100-150 **SOLD $75(89)**

CROW-STYLE RECTANGULAR POUCH
Fully-beaded w/Crow pink,gr. yellow, red w. heart, white & cobalt design. Long twisted leather dangles have ermine & tin cone trim. Apx. 20" total L. Est. 95-150 **SOLD $95(89)**

Left to Right: CHEYENNE-STYLE BEADED PAINT BAG
Beaded both sides in stripe motif:white, gr. blue, cobalt, t. gold, forest green & old-stock transl. pink. Bead edging at top. Smoked brain tan. 2.75" W X 9" L incl. fringe. Est. 75-125 **SOLD $85(91)**

CROW-STYLE FULLY-BEADED STRIKE-A-LITE BAG
Classic hour glass pattern:transl. old pink, pink w. heart, t. navy, pale blue, mustard & white. Aged tin cone fringes on flap & bottom. 4 tin cone & lt. blue opaque Russian facets on suspensions. Ochred hair pipe on top thong. 3.75"W X 13" L. Est.125-175 **SOLD $125(91)**

Left to Right: LAZY-STITCHED STRIKE-A-LITE BAG
Beaded both sides. Step triangle in lt. blue w/white, t. lt. green, red w. heart, rose w. heart & lt. blue. Beaded edge is rose w. heart & white. White brain tan. L-5." Est. 200-295 **SOLD $200(95)**

PONY-BEADED BLADDER BAG c.1830 style.
Buckskin top w/Pony Trader blue, white & old red w. hearts. Previously used for tobacco. Apx. 6" L. Est. 95-150 **SOLD $105(95)**

See Pipe bags p. 148 for descriptions of other items.
Bottom Right: KIOWA-STYLE POUCH
Made of heavy cowhide. Design is cranberry red bkgrd. w/ black & white design. Aged tin cone fringe. 4" Widest pt.-6"L. Est. 275-350 **SOLD $300(96)**

Left to Right, Top to Bottom: TURTLE SHELL POUCH
Gr. yellow & cranberry red diagonal stripe design on flap. Buckskin neck strap. 4" long fringe. 4.75" L X 4.25" W. Est. 40-85 **SOLD $45(95)**
SIOUX-STYLE MINI TIPI BAG
Sioux green stripes w/cobalt & gr. yellow blocks; also cobalt & rose w. heart. Side dangles w/tin cones & faded red fluffs. Heavy patina. 4.25"LX3.25"W Est. 100-200 **SOLD $100(95)**
APPLIQUE FULLY-BEADED POUCH
Pale blue bkgrd. w/design in pumpkin, brick w. lined, copper facets & med. blue outline. Bead wrapped leather thongs. 4.25"L X 3.25"W Est. 95-125 **SOLD $125(96)**
CROW-STYLE MINI PIPE BAG
Lazy-stitched in lt.blue w/Sioux green, pink w. lined, dk. cobalt, pumpkin & cranberry red. Smoked brain tan. 12"L w/fringe. W-3.25." Est. 150-250

1830-STYLE PONY-BEADED STRIKE-A-LITE POUCHES
Each is made of smoked moosehide-tin cone fringes on beaded flap & bottom.
Left: White & black geometric motifs. Black rectangular designs w/red w. lined Crow beads & white oval old trade beads. 2.25" W X 5" L incl. tin cone fringes. Est.85-150 **SOLD $95(93)**
Center: Cranberry red w/white geometric motif- twisted long bottom thongs w/tin cones. 5" W X 6.5" excl. fringe. Est. 120-200 **SOLD $135(93)**
Right: SO. PLAINS-STYLE FULLY-BEADED STRIKE-A-LITE
Lt. blue cut beads & cranberry, dk. cobalt, gr. blue w/white outlines. Hand-made tin cone fringe on bottom & flap. Mescal beans & dk. blue Prosser beads on top thongs. 6" L. 3" W. Hangs 12" incl. twisted buckskin side thongs w/ tin cones. Aged. Est.195-300 **SOLD $125(93)**

TRIANGULAR FLAP BAG
Lazy-stitched & fully beaded front flap on thick buckskin. Pred. white, w/ *old* red w. hearts & periwinkle beads. Bag has beaded border & roll beaded edges. Thong drops have tin cone ends. Wrapped beaded fringe "tassel" at flap bottom w/ tin cones. Heavily patinaed.4"W x 4"L. Flap 11.5" incl. fringe Est. 125-250 **SOLD $100(98)**
Note: Consignor believed this piece to be old. Made as an "artifake," clue here is hide patina inside & outside too dark (smells like oil) in contrast to lite patina on beads.

TRIANGULAR FLAP BELT POUCHES
Original in Ida. Historical Society, Boise. Border beaded flaps in triangular motifs 1)white & black w/bead wrapped thong suspension 2)same w/red w. heart & white 3)cranberry & white w/tin cone decoration flap & pouch. Each edge-beaded & yellow-ochred smoked buckskin. 7" flap 3.5" sq. pouch. Est. 60-95 each **SOLD $50 each (89)**

155

Left: **TRIANGULAR BELT POUCH, AWL CASE & BELT W/TABS**
mid-19th century style
Seldom seen in old photos; sometimes w/women wearing them. Seed beaded in white, w. center red, pumpkin, & black. Ornamented w/tin cones & red wool. Edged-beaded in white ponies. Smoked moosehide. Apx. 60"L. Pouch apx. 10"L X 4"W. Est. 250-350

Right: **FLATHEAD INDIAN BEADED TRIANGULAR FLAP POUCHES**
late 19th century-style.
Each has fully-beaded flap w/red Fox braid binding & dangles. Plain buckskin pouch w/Crow/brass bead & tin cone dangles. Flap apx. 8" L.- pouch 4" sq. Est. 150-200. **SOLD $125(85) Trading Post**

CHEYENNE-STYLE WOMAN'S AWL CASES
Seed bead wrapped w/5" long flap closures trimmed w/4 tin cones. Rawhide inner wrapped w/ buckskin. Case is apx. 8" L.
1) Pred. lt. blue w/rose w. center, gr. yellow, Sioux green, Chey. pink & dk. cobalt. Flap white edge-beaded. Brass beads on top thong. Long twisted fringes on bottom (not shown). Est. 125-175 **SOLD $125(87)**
2) Gr. yellow, periwinkle, & w. center red. Flap edge beaded w/navy & white. Top thong has brass & trade beads. 8" L. buckskin dangles beaded in white & navy. Est. 125-175 **SOLD $125(87)**

CROW INDIAN-MADE WOMAN'S AWL CASE
Shown fastened to dress top as seen at 1986 Crow Fair. Fully bead-wrapped. Buckskin top is beaded both sides w/tin cone trim. Rawhide inner wrapped w/ buckskin. Colors: lt. blue, gr. yellow, med. green, white, t. blue & w. lined rose. White & blue Crow beads on attachment thong. Case is 7" plus 3" edge-beaded buckskin dangles on bottom. Est. 125-175 **SOLD $95(86)**

Left: Left to Right: **PONY BEADED POUCH**
Gr. blue bkgrd. w/white hour glass design. Short strap w/trade beads. Heavy brain tan. 6" L X 4.25" W Est. 135-175 **SOLD $150(95)**
FULLY-BEADED POUCH W/TAB
Lazy-stitched white bkgrd. w/dk. cobalt, gr. yellow & cranberry red design. Bottom tab is fully-beaded & bound w/red wool. Tin cone fringe & drawstring top. White brain tan. Total L-11.5." W-3.75." Est. 80-175 **SOLD $139(95)**

Right: **CROW-STYLE BEADED RATION POUCH**
Unusuual U-shaped configuration. Old-time bead colors on smoked buckskin. Side thongs trimmed w/brass beads; tin cones on beaded tab. 3.25"W X 8.5"L. Est. 195-275 **SOLD $120(87)**

Left: **CROW WOMAN'S AWL CASE**
Same construction as preceding. Colors: pred. white & t. red w/ lt.blue & forest green. 7" case has 7" beaded dangles w/tin cones. Est. 125-175 **SOLD $125(92)**
SIOUX/CHEYENNE-STYLE BEADED NECK POUCHES
Fully-beaded 1 side. White brain tan. Each is 1.5" X 2.75" on thongs. Est. 65-85
Center: White w/lt. periwinkle, cobalt & gr. yellow geometrics. **SOLD $60(92)**
Right: White, Sioux green, w. heart. Pink & cobalt geometrics. **SOLD $60(92)**

Left: **EARLY PLAINS-STYLE HOURGLASS NECK POUCHES**
Each is smoked brain-tan w/twisted thongs & lightly red-ochred. Fully-beaded stripes. Buffalo-wool stuffed. Est. 75/95 **SOLD $75 each (90)**
Left to Right: A) White pony, gr. green & w. center red seed beaded; red tradewool drop w/blue wool keyholes white edge-beaded.
B) Black, gr. yellow, red w. heart pony beaded w/4 pearl buttons on bottom flap. Yellow ochre long fringes. Pony trader blue edge-beaded.
C) Pony trader blue,white & red w. heart pony beaded. Red wool drop w/large pearl button & ermine strips.

Right: **BEADED MEDICINE POUCHES**
Each one different. Fully-beaded in old-time colors w/edge-beading. Crow bead thong fasteners. Smoked brain tan leather w/bottom fringes & twisted thongs to wear around the neck. Bag apx. 2.5" X 3" excl. fringe. Est. 35-55 **SOLD $35 TRADING POST 96**

Painted Rawhide Items (Parfleche)

COMANCHE-STYLE PARFLECHE
1830-Style
Original in Smithsonian Inst.; collected by George Catlin, C.1834 Triangles in dk. red w/ black outlines & blocks. Rawhide painted w/clay & hide glue paints. Buckskin fringe sewn w/deer rawhide. Dk. smoked & red ochred patina. L-10.75" W-10.25" Fringe-23." Est. 190-275 **SOLD $250(95)**
See: Torrence, Gaylord, *American Indian Parfleche,* Seattle, U of Wash. Press, 1994:140.

SIOUX-STYLE PARFLECHE W/ LONG FRINGE
Red ochre cross hatch & geometric designs in cobalt & yellow ochre outlined in black. Flap is cut-out triangles. Back has vertical stripes in red ochre & black. Heavy brain-tan fringe hangs 40." Case is 14.5"W X 10.5"L Est.350-425 **SOLD $350(93)**

BLACKFOOT-STYLE PARFLECHE BAG
Geometric motif in yellow, red ochre & dk, green. Red tradewool trim. Lightly patinated w/red ochre. 12" W X 9" H. Fringe hangs apx. 22." Est. 200-300 **SOLD $150(87)**

PARFLECHE BAG
Design in vermillion & mustard yellow ochre w/wide cobalt outline & center stripe. Fringed flap. Laced w/buckskin. Heavy patina. Looks old. L-12." W-12." Est. 200-300 **SOLD $125(95)**

NO. PLAINS-STYLE PARFLECHE BAG
Red-ochre & dk. green painted geometric design. Buckskin fringe on sides & flap. Red cloth trim on flap. Green stripes on back. Hand-pounded buffalo rawhide. Subtle patina. 13" L. X 10" W. Est. 200-300 **SOLD $150(86)**

Left to Right: ARAPAHOE-STYLE PARFLECHE CASE 1850-Style.
Fringed, quill-wrapped & pony-beaded upper flap. (see detail photo). Design elements are red ochre & med. green outlined in black. Smoked brain tan side fringes:24"L. Light patina. 9.5" x 9.75." Est. 200-350 **SOLD $275(96)**
See: Torrence, *American Indian Parfleche*, p.127.
CROW-STYLE PARFLECHE CASE
Navy over red wool beaded & fringed flap. Saved list red wool bound. Muted red, yellow, green & blue-outlined in indigo. Long white brain tan fringe:36"L. Buckskin laced & tied. 10.5" X 11.5." Est. 225-325 **SOLD $225(96)**

NO. PLAINS-STYLE PARFLECHE BAG
Muted green, red, yellow ochre w/indigo outlines. Red wool binding. Buckskin laced. Hangs 15"L. Light patina. 9.75" W. X 9" H. Est.150-250 **SOLD $90(93)**

BUFFALO HIDE ARAPAHOE-STYLE PARFLECHE BAG
Dark colors in green & red w/ brown outline. Diff. design each side. Laced w/buckskin. Heavy convincing patina-looks really old. L-12.5." W-11.5." Est. 200-300 **SOLD $190(95)**

PR. OF PAINTED PARFLECHE BAGS
Horseshoe shaped in red & yellow ochre, olive green, blue outlined in black. Red undyed selvedge wool bound w/buckskin thongs.12" X 12" X 4.5." Est. 325-425 **SOLD $350(94)**

158

Upper Left: PARFLECHE ENVELOPE
Red ochre & lt.green triangles w/cobalt, green & yellow lines. Dk. brown outline. Navy undyed selvedge trim binding laced w/ buckskin. Light weight rawhide. L-14.5." W-14." Est. 150-250 **SOLD $150(95)**

Lower Left: BUFFALO PARFLECHE MEDICINE BAG
Boat-shaped. Bright geometric in red & yellow ochre, cobalt, & green w/cobalt outline. Red undyed selvedge binding laced w/buckskin. Heavy rawhide. L-14.5." W-7 ". Est. 100-195 **SOLD $150(96)**

Far Right: SIOUX-STYLE PARFLECHE CYLINDER
Bold colors in red, yellow ochre, & green w/ dk. blue outline. Top & bottom ends painted. Buckskin tie thongs & fringed bottom. L-18." Est. 130-175 **SOLD $175(95)**

Left to Right: CHEYENNE-STYLE FOLDING PARFLECHE
Geometric design in subdued blue, red, & yellow w/black outline. Blue outline on back. Gray-tone heavy rawhide. Patina-looks old. L-28" W-14.75." Est. 250-475 **SOLD $400(95)**

LARGE SIOUX-STYLE ELIPTICAL PARFLECHE BAG
Geometric pattern in red ochre, yellow, cobalt, & green w/brown outline. Back has cobalt stripe pattern. Laced w/heavy cord and buckskin. 2" fringe. Brain tan buckskin bottom & top w/drawstring. L-23." W-12." Est. 150-300 **SOLD $150(95)**

SIOUX-STYLE PARFLECHE BOX
Bright colors:green, red, yellow & blue w/black outline. Heavy rawhide. Buckskin ties & lacing. 18"L. X 12"W X 9.25"H Est. 250-400 **SOLD $250(96)**

Left to Right: LARGE PARFLECHE BOX
Bright colored design in yellow, red ochre, & green w/wide cobalt outline. Laced w/buckskin. L-14" W-8" H-5" Est. 275-400 **SOLD $300(95)**

SMALL PARFLECHE BOX
Muted colors in red & yellow ochre, cobalt, & green w/dk. brown outline. Laced w/buckskin. L-6.75" W-5" H-2" Est. 60-125 **SOLD 65(95)**

SIOUX-STYLE BUFFALO PARFLECHE BOX
Design in red & yellow-ochre, indigo outlined w/black. Red tradewool bound on 4 corners. Very sturdy w/light patina-looks old-time. Est. 200-375 **SOLD $250(94)**

LARGE CROW-STYLE FOLDING PARFLECHE
Old-time colors:Red-ochre, yellow-ochre, yellow-green & indigo geometric elements outlined in indigo & bordered w/green. Heavy cowhide. 13"W X 23"L. Est. 250-375 **SOLD $250(94)**

SIOUX-STYLE LARGE FOLDING PARFLECHE
Red ochre, yellow ochre, indigo & muted green w/black outline. Smoked brain tan ties. Elkhide. Light patina. 13"W x 20.5"L. Est. 250-325 **SOLD $300(96)**
See: Torrence, *American Indian Parfleche*, p.95

Above: **SIOUX-STYLE PAINTED PARFLECHE CASE**
Blue, yellow, red & green w/ blue outlines;painted each end. Brain tan thong fringes. Somewhat wrinkled; otherwise, in good cond. 17" L. w/10" fringe. Est.150/225 **SOLD $125(89)**

BLACKFOOT-STYLE CYLINDER PARFLECHE
Yellow ochre, green, black, & pale orange. Elk dry-scraped rawhide & clay paints. Buckskin ties fringe. Heavy smoke patina. L-20.5." Est. 125-225 **SOLD $150(95)**
See: Scriver, Bob, *The Blackfeet*, Kansas City: Lowell Press, 1990. Bear Knife Bundle; pp. 240-245.

LARGE PARFLECHE CYLINDER
w/long buckskin fringe. Used for warbonnet or medicine case. Red, yellow & deep blue outlined w/black. Painted ends. Lt. patina-looks old. Case is 21"L. Fringe hangs 21." Est.350-450 **SOLD $425(92)**

Below: **KIOWA-STYLE CYLINDER** c.1850-Style.
Red & dk. green clay paints. Deer rawhide w/ buckskin fringe and lace. Heavy smoke patina. 15" L. Est. 125-200 **SOLD $125(96)**
See: Torrence, *American Indian Parfleche*, p.135
CHIRICAHUA APACHE-STYLE, PARFLECHE QUIVER c.1890-Style.
Top has rawhide cutout over red Pendleton wool w/aged tin cone dangles. All natural paints on elk rawhide. Smoke patina. 30.5" L. Est. 250-325 **SOLD $325(96)**
See: Torrence, *American Indian Parfleche*, p. 156.
Additional reading:
Morrow, Mabel, *Indian Rawhide*, Norman: Univ. of Okla, 1975.

NEZ PERCE-STYLE LARGE CYLINDER
Heavy cowhide painted yellow ochre central diamond w/triangular elements in dk. cobalt, muted green & red ochre. Both ends painted w/star motifs. 32" L. heavy brain tan fringe. 22.5" cylinder. Est. 275-395 **SOLD $425(96)**
See:Torrence, *American Indian Parfleche*, p. 225.

160

Weapons, Sheaths & Scabbards

KNIFE SHEATHS & KNIVES

Left to Right: NO. PLAINS-STYLE FULLY-QUILLED KNIFE CASE
Simple band-style:white w/periwinkle & mustard step-triangle & cross motifs. Tin cone fringe. Heavy rawhide liner. Long buckskin neck strap. 2"W X 7"L. Est. 200-300 **SOLD $275(94)**
CREE-STYLE QUILLED KNIFE CASE
Stylized floral motif in lt. blue, red, brown & yellow. Top is fully-quilled in alt. stripes of yellow & brown. Zig-zag, simple band, single thread, & 2 quill triangle edging techniques. Heavy rawhide liner. Long buckskin neck strap. Quill wrapped buckskin thong drops w/lt. blue horsehair tin cones. 2.25"W X 7"L. Est. 175-250 **SOLD $175(94)**

QUILLED KNIFE CASE & HAND-MADE KNIFE
Eastern-style. Brain tan buckskin. Golden yellow, white, & grey-blue quills. Tin cones. Knife has bone handle. Quillwork is *woven* central white panel & 2 color zig-zag stripe bands & simple band! Tin cones hang at bottom. Rawhide insert. Tiny dag has heart shaped opening on blade;ivory handle has hole w/braided buckskin tie. 6.5" L. x 2.5" W. Knife 6.5"L. Est. 400-550 **SOLD $375(98)**

LARGE SIOUX-STYLE FULLY QUILLED KNIFE SHEATH
Combined zig-zag & simple band techniques in:white w/lt. blue, yellow, red & dk. blue. Lazy-stitched border in white, brick, red w. heart, dk. & med. blue. Tin cone fringe w/red horse hair. Twisted fringe 6"L. Thick rawhide insert. 8.5"L X 3"W. Est. 250-400 **SOLD $285(94)**

NO. PLAINS-STYLE FULLY QUILLED KNIFE CASE
Unusual design in burnt orange zig-zag style w/white, pink, red & yellow motif outlined w/single line dk. blue. Rawhide insert. Twisted buckskin neckstrap. 2.5"W X 7"L. Est. 175-250 **SOLD $275(94)**

Left to Right: PARTIALLY QUILLED KNIFE CASE
Basic zigzag quill technique. Bright red w/yellow, white & dk. blue geometric design. Quill wrapped thongs at bottom w/tin cones. Rawhide insert. White brain tan w/lt. red patina. Twisted leather neckstrap. L-7." W-2.25" Est. 100-175 **SOLD $175(95)**
OTTAWA EARLY-STYLE QUILLED KNIFE CASE
Simple band quillwork. White bkgrd. w/red border;design in lt. purple, yellow & red. Red wool top w/Pony trader blue beads. White brain tan w/rawhide insert. Braided leather neckstrap. 8.5"L X 2"W. Est. 150-250 **SOLD $150(96)**
PLAINS-STYLE FULLY QUILLED KNIFE SHEATH
Dk. red bkgrd. w/grey-blue & pale yellow geometric motifs. Simple band quill technique. Rawhide insert. Short leather strap. 8"L 2.25"W Est. 200-350 **SOLD $375(95)**

SIOUX-STYLE PICTORIAL KNIFE SHEATH
Partially-beaded bottom is Indian w/warbonnet; fully-beaded top has horse motif. All in old style seed bead colors. Long buckskin fringe. Red-ochred brain tan over heavy leather. Est. 350-500 **SOLD $250(88)**

161

Left to Right: NO. PLAINS-STYLE QUILLED & PONY-BEADED KNIFE SHEATH c. 1840-Style.
Top is lt. yellow zigzag quilling w/Pony trader blue seedbeads outlined w/orange single line quill. Bottom is pony beaded in t. dk. blue & white. Tin cone fringe. Edge laced w/sinew. Dk. green stained rawhide. Patinated. L-10", W-3.25." Est. 300-375 **SOLD $300(95)**
SIMILAR w/brown stained rawhide Additional quill-wrapped thongs w/tin cones attachment. Est. 300-395

Below: SIOUX-STYLE KNIFE CASE W/OLD KNIFE
Beautiful colors: pred. gr. blue, w/gr. yellow, pale rose w. heart & dk. cobalt sinew-sewn & lazy-stitched. Top has hour glass motif; bottom is concentric stripe border design. Roll bead top edge is dk. cobalt. Row of hand-made irregular size tin cones. 4 bead-wrapped thong suspensions (9-10"L) w/tin cone & horsehair drops. Case 11" X 3.5"W. Heavy latigo liner w/dk. buckskin cover. Very nice "artifake."
NOTE: Consignor thought this was an old piece-CLUES Darkened leather shows no wear or change in interior patina. Tin cones are blackened, not aged naturally. Beads are new repros. Horsehair multi-colors not usual solid color. Est. 250-350 **SOLD $275(98)**

OLD-TIME QUIRT STRAP HANDLE
White applique borders & hour-glass motif w/ rose w. heart, gr, yellow & cobalt stripe central panel over red wool. Black Fox braid bound. Pale green wool tassels. Plaid lining is red ochred. Patinaed to look old. 24"L X 2"W. Est. 90-150 **SOLD $125(98)**

ATHABASCAN-STYLE DAG CASE
Red wool trade cloth partially applique-beaded in white, gr. blue & cobalt beads. Case & strap edges are bound w/deep red Fox braid & bead edged. Back of strap is lined in black w/tiny white stars calico. 4" W. x 11"L. 28" strap. Expert workmanship. Est. 175-250 **SOLD $215(98)**

Left to Right: SIOUX-STYLE FULLY-BEADED KNIFE SHEATH
w/old butcher knife Buckskin covered rawhide & lazy-stitched in pred. gr. yellow. Yellow-dyed horsehair & hand-made tin cone dangles. Hardwood knife handle has brass rivets. Slight patina. Length 16." Est. 250/300

LARGE SIOUX -STYLE FULLY-BEADED KNIFE SHEATH
w/old butcher knife. Rawhide covered w/buckskin lazy-stitched in pred. lt. blue. Hand-made tin cone fringes & red-dyed horsehair & tin cone dangles. 4" X 21" total L. Est. 275/350

LARGE SIOUX-STYLE KNIFE SHEATH W/BEADED HANDLE
Buckskin covered rawhide in lazy-stitch pred. lt. blue & gr. yellow. Hand-made tin cone fringe & red-dyed horsehair w/tin cone dangles. 4" X 20" long. Est. 275/35

CANADIAN-CREE STYLE KNIFE SHEATH
Fully-beaded on buckskin over rawhide in pred. t. dk. green, lt. blue, gr.yellow & t. red seed beads (old stock). Aged tin cone fringe & thongs. 9" X 4". Est. 300-450 **SOLD $250(86)**

NO. PLAINS-STYLE FULLY-BEADED KNIFE SHEATH
Mustard bkgrd. w/cranberry cobalt & apple green geometric design. Bottom drop is bead wrapped same colors. Red horsehair tin cone drops. Lazy-stitched buckskin over rawhide sheath. 10.75"L. Est. 350-475 **SOLD $350(95)**

Left to Right: **BLACKFEET-STYLE BEAVERTAIL SCABBARD W/DAG KNIFE** Flathead Indian made fully-beaded beadwork panel in Chey. pink, t. cobalt, & red. Horse tracks motif in white, pink,& turquoise. Bound w/red Fox brand braid. Durable heavy cowhide lining. Est. 350-500 **SOLD $250(88)**

DAGGER ONLY 6.5" hand-forged steel blade w/hardwood handle w/copper rivets. Est. 75-95 **SOLD $55(86)** Trading Post

SIMILAR. Red w. heart, dk. cobalt, lt. blue & white bear paw & cross old-time motif, includes dag knife. Est. 350-500

SIMILAR. Partially-beaded in rose w. heart, gr. yellow, lt. blue, Chey. pink & dk. cobalt w/red wool inlay. Edge-beaded. Includes Dag knife. Est. 350-500 **SOLD $195(86)**

HUDSONS BAY DAGGERS & SCABBARDS

The following 5 items are copies of a unique knife & case style that was traded by both the Hudson's Bay Co. & Northwest Co. in the 19th century. The knives are called Hudson's Bay "hand dags" or "beaver tail stabbers" & are the only knife style made exclusively for the Indian trade. They were generally found among the Indians of the Northern Plains & Western Canada.

Ilustrations of four documented museum specimens can be found in: Russell, Carl P. *Firearms, Tools Traps of the Mountain Men* New York, Alfred A. Knopf,1967:174-177.
Grant, Madison *The Knife in Homespun America*, York, Pa: Maple Press, 1984:117-21;132-3.
Hanson, Chas. "The Hand Dag," *Museum of the Fur Trade Journal,* Vl.#1, Chadron, NE. 2-5.

The special sheaths to hold this shape knife usually features an unusual "beaver tail" tab on the bottom.

See displays of several original Blackfeet dags & sheaths at the Glenbow, Calgary, AB, Canada & Buffalo Bill Historical Center, Cody, Wyo.

CREE-STYLE DAG CASE & KNIFE. Sewn quillwork-faded red, yellow & white on buckskin over rawhide. (80)11" looped quill-wrapped red & white thong trim. 12" long sheath. "HBC-style Dag" w/antler handle & copper rivets. 8" blade-7" handle. Both are patinated. Est. 700-900 set

BLACKFEET-STYLE DAGGER & SHEATH C.1860-Style Traditional Blackfeet design: white bkgrd. w/geometric motifs in w. lined rose, med. blue, cobalt blue, t. green & gr. yellow. Applique stitched. Smoked elk hide. Sinew sewn. Rawhide liner. Wooden handle, handmade copper riveted steel dagger. 20.25" L. w/knife. Est. 400-650 **SOLD $475(95)**

163

Left to Right: **NO. PLAINS-STYLE FULLY-BEADED KNIFE SHEATH**
Applique beaded in pred. Crow pink w/dk. blue horsetrack motifs. 13" L. moosehide fringe on side & bottom. 14" carrying strap. Heavy rawhide liner. 9"L X 3"W. Est. 150-275 **SOLD $165(94)**
CROW-STYLE RAWHIDE BEADED KNIFE CASE
Top is Crow pink bkgrd. Lazy-stitched strip down side in alt. white, gr. blue & dk. blue bars. Rawhide is red-ochred. Red wool bound top. 12" belt strap. 11.25"L X 3.25"W. Est. 150-250 **SOLD $165(94)**
BLACKFEET-STYLE FULLY-BEADED KNIFE SHEATH
Applique beaded in med.blue bkgrd. Pumpkin & black triangular border design. 2" buckskin fringe on side. Heavy rawhide insert. 11"L X 3.25". Est. 250-395 **SOLD $275(94)**

NO. PLAINS-STYLE FULLY-BEADED LAZY-STITCHED KNIFE SHEATHS
Each is buckskin-covered rawhide, sinew-laced, w/hand-made tin cones. Very sturdy w/old-time buckskin thongs.
Far Left: White bkgrd. w/dk. cobalt, pumpkin, & t. green. Tin cone fringe. 10"L X 3.5"W. Est.180-275 **SOLD $180(93)**
Center: Pumpkin bkgrd. w/lt. blue & dk. cobalt step triangle motifs. 8 tin cones w/red horsehair attachments on side. 11"L X 3.5"W. Est.180-295 **SOLD $230(93)**
Far Right: Forest green w/white, lt. blue, pumpkin, & t. blue stripe & block design. Tin cone fringe. 10"L X 3.5"W. Est. 180-275 **SOLD $205(93)**

Left: **PIPE POUCH**
Old-time bead color stripe pattern. Cut slots for pipe. Smoked brain tan. Old-time English clay pipe incl. (not shown) L-6.5" Est. 80-150 **SOLD $85(95)**
Right: **FULLY-BEADED SHEATH W/KNIFE**
Lazy-stitched w/apple green bkgrd. & lt. blue, cobalt, white & dk. red. Leather sheath w/rawhide insert. 8.5"H.-2.75"W. Includes antler handled knife w/ patina. Blade L-5.25". Handle-5" Est. 325-400 **SOLD $375(95)**

CROW-STYLE RAWHIDE BEADED KNIFE SHEATH & KNIFE
Red-ochre painted buffalo rawhide w/ Crow pink, gr. green & cobalt striped border. Buckskin covered top is lt. blue w/gr. yellow, cranberry, cobalt, & white. Brass tacks at belt opening. Camp knife stamped stainless steel w/brass guard;rivets in hardwood handle. Knife 11"L. Blade 6.5." Case 10.5"L X 4.25"W. Est. 300-425 **SOLD $290(92)**

NO. PLAINS-STYLE RAWHIDE BEADED KNIFE SHEATH
Lazy stitched top design is old red w. heart bkgrd. w/lt. blue, forest green & gr.yellow. Bottom has lt. blue w/ cobalt, rose w.heart, white & gr.yellow stripe border. Aged tin cone fringe. Rawhide sheath w/patina. Total L-13", W-4.5." Est. 375-495 **SOLD $400(95)**

Top to Bottom: **BLACKFOOT-STYLE RAWHIDE KNIFE SHEATH W/KNIFE**
Applique stitched, red ochred & sinew sewn. White bkgrd. w/gr. blue triangles & dk. cobalt outline. 12.5"L X 4"W. Est. 200-295 **SOLD $215(95)**
SIOUX-STYLE RAWHIDE BEADED KNIFE SHEATH Dk. green stained. Lazy-stitched & sinew sewn. White w/Sioux green, med. blue & rose w. heart, pale blue & gr. yellow. Aged tin cone drops. 12"L X 3.25"W. Est. 225-300 **SOLD $245(95)**

164

CROW-STYLE RAWHIDE SHEATH W/OLD KNIFE
Fully seed beaded buckskin top w/partially seed beaded bottom. in gr. yellow, white & gr. blue old stock beads. 13"L. Patinated. Est. 300-400 **$275(86)**

CROW-STYLE PARFLECHE KNIFE SHEATH
w/old-time color beadwork border & flap. Navy tradecloth welting w/white edge-beading. Painted both sides w/vermilion; blue & green along sides. Patinated.11" L. plus edge-beaded drops on bottom. Est. 300-400 **SOLD $150(88)**

Left to Right: **NO. PLAINS TACK KNIFE CASE**
Top & sides beaded in 13° cuts & pony beads. Cuts are lt. blue, cobalt, Chey. pink; seed beads in white, red w. lined, gr. yellow, dk. cobalt. Cross & horsetrack design on top is bordered w/white pony beads. Includes Green River 7" forged butcher knife. 11"L X 3.5"W. Est. 300-375 **SOLD $290(93)**
OLD BUTCHER KNIFE W/BEADED HANDLE
Steel blade stamped "A. LACROIX-FRANCE". Buckskin covered handle peyote beaded in lt. blue, cobalt, gr. yellow, green intricate design elements. Est.125/175 **SOLD $125(93)**

Left to Right: **TACKED KNIFE SHEATH**
Made of heavy cowhide leather w/brass tacks. Patinated. Provenance unknown. 5.75"W X11.5"L. Est. 85-150 **SOLD $130(96)**
RAWHIDE BEADED KNIFE SHEATH
Lightly red-ochred rawhide w/brass tacks. Old-time beadwork on top & bottom border. 3"W x 11.5"L. Est. 160-250 **SOLD $150(96)**

Left to Right: **LARGE ASSINIBOINE-STYLE KNIFE SHEATH**
w/Green River 8" butcher knife. Flathead Indian beadwork panel is fully-beaded in old-style beads. Heavy hide liner. Red Fox brand braid binding. Design is influenced by a well-known early original.* Apx. 15" L. Est. 250-325 **SOLD $250(94)**
*See: *The American Indian/ The American Flag,* Exhibition Catalog, Flint Inst. of the Arts, Mich. 1975:96.
FULLY-BEADED KNIFE SHEATH
Same construction as previous. Includes Green River knife. 8"L. Est. 75-95 **SOLD $85(94)**

LARGE BLACKFOOT-STYLE KNIFE CASE W/KNIFE
Very sturdy case is buckskin covered latigo-applique top & sides in lt. blue, red w. heart, gr. yellow & dk. cobalt typical step-triangle motifs. White edge-beaded top. Side bound w/red wool & laced w/buckskin. Heavy dag-style knife has elk leg bone handle w/brass hilt & steel blade. 15.5"L. Case is 14" X 4.25"W. Est. 375-550 **SOLD $350(98)**

Left to Right: RAWHIDE SHEATH & KNIFE
Front of sheath is black bear hide laced w/rawhide. Knife has rawhide cover laced over the wood handle. Convincing patina. 11.5"L. Est. 90-185 **SOLD $90(96)**
RAWHIDE SHEATH
w/antler handled knife. Heavy duty sheath w/deer hide on front laced w/sinew. Knife has old blade, sharpened on one side (Indian-style) & antler handle w/2 lead inlaid crosses. Patination makes it look old. 13.5"L. Est.125-250 **SOLD $125(96)**
RAWHIDE SHEATH
w/trade knife. Wooden handle w/6 rivets. Sheath is laced w/ buckskin & has old-time patina. NOTE:An old one like this would cost big bucks and most people won't be able to tell the difference. 15"L. Est. 125-250 **SOLD $125(96)**
SKINNER SET W/LEATHER SHEATH, SKINNING KNIFE & STEEL
Knife blade is stamped *"I Wilson Sycamore St. Sheffield, England, The Berserker"* with a diamond & peppercorn symbol. Steel is stamped *"Forged Steel, Sheffield, England"*. Sheath has 2 belt loops. 4" x 11." Est. 95-150 **SOLD $50(96)**

PARFLECHE KNIFE CASE
Very heavy rawhide painted on both sides. Bound w/dk. red wool & laced w/buckskin. 11.25"L X 4.25"W Est.85-120 **SOLD $95(96)**

ATHAPASCAN-STYLE KNIFE CASE
Smoked moosehide partially-beaded w/old-time pony beads & dentallium shells. Woven pony-beaded neck strap. Hand-forged iron volute knife. 20" L incl. strap. Est. 175-300

PRE-1840 STYLE DAG SHEATH & KNIFE
Hand-forged steel blade w/ brass wire wrapped wood handle w/copper rivets. Heavy harness leather sheath has white & black pony beaded panel (red-ochred) w/tin cone fringe. Sheath 16"L. 19" L. w/knife. Est.175-250 **SOLD $175(92)**

ATHAPASCAN-STYLE KNIFE W/VOLUTE HANDLE
Hand-forged iron knife unique among Northwest & Western Canadian tribes. Made by a Montana blacksmith. 15.75"L. Est. 45/85 **SOLD $75(91)**

CROOK KNIFE W/CURVED BLADE This was the #1 style carving knife for Indians 200 years ago. Stamped *"1-XL George Wostenholm, Sheffield, England"*. Hard wood handle w/N.W. Coast-style bear effigy head. Right handed. 12.5"L. Est. 175-300 **SOLD $175(96)**

LARGE WEAPON CASES

CROW-STYLE LANCE CASES
Painted parfleche cases bound w/undyed selvedge red wool & buckskin lacing, 53"L.
A) Seed bead colors: Crow pale blue, corn yellow, gr. green, w. center rose & white. Smoked Indian-tanned fringe apx. 15" L.
B) Crow pink, mustard, w. center rose, dk. blue & white. White Indian-tanned braided fringe w/brass hawk bells. Est.850-1000 **SOLD $850(88)**
Each

CROW-STYLE LANCE CASE
Incised rawhide sheath. Red & navy wool bound. Beadwork panels are pumpkin, pale blue, white, Crow pink, dk. cobalt, pink w. heart & emerald green. Used but good cond. 4' L. Est. 625-750 **SOLD $650(92)**

CROW-STYLE RIFLE CASE
Fully-beaded seed bead panels are Flathead Indian-made. Pred. lt. blue & white w/ gr. yellow, red w. heart & cobalt geometric designs. Brain tan hide w/long fringe each end. 39"L. Est. 750-900 **SOLD $750(89)**

NO. ATHABASCAN INDIAN-MADE MOOSEHIDE GUN CASE
4 pinked & fringed hide panels w/stylized multi-color beaded floral motifs. Button closure. Fringed on bottom & end..Interesting chain-style hide shoulder strap. Exc. cond. 45"L. 8"W taper to 2.5". Est. 350-600 **SOLD $350(94)**

CROW-STYLE RIFLE CASE
Influenced by an early original. Moosehide panels each end are partially applique beaded in pred. white & pale blue w/red wool inlay (see detail photos). Narrow alt. strips of red & navy wool along bottom. Very long buckskin fringe, apx. 36" L. Case apx. 42"L. Est. 950-1200

WAR CLUBS, TOMAHAWKS, ETC.

Top to Bottom: **TLINGIT-STYLE FIGHTING DAGGER**
The bear head signified power & could be used to frighten your opponent. Carved bear head w/ abalone shell inlaid eyes.(See detail). Buckskin thong attaches w/thumb loop to hand during combat. Rawhide wrapped handle & large steel blade. 16.5"L. Est. 250-550 **SOLD $ 255(95)**
BALL-HEADED WOODEN WARCLUB
Wooden handle w/attached wooden ball. Varnished. 18"L. Est. 50-95 **SOLD $85(95)**

CROW STYLE TOMAHAWK
w/steel blade & beaded handle drop. The hardwood handle is carved & file-marked. The beaded drop is buckskin w/old bead
colors;lt. blue, white, gr. yellow, & Chey. pink on red wool. Brass hawk bells are attached to the fringe. The head came from Spain & has a "*RO*" touchmark. Apx. 17" L. Est. 350-550 **SOLD $250(86)**

Left to Right: SIOUX-STYLE SNAKE HEAD WAR CLUB
Brass tacks in wavy "snake" design entire length-stained red one side & black the other. Handle end has fringe & 3 kinds of feathers;incl. legal eagle w/3 red spots. Double steel knife blades are 4.5"L. 35"L. Est. 75-150 **SOLD $125(94)**
ARAPAHO-STYLE WAR CLUB
Fancy club w/beadwork on handle & club in white, trans. red, pumpkin, & cobalt. Natural oval-shaped stone head held in place by beaded & fringed buckskin. Rawhide wrapped handle. 26"L. Est. 200-350 **SOLD $200(94)**

NO. PLAINS-STYLE GUNSTOCK WAR CLUB
Brass tack ornamentation & snake-skin wrapped heavy wood. Brass thimble w/ermine strip & peacock feather drops. Hand-forged iron blade 8"L. 34" L. Est. 350-450 **SOLD $350(93)**

SIOUX CATLINITE HEAD WAR CLUB
Old red pipestone head from Pipestone, Minn. Recently restored handle is buckskin wrapped & bead wrapped in old-time colors. 2 tin cones w/ red wool on head. 17.5"L-5.5" head. Est.175-350 **SOLD $250(93)**

OLD-STYLE ANTLER TIP WOODEN WAR CLUB
The originals were made from wood gathered from wagon trains & made to use in battle. This one is decorated w/brass tacks. Wrist strap is undyed selvedge red wool edge-beaded w/white beads & bound w/blue Fox braid. Dk. blue zig-zag beaded design. Wood 26"L. 4" tip. Est.125-175 **SOLD $95(91)**

Top to Bottom: PLAINS-STYLE STONE HEADED WAR CLUB
Replica of an old-style club. Red stone head feels like sandstone. Handle is covered w/sewn buckskin w/fringes at the end. 19"L. 6.25" head. Est. 60-120 **SOLD $60(91)**
HAFTED GRANITE AXE
Wooden handle hide-glued & leather tied to stone axe head. Granite head is finely-shaped & may have been made from an old one. 13"L-head 3.75." Est. 50/100 **SOLD $68(91)**
FLOPPY STONE HEAD SKULL CRACKER
A copy of the popular war club used by numerous tribes. Buckskin covered stone head is tacked to the wooden handle. A buckskin cover w/fringe produces a hand-hold on the handle. 22"L. Patinated to look old. Est. 50-100 **SOLD $55(91)**

Top to Bottom: SIOUX-STYLE CATLINITE HEADED WAR CLUB
Double-headed w/bead wrapping in lt. & dk. blue & w. lined red seed beads. Rawhide covered handle. 24" L.-6" head. Est. 250-350 **SOLD $150(95)**
CHEYENNE-STYLE STONE HEADED WAR CLUB
Rawhide wrapped handle w/lazy stitched beadwork in dk. blue, mustard yellow & white-lined red. Handle wrapped w/undyed selvedge red trade cloth & 2 hawk bells. Wool backed otter fur wrist strap has dangles of horsehair, tin cones & brass beads. 27.75"L Est. 275-450 **SOLD $300(95)**

169

NO. PLAINS STONE WAR CLUB
Rawhide wrapped handles partially pony-bead wrapped. Rawhide held stone. Horse hair at top w/fully pony-beaded wrist handles on brain tan in gr. blue, gr. yellow & porcelain white. Tiger turkey feather suspended from stone head. 29"L. Est.110-150 **SOLD $125(92)**

QUIVERS, BOWS & ARROWS

BUFFALO QUIVER & BOW CASE SET
Hair-on hide. Sinew-backed bow w/sinew string. Arrows have chipped obsidian & chert points.(See detail photo). Unpainted shafts.27" L w/arrowhead. Quiver-25"L. Bow case-34"L. Est. 400-700 **SOLD $600(95)**

QUIVER & BOW CASE SET
Smoked brain tan w/long fringes laced w/buckskin thongs. 49" sinew-backed osage orange bow w/twisted sinew string. (5) 27" arrows are striped turkey feather-fletched w/knapped flint points. (See detail photo). Quiver w/fringe is 38"L. Bowcase w/fringe 52"L. Est. 600-800 **SOLD $750(96)**

NO. PLAINS BOW CASE & QUIVER
Smoked brain-tan w/lacing over dk. blue wool binding. Lazy-stitch beadwork bkgrd. panels are old Italian 4° Chey. pink w/dk. cobalt & pumpkin design elements. Hangs 45" L. X 30" W. Est.400-600 **SOLD $375(92)**

NO. PLAINS STYLE QUIVER
Made of brain tanned hair on fawn skin w/feet. Top has green wool w/red, white & black rolled edge beading. 21"L. 6"W. Est. 225-275 **SOLD $225(96)**

NO.PLAINS-STYLE BOW & QUIVER SET
Case is comm. leather painted w/black stripes; red twill tape bound. Rolled beaded openings in white, red w. heart., t. green & black ponies. Twisted fringes. 8 arrows & sinew-backed bow; sinew wrapping painted red & green. Sinew-strung bow:4' L. 21" L. arrow case. 36" L. bowcase. Est.425-575 **SOLD $400(93)**

RATTLESNAKE SKIN COVERED OSAGE ORANGE BOW
w/double nocks & Indian reflex. Sinew-backed & wrapped. Hand grip is wrapped w/ smoked buckskin. Twisted nylon string. This bow is a Indian-style bow made to use. 40"L. Est. 250-400 **SOLD $351(96)**

NO. PLAINS STYLE QUIVER Smoked moosehide w/4 bead striped panels in white, gr. yellow, c. pink & black on red undyed selvedge wool. Long buckskin fringes each end. Bowcase 41"L. Arrowcase 22.5"L. Est. 475-750 **SOLD $500(94)**

CROW-STYLE OTTER QUIVER & BOW CASE
Classic Crow-geometric style applique beadwork (seed beads): lt. blue, gr. blue, white, gr. yellow, w. center red, dk. cobalt & med. green. Shoulder strap panels are otter hide backed w/red undyed selvedge wool w/navy Fox braid binding. Fully beaded panels on case & otter trimmed w/cloth inlay. Hangs apx. 60." Est. 1000-2500

PLAINS-STYLE BOW W/2 ARROWS
Sinew strung bow-45" long. Arrows are steel-tipped, 28" long. Patinated. Est. 200-300 **SOLD $225(87)**

Left to Right: **OBSIDIAN HEADED ARROW**
w/striped turkey feather fletching. Tamarask wood from Wyom. Transl. mahogany obsidian point. Sinew-wrapped. Aged to look old. 27.5"L.Est. 35-55 **SOLD $40(95)**
SAME 28.25"L Est. 35-55 **SOLD $40(95)**
ARROW W/STEEL TRADE POINT
Straightened willow w/turkey fletching. Sinew-wrapped w/ painted stripes. Aged, looks old. 24.75" L. Est. 25-50 **SOLD $25(95)**
SAME 25.5" L Est. 25-50 **SOLD $20(95)**

Left to Right: A) **SIOUX-STYLE ARROW**
w/white Wyom. agate point. Tamarack wood from Wyom. wrapped w/real sinew. Painted red stripes like the old ones. 28"L. Est. 25-50
B) SAME w/ blue sheen obsidian point. No stripes. 27.5"L. Est. 25-50
C) SAME w/ brown flint point. Green stripes & 2 red "blood grooves". Carved bowstring notch. 25"L. Est. 25-50
SOLD EACH $45(96)

LANCES, ETC.

NO. PLAINS-STYLE, CROOK LANCE W/ HAND-FORGED BLADE
Entirely otter-wrapped w/dangling "scalplock" 5" shield. 4 painted eagle feathers. Blade (in ground) 7"L X 2.5"W. 7.5' L. total. Est. 395-475 **SOLD $396(93)**

NO. PLAINS-STYLE UNDYED SELVEDGE RED TRADEWOOL COVERED LANCE
Double selvedge wool w/otter wrappings each end & center. Cloth secured w/brain-tan thong wrapping entire handle. Wool flap has legal feathers w/yellow fluffs. Hand-forged steel blade: 9" X 1.5" W. 67" L. Est. 200-300

Top to Bottom: **CROW-STYLE CEREMONIAL BOW LANCE** *Rare & old obscure tradition.* Red & blue wool wrapped w/hawk bell & ermine strips & dyed legal feather embellishment. 58" L-5" blade. Est.175/225 **SOLD $100(91)**

CROW-STYLE OTTER WRAPPED LANCE
Red cloth wrapped w/thongs & brass tack ornaments. 12" hand-forged blade. Horsehair "scalplock." 10" bear rawhide cut-out, red-ochred & "spider web" painted hoop. 3 ermine & otter-strip dangle clusters. Light patina. 5' 2"L. Est. 300/375 **SOLD $225(91)**

BLACKFOOT-STYLE WAR LANCE
The original is c. 1870 the Carberry Coll. Steel point on ash shaft w/buffalo rawhide sinew-sewn over copper riveted blade attachment. Imitation eagle feathers w/wool wrap hang from middle of lance. Lock of long human hair at end of lance w/blue cobalt padre beads. Rubbed w/clay & bear oil. Smoke patination. Lance 60" L. Blade 14.5 L. X 1" W. Est. 125-200 **SOLD $155(95)**
See photo: Scriver, *The Blackfeet*, 8-9.

NO. PLAINS-STYLE LANCE
Old steel pitchfork tine point-13" L. Top wrapped w/fur, buckskin, & imitation eagle feather. End wrapped w/ buffalo rawhide. Lodgepole pine shaft w/heavy smoke patina. Shaft L-59." Est. 100-200

Shields

GROS VENTRE-STYLE SHIELD
Pohrt Collection. Original is c. 1860. Bull Lodge. Dramatic painted red & white "target" on black bordered w/red undyed selvedge wool & tiger turkey feathers wrapped w/red wool. Buckskin thongs w/ hawkbells suspended from cloth. Apx. 20" diam. Est. 250-375 **SOLD $150(86)**
See narrative account & full-page photo: Penney, David W., *Art of the American Indian Frontier*, Seattle: Univ. of Wash.,1992: 279-281.

ARIKARA -STYLE BEAR SHIELD
Original in the Heye Fdn. NYC. c. 1850 Collected on the Fort Berthold Res. in Mont. Brain-tan buckskin cover painted pale ochre bkgrd w/bear image in grey, yellow & red. Red undyed selvedge wool & turkey feather attachments (red wool wrapped). Hand-pounded rawhide inner.18" diam. Est. 200-350 **SOLD $100(89)**
See: Feder, p. 37.

SIOUX-STYLE PICTOGRAPHIC SHIELD
w/4 painted feathers (red wool wrapped) & hawk bell attachments. Rawhide insert w/painted buckskin cover. 15" diam. Est. 200-300 **SOLD $150(87)**

173

CROW-STYLE SHIELD
Original in Field Museum of Natural History, Chicago. Descriptive card reads "..shows a buffalo bull struck by lightning as he urinates. The Crow said that a buffalo bull urinates just prior to charging into battle, thus the image is one of power & strength." Center fan has tiger turkey feathers trimmed w/beaded red wool. Brain-tan cover over hand-pounded rawhide. 19" diam. Est. 200-300 **SOLD $150(90)**

HIDATSA STYLE BEAR CUT-OUT SHIELD
Original in Buffalo Bill Historic Center, Cody, Wyo. Rawhide painted bear w/turkey feather & ermine attachments. Card reads....." *a silouette of a painted cut rawhide bear which served as a protective medicine".* Top part of shield painted pale orange w/red ochre spots. Brain-tan leather cover w/hand-pounded rawhide inner. 18 " diam. Est. 200-350 **SOLD $150(89)**

CHEYENNE-STYLE SHIELD W/ BANNER.
Brain-tanned painted buckskin cover over rawhide-partially lazy-stitch seed beaded in white, blue, gr. yellow & w. lined rose. The turkey feathers hang on a drop of 36" red undyed selvedge wool. 15" diam. Est. 250-400 **SOLD $175(87)**

DAKOTA SIOUX-STYLE ELK RAWHIDE SHIELD
w/canvas banner. *Original is pre-1850; Vernon Collection, Coulter Bay Museum, Grand Teton Natl. Pk., Wyo.* 8 legal feathers wrapped w/red wool & long thong trim on grey painted banner. Elk track motif on shield-4 deer hoofs & quill-wrapped hair drop w/brass bells. Patinated. 22" diam. Est. 200/300 **SOLD $200(92)**
See: Walters, Anna Lee, *The Spirit of Native America* , San Franciso: Chronicle Books,1989:71.

NO. PLAINS-STYLE SHIELD W/BEADED HORSETAIL
Very heavy laminated rawhide simulating original buffalo hump-style. Covered w/ smoked brain-tan painted in red & black motif. 5 "firecracker" red wool wrapped legal hawk feathers on bottom. 18" diam. Hangs 27" + buckskin strap. Est.250-375 **SOLD $250(93)**

CHEYENNE-STYLE SMALL SHIELD
Original was collected by Custer at the Battle of Washita in1868. Detroit Inst. of the Arts. Brown & pale green w/bird & crescent elements outlined in red ochre. Green ochred thongs & turkey feather, & hawk bell attachments. Buckskin over willow hoop. 13" diam. Est. 85-135 **SOLD $65(89)**
See: Mauer, Evan M., *Visions of the People*, Minneapolis: Inst. of the Arts, 1992:115

CHEYENNE-STYLE SHIELD
Painted bear track & green stripe motif; red undyed selvedge wool, imitation hawk & eagle feathers & imitation bear claw attachments. Brain tan over rawhide insert. 19" diam. Est. 225-350

SIOUX-STYLE PICTOGRAPHIC SHIELD
Painted ledger-style battle scene w/red undyed selvedge, clipped duck feathers & turkey. Small twisted rawhide shields are to catch the enemy in the web. 19" diam. Est. 275-400

CHEYENNE-STYLE SMALL BANNER SHIELD
This is the actual size of the originals made for the Field museum in Chicago. Painted dragonfly & crescent motif on buckskin w/ rawhide back. Red undyed selvedge drop w/ duck feathers embellished w/ermine & horsehair. 8" diam-15" cloth banner. Est. 95-135 **SOLD $75(85)**
"By the late 1890's, Cheyenne men made models of shields for anthropologists & collectors." Craig D. Bates, written communication,1985.

Pipes & Pipe Tomahawks

NO. PLAINS CALUMET-STYLE FANCY PIPE
w/Blackfoot-style catlinite bowl. Imitation eagle feathers w/brass & Crow bead drop w/red fluff. Stem is wrapped w/red undyed selvedge wool, red Fox braid, hawk bells & white beads alt. w/wrapped horsehair. Apx. 30" L. Est. 200-300 **SOLD $250(94)**

Top to Bottom: **HORSE HEAD CATLINITE PIPE & STEM**
Bowl is 3.5" X 2.5"H. Carved twist stem is 19"L X 1.13" diam. Est. 195-300 **SOLD $250(94)**
CATLINITE PIPE W/STEM & TAMPER
L-shaped pipe. 2" of stem is bead-wrapped in alt. red & white stripes w/sweet grass attachment. Tamper is bead-wrapped & carved like a buffalo hoof. Bowl:2.5" X 2.5". Stem is 16"L. Est. 175-300

Top to Bottom: (Note: Both pipe bowls turned sideways for better view)
CATLINITE PIPE W/FLAT STEM
L-shaped bowl. Stem has double row of brass tacks. Bowl:4" X 3". Stem:2" W X 22"L. Est. 175-350
OMAHA-STYLE CATLINITE PIPE W/FLAT STEM
T-shaped pipe. Stem has zig-zag pattern incised entire length. 3" end has bead-wrapped stripes:gr. yellow, dk. blue, red w. heart & red horsehair drop. Bowl:5" L X 2" H. Stem 21"L. 1.5"W. Est. 250-400 **SOLD $275(94)**

CATLINITE ELBOW PIPE W/LEAD INLAY
File burned round stem is 10.5"L. Bowl is 5" H. X 2"L. Est. 100-150 **SOLD $100(96)**

Top to Bottom: **BLACKFEET-STYLE LEAD INLAY PIPE**
Traditional black steatite acorn-shaped w/2 horizontal stripes of lead (See detail). 2.75" H. Round stem is 14.5"L. Est. 100-150 **SOLD $100(96)**
PIPE TAMPER
Hand-carved wood w/bead wrapped buckskin: blue, gr. yellow, forest green & red w.heart. 12"L. Est. 20-40 **SOLD $25(95)**
BLACKFEET-STYLE LEAD INLAY PIPE
Traditional black steatite w/fancy scalloped lead inlay. (See detail). 2.75" H. Flat stem is 14"L. Est.110-175 **SOLD $110(96)**

CROW-STYLE IRON HAND-FORGED PIPE TOMAHAWK
Fully-beaded drop w/braided buckskin fringe. Old-time bead colors: gr. yellow, cobalt, lt. blue, red w. heart. in typical geometric style. Tomahawk has weeping heart cut-out; stamped "G.S.Ainslie." Brass wire-wrapped & brass tacked handle. Beautifully aged piece that looks old. 22" handle-10" blade Est. 575/750 **SOLD $500(91)**

Top to Bottom: **BRASS PIPE TOMAHAWK W/STEEL INSERTED BLADE**
Elaborate foliate designs etched in pipe head. Wood handle is covered w/snake skin & fur. Trade bead dangles. 18" L w/7.25" pipe head. Exc. cond. Est. 75-150 **SOLD $95(95)**
BLACKFEET-STYLE PIPE W/LEAD INLAY
Black steatite has ring of lead inlay around bowl & in stem hole for reinforcement. 11.75" long w/1.5"X 2.75" bowl. Est. 75-150 **SOLD $90(95)**
BLACKFEET-STYLE CATLINITE PIPE W/LEAD INLAY
at stem hole. Ash stem w/file burned designs. 10"L w/1.88 X 3" bowl. Est. 100-150 **SOLD $110(96)**

CAST IRON PIPE-TOMAHAWK
w/fringed hide & red w/black bead wrapped handle. Dark patina w/ bone mouthpiece.18.25" L X 8" head Est. 150-250 **SOLD $187(95)**

CROW-STYLE PIPE TOMAHAWK w/beaded drop. Cast iron head & brass tacked wooden stem wrapped w/fringed buckskin. Fully-beaded drop in Crow pink, w. center rose, cobalt & t. dk. green has red wool inlay. Buckskin fringed drop. Patinated. Apx. 16" L. Est. 275-400

CAST PEWTER? PIPE TOMAHAWK c. 1940?
Cut-out weeping heart design in blade. Pewter inlay w/stamped designs in burntwood stem. Heavyweight. Looks aged. 18"L. Est. 100-250 **SOLD $95(95)**

Top to Bottom: **BRASS PIPE TOMAHAWK W/ORNATE CURLEY MAPLE HANDLE**
Head is decorated w/intricate engraved & stamped foliate & geometric designs. Iron blade attached w/4 silver pins. Stem is beautifully decorated w/silver wire inlay. brass tacks, lead inlay & carved foliate designs. Mountpiece is carved bone & the plug is carved bone in the shape of an eagle's head. 17.5" w/6" head. Est. 500-800 **SOLD $650(95)**

CAST IRON PIPE TOMAHAWK
Dark stained wooden handle. Tulip-shaped bowl, foliate designs chiseled into blade & 3 holes w/beads, feathers & 1854 US copper coin drops. Stem is highly ornamented w/ivory, silver & copper cut-outs; twisted brass wire & small brass tacks This is a beautiful & unusual tomahawk. 19"L w/8.5" ornate head. Est. 250-500 **SOLD $235(95)**

IRON PIPE TOMAWAWK W/HARDWOOD HANDLE
Made & signed by "B.F. Ainslie." Polished w/tacked handle & ermine skin drop. Superb workmanship. 8.5"L blade w/21.5" handle. Exc. cond. Est. 400-800

Horse Gear

CROW-STYLE MARTINGALE
(Horse Chest Ornament) Seed-beaded in old colors: Crow pink, rose w. heart, cobalt, corn yellow, lt. blue, pale blue, t. dk. green & white. w/red wool tradecloth inlay. Bound w/blue undyed selvedge wool. Old brass bell trim. 44" L. X 19.5" W. Est. 1500-1800 **SOLD $1200(86)**

Left & Center: **ARAPAHOE-STYLE PIPE BAG W/ BLACKSTONE PIPE**
Black bowl & stem. Bowl is 2" H. 9.75" stem. Bag is lazy-stitched in mustard, cobalt, blue w. lined & cranberry red. Rolled edge beading on side & top. Hawk bells & brass beads. Cloth lined. Aged smoked brain tan. 5.5" W. 10.75" L. Est. 250-375 **SOLD $200(96)**
Right: See hairpieces p. 141.

SIOUX-STYLE PIPE & BAG
Red elbow pipe. Beaded & fur wrapped stem w/pale blue bkgrd & cross design in white, red, & mustard center w/dk. cobalt, & brick. Trade & brass bead drop. Stem-11"L X 1.5" W. Bowl-3"L X 2.25" H. Bag is partially beaded both sides in stylized floral pattern. Trade bead dangle. Drawstring top. Patina from use. 17" L X 6" W. Est. 400-600 **SOLD $495(95)**

NO. PLAINS-STYLE BRIDLE
Brain-tan leather backed w/ heavy navy wool blanketing. Gr. blue, mustard, dk. cobalt, pink w. heart & white beadwork. Edge-beaded w/gr. blue & Pony Trader blue pony beads. 12" X 2" band & 18"L each side X 2.5." Braided leather rope w/red & blue wool wrapping. Hangs 32." Est. 600-750 **SOLD $650(93)**

Left to Right: NO. PLAINS HORSE GEAR SET 6 PIECES Late 19th Century style.
A) "PRAIRIE CHICKEN STYLE" SADDLE
Elk antler pommel & cantle attached to wood pieces covered w/ buffalo rawhide (some hair-on) brass tacked & stitched into place. Pommel & cantle are covered w/ white brain tan buckskin; decorated w/brass tacks. The rigging & stirrup straps are heavy brown cowhide. Wooden stirrups are covered w/ buffalo rawhide brass tacked & held in place w/twisted horsehair wrappings. 12" H. X 14"W X 12" seat.
BLACK HORSEHAIR HACKAMORE (BRIDLE)
Indian-style w/nose strap wrapped w/red & grey yarn. 19" L. w/10' guide rope. Est. 650-800 **both SOLD $675(94)**
B) PONY-BEADED SADDLE BLANKET (Shown under saddle) Canvas w/beaded panels on heavy wool bound w/yellow & red Fox braid. 35"X 47". Shows moderate use. Est. 350-500
C) FANCY RED & NAVY TRADEWOOL CRUPPER
Central panel is heavy navy undyed selvedge blanket w/triangular red wool applique & brass spot designs. 2 side panels are red heavy blanket. Large panel has tri-cut amethyst & pale blue flower petal beadwork. Each panel bound w/yellow Fox braid. Canvas backed. 45"L each piece. Est. 300-500
D) PR. OF SKUNK NECK COLLARS
Mounted on 3 panels of red undyed selvedge wool blanket w/pony beaded design in gr. blue & gr. yellow; bound w/yellow Fox braid. Backed w/green old-time calico. Each piece is 42.5"L X 10"W. Est. 300-500
E) BREAST COLLAR OF GREEN UNDYED SELVEDGE WOOL Mounted on heavy leather strap w/sheepskin backing. Double white selvedge at center w/red wool central strip bound w/yellow Fox braid. Ornamented w/7 heavy brass cast sleigh bells, 6 cut deer hooves, & leather thong fringe. VG cond. 41" Est. 300-400

SIOUX-STYLE SADDLE BAG
Lazy-stitch panels on flap & bag :white bkgrd. w/Sioux green t. red, dk. blue & gr. yellow cross & geometric motifs. Panels on fringed tanned buckskin attached to black heavy harness leather ornamented w/brass spots. Very sturdy construction-made for use. 34" total L-Bags 9"L X 8.5"W. Est. 250-450 **SOLD $250(94)**

CROW-STYLE FULLY-BEADED HORSE FOREHEAD ORNAMENT
Characteristic keyhole shape. Crow pink, lt. blue, t. dk. green, rose w. heart, & cobalt bordered w/white. Red & navy wool outer fringe connected by Crow pink seed beads. Apx. 16" total L. Est. 475-650

CROW-STYLE FULLY-QUILLED HORSE FOREHEAD ORNAMENT
Keyhole shape. Top part quillwork styles; basic zigzag, simple band, & single thread-line. Tab is simple band technique in pumpkin, periwinkle, rose, white, & dark purple. Top & bottom have red, pumpkin & black horsehair tassels wrapped w/yellow or red cotton w/white shell separators. White beaded border. Brain tanned smoked hide. Total L. w/hair-19" Est. 600-900 **SOLD $600(95)**

Left to Right: ELK ANTLER RIDING QUIRT
Fully-beaded wrist strap in lt. blue, gr. yellow, cobalt, & t. green lazy-stitch. Antler studded w/brass tacks & incised red design elements. Strap leather wrapped w/red wool & buckskin fringe. Hangs 4'. Est. 350-450 **SOLD $350(89)**
CROW-STYLE FULLY-BEADED QUIRT
Wrist strap & buckskin-covered wood fully-beaded in lt. blue, brick w. heart, gr. yellow, cobalt, & t. green. lazy-stitch. Whip is braided rawhide; handle is embellished w/twisted fringe & 4 quill-wrapped dangles w/red wool & tin cones. Hangs 4'. Est. 350-450 **SOLD $350(90)**

178

BLACKFEET/CREE STYLE WOODEN QUIRT
Wrist strap is red wool w/abstract floral beadwork in old-time bead colors; red yarn tassels. Bound w/gold cotton;lined w/mattress ticking. Carved wood is stained 1/2 green & 1/2 red;brass tack trim. Latigo strips wrapped w/red & blue wool. Est. 300-450 **SOLD $375(94)**

SIOUX-STYLE WOODEN QUIRT
Lazy stitched fully-beaded strap in lt. blue, old red w. heart. & gr. yellow w/dk. cobalt outline in white brain tan. Twisted fringe w/ tin cones & red cloth. Wood embellished w/brass tacks. Buckskin braided whip wrapped w/red cloth . Wood L-20." Strap L-20." Est. 325-450

QUIRTS

NO.PLAINS-STYLE ELK ANTLER INCISED QUIRT
Beaded buckskin handle w/Crow pink & med. blue lazy-stitched border & feather, tracks & cross motifs. Latigo twisted whip (not shown). Cross-hatched triangles & 4 animals incised on antler. Hangs 38." Est. 125-175 **SOLD $125(92)**

Children's Items

DOLLS, CRADLEBOARDS & TOYS

PLAINS-STYLE MALE WARRIOR DOLL 1840
Wears checked gingham shirt, breastplate, yellow-ochred beaded leggings, beaded pipe bag, white selvedge, red breech clout (see backview), brass button hairplates, & painted shield. 12" H. Est.250-350 **SOLD $250(89)**

NO. PLAINS-STYLE WOODEN DANCE QUIRT
Handle painted red-ochre 1 side;yellow ochre the other. Both sides decorated w/ brass tacks. Brain tan wrist thong & whip-14"L. Total L 31." Est.25-70 **SOLD $30(94)**

NO. PLAINS-STYLE MALE WARRIOR DOLL
Detailed old-time buckskin outfit partially beaded morning star designs on fringed shirt. Carries beaded rifle case red ochred w/red seam welt. Fully-beaded strike-a-lite pouch on tack belt;fully-beaded knife case,white selvedge breech clout;claw necklace, quill choker, buffalo hair, red cloth wrapped braids,buckskin painted stripe leggings have beaded strip;beaded mocs, etc. Red ochre face paint. Looks authentically-old w/patina. 13.5"H. Est. 550-900 **SOLD $600(97)**

SO. CHEYENNE-STYLE DOLL
Body & dress all smoked brain tan w/ beaded & war painted face. Detailed accessories:fully-beaded lazy-stitched belt, knife case w/thunder-bird motif; strike-a-lite w/hand-made tin cone fringe, moccasins & leggings in white w/cran.red, cobalt, gr.yellow, & lt.blue. Dress is fringed & partially beaded;lightly yellow ochred w/red ochre nr. hem & thongs w/mescal bean trim. Red wool wrapped braids buckskin tied w/blue Crow beads. 13" H. Est. 495-750 **SOLD $600(97)**

CROW-STYLE DOLL
Cloth body & painted buckskin face. Faded red undyed selvedge red wool dress w/old monie cowrie shells. Beaded eyes, mouth & earrings. Real braided buffalo hair. Partially beaded yoke. Tack leather belt w/tin cone dangles & 8" drop. Miniature knifecase w/knife, awl case w/awl, & belt pouch on belt. Fully-beaded cloth leggings & moccasins. Looks like an old one. 18.5" H. Est. 525-750 **SOLD $550(95)**

SIOUX-STYLE DOLL W/TRADECLOTH DRESS
Navy wool undyed selvedge dress trimmed w/peach silk ribbon, & brass sequins;red wool yoke. Old striped calico underskirt; heavy leather concho belt & drop; beaded parfleche knifecase; beaded leggings & mocs. Buffalo wool hair. Apx. 11" H. Est. 250-350 **SOLD $250(91)**

BLACKFEET-STYLE FEMALE DOLL
Brain tan buckskin dress, papoose & mocs. Yoke, hem, knife sheath, belt pouch, etc. beaded w/white pearl, cobalt & red seed beads. Heavy leather belt. Breast plate of strung quills w/bead dangles. Body is smoked buckskin w/real hair. 10" H. Est.175/250 **SOLD $160(91)**

Left to Right, Front & Back Views: SIOUX-STYLE TRADITIONAL FEMALE DOLL
White buckskin dress over painted muslin body. Dress has fully-beaded yoke w/med. blue bkgrd. & white, cobalt, & mustard; fully-beaded moccasins, same colors. Black horsehair braids. Concho belt, quill earrings, & quill long breast plate. 14" H. Est.325-400 **SOLD $325(94)**

BLACKFEET-STYLE MALE TRADITIONAL DOLL Painted muslin body. Horsehair braids. Painted buckskin warshirt & matching leggings. Beaded moccasins. Red wool breechclout & neck trim. 15" H. Est.325-400 **SOLD $325(94)**

SIOUX-STYLE GHOST DANCE FEMALE DOLL
Painted buckskin dress in blue, w/red, black & yellow. Grey horsehair braids painted red at part. Partially beaded moccasins. Painted muslin body & beaded face. 13.5" H. Est.295-375 **SOLD $295(97)**

SIOUX-STYLE GHOST DANCE MALE DOLL
Red, white & blue outfit. Painted muslin body; top 1/2 of face painted red. Black horsehair braids w/feather. Blue bkgrd. w/white stars & red fringed leggings & shirt. Red wool breechclout. 14" H. Est 295-375 **SOLD $295(97)**

SIOUX-STYLE FULLY-BEADED DOLL CRADLEBOARD c.1985
"Son of a Morning Star" movie prop. White bkgrd. lazy-stitched w/t. navy, pink & gr. yellow traditional Sioux designs w/red wool wrapped thong clusters. Upper wooden slats have green wool w/brass spot ornamentation. 18"L X 8"W. Est. 450-550 **SOLD $300(91)**

CROW STYLE MINI-CRADLEBOARD
Fully-beaded geometric headboard in old-time colors. Top & bottom bound w/red tradewool. Characteristic Crow-style carrier tied together w/fully-beaded panels. This configuration is unique to Crow cradleboards. White brain tan. Fringed top & bottom. Total 22"L.7" W. Est. 695-875 **SOLD $700(95)**

SIOUX STYLE MINI CRADLEBOARD
Lazy-stitched fully-beaded white bkgrd. w/Classic Sioux step-triangle pattern. 3 beaded medicine balls on top opening. Brass bead & hawk bell drops. Buckskin w/muslin lining-buckskin ties & rawhide back. Wooden back slats decorated w/brass tacks. Patinated. Cradle apx 17" L. X 10" W. Boards L-27." W-2.25." Est. 750-1200

CROW-STYLE TOY LANCE CASE
Painted parfleche bound w/red undyed selvedge wool; beadwork is white, green, pale blue, gr. yellow, t. red & navy. Smoked brain tan lacing & fringe. 20" L. Est. 200-300 **SOLD $185(90)**

CHILD'S WILLOW BACKREST SET
Blackfoot-style. Navy wool canvas-backed loop trimmed w/red wool. Bound w/bright green undyed selvedge wool. 29" long X 18" wide. Est. 200-300 **SOLD $195/pr.(86)**

FETISHES, AMULETS, CHARMS, ETC.

CROW-STYLE BUCKSKIN TOY HORSE
Yellow-ochred w/buffalo hair clipped mane & tail. Old-stock colors cut-beaded miniature martingale, saddle bag, saddle flaps, stirrups & crupper. 9"H X 9"L. Est. 300-400 **SOLD $275(91)**

Left to Right: **CROW-STYLE MINI STONE SHIELD**
Ochred buckskin-covered stone w/ painted design. *Similar to one that belonged to "Little Head".* * Edge-beaded w/Pony Trader blue beads. Trade beads are blue prossers, rose w. hearts, brass wire-wound Crow, etc. on red-ochred thongs. 2" diam. Est. 60-125
*See: Wildschut, William ,*Crow Indian Medicine Bundles*, New York: Heye Fdn.,1975: Fig. 33-34.
FULLY-QUILLED TURTLE AMULET
White, orange, & red zig-zag sewn quilllwork edge beaded in forest green. Appendages have tin cone-red horsehair. Buckskin backed. Apx. 4"L. Est.125-150 **SOLD $100(93)**

GROS VENTRE-STYLE INDIAN MADE DIAMOND-SHAPE AMULET
Fully-beaded diff. colors each side. 1)T. rose, t. blue & gr. yellow 2)Sioux green, gr. blue & porcelain white. Red white heart edge-beaded. Apx. 6"L. Est.75-125 **SOLD $75(93)**

SIOUX-STYLE FULLY-BEADED AMULET
A lizard-shaped fetish made to hold a child's navel cord for good luck & long-life. White bkgrd. w/gr. yellow, Sioux green & dk. cobalt blue. Red quill-wrapped thong appendages. 8" + dangles. Est.150/175 **SOLD $125(91)**

Left to Right: **BEADED TURTLE FETISH**
Lazy-stitched. Sioux green bkgrd. w/yellow, cobalt blue & red design. Bead wrapped legs w/brass hawk bells. Thongs, beads & tin cone w/horsehair for tail. 9"L incl. horsehair. Est. 95-125 **SOLD $100(95)**
SAME. Lazy-stitched. T. red bkgrd. w/gr. yellow & Sioux green design. Tin cones & black horsehair for legs. Fringes & trade bead dangles. 10"L. incl. horsehair. Est. 85-115 **SOLD $95(95)**
BEADED LIZARD FETISH
Applique-stitched in t. blue, t. rose, t. red & white. Bead wrapped legs w/hawk bells & tin cones at tail. 6.5"L. Est.75-95 **SOLD $75(95)**
SAME. Applique-stitched in t. green, t. rose, white & lt. blue. Tin cones & black horsehair for legs. Fringes & trade bead dangles. 9.5"L. Est. 90-100 **SOLD $95(95)**

Top: **FULLY-BEADED SNAKE FETISHES**
Yellow w/black Edge-beaded. Buckskin backed. 4.5" L. X 2.5" W.
Bottom: SAME. gr. blue w/black. Est. 70-95 each **SOLD each $65(89)**
Left: **BEADED TURTLE FETISH**
Applique:white, gr. blue, gr. yellow & Crow pink. 5"L. Est. 75-100 **SOLD $50(89)**
Right: **BLACKFEET-STYLE LIZARD FETISH**
Fully-beaded in white, red, gr. yellow, & Sioux green. Crow bead appendages w/facets & tin cones. 9"L. Est. 85-110 **SOLD $60(89)**

NO. PLAINS-STYLE LIZARD FETISH Fully-beaded applique stitch pred. Crow pale blue, w/cranberry red, dk. cobalt & gr. yellow w/beaded edging & wrapped legs. Legs have brass cone, brass hawk bell thong drops. Expertly & tastefully made. Convincing old-time patina. 3"W X 7"L. Exc. cond. Est. 125-175 **SOLD $125(97)**

Top to Bottom: QUILLED PIPE TAMPER
Hand-carved wooden stick;top is 3.5" quill-wrapped in red, blue & yellow. Quill-wrapped thongs w/tin cones. 13.5"L. Est.75/95 **SOLD $75(92)**
SIOUX-STYLE FULLY-QUILLED REPTILE AMULET
Pred. red w/white zig-zag sewn quillwork. Muted green & lt. blue quilled edging. Tin cones w/red horsehair legs. 6"L. Est.175/250 **SOLD $200(92)**

Left to Right: CHEYENNE-STYLE BUCKSKIN BUFFALO EFFIGIES
Sinew sewn & stuffed w/ buffalo hair & a bone from an ancient buffalo jump. Red ochred & painted w/ cross motif. Rawhide painted horns.Crow beads & dangles hang from tail;Crow bead & dew claw dangles on feet. Feather fluff & tin cones on hump. 8.5"W X 6"L. Est.120-150 **SOLD $95(91)**
SIMILAR. 7"W X 4.5" L + dangles. Est.85-110 **SOLD $85(91)**

Left: QUILLED TURTLE FETISH
Golden yellow & purple sewn quilled central motif w/ beadwork in med.blue edge beaded in old white pony beads. Smoked brain tan. 2"W x 4.25" L.Est. 95-150 **SOLD $100(96)**
Center: See p.153, replica pipe bags.
Right: FULLY-QUILLED LIZARD FETISH
Sewn quill work on both sides:Side shown is a white, dk.blue, red & yellow;Other side is pink & white. Edge beaded w/old white pony beads. Red quill wrapped horsehair legs. Est. 135-185 **SOLD $165(96)**

Upper Left: CROW-STYLE RAWHIDE ELK EFFIGY*
Original from Love Tail's love medicine bundle.
Painted w/yellow & blue old style Indian paint & red eye & bullet holes. Imitation elk tooth dangle. Back has old painted parfleche designs. 8.5" X 10." Est.25-45 **SOLD $30(95)**
*See Wildschut,Fig. 55.
Lower Left: CROW-STYLE RAWHIDE HORSE EFFIGY
Painted black & yellow w/ small red buckskin tobacco pouch w/white beaded edge. 8.5"X12" Est. 25-50 **SOLD $30(95)**
Far Right: TWO SMALL RAWHIDE EFFIGYS Painted red & white w/blue crow beads & seed bead eyes. Horse-1.5" X 3.5." Elk-3" X 4.5." Lot Est. 15-25 **SOLD $20(95)**

BADGER MEDICINE BAG Red ochred brain tan w/gr.yellow, med.blue, dk.cobalt & red w. lined beadwork. Aged tin cones & hawk bells on fringe. Trade & brass beads on top thong. 10" L. incl. fringe. Est. 60-95 **SOLD $100(96)**

"PULL" PORCUPINE BRUSH
Wrapped quill strip in red, white, yellow, & med. blue. Handle partially beaded in dk. red w. heart, dk. blue & pumpkin. on smoked brain tan. Hairbrush L-5.5." Handle L-4." Est. 95-150 **SOLD $170(95)**
"PUSH" PORCUPINE BRUSH
Wrapped quill strip in yellow, blue, & rose. Handle partially beaded in cranberry red, pale blue, & mustard on brain tan. Hairbrush L-8." Handle L-3.5." Est. 95-150 **SOLD $125(95)**

183

Dance Paraphernalia & Musical Instruments

See also Chapter 5 Indian-made Drums, Flutes, etc., p. 149-151 in companion volume.

N0. PLAINS-STYLE GRASS DANCE SOCIETY WHIP
Hand-carved wooden handle studded w/ brass tacks; handle is navy undyed selvedge wool. Full foxhide hangs from handle embellished w/red & blue undyed selvedge tradecloth. Fox hangs 52"-quirt apx. 50." Est. 175-250

Top to Bottom: **OSAGE OLD-STYLE FEATHER FAN**
Buckskin-wrapped handle in abstract floral:cranberry red, mustard, C. pink, dk. blue & porcelain white outline. Bkgrd:gr. blue & red w. heart. Tiger turkey w/red fluffs. 16"L. Est. 175-250 **SOLD $150(96)**
CHEYENNE OLD-TIME FEATHER FAN
Buckskin-wrapped handle has 14"L fringe w/beaded stripes in white w/gr. yellow, red w. heart & Chey. pink. Bead-wrapped drop w/hawk bells & aged tin cones. White feather fluffs on legal lightning striped eagle feathers. 17"L. Est. 175-250 **SOLD $200(94)**

KIOWA-STYLE PEYOTE FAN
Beaded handle is gourd stitch:white bkgrd. w/ intricate design in apple green, Chey. pink, mustard & med. blue w/ cobalt outline. 2 feathers also have beaded base. Pheasant and macaw feathers. White buckskin twisted fringe. Fringe- 12.5"L Feathers-14"L. Est. 450-650 **SOLD $440(95)**

HORSE DANCE STICK
Brass tack eyes w/ red face paint. Buffalo hair mane. Buckskin reins w/red w. lined Crow beads, brass beads & brass hawk bells. Red undyed selvedge wrapped w/buckskin lace on handle. 27"L. Est. 295-395 **SOLD $295(96)**

SIOUX-STYLE HORSE DANCE STICK
Made of rust painted wood w/yellow, black & red painted designs. Buffalo hair mane & real horsehair tail. Red cloth w/feathers & trade beads hang from center. 21"L. Est. 90-150 **SOLD $135(96)**

NO. PLAINS-STYLE RAWHIDE PERFORATED MEDICINE RATTLE
Inspired by a rare original. Wrapped w/old red wool has black horsehair drop & pale yellow feather fluff drop. Looks old. 20"L. Est. 95-150 **SOLD $75(92)**

184

CROW-STYLE DEER TOE RATTLES Pre-1840 style
Black & white pony bead wrapped handle & sewn triangles on 11" buckskin drops. 15" long. Est. 125-175 **SOLD $95(88)**
Pony Trader blue, white & rose w. heart pony beads wrapped handle (over red tradecloth) & sewn beadwork on moosehide drops. Est. 125-175 **SOLD $150(93)**

NO. PLAINS OLD-TIME RAWHIDE RATTLE W/BEADED DROP
Drop has triangle designs in t. red, porcelain white, cobalt & c. pink. Artif. sinew sewn & wrapped handle. 11"L. Drop 5" w/buckskin fringe. Est. 100-175 **SOLD $85(94)**

Top to Bottom: **GOURD RATTLE W/BEADED WRAPPED HANDLE**
Lt. blue w/designs in maroon, brown, yellow, green, & med. blue. White horsehair top & bottom. Red, white & blue bead strings & matching ribbons hang below gourd. Intricate design. 17"L. Est. 125-175 **SOLD $193(95)**
SIMILAR construction. Pattern pred. white w/red, lt blue, & cobalt beads. Black horsehair each end. Est. 125-175 **SOLD $125(96)**

CROW-STYLE "CRAZY DOG SOCIETY" RATTLE
Original in Buffalo Bill Historical Center-Cody, Wyo. Red elk rawhide hoop sewn w/elk sinew. Faded red wool undyed selvedge cloth bound to willow grip w/buckskin. Brass bells & imit. eagle feathers w/red cloth embellish hoop top. Smoke patina. Total L-14." Hoop W-5.5" Est. 95-150

PAINTED HAND DRUM W/ BEATER
Primary colors yellow w/black, dk. blue, red & green. Rawhide covered wood frame w/heavy wire across back wrapped w/red cloth. Sturdy construction. Good sound. Cloth covered beater. 17.75" diam. Est. 375-450 **SOLD $400(95)**

ADDITIONAL RECOMMENDED TITLES: Early Pre-Reservation Period, Plains & Plateau Culture. *Splendid Heritage*, Masco Coll. Exhibition Catalog, Santa Fe, Wheelwright Museum 1995. Thomas, T. & Ronnefeldt, K., *People of the First Man* (1830 Bodmer paintings) NYC: Promontory, 1982. Hanson, James A., *Little Chief's Gatherings*, "G.K. Warren 1855-56 Coll." Crawford, Fur Press, 1996. Taylor, Colin F., *The Plains Indians*, London: Salamander, 1994.
Plateau Material Culture
Wright, Robin K., *The Time of Gathering*, Seattle: Univ. of Wash. 1991.

Recreating the Past

Fort Union Trading Post National Historic Site, 1829-1867

The American Fur Company's greatest outpost on the Upper Missouri was central to the fur trade for Assiniboine, Crow and Blackfeet Indians who were immortalized by the pen and brush of it's famous visitors; George Catlin, 1832; Prince Maximillian of Weld, Karl Bodmer and later by photographer Illingworth in 1866. It is now fully re-constructed upon the original excavated site;the stone bastions, log palisades and central Bougeois House look like they did in 1851 when the fort was at it's peak. See photo below center w/ re-created buffalo hide tipi in the foreground and Preston taking video shots. Even the imposing flag pole has been re-created and hoisted by a group of volunteers from the local vicinity of Williston, No. Dak..

The sketches shown here were all done by Swiss artist Rudolph Frederick Kurz who worked at the fort in 1851. Upper right is the interior of the "Indian Reception Room." Upper left on this sketch portrays an eagle flag used in both trade and recognition of high ranking visitors, in this case, a Cree chief*.

Courtesy Montana Historical Society, Helena

A trade Rendezvous is held annually as a living history re-enactment. The authors, Preston Miller and Carolyn Corey, and Allen Chronister were speakers at this event in 1990. They are posed here on the re-constructed porch emulating the "Indian Chiefs and Squaw" photo taken by Wm. H. Illingworth in 1866 on the original porch of the Bourgeois House (far right). This photographer also took the bottom right facing page photo of the same house in that year; these are the only known photographs taken of the fort. Note condition of the house shows deterioration; the fort was dismantled in 1867 due to a decline in trade after the Civil War. The materials were used to construct an army post, Fort Buford, nearby.

Far right, is a Kurz sketch of a Salteaux (Chippewa) woman, also shown seated in the trade room sketch above. The dress top on Carolyn's strap dress was made by Allen Chronister, solely from this black and white sketch. Both headdresses worn by the men were also made by Allen who is also an attorney and historian. Lower right is a photo in a museum of the original 1830-style moccasins worn by Carolyn. Her replica pair has painted parfleche soles. Preston made his Plateau-style coat over 20 years ago and has worn it to many Rendezvous!

Suggested reading:
People of the First Man, First-hand Account of Bodmer-Maximilian's Expedition up the Missouri R.,1833-1834, NYC, Promontory Press, 1982, pp. 49-68. Journal entries and paintings at Ft. Union.

*See: Thompson, Erwin N. *Fort Union Trading Post,* "Fur Trade Empire on the Upper Missouri," Medora, Th. Roosevelt History Assn., 1986.

Rendezvous Scrapbook

by Carolyn Corey

The authors are at the confluence of the Green River and Horse Creek in Wyoming in 1992, the actual site of the *1830-40 "Green River Rendezvous."* (Note beaver cut tree trunks to the left.) This is in an area rich in beaver which were sought after by the dominating American Fur Co. and other smaller competitors. By 1840 the beaver were depleted and the beaver hat was no longer in fashion and it was an end to the era of the mountain man.

Preston attending his trade goods at the *Western Nationals in Colo. 1984*

A *Rocky Mountain Rendezvous** is an annual meeting of trappers and Indians with traders at specified remote sites to obtain furs in order to transport them by caravan back to the East. These events were lively affairs with contests, brawling, drinking and gambling as well as trading. "By night the cottonwoods along the creeks and the tents of the trappers were like the tourist camps outside of town today." (*Across the Wide Missouri* by Bernard de Voto, Riverside Press, Cambridge, 1947.)

See also: *Rocky Mountain Rendezvous* by Fred R. Gowans, Provo: Brigham Young Univ. Press, 1976.

*See Chapter 2, *Hudson's Bay Co. Collectibles* for an in-depth discussion of the fur trade era

The following photos were taken primarily at Western National Rendezvous attended by the authors as traders. These events, like the originals in the 1830s, are held annually in a different locale each year. The attendees must wear period clothing at all times and all cooking and living quarters must also be appropriate.

Mark Miller and son Jesse at the *Polebridge, Mont., Rendezvous, 1992.* Mark holds a Crow rifle case that he made-Jesse wears an original "saved list" breechclout plus a knife case that Mark made. Mark also does excellent restoration work.

This Blackfoot-style tipi was painted by Mark, who is seen in the foreground. *Thompson River, Mont. Rendezvous, 1979.*

A group at the *Polebridge, Mont. 1992 Western Nat. Rendezvous.* A beautiful site that is near Glacier Natl. Pk. and feeding ground for grizzlies when we're not here!

Top left: Carolyn, above right, adjusts her dog Brownie's travois at *Polebridge Mont. Rendezvous, 1992.* She wears a Blackfeet "Sunday dress" that she made. (Also see title page photo with same dress.)

Top right: Above left, (L to R) Preston Miller; Harriet Blas, trader, wearing green "saved list" she made from Carolyn's wool; Carolyn wearing Cheyenne dress she made from her wool; and Jill Barber in a buckskin dress she made. *Vipond Park Naional Rendezvous, Montana, 1991.*

Left and bottom left: Benson Lanford, below, Plains historian and Indian Art dealer, is a new trader to the Rendezvous circuit. He wears a traditional Prairie outfit w/old beaded rainbow selvedge breechclout and old and new woven beadwork sashes, garters and armbands; otter turban and ring brooch covered shirt. *Vipond Park Rendezvous, Mont. 1997.*

Leo and Katie Hakola, far right, at the *Polebridge, Montana, Rendezvous, 1992.* Leo is a bead trader who is wearing the dragon breastplate, shown on p.59, which he has embellished with trade beads from his stock. Katie is known for her unique original beadwork, some of which she is wearing.

(Below right) Judge Clyde M. Hall, Shoshone-Bannock tribe, Fort Hall, Ida. who brought a Powwow group from his reservation to participate in nightly dances at the *Jackson Hole Wyo. Centennial Rendezvous, 1990.* He wears "saved list" leggings and breechclout from Carolyn's cloth; note blanket strip over his shoulder. He also wears a loop necklace and hairbow ornaments like those pictured on p.126.

189

Above left, Carolyn and Preston dressed for a living history weekend at *St. Mary's Mission at Stevensville, Mont.* commemorating the Montana Statehood Centennial, 1989. This was the 1st permanent white settlement in Montana which was established in 1841.

Close-up, above right, shows they are wearing traditional Blackfoot clothing made from striped selvedge tradecloth, also called Hudson's Bay stroud, dyed by Carolyn. Her dress is a copy of a Piegan original in the Phoebe Hearst Museum of Anthropology, Univ. of Calif at Berkeley. (See other women wearing her dress below.) Her capote (hooded blanket coat) is a copy of one in the Glenbow Museum, Calgary, Alb. Canada. Preston's shirt is a composite of Blackfeet styles. Note his genuine bear claw necklace.

Juanita's father, artist Jim Fogarty, did the painting (far right) which was featured in an article written by the author on how to make this Piegan dress in *The North American Indian Magazine*, Vol. 1, #3, Chico, 1981.

Carolyn wears dress described above and stands w/ Keith Gilbert, master craftsman, wearing Crow-style shirt and hat that he made. He holds a Sioux-style rifle case and Crow-style blanket. His shirt is made from a Hudson's Bay blanket. *Polebridge Rendezvous, Mont. 1982.*

Carl Ontis and Elizabeth Pidgeon pose on Bastille Day at Colorado Western Nationals, 1983. Note the French cockade ribbons on their hats. See description of dress above. Note Liz has "tatooed" chin. Carl wears 2 triangular flap bags.

Juanita Fogarty poses in her home with HBC copper pot, otter braid wraps and traditional scarf in 1980. Her mother is Joyce Growing Thunder, well-known Assiniboine beadworker.

Top Row:
Left: Bob Brewer, master replicator, poses w/his pistol case in 1985 (seen in the companion volume, p. 194). He and his brother Bob have made many authentic movie props ie; *Dances with Wolves, Son of the Morning Star*, to name a few.

Center: Steve Rickard, "Red Tail", a craftsman who is frequently seen at Powwows, is here at Four Winds Trading Post getting ready to dance at the *July 4 Arlee Flathead Powwow in 1986*. He wears a flag shirt he made as well as a quirt, breastplate and mocs. He also gives school lectures on Plains Indians.

Right: Pat McCurry, craftsman and musician, wears Lakota war shirt he made that sold in our 97 Auction, p.129. Note buffalo tooth necklace and red "saved list" breechclout. *Red Lodge, Mont. Rendezvous, 1989.*

Second Row:
Left: Jean Heinbuch, quillworker and author, shows one of her quilled pipebags at the *Kalispell Mont. Free Trappers Winter Rendezvous, 1985*.

Center: Jerry Farenthold, craftsman, poses in the Metis Indian outfit he made and wore to win "Best Indian Outfit" contest at *Fort Bridger, Wyo. Rendezvous in 1984*. Notice the beaded leggings, German silver armbands, assomption sash and bear claw necklace.

Right: Doreen Meisner, "Red Quill Woman", does quillwork at *Vipond Park Nat. Rendezvous, Mont. 1991*, in front of her tipi. Note backrest, buffalo skull and her tradebeads.

Gary and Louella Johnson from the Crow Reservation in Montana are frequent participants at Rendezvous.
Upper Right: Gary is shown preparing Louella's horse for the parade at *Crow Fair 1985*.
Lower Left: She is shown in her traditional Crow elk tooth dress at *Moccasin Basin, Wyo. Nat. Rendezvous, 1987*, wearing beadwork made by her husband, Gary. Louella's Crow maiden name is White Man Runs Him.
Center Above: Metis frock coat Gary recently made for himself.
Above Right: He sits at a backrest that he constructed w/the top adorned in a rare Plains Cree style backrest banner that is symbolic of a buffalo surround. The bottom part is a buffalo calf hide decorated w/quilled patterns that are symbolic of buffalo eyes and ears. The background material is Carolyn's "saved list" tradecloth. *Jackson Hole Wyo. Centennial Rendezvous, 1990*.
Below Right: Gary, Carolyn, Preston and Bob Guiterrez sit in a "kiva" at a Rendezvous social gathering *Polebridge, Mont. 1992*. Carolyn is wearing a Chippewa-style strap dress (w/sleeve cape) that she made. The cloth is her "saved list" wool. *Photo taken by Leo Hakola*